38,50

# Paintings from the Marches

# Paintings from the Marches | Gentile to Raphael

*by Pietro Zampetti*    *Translated by R.G. Carpanini*

*Phaidon*

Phaidon Press Limited, 5 Cromwell Place, London sw7

Published in the United States of America by Phaidon Publishers Inc.
and distributed by Praeger Publishers Inc.
111 Fourth Avenue, New York, N.Y. 10003

First published 1971
Originally published as *La Pittura Marchigiana da Gentile a Raffaello*
© 1969 by Electa Editrice, Milan
Translation © 1971 by Phaidon Press Limited

ISBN 0 7148 1500 4
Library of Congress Catalog Card Number: 71-158101
All rights reserved

Printed in Italy by Fantonigrafica, Venice

# CONTENTS

*To my father*

The first attempt to gather what is known of the art of the Marches into a single, historically coherent work was made in 1834 by Amico Ricci, in his *Memorie storiche delle arti e degli artisti della marca di Ancona* in 1834. This book is still a most valuable work of reference because of the many notes, documents, and the often useful critical judgements it contains. Ricci himself had followed in the steps of another illustrious son of the Marches, Abbot Luigi Lanzi, who, in 1789, laid the foundations of modern art historiography with his *Storia pittorica d'Italia*.

Almost a century passed after Ricci's publication before another book appeared on the subject. In fact, it was in 1929 that Luigi Serra published the first volume of *L'Arte nelle Marche*, a work of fundamental importance. The second and last volume came out in 1934, but it only goes as far as the sixteenth century, and only deals with the beginning of this—Raphael, for example, being excluded.

Serra's work is still valid, because of the amount of information, attributions and illustrations it gathers together. He must also be given credit for having fully taken into account what had been done before him, especially during the years of intense research between the end of the nineteenth century and the first decades of the twentieth. It was during this period that worthy local scholars carried out their most important research in the archives. Besides this, the art, and particularly painting of the Marches, began to draw the attention of the most perceptive critics. Cavalcaselle, Frizzoni, Berenson, van Marle and Venturi began the systematic study of the region's art and painting, with particular reference to the fifteenth century, and this led to the important Macerata exhibition of 1905, which succeeded in arousing considerable interest in a cultural phenomenon that had been largely ignored until then.

Serra deliberately entitled his book *Art in the Marches*, and not "the Art of the Marches", since, he affirmed, "it is better to begin by recognizing, in accordance with the principles of absolute objectivity, that the Marches did not have a consistent, organic, autonomous artistic development through the centuries, with their local centres of creative production, and works of art connected by clearly unmistakable characteristics of their own". He insists that it is not enough to point to particular movements in art, which sprang up here and there at different times—such as Romanesque architecture, Fabrianese painting between the fourteenth and fifteenth centuries, or the painting of San Severino and Camerino in the fifteenth etc.—in order to justify our proclaiming the existence of a school of art in the Marches.

But those who believe art to be an aspect of history, and that it can only be born of a particular cultural situation (of which it is the reflection), will find Serra's statement categorical to a fault. There is a great variety of artistic expression to be found in the Marches, and this bears witness to a unique historical situation, determined by the small busy towns scattered throughout the hinterland. If, therefore, art is an aspect of history, there is no doubt that the art that flowered in the Marches can only be called "the art of the Marches". For example, we may say that even the "school" of Urbino, to which many artists of different cultural backgrounds contributed, was a clearly autonomous unit of its own. And this, because of the particular atmosphere that prevailed at the court of Federico da Montefeltro, and the effect such artists as Piero della Francesca and Luciano Laurana had on it.

It is difficult to tell whether history conditions artistic creation in a certain way, or whether it is the latter that determines those characteristics which later become the hall-marks of a culture. The two factors are probably inseparable. But the fact is that the particular mode of expression we have referred to could only have been the product of a local situation. To continue with Urbino we may say that its characteristic culture, or, if we prefer, those ideals to which it aspired, could only have been realized at that particular moment in time, and in that particular place. It is hardly necessary to add that, but for this cultural climate, neither Raphael

nor Bramante would have emerged, at least, not in the way they did. And our purpose here is not to formulate hypotheses, but to make statements based upon an historical examination of the facts. There is no doubt that the flowering of Marchigian painting in the fifteenth century is closely connected with a period of political stability and economic prosperity. The various aspects of the major schools of painting in the Marches will be analysed in their differences and similarities, as well as in their relationship to the rest of Italian painting. But if there is one characteristic that immediately emerges as a single constant factor in the painting of this region, it is its readiness to accept the most diverse tendencies, its capacity to assimilate the figurative styles of northern and southern Italy. The region was a meeting place. It was also a place where different influences clashed. But it succeeded in fashioning out of these influences a clearly distinguishable style of its own, which was often expressed differently within its various currents.

This book, therefore, is an attempt to trace a panoramic view of a century of Marchigian painting on the basis of studies that have appeared since Serra's publication. The subject, though limited, is nevertheless vast, and this work is exploratory and does not aim at being definitive. It does not even claim to include all that has been written on the subject, since the attention of critics has been gradually, but increasingly drawn to the art of the Marches in recent years, and it has been impossible to check everything. It is only a contribution to the far greater task of enquiring into the history of painting in the light of new experiences and new critical exigencies, that is, by regarding art as the evidence of a historical moment.

In 1950, an exhibition of Venetian painting in the Marches was held at Ancona. This was intended by the organizers to be the starting-point for a critical re-examination of the whole of the region's painting, a project that was to be realized through a series of similar exhibitions of regional art. Though these intentions came to nothing, there has been no abatement in the study of the subject. The work carried out by the Superintendence of Art Galleries in promoting indispensable restorations, especially of frescoes, has led to a more direct familiarity with fifteenth-century art. It is sad to have to add that, in spite of what has been done, there are still far too many work of art in the Marches in danger of being lost. Too many churches, in a state of near or total neglect, remain defenceless, and exposed to the danger of being despoiled of their artistic treasures. Works of art are jealously watched over by museums, especially abroad, but those that remain in their original locations—which are often isolated—have the saddest of futures before them. Even the authorities and offices assigned to the conservation of these treasures focus their attention more on what has already been saved, rather than on what remains to be saved. The Marches are thus on the point of losing part of their artistic patrimony, and of seeing works of exceptional value

for the history of the region's civilization, about which so little is known, destroyed. The same is true as regards the minor arts, that is to say, craftsmen's work, examples of which are becoming ever more rare and difficult to find. For though modern technology has made them obsolete, some of these objects are the precious evidence of the work of generations. These generations succeeded in giving life to the humblest of objects by virtue of their creative instinct, the same instinct whereby man has given value to his experience, confirmed his individual existence, and made tolerable, acceptable even, a life of hardship, where the only hope lies in the giving of oneself to the created object.

What is needed is a regional museum, to gather together works of art and the works of artisans; everything, that is, that history has handed down to us. And this must be done before these works are lost or destroyed by our consumer civilization and by the ubiquitous impulse to make everything new, whether it be in the church or in the home, in accordance with certain widespread needs. Such a museum, efficiently organized and supported by all the provinces of the Marches, would be the witness to a great civilization, and provide a highly significant contact with a truly authentic way of life. Moreover, it would serve to awaken in us a sense of history and a conscious, critical awareness of historical values.

One positive event was the 1961 Venice exhibition dedicated to Crivelli and his school. The reappraisal of Crivelli's artistic personality, since he was Venetian by birth and Marchigian by adoption, has once more raised the question of the study of local art, a question that was dropped after the above-mentioned Ancona exhibition of 1950. The Venice exhibition, together with Zeri's perceptive work on the subject (we owe much to this scholar for his reconstruction of the artistic personalities of certain local artists), have placed the study of art in the Marches on a new basis, separating it once and for all from that of Umbria, with which it has been too often confused. It must not be forgotten that the Perugia exhibition of 1907 also included many artists from schools in the Marches, thus committing a grave critical error, since the latter are quite different from the world of Umbria, both stylistically and qualitatively.

Many studies have appeared since 1961, and we are waiting for still more. Here we should mention Vitalini Sacconi's volume on the school of Camerino, and that of Dania on the painting of Fermo and its surroundings.

The present work might serve to arouse interest, and slow down the rate at which works of art are leaving the Marches, one of the most plundered regions in history. It has already lost a part, at least, of its real artistic physiognomy, and to see the art of the region, one must go to the Brera, the National Gallery in London and to museums in America. Since 1861, when Morelli and Cavalcaselle drew up the first of works of art in the region, on the invitation of the Minister Quintino Sella, some have been

exported and others lost. Nor can it be said that the immediate prospects are such as to reassure those who feel the call of history.

I am grateful, therefore, to the Land Credit Institute of the Marches for the generosity and farsightedness it has shown in making the publication of this book possible, and for having entrusted me with the task. This has given me the opportunity to connect the studies planned and begun as long ago as the 1950 Ancona exhibition, with those resumed in 1961 after the exhibition in Venice.

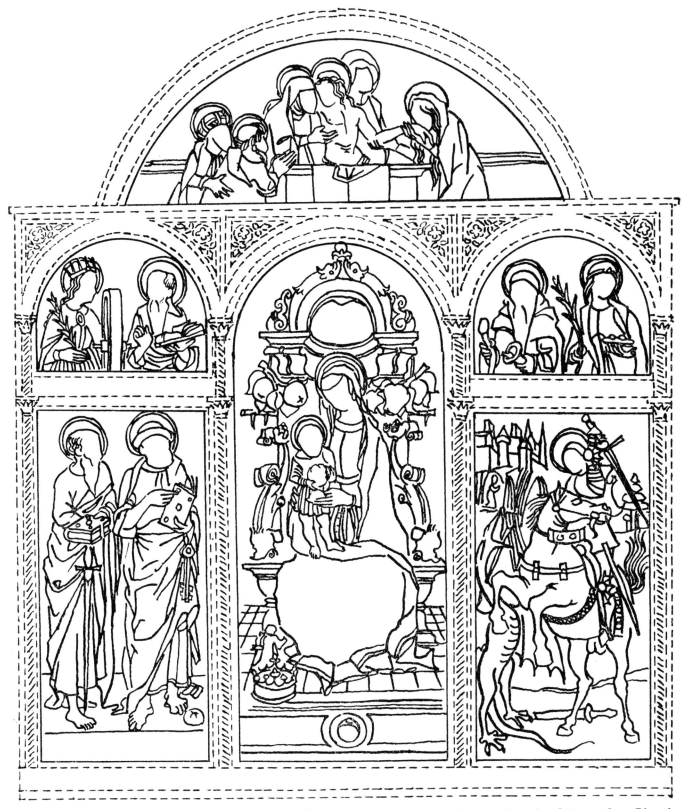

Reconstruction of the altarpiece by Carlo Crivelli (1470) formerly in the Parish Church of Porto San Giorgio (Porto di Fermo), now dispersed.

Centre: *Madonna Enthroned with Donor*, Washington, National Gallery of Art, Kress Collection; lunette: *Lamentation*, Detroit, Institute of Fine Arts; left lunette: *SS. Catherine and Jerome*, Tulsa, Philbrook Art Center; below: *SS. Peter and Paul*, London, National Gallery; right lunette: *SS. Anthony Abbot and Lucy*, Cracow, Museum; below: *St. George killing the Dragon*, Boston, Isabella Stewart Gardner Museum.

The history of fourteenth-century painting in the Marches has still to be written. Many examples of it still remain and bear witness to a period of social vigour and, perhaps, economic well-being, while they most certainly present us with evidence of a real living culture. The frescoes at Tolentino, Jesi, Fabriano, Montefiore and Urbino are tied to a figurative style that is Romanesque in origin—unfortunately, except for a few series of fragmentary frescoes and an occasional painted cross, little remains of Romanesque art in the region. But it is a style that has also felt the influence of the artistic revolution brought about by Giotto. In fact, all the painting of the Marches in the fourteenth century reveals the direct or indirect influence of the great Florentine master.

The studies carried out in the last few decades have led to the attribution of much that is contained in Marchigian painting to the influence of Rimini. And yet, the identity of the artist responsible for the frescoes in the major chapel of S. Nicola at Tolentino is still unknown, though he was first said to be Baronzio, then Pietro da Rimini, and finally, one of the latter's followers. But it is now clear—as Volpe, indeed, admits—that the Tolentino cycle is the result of a collaboration between many artists under the direction of one leading personality. This, in turn, implies the existence of a school of local extraction which enabled many artists to express themselves in a style that was both uniform and coherent. The same may be said of the other cycles, in which, side by side with a style of Riminese derivation, can be found elements directly connected with the world of Assisi, where, as we know, Giotto, Simone Martini, Pietro Lorenzetti and other great Tuscans of the fourteenth century had worked, protagonists in the greatest pictorial flowering of the time. The same is also true of that other important current which has its very active centre in the town of Fabriano. For here too we find genuine, even if anonymous, artists, with their own unmistakable personalities, such as the Master of S. Emiliano, the so-called Master of the Coronation of Urbino, or again, the Master of Campodonico, whose importance goes

beyond the merely local, as is well borne out by his stupendous *Crucifixion* in the church of S. Biagio in Caprile.

If, besides this, one takes into account the Riminese painters who were particularly active in the northern parts of the region, as well as the artists from Bologna and Venice who can be found painting throughout the Marches, it becomes clear that the region was deeply involved in the development of contemporary painting, and that it was culturally open to the most diverse influences and ready to assimilate all that was best in them.

It follows that the region must have already been sufficiently sensitive artistically to understand these many complex cultural ferments. Without postulating the existence of a composite regional style, we must recognize the fact that by the fourteenth century the region had already emerged from its apprehensions, its uncertainties and poverty, and was intellectually, economically, and therefore culturally alive to the most significant discoveries of the time. The very rise of numerous small centres, especially in the central parts of the region, the splendour of the churches and public buildings with which the people embellished these towns and others of greater importance in the course of the century, provide the best proof of a society on the move; proof, moreover, of a society in contact with other centres and regions, some of which were among the most advanced and dynamic of their time. If art is the witness to history, if it is the fruit of a particular social condition, then we must grant that the culture of the region must have been particularly fecund to have generated this otherwise inexplicable art. This now remote world lies buried beneath the dust of time, out-distanced and overwhelmed by the continual advance of civilization. Those who wish to uncover it must try to imagine the times as they were then, while keeping a constant eye on Italian art as a whole.

The first point to be noticed, after the most perfunctory examination of cultural conditions in the region, is the pullulation of small, active centres. This goes hand in hand with the lack of any leading

city such as might have performed the functions Florence did for Tuscany, or Bologna for Emilia. These innumerable communities gave birth to an equally great number of centres of painting. The latter, though similar, differed nevertheless, since some of them were dominated by a particular artistic personality. This artist would often combine within himself a number of heterogeneous tendencies. For if there is any region where artistic creation is the fruit of a kind of compromise between different artistic styles, it is the Marches, linked as they are to Venice by sea and sharing frontiers with the regions of the Tyrrhenian coast, Tuscany and Umbria. The many influences mentioned above testify to the fact that its cultural relation with the outside world must have been very close, for later they were to prove strong enough to influence and even generate the art of the region. Thus, one of the characteristics of Marchigian art, which is traceable throughout the fifteenth century, is its capacity to reconcile different stylistic tendencies and to absorb them in apparently impossible ways. That these styles then burgeoned in new works of art seems to be the result of a dialogue, rather than the imitation of this or that particular artistic current.

Our task then, is to reconstruct a culture that has been partially lost. Only in this way can a historical explanation be found for the strongly marked artistic currents that appeared in the Marches from the very beginning of the fifteenth century. Moreover, this considerable upsurge of creative activity is perhaps more important than it has hitherto been thought to be. One example is sufficient to illustrate this. The question whether Gentile was, or was not, a direct follower of Allegretto Nuzi, is of minor importance compared to the fact that he was the product of a clearly distinguishable background, which had already produced Allegretto, the Master of Campodonico, and the Master of S. Emiliano before him. That is, we must bear in mind that a school of painting already existed at Fabriano in the fourteenth century, and that this prepared the way that Gentile was to follow later, in his own original manner, picking up where others had left off.

The need to study fourteenth-century painting in the Marches has been recognized for some time, since it has now become clear that what came after in the following century did not spring from a vacuum, but emerged out of a widely evident, pre-existent complex of styles. This is confirmed when we look at the problem of that mysterious painter, Antonio Magister, to whom various works in the northern part of the Marches have been attributed recently. These include the *Crucifixion* at Mombaroccio and the fresco of the *Coronation* (previously in the church of S. Domenico and now in the Palazzo Ducale of Urbino). This interesting artist, in his efforts to achieve a refined stylization, seems, like his friend from Camerino, Cola di Pietro (if the latter really is the author of the *Crucifixion* in the Art Gallery of Camerino), to be the forerunner of certain stylistic characteristics later adopted by Carlo

da Camerino. It will not seem altogether strange therefore, if we affirm that these various tendencies served to inject life into the art of the Marches, not to force it to move in any particular direction, so that it was finally able to flower in its own independent way.

The fresco of the *Crucifixion* in the convent of S. Chiara at Camerino is of considerable importance for an understanding of the values of a figurative art that is typically regional in character. It was partly inspired by the works of the Master of Campodonico, and probably by the painting of Tolentino, while its sapid naturalistic details are full of an almost popular vigour. One cannot think of the school of San Severino, without seeing in the anonymous painter of this fresco (who, according to some critics, is to be identified with the still little-known Cola di Pietro) the inspirer of its leader, Lorenzo Salimbeni. For the fresco goes beyond what is still austerely fourteenth-century, combining pleasant narrative with a keen eye for episode and characterization, and re-presenting these elements in a form unmistakably connected with the courtly Gothic.

It was from the encounter between many different artistic tendencies, which took place during the heyday of Gothic art, that the little towns of the Marches, lapsed in the obscurity of their long slumber, drew what was necessary for the creation of their own local schools. And unless we take this historical situation into account, no real comprehension of what they achieved is possible.

At the beginning of the century, and perhaps even before the year 1400, the figurative art of the Marches is suddenly to be found totally in line with the more "progressive" trends in art, that is, those open to what is generally called "International" Gothic. The latter, in its remotest origins, goes back to Simone Martini, and after spreading throughout France, extended to the rest of Europe. Hence its name, though it is sometimes referred to as "Cosmopolitan" Gothic, with the obvious allusion to an identical concept of art that manifests itself everywhere in fairly similar ways. The most striking characteristics of this style are its linearity and its refined, even exaggerated decorative elegance. It rejects the severe, essential structures of Giotto's art—where the need to create space around the human figure had already been recognized and brings out the painting's rhythm at its surface level, leaving it free of anything that might suggest a third dimension, something that would be wholly out of place in a world seen as legend and fable.

Nor is this style simply the final manifestation of Gothic art. It was born of new needs generated by material well-being and the nascent humanist learning, which was particularly cultivated by the refined courts of the time. Thus, this art is also called, and rightly so, "Courtly Gothic", a term which defined both origin and character. Its favourite subjects are both traditional, that is, religious, and profane, since there are many paintings in this style

which depict chivalrous scenes, with elegant ladies and "gentle" knights: a complete novelty in medieval painting. Sometimes even the sacred subjects lose their religious intensity, their ascetic fervour, so indissoluble a part of the mystic feeling of the time, and become almost lost in the prominence given to details of colour and form, or to narrative motifs of a profane nature. Everything is a pretext for arousing, not a noble religious feeling, but, on the contrary, an interest in, and a love of, elegance and the profane. One typical example is sufficient to illustrate this, and it comes appropriately enough, from Gentile da Fabriano. We can see, for example, in his *Adoration of the Magi* (plate 12), how the religious event is swamped by the attention and descriptive curiosity with which the fabulous kings and their retinues have been portrayed.

Another aspect of late Gothic painting is its interest in nature, an interest which might seem to be in contradiction with what we have observed so far, but which exists nonetheless. In fact, it loves to dwell on the minutest details of reality, isolating them from the whole, and enquiring into them analytically. This explains the importance attached to design, of which we have precious evidence in the work of the Lombard, Giovannino de Grassi, and in the even more famous sketches of Pisanello.

Evidently, this style—which spread through France, Germany, Bohemia, Italy, England, and Spain—is indicative of a change in the cultural scene, with respect to what was traditionally Gothic. It goes beyond the latter, and represents something new. It is certainly not to be seen in relation to the Renaissance, which had quite different artistic aspirations, and whose art was motivated by deeply felt experiences, such as we see in the works of its leading figures, from Masaccio to Michelangelo. But neither is it the final manifestation of Gothic, that is to say, something bound to a waning world. Instead, it is the expression of a civilization at a moment of crisis, torn between asceticism and a new-found interest in the world, and caught up in that see-saw of sensations and ideals that had already perturbed the subtle sensibility of Petrarch, the great friend of Simone Martini. International Gothic is the fruit of this crisis, of a historical moment, whose contradictions and ideals it clearly and faithfully portrays. In brief, it is the visual evidence of an evolving civilization, which is no longer that of the Middle Age, nor yet that of the Renaissance.

As we have said above, this art was born of the encounter between Sienese Gothic and French culture, especially that which flourished at the court of the Dukes of Burgundy. But it is composed of an infinite number of elements, and the circumstances which gave birth and origin to certain formal styles—which appear in different parts of Europe almost at the same time—are still obscure. One must remember the great importance given to the miniature as a result of the renewed interest in culture. These miniatures, of which there were many in Lombardy, are found in prayer-books as well as in medical prescriptions, the so-called *Tacuina sanitatis*,

famous for their illustrations. It was precisely the miniature, together with the sketch, that did most to spread the Gothic style. Easily carried from place to place, it made possible the exchange of ideas, brought together and mingled creative incentives, and finally led to the fusion of tendencies, perhaps considerably different from each other, in one common crucible.

It has been noticed that Gentile himself, in his early works, has a tendency to adopt a miniature technique, but enlarging it to cover the whole surface of the panel. This is very significant, especially if we bear in mind that his liking for this method is particularly evident in those works which are attributed to his youth, such as the Berlin altarpiece and the polyptych panels in the Brera.

We now come to the most interesting part of our subject. In fact, at the beginning of the century, the Marches were one of the regions most open to the influence of the courtly Gothic, and not only as it was expressed in the Italian schools, but as it was to be found throughout Europe.

The courtly Gothic was quick to flower in the Marches, even before other Italian schools. Its birth was sudden, but clearly distinguished. Its centres were San Severino, Fabriano, Camerino, to which we must add Gubbio, halfway between Fabriano and Urbino, situated in Umbrian territory but politically tied to Urbino since 1385. It was here that Ottaviano Nelli was born and worked before he went into Montefeltro as far as Fossombrone. He also came across the Salimbeni brothers, who were active at Urbino where they had moved from San Severino. To these must be added Gentile da Fabriano, as well as Carlo and Arcangelo di Cola of Camerino, while pictorial cycles in the style of International Gothic multiplied throughout the region, from Fermo to Urbino. The most surprising fact—and the one most worthy of notice—is that Lorenzo Salimbeni, Gentile da Fabriano, and Ottaviano Nelli, who were already active at the beginning of the century, were all born about 1370, with Carlo da Camerino perhaps a little earlier, and Arcangelo di Cola just a little later. Other artists whose names are known, such as Olivuccio di Ceccarello, and others, who are anonymous, were all active at the same time, that is, in the first decades of the century. Also present were Antonio Alberti of Ferrara and the Venetians, Jacobello di Bonomo, Zanino di Pietro, Jacobello del Fiore, and Nicolò di Pietro, not to mention those Tuscan and Umbrian "neighbours", whose presence was more a matter of influence than direct participation.

This style pervaded the whole region, which was affected by it as if shaken by an all-penetrating gust of wind. Nor was it an ephemeral, inconsequential phenomenon, but something deeply rooted and fertile, which lasted beyond the prescribed limits of a current, though elsewhere it immediately dissolved on contact with the new ferments of the Renaissance. It conditioned painting in the region beyond the first half of the century, and often provoked "returns", or revivals, as in the case of the Urbanis and Lorenzo

d'Alessandro from San Severino, or that of Boccati, who, after working along Renaissance lines, rejoined the major stream of late Gothic art in his polyptych of Belforte.

Critical research into the origins of International Gothic in the Marches has not yet been completed. But a little credit will have to be given to the region's local artists in the end, instead of constantly enquiring into how the style came to the region. On the other hand, it is clear that the chance of its being taken up by local artists germinated spontaneously, as the result of certain cultural conditions. And since it spread so widely, and proved so congenial, one must indeed acknowledge that the cultural situation made its acceptance possible, and even stimulated it perhaps. The fact that it developed in the small, but advanced courts of Fabriano, Camerino and Urbino, is in itself significant. And the absence of any leading artistic personality—such as Giotto in Florence—probably widened the sphere of creative possibility. The presence of the Visconti in the Marches, and their relations with the region—the territory was the subject of dispute with the Popes, who only succeeded in annexing it in the seventeenth century with the death of the last Duke of Urbino—may partly explain the flowering of Gothic and the simultaneous presence of a number of famous artists. But however one may approach the problem, and whatever further discoveries may be made to help us understand historical context, it seems clear that the Marches produced an acknowledged school of painting, which was one of the most alive and progressive of its day.

A current opinion regarding the influence exercised by the Venetian school hardly seems acceptable when one analyses the archaic nature of the work produced by the Venetians in the region, that is, by Jacobello di Bonomo and Jacobello del Fiore himself. The latter, whose polyptych at Montegranaro di Pesaro appears still so static, underwent a marked change after his stay in the Marches, or, at least, after his contact with Gentile, whom he studied very closely, as we can see from his *Scenes from the Life of St. Lucy* at Fermo.

The problem, therefore, must be turned round, and the emphasis placed on the influence exercised by Gentile on Venetian painting. It is still an open question whether Zanino di Pietro ever stayed in the Marches. He worked in Central Italy, and is the same artist to whom Longhi has attributed the Marciana tapestries. He remains an obscure figure in many ways, but he was by no means unaware of Gothic art beyond the Alps, particularly that of the Rhine valley. But it seems excessive to regard him as the sole originator of the courtly Gothic in the Marches. Nor does the sculpture of Venetian influence, widespread throughout the region in the course of the century, from the Delle Masegne brothers to Giorgio da Sebenico, seem an adequate explanation. Moreover, one must remember that within the same current, that is, among those schools centred in the small towns that lie between the Appenines and the Adriatic, there were many currents, not just one, and that this should encour-age us to enquire in many directions, if we are to discover the real influences that prevailed. After the studies carried out by Zeri, interest in the earliest beginnings of the courtly Gothic has shifted to Camerino. In fact, the first steps in the direction of a new style were taken by Carlo, author of the *Crucifix* at Macerata Feltria, signed in 1396. This style finds its most perfect expression in the *Annunciation* at Urbino, where the Sienese influence combines with a certain solidity and the need for a solid, palpable environment. The author of this painting, who has only recently been rediscovered, is far from being completely known. But it is clear that he was one of a group of wandering artists who worked beyond the walls of their native town, and at Ancona in particular, where another obscure figure, Olivuccio di Ceccarello, was also active. Olivuccio must have already been famous in his day, if he was known to the Duke of Milan, and he might even have been the vehicle by which certain aspects of the Lombard style passed into the Marches. But if Carlo is the author of the *St. Francis* of Falerone, it is clear that he was familiar with all the stylistic devices of the courtly Gothic, such as the arabesque line and the lawn dotted with flowers. We also find in him the same caustic searching after truth that is later to be found in the more significant works of the Salimbeni. Nor must we forget, in tracing the origins of Marchigian art, the affinity and assimilability between this art and that of Bologna and Emilia in general. The first documented appearance of Lorenzo Salimbeni is in January 1400. In that month he signed the small tabernacle now in the Art Gallery of San Severino, a work wholly imbued with the most refined and precious of Gothic styles. We may assume, though it is not certain, that at the same time Gentile was putting the finishing touches to the *Madonna in the Garden* (plate 3; formerly at Fabriano, now in the Berlin Museum).

So that within a very short period of time, and within a few hours' walking distance of each other, two artists apparently cut off from the most vital and stimulating currents of the day are to be found assiduously practising the courtly Gothic style, and even contributing to the development of its main characteristics. It is difficult to find more outstanding antecedents for this style. Only Giovannino de Grassi comes slightly earlier; Michelino di Besozzo certainly does not, nor does any other painter tied to the particular current he followed. But one of the most surprising aspects of this parallel activity carried on by the Marchigian painters—Carlo da Camerino, Lorenzo Salimbeni, Gentile da Fabriano—is the fact that they worked in absolute independence of each other, with a vigour and vitality that drove each of them to follow his own way. Only later—particularly in the Urbino frescoes (1416)—does Salimbeni, or rather do the Salimbeni brothers, show (plates 104–120) that they have learnt from the example of Gentile, even if they accentuate the taste for episode and often pungent, analytical narrative. As painters, they are substantially different and complex in spite of their partnership, and it is quite untrue to say that only one

style predominates in these frescoes, and that its elements are indistinguishable. The truth is that the Urbino frescoes are an anthological "summa", where the two similar, but different, personalities of Lorenzo and Jacopo clearly express themselves, as we can see in the two *Madonna and Child* paintings. Placed side by side, one reveals the precise, elegant style of the miniature; the other, almost an explosive improvisation, has the unpolished forcefulness of a psychological *exposé*. The two tendencies converge in the *Crucifixion*: one is contemplative and refined, and the tenderness with which the story is told seems to take Gentile as its model as we can see in the group of holy women, or in the gentle, thoughtful face of the centurion, with its soft tints; the other is violent and turned towards a psychological interpretation which becomes caricature. This can be observed, for example, in the scene of the soldiers, some on foot, some astride rampant horses, and all caught up in an impossible whirl of figures, banners, flags, trumpets and spears. This is a world in revolt, worthy of Paolo Uccello's "metaphysical" painting, if only because of the unconcern with the beholder. The little scenes of quarrelling children, indifferent to the tragedy of the Cross and the drama around them, seem to suggest confusion for the sake of confusion and the absence of any co-ordinated organization of the whole.

Gentile's artistic development is too well-known for us to have to describe it, even summarily. But perhaps it is better to underline independence of his development and the constant coherence of his artistic sensibility, which is eminently thoughtful and contemplative.

From the little Berlin altarpiece (plate 3) to the Brera polyptych, which was formerly at Val Romita di Fabriano (plate 5), his style changes but its inner substance remains the same. The Lombard influence seems to prevail in the first painting, whereas the Sienese element is uppermost in the second. Longhi sees a possible connection between Gentile's early period and the miniature painting of Orvieto. But the fact remains that at Assisi—and in the painting of Simone Martini in particular—he could have found sufficiently provocative material to inspire his creative energies. Nor can we accept the facile objection that Simone's work was already out-of-date in Gentile's day. In the *Scenes from the Life of St. Martin*, the figures on the under-side of the arch above the chapel of the lower church of St. Francis would have been quite enough to capture the mind of the young, thoughtful, imaginative Gentile. This, together with the stimulus of the art of his own day, would have sufficed to spur him on to create that still, spell-bound world of refined narrative, such as we see for example, not so much in the festive *Adoration* at the Uffizi (plate 12), as in the two scenes depic ted in the predella to the left (plates 10–11), which are sublime in their compositional composure and magical execution. It is here we sense that inner search for an equilibrium which only the young Raphael—in what appears to be an analogous spiritual condition—was to attain later.

How decisive an influence Gentile was for Venetian art—for the contrary cannot be proved —is illustrated by the sudden change it underwent, first and foremost in the works of Jacobello. Unfortunately, little is known about the latter's activities in the Venetian-Lombard area, since what he left in Venice and Brescia has been destroyed. But the consequences of his work are sufficiently indicative to justify the classification of certain works under the title of Venetian-Marchigian painting. These works combine Gentile's style with local feeling, as we see for example in the controversial *Scenes from the Life of St. Benedict*, and, to a lesser extent, in the eight panels at the Musée des Arts Décoratifs. The same combination can be found in the many traces of Gentile throughout the Veneto and Lombardy.

As we know, Gentile's work took him to Florence and Tuscany at the most critical moment in Italian culture, when the first signs of a new figurative art based on the principles of the Renaissance were making their eruptive appearance. His *Adoration of the Magi* (plate 12) only just precedes the frescoes of the Brancacci chapel. He clearly felt the influence of Masaccio, but his relationship to Masolino is not so easy to establish. In the *Madonna* of the Quaratesi polyptych (plate 17), not only does he make his figures more solid through the use of *chiaroscuro*, but he even takes up Masaccio's iconography. At the same time he gives space a more dynamic function, whereas previously it had always been so monotonous and static. The elegant Gothic volutes and the ample folds of drapery give way to a greater corporeal consistency and a stricter method of design.

Gentile is at his closest to Masaccio in the fresco of the Madonna at Orvieto. At last he seems to have abandoned the search for dreamy gracefulness, and to be looking for the truth that springs from the contact with reality. Thus, the face of the Virgin, and even more, that of the Child, with their open almost startled expression, frankly express a desire to attract the attention of the beholder. Perhaps the fact that Allegretto Nuzi had already tried to follow a similar path is not insignificant.

From the festive Gothic of his early days to the realization that new artistic needs would have to be met, Gentile developed his style to the point where it must have become fully steeped in psychological naturalism. It must have been so in his last Roman works, now lost unfortunately, on which his reputation as the leading Italian painter of the time was based. For, on looking at the prophets in the frescoes of S. Giovanni in Laterano, Facio was able to observe that they seemed more like sculpture than painting. Gentile most certainly met another painter from the Marches in Florence, Arcangelo di Cola from Camerino. Arcangelo had been in Florence for some time before Gentile, and had gone there with full confidence in his own capacities. He had received his training in the school of Carlo da Camerino, a painter of great culture and marked personality, as we have seen. But Arcangelo

must also have turned elsewhere, if he was in fact the author of the little picture at Ancona (plate X), in which the Virgin and Child appear, surrounded by a corona of angels, against an extremely refined, gold background, inspired perhaps by Lorenzetti. In Florence (but perhaps even earlier, in the Marches) Arcangelo met Gentile, and became a keen and highly sensitive interpreter of his work. We can see in the *Madonna* of Rotterdam (plate 58), and in the delicate "stories" in Philadelphia (plate 53–57), that he followed a path in many ways similar to that of the great master of Fabriano, so much so as to make us think of a possible partnership between the two. He started painting in a refined Gothic style, which is exaggerated to the point of the heavenly bliss depicted in the above-mentioned panel at Ancona. He then turned to the totally luminous, elegant, almost profane painting so typical of the most precious of Gothic styles, only to be carried along by the changes that so characterized the decade between the twenties and the thirties, until he finally developed a more solidly based style of painting through the use of the contrasting effects of *chiaroscuro*. What is astonishing in the Osimo fresco (plate XI), which appears to be a late work (though some see it as an early one) is the search for space, for the third dimension, which we can see in the way the throne has been set at a distance, thus creating an empty space between the divine figures and the saints on the two sides. In brief, Arcangelo is an artist of considerable stature, whose great, pondered compositional structures can also be seen in his later works, which were, by then, clearly beyond the direct control of the great Fabrianese artist. The florid Gothic style, which prevailed from the beginning of the century to about 1440, was not just received into the Marches, a fact already significant in itself, but it sparked off a surprising burst of creative activity, which went beyond the limits of the region. Links with Lombard painting, or rather, with the Lombard miniature, there certainly are, but they are not sufficient to explain the flowering of so many artists and so many currents. The Gothic style lasted for a long time in the Marches; it ran off into little streams, and sometimes it had considerable consequences. The work of Giacomo da Recanati, Pietro di Domenico da Montepulciano, and Marino Angeli—the latter active in the lower Marches—is particularly significant in this respect. The Gothic influence can even be seen in the first works of Lorenzo d'Alessandro and Ludovico Urbani, artists tied to the influence of Salimbeni, but also attracted by Bartolomeo di Tommaso, who was active in the Marches. Throughout the region, from the frescoes done by Antonio Alberti of Ferrara in the church of the cemetery at Talamello—that is, in the extreme north—to the anonymous frescoes at Fermo, where the most diverse currents of the courtly Gothic seem to have gathered in the Oratory of S. Monica, there is hardly a town without some evidence of this particularly creative period in figurative art. This is true of Fossombrone, Cagli, Fano, S. Maria di Chienti, S. Vittoria in Materano (where the Abruzzese

painter, Giacomo da Campli worked towards the end of the period in a composite style of his own), and of Monte S. Giorgio; too vast a complex to have grown up by chance, and a most precious record of the dominant style and culture of the time.

The diffusion of the courtly Gothic style was at its moment of greatest expansion when the first signs of the Renaissance began to appear in the region. It is not easy to say where they appeared, or rather, when they began to be accepted. Both phenomena probably took place contemporaneously, though in different ways, in the two towns, which on account of the cultural formation of their rulers, appear to have been the most receptive towards the new cultural needs of the time: Camerino and Urbino. One must admit that Camerino is lacking in early examples of the Renaissance style of architecture. This is most probably due to the many difficulties its town planning had to face, partly because of natural catastrophes, such as earthquakes, and partly because the sandstone used for building flakes and crumbles into small pieces on contact with certain elements in the atmosphere. It is in painting that we find the first evidence of the Renaissance style. In 1445 Giovanni Boccati was at Perugia, where he plunged into the stylistic development that was taking place along Florentine lines. He approached the latter with keen intelligence, dazzled by the brilliant achievements of Domenico Veneziano, and was not unaware of those attained by Tuscan sculptors, or of the artistic sensibility of Filippo Lippi. Almost at the same time, but with a more thorough, disciplined vigour, Gerolamo di Giovanni was absorbing the teachings of Piero della Francesca, which already appear in his fresco dated 1449. And only a little later, the same path was taken by Giovanni Angelo d'Antonio, now clearly identifiable with the mysterious Master of the Barberini Panels.

Evidence of the influence of the Renaissance can also be found at Urbino towards the middle of the century in the main door of the church of S. Domenico, which the Florentine Maso di Bartolomeo was commissioned to do by Federico da Montefeltro in 1449, and which was completed two years later. In 1450, Luca della Robbia placed his *Madonna and Child with Saints* in the lunette of the same door, this work being one of the most significant examples of his artistic sensibility.

The Renaissance influence gathered in these two towns, with local artists being more active at Camerino, whereas Urbino could command the presence of illustrious artists from outside, such as Piero della Francesca, Luciano Laurana, Melozzo da Forlì, Justus of Ghent (Joos van Wassenhove), Pedro Berruguete and others. Only later did the presence of so many great personalities give birth to a local art, in the person of Giovanni Santi. Then, in greatness and in silence, came his son, Raphael, the fruit of a culture that had fermented for a whole century. A third town must be mentioned here as a centre of Renaissance influence, and that is Loreto. The sacred character of the town, which was almost

completely under the wing of the Basilica, isolated it from the main stream of figurative art in the Marches, but one must not forget that Melozzo da Forlì and Luca Signorelli went to Loreto, and that the construction of the Basilica itself took more than a century, in the course of which it attracted the presence of many great artists, from Giuliano da Sangallo to Donato Bramante. After the heyday of the Gothic style was over, the painting of Fabriano lost, at least partially, its creative character, which had been conspicuous in the fourteenth century. I continue to believe that the habit of drawing together the fantastic and the real crept into Gentile's style through the careful observation of his illustrious local predecessors. A critical reappraisal of the work of Allegretto Nuzi should go beyond the usual, predictable conclusion that he was the uncreative follower of Tuscan models. It would be better to analyse the whole of his artistic development, pointing out those touches of vivid description and humanity which anticipate certain elements in Gentile's late period, even though on a profoundly different stylistic level.

Except for minor local artists, such as the Master of Staffolo and other followers of Gentile, the only painter of note that Fabriano produced was Antonio, whose more archaic works were certainly influenced by Antonello da Messina. Antonio left his mark, either directly or indirectly, by virtue of a style that is at once severe and violent, meditative and poignant, almost to the point of being sorrowful. He is, in a certain way, the opposite of Gentile, whom he must have known in one way or another, and rejected artistically. In his *St. Jerome* (plate 38) in Baltimore (formerly at Fabriano) he sets about his task in a strictly Renaissance manner, that is, with a thoroughly geometrical and spatial technique. He endows the saint with the solemn dignity of a person conscious of his humanity, in a way that Antonello and Carpaccio were to do in the same half of the century. This solemn, austere concept of human nature justifies the attribution to him of the *Madonna* at Matelica (plate VIII), which has recently been connected with the school of Jacopo Bellini. The almost icon-like power of the figure, together with the rough fullness of form and the seriousness of character, shows that it could only be the work of an artist as austere as Antonio, even if he does use certain soft colours of Venetian derivation. But the sense of proportion and the subordination of colour to form are always present, qualities which make the *Crucifixion* in the Piersanti Museum (plate 43) such a great painting.

We have now come to the period, after the middle of the century, when Venetian influence began to gain the upper hand in the districts along the Adriatic coast. One artist affected by it was Francesco di Gentile from Fabriano, whose artistic personality is difficult to grasp, since it fluctuated on coming into contact with the most diverse influences. He took up one tendency after another with some facility, and seems at his ease in complex paintings where there is an abundance of narrative description. In fact,

his intricate *Crucifixion* in the Museum of Matelica (plates 35–35a) is of great interest, not least on account of the subsidiary scenes, which are described in a characteristic caustic spirit. Towards the end of the century Francesco came under the influence of the works Carlo Crivelli had left at Fabriano. As a result his style hardened, and his paintings became more concentrated. The restlessness so typical of late Gothic, or rather of the Renaissance misunderstood, disappears, and he succeeds in "fixing" his images, as we see in the *Madonna with the Butterfly* and in the *Portrait of a Young Man* (plates 29–31). But his colours remain dull and monotonous, with only an occasional use of brighter tones. He seems almost more concerned with design than with painting, and in this sense he is as much of an artist in his own right as Gentile or Antonio.

Renaissance ideas caught on quickly at Fabriano, but in a way unlike that at Camerino and Urbino. Antonio made a complete break with the style of Gentile, and already in 1451, in his *St. Jerome* (plate 38; Walters Art Gallery, Baltimore), we can see evidence of his contact with southern Italian painting, and through this, with Flemish art. After the middle of the century, other artists and painters of various extraction came from the Veneto and produced a considerable number of works in the region. But they also gave a new impulse to the renewal of the art forms they found, thus upsetting certain main currents in Marchigian painting, especially that of Camerino, of which more will be said later. In the artistic circles of San Severino, the main figures to emerge were Lorenzo d'Alessandro and Ludovico Urbani, both practitioners of a transitional style in which various elements are at play. In his early works, Lorenzo is very close to Bartolomeo di Tommaso, as we have said before. But he was also attracted by Bonfigli, and, therefore, by contemporary Umbrian painting, until he finally took up the style of Carlo Crivelli. Ludovico Urbani is a more complex, unpredictable figure. Also a follower of ornate Gothic in his youth, he was attracted by stylistic characteristics that combined the influence of Crivelli with others that probably derived from Foligno. Also present at San Severino was Bernardino di Mariotto, who had received his training in Umbria, but who slowly moved towards a style in which Crivelli seems to be a prominent element.

Therefore, what we have said about Gothic art may also be applied to the Renaissance. That is, there was no such thing as a school of painting in the Marches but only small centres of art, with their own independent characteristics, even though a fairly homogeneous style common to them all did exist.

What is most surprising is not so much the convergence of Tuscan influences at Urbino—which is understandable if we consider its close proximity to Tuscany and the personality of Federico da Montefeltro, with the many opportunities he had of establishing contacts—as the spirit of enquiry and knowledge that we find in the painters of Camerino. There are no documents regarding the journeys of Gerolamo in his youth, but it is certain that he

went to Borgo San Sepolcro or to other places where Piero della Francesca went, since his adherence to the latter's style is all too evident, even if his mental outlook, though just as frank and open-minded, is different, and his work less thorough and resolute. He is a somewhat idiosyncratic painter, who seems to see only the appearance of things in their authentic, visible simplicity, in contrast with the complicated elegance of late Gothic painting. Thus he painted almost instinctively those women with their characteristic fountain-like freshness, who remain luminous and transparent in the human tenderness they convey, and those faces taken from real life, after the frank, ingenuous, laughing, shy simplicity of the local peasants. The slender young girls whose features adorn the frescoes of Montecavallo and Bolognola (plates 77, 88, 89) are, perhaps, the finest example of an art that interprets a real human condition. On the other hand, the elegant, refined Boccati in his first works seems more infatuated with an art that searches after a world of legend and fable. This is how he appears in the first work known to us, a real masterpiece, the *Madonna of the Bower* (plates XIII, 59), where he reproduces in a Renaissance key the enchanted world so typical of the most refined, dreamy Gothic art. The angels singing and playing their instruments under the green trees have been treated with a sensibility unequalled in the painting of the time. Nor can we invoke the names of earlier artists such as Luca della Robbia, Donatello, or Domenico Veneziano, whom Boccati certainly followed in the assimilation of the sensitive awareness of light, and in the tenderness of image so congenial to him. The Saints, whose ritual solemnity renders the foreground monotonous, are completely surpassed for creative skill by the large group of angels, each of whom has been observed with wonder and attention. These are real choir-boys, a *schola cantorum*, and each of them sings in his own way, the expression varying from the frank and assured, to the ecstatic, to mid-way between the amused and the spell-bound (plate 60). The painter's ability in portraying a child's soul is quite exceptional, and this insight is joined to his capacity to gather the whole into a formal unity. Thus, he has succeeded in creating a rarefied, enchanted atmosphere beneath the green of the pergola, while the soft, gentle light of the still atmosphere envelops the music-making of the little *putti*.

Solemnity and frank simplicity, therefore, are the characteristics of Gerolamo's art, while in Giovanni Boccati we find a penchant for fable and an insight into the most subtle labyrinths of the human consciousness.

Was it coincidence or personal choice that took first Boccati, then Gerolamo di Giovanni to Padua, at the very moment when the city was passing through the most stirring and dynamic phase of its artistic revival? Though the question cannot be answered, it would seem improbable that the two painters happened to meet there by chance. It must be admitted however, that Boccati's

visit to Padua seems to be of little importance for his painting, whereas Gerolamo's debt to Mantegna is considerable. Nor can we judge how much Boccati contributed to the exasperated concern with style that characterised the school of Padua, if we accept as Gerolamo's (as Longhi has suggested and stylistic comparisons confirm) the *Departure of St. Christopher* (plate 78) in the fresco cycle of the Eremitani. The perspective is fundamentally the same as that in the *Annunciation* of Sperimento, now in the Civic Gallery of Camerino (plate 79). The compact, precise way in which Boccati arranges his compositions can only confirm his acceptance of Renaissance ideas. These ideas he first expressed after the manner of Piero della Francesca, but after his contact with the Paduan school they are expressed in a more tortured style.

However, Gerolamo di Giovanni's approach underwent a most striking change. This is borne out by the San Pellegrino polyptych, and again, in an almost sensational manner, by that of Monte San Martino (plate 91). It is remarkable how this painter, who must have been quite aware of what was happening at Urbino (as we can see from the Urbinese architecture in the *Annunciation* at Camerino, plate 79), later went back to a style which announces a gradual return to the Gothic world, and to those stylistic characteristics typical of the transitional period between Gothic and Renaissance. The crisis came in 1465—certainly not much earlier, since he painted the *Madonna of Mercy* (plate 85) for the *gonfalone* (banner) of Tedico in 1463, while the preceding year he still seems firmly tied to the wholly Renaissance perspective and dynamics in his fresco for the church of San Francesco at Camerino (plate 90), Isolation had evidently led the artist to a reappraisal of his art and to a new artistic outlook. The clash between old and new can be seen for the first time in the Brera polyptych (formerly at Gualdo Tadino; plate 84), which must fall into this highly anachronistic phase in Gerolamo's painting. He then went on to complete his development, if such a term may be used, in a tortuous way. For though he began painting in a decidedly Renaissance manner, his later works are the result of a strange mental hotchpotch of labyrinthine complexity. This consists of already obsolete Renaissance elements mixed up with recently revived touches of late Gothic, all of which put together makes up a vigorous, authentic, but archaic style. The phenomenon can be clearly observed in the famous *S. Apollonia* of the Brera polyptych. This stands out against the gold background of the altar, caught in the ethereal atmosphere of a spell, but devoid of the human commitment of his early works. But the source of his inspiration for these pictorial meditations is clearly revealed in the last work he signed, the little triptych of Monte San Martino of 1473 (plate 91). Bartolomeo and Antonio Vivarini had arrived in the Marches some years before, after 1460, and it is clear that their polyptychs (those of Osimo and Corridonia are known to us) must have caused quite a stir among the local artists, with their entrancingly decorative frames and the glittering

gold of their backgrounds. Gerolamo must have known these paintings, if only because of his stay in Padua, where the Vivarini brothers had worked, for it is clear that he fell under the influence of their gentle, sumptuous style. This caused him to forget his previous recognition of the need for a thorough geometrical basis, and he chose to follow in the steps of his colleague and fellow townsman, Giovanni Boccati. In fact, in the Monte San Martino polyptych, even the rules governing space and the proportions between the figures and the size of the panel are disregarded. As a result, St. Michael overlaps the sides of his panel and is disproportionately larger than St. Martin opposite. In the centre panel, the Virgin has an enchanted air, in the Boccati manner, and the angels behind the throne follow suit.

It was indeed a strange *contaminatio* that plunged Gerolamo into this incredible decadence and led him to imitate, if not plagiarize, an artist such as Bartolomeo Vivarini, just when the latter, artistically played out, was producing his worst work. At the same time we catch him turning to his own colleague from Camerino, another painter left behind by contemporary trends, if not actually engaged in reviving obsolete ones. In 1473 Carlo Crivelli signed the polyptych at Ascoli Piceno (plate 139), but any chance of an understanding between him and Gerolamo seems impossible, since the latter was totally unaware of Crivelli's existence. But the almost unbelievable fact is that it was Gerolamo who caught the attention of Crivelli, not, of course, with such late works as those of San Pellegrino and Monte San Martino, but with the early ones he had painted under the influence of Piero della Francesca. The *Madonna and Child* of the Bolognola chapel (plate 89), for example, is of considerable importance, since it undoubtedly provided Crivelli with a model when he painted the same subject for the altarpiece of Fermo in 1470 (plate 136), a work now exhibited in a fragmentary state in the Museum of Macerata. Any suggestion to the contrary—that it was Gerolamo who borrowed from Crivelli—falls before the fact that already in the San Pellegrino *Madonna* of 1465, Gerolamo's decline is clearly evident, and the same painting demonstrates his interest in Bartolomeo Vivarini, an interest which was to increase in the following years. Therefore, this artistic stage of Gerolamo's precedes even the arrival of Crivelli in the Marches, which must be placed immediately before 1468, the year in which he signed the polyptych of Massa Fermana. That Gerolamo should have returned to his previous style after 1470—date of the Crivelli *Madonna* in discussion—is not possible, bearing in mind the logical step that leads us from the polyptych of San Pellegrino to that of Monte San Martino. Thus it can be demonstrated beyond all doubt that it really was Gerolamo di Giovanni who influenced Carlo Crivelli, and who led him to that new use of light which appears in the artist's work from 1470 onwards, and which is so evident in the figures of the polyptych of Montefiore dell'Aso (plate 141).

The many *Crucifixions* and frescoes scattered throughout the district of Camerino reveal—in spite of their bad state of conservation, and the general state of neglect of the churches that contain them—the outstanding personality of this unpredictably talented artist, who occasionally succeeds in expressing a new power, as in the fresco of Raggiano, though it is impossible to say whether this is a mature or early work. There are other works too, such as those of Altino, or the *Madonna del Latte* in the church of Santa Maria della Macchie, though it is not at all easy to know whether this is his or the work of a similar painter, so full of surprises is the conclusion of his artistic career. Anyway, if these works are his, they must be assigned to his last period.

The artistic development of Giovanni Boccati is less intense than that of Gerolamo di Giovanni, of which we have just given a brief summary. Boccati, who also began in a Renaissance style, never worried about mastering the principles of perspective, or about the moral commitment of his figures. What he took from the Renaissance, or rather from the teachings of Domenico Veneziano, was the love of luminosity, by which he created those gentle forms that were to remain dear to him for the rest of his life. To blame Boccati for not having understood the real nature of the Renaissance would be like reproving him for not having been another person. I believe that his authenticity lies precisely in the fact that he persisted in his own vision, without worrying too much about what was going on around him. As we have said before, his sojourn in Padua left no traceable mark on his style. The frescoes of Urbino, though fragmentary and restored, are very important, and reveal something of the influence of Mantegna in the angels above the chimneypiece. But the illustrious persons represented—of whom only Mucius Scaevola is recognizable—are dealt with solely from the point of view of narrative and fable. They are still legendary figures, gentle and gracious in their bearing, such as an artist of the courtly style, not one affected by the experiences of Padua, might have conceived. As for the date of these frescoes, I do not believe that it can be a late one, as Zeri suggests. It seems more probable that they were carried out immediately after the artist's return from Padua, thus filling the gap in time between his recorded presence in the Venetian hinterland and his reappearance in his native region. On the other hand, the only trace of Paduan influence—or rather the most evident—seems to have found its way into some of the expressions on the faces.

Their travels over, Gerolamo and Boccati were back in Camerino after 1460, and there is abundant evidence to prove their presence there. The clearest proof that Boccati was working in his native town is the Belforte polyptych of 1468 (plates XIV, 65-68). What we have said of Gerolamo is true of Boccati, though to a less remarkable degree. He too, returned to the late Gothic sacred legends, though his basic style remained more coherent, and it was more the formal, external elements of his art that changed,

rather than its substance. However, the persistence of late Gothic elements is a fact that draws our curiosity and deserves attention. Evidence of it, for example, are the lawns dotted with flowers upon which the Saints stand (plates 66–67) placed to the right and left of the central panel of the Madonna of Belforte, who its enthroned, surrounded by a choir of angels.

The painter's detailed enquiry into the most refined aspects of the legend finds a natural subject in the little figures that decorate the outside pilasters, those of St. Barbara, St. Catherine, and St. Agatha. This we can see in their enchanted sweetness, in the luminosity and sensibility of their colours, and in their innocence, which is not just visual but substantiated by a creative efficacy and moral candour that are unprecedented and unrivalled, and can only be compared to certain works of the Sienese school. I would not say, as Longhi does, that this is a benighted form of the Renaissance, but that it is the figurative expression of an authentic, vigorous, indigenous culture. Both Boccati and Gerolamo di Giovanni are its authentic interpreters, each according to his own sensibility. Whether they are to be considered Gothic or Renaissance artists, or halfway between the two, is less important than the fact that their paintings have captured the image of the fifteenth century civilization of Camerino for all time. The long journeys they undertook are just one aspect of the particular situation in the Marches at the time. Why they were so thoroughly addicted to the wandering life is not easy to explain, as we have already said. Nor is it possible to point to the local situation alone, with its political struggles and their economic consequences. If this were the real explanation, then there would have been no need to go as far as Padua, a city, moreover, that had attracted quite a number of other artists. The reasons must have been quite different, determined above all by the question of cultural relations and the great desire for knowledge, which, for reasons not easily explained, motivated many local artists. Nor were Boccati and Gerolamo the only ones to leave their native town. Giovanni Angelo d'Antonio (known to us through the documents found by Feliciangeli), whose artistic activity has only recently been constructed by Zeri, is another example of the wandering artist from Camerino. A very cultured man, connected with the court of the Varano, companion of Boccati in his travels, as well as the friend of the Medici of Florence, he was a man of refined tastes, besides being a musician. The letter he wrote from Camerino in 1451 to Giovanni Medici, Cosimo's son, is signed "painter from Camerino", with the addition, "who played the lute". Giovanni Angelo, therefore, was not only a painter, but a courtier, and the friend of poets and patrons, in a manner typical of the Renaissance. The same can be said of Giorgione, a few decades later, since he too was both painter and music-lover.

Recent studies have thrown much light on the figure of Giovanni Angelo. His evident adherence to Renaissance methods—which is certainly more pronounced than Boccati's—affects more the surface of his painting than its substance. That is, it serves to create a fantastic atmosphere, in which architecture and light have their own parts to play, thus appearing intrusive rather than showing a thorough commitment to the principles of Renaissance perspective. Giovanni Angelo, too, saw humanistic figurative art as something to be borrowed from, rather than lived through and nourished from within. He too shows the same local disposition to seize upon the most diverse figurative elements and blend them into a single, smoother vision set in the atmosphere of a dream. This applies to the *Scenes from the Life of the Virgin* (plates 73–75), where the figures take their place so naturally beside those of Boccati in their enchanted, sometimes melancholic, but never violent participation in the events around them. Zeri has contributed to the identification of Giovanni Angelo's works, using even the men's fashion to establish their dates. But the gentleman with the strange cap over his shoulder in the *Presentation of the Virgin in the Temple*, is following a fashion that was by no means new at Urbino, but had existed much earlier in the century, since similar caps are worn by the gentlemen in the *Baptism of Christ* (plate 119) in the frescoes of the Salimbeni, which date from 1461. However, there is no doubt that Giovanni Angelo's work fully recalls the style that prevailed in the city of the Montefeltros and that reappears in the work of Boccati, as if to confirm that they had both been at the court of Urbino. But, in spite of appearances, Giovanni Angelo lacked what we may call a truly Florentine grasp of Renaissance values. As we have said before, he did not feel the values of perspective as a scientific fact, which had been explored by the most committed artists up to the time of Piero della Francesca. However, he has touches of great creativeness, and towards 1460, and beyond, we can see that he adapted better to the new discoveries.

Boccati's altarpiece from Orvieto, which we may notice follows the Belforte polyptych, seems to signify the artist's return to the Renaissance world he had, in fact, abandoned; almost a return to his youth one might say. But its attempt at perspective is almost naïve, really following the fable, and the whole altarpiece certainly cannot be regarded as the result of a coherent style. The only positive note, perhaps, may be found in the garland-bearing angels, which seem to testify to some kind of a partnership with Giovanni Angelo, in so far as they resemble those painted by the latter on the outside of the entablature of Federico da Montefeltro's alcove. In any case, this vacillation of Boccati's between nostalgia for late Gothic and the appeal of the Renaissance seems to end in favour of the former, on the qualitative level; there is no doubt that the Orvieto altarpiece falls short of the Belforte polyptych as far as creativity is concerned. But we have not yet done with the school of Camerino. After Giovanni Angelo, an unknown, violent painter appears on the scene, a painter who would seem to be quite unlike anyone else, and whose work seems to consist in a cycle of frescoes which decorate a little country chapel in an isolated part of

the Camerino hills. The Master of Patullo, rediscovered by local scholars, is now one of the problems of fifteenth-century painting. The first undeniable fact is that he had definitely been in contact with the Paduan school. Allusions to certain episodes in the *Scenes from Life of St. James* in the Eremitani recur so frequently, that further comment seems unnecessary, except to solicit a comparison between the great Paduan cycle, now largely destroyed, unfortunately, and this small, mordant account of the *Passion of Christ* (plates XVI, 93-95) by our anonymous Master. He has been named after the rural district where the chapel which contained his frescoes is to be found. The Paduan influence obliges us to suppose that the painter had visited the city. Thus, we have a third artist, at least, who went north to the Padua of Mantegna, that great melting-pot of new ideas. Nor is the case without parallel, when we think of yet another artist who worked on the boundaries of the Marches, that is, Giovanni Francesco da Rimini, who also drank at the same well. Nor need we mention Carlo Crivelli and Nicola di Maestro Antonio, who also came to the Marches, by different artistic routes, and perhaps unknown to the others, after being in contact with the Paduan school, either directly or indirectly.

The work of the Master of Patullo is distinguished by a tortured, caustic expressiveness, which is sometimes naïve, but always alive and pungent. He may have had some contact with, or felt the influence of, the violence in the work of Bartolomeo di Tommaso, the artist from Foligno, who was so actively committed to an expressionistic style. But our Master is also distinguished by a certain luminosity of his own and by the delicate, yet strong tonality of his colours, where we sometimes find a clarity aimed at giving vibrant life to his frescoes. That he might have had some contact with Gerolamo di Giovanni is also possible. A certain connection may be traced in the *Crucifixion*. But Gerolamo's art is far more the result of meditation, and, frankly speaking, more "opportunistic". That of the Patullo Master is the art of a vitriolic neophyte, who throws himself into the fray with all the conviction of an angry protester. In the *Deposition*, and in the *Christ before Pilate* (plate 93), where the same problems Mantegna had tackled —such as the organization of the perspective from below upwards —and the loving depiction of archaeological remains—reappear so clearly, the painter's tortured style takes on the value of a manifesto.

The painters of the school of Camerino stand out among others in the Marches, by virtue of the great curiosity that led them to make contact with the most diverse currents in Renaissance painting, from Tuscany to the Veneto, from the Veneto to the court of Urbino. Amidst the multiplication of tendencies that characterized the artistic scene of the time, this school is conspicuous for its vitality, and has a particular importance of its own on account of the great variety of artists.

We have spoken of Carlo Crivelli's arrival in the Marches as an event of exceptional importance, since his presence firmly established a style and a current that were to be felt for the whole of the second half of the fifteenth century, especially in the central-southern parts of the region. He himself, as a result of approximately thirty years' recorded residence in the area, became one with the local artists, all the more so since all his works, except for one or two early ones, were done either at Ascoli, Fermo, Camerino or Fabriano, though many of them now belong to other countries and can be found in galleries all over the world. In the context of this introduction, it is interesting to note that he came to the Marches already steeped in the training he had received at Padua. Moreover, at about the same time he was studying, Boccati, Gerolamo di Giovanni and other artists from the Marches, particularly from Camerino, were also staying in that city. However, no interchange between these painters and Crivelli took place on Marchigian soil. Perhaps they did not know each other, while it was Crivelli himself, if anything, who took an interest in certain early works of Gerolamo's, as we have already pointed out. On the other hand, many painters indifferent to the world beyond the Alps were affected, in a way that was sometimes naïve, never genuine, by the tormented sensibility that is the basis of Crivelli's tense, violent style. Neither the delicate Stefano Folchetti, nor Cola dell'Amatrice, nor other painters who wavered betweed Crivelli the elder, Vittore and Pietro Alemanno, realized how great were the innovations—and not just the formal, stylistic ones—that formed the basis of this new pictorial language. The anonymous painter of the frescoes at Fermo (S. Agostino), and the other from Castigliano, and others again in the less accessible churches, are often the closest to him in authentic feeling; in short, this is a phenomenon similar to the relationship between the Master of Patullo and the school of Padua.

Nicola d'Ancona cannot be related to these followers of Crivelli. He was one of the many Marchigians attracted by the world of Padua. Nor would it be surprising to find him in Padua about 1450, or even earlier, among the pupils of Squarcione, beside his close colleague from across the Adriatic, Giorgio Schiavone. Nicola d'Ancona forces visual reality to the point of caricature, but there is a constant pathos and moral tension in his works that make him quite an isolated case, unique in the history of art. The almost hallucinatory precision of detail and the metallic impact of his figures arouse one's attention and excite one's feelings. Time tempered Nicola's youthful vigour, and contact with new discoveries in painting served to attenuate some of his more extreme attitudes. But he never lost that passion, and that sense of anxiety, which characterize his most significant works, such as the former Watney altarpiece (plate 156), or that in the Massimo Collection (plate 160), with its wonderful predella and lunette. The situation was quite different at Urbino, which we shall mention only briefly, since more will be said about it later on. Here, the presence of many famous artists paralysed all local initiative in some way. Timoteo

Viti sought work, or rather, an artistic direction, in the city of Bologna.

The only painter worthy of the name who emerged from the splendid group of artists gathered about the court of the Montefeltro was Giovanni Santi, more famous as the father of Raphael than as a painter in his own right. And yet he was no mean painter. In that atmosphere of exquisite sensibility, generated by a culture that seemed within reach of the most advanced discoveries of the Renaissance, Santi's work served to diffuse a particular style, and to render it more accessible. His frescoes at Cagli (plates 166–167), and some of his panels, such as those of S. Maria Nova at Fano, clearly show how he succeeded in assimilating various styles, and in creating one that is substantially different from those in the other schools scattered throughout the Marches; a style, moreover, that owes nothing to any painter from the court of Federico. In brief, he was the founder of his own school, one of the many in the region, and one that spread, since minor painters, such as Evangelista di Pian di Meleto (plates 173–176) and Bartolomeo di Gentile (plates 178–179), preferred to learn from Santi rather than remain in static admiration before the masterpieces of Piero della Francesca. Nor can it be said that he was the slavish follower of Perugino; if anything, he runs parallel, and is connected with the artist from San Sepolcro.

This is the world that gave birth to Raphael, who never departs from that sense of proportion, that search for inner harmony which seems to characterize the art of the Marches, and which, by mitigating their severity, transformed even those artists who had gone quite different ways in their youth, from Nicola d'Ancona to Gerolamo di Giovanni. The inner serenity, the relationship between man and environment, the dignity and genuineness of the figures are constant elements in the painting of the Marches, and seem to unite its two greatest exponents, Gentile and Raphael. Man and the space in which he lives, together with the search for harmony and balance, are what Rapahel took with him to Rome from Urbino. And this is what we find in the sublime dignity of the *School of Athens* (plate 186), before it gave way to the doubt and drama of a changing world at the beginning of the sixteenth century. The changing times made themselves felt in the Marches through the work of an alien painter, a Venetian, who gave so much of himself to the region, Lorenzo Lotto. It was in Lotto that the tendencies in local painting—which were many and diverse, though akin—were to find the painter who was to make a radical change in their style and interests. Just a little earlier, Raphael had set out for Rome. These two events marked the end of the region's independence, and with it, the end of its creative autonomy.

The historical situation at Fabriano explains the flowering of a school of painting which reached its apogee during the fourteenth and fifteenth centuries. In the course of the Trecento, and particularly in the second half of that century, the Chiavelli family gradually worked its way to power, and, after long struggles, succeeded in replacing the free Commune with a Signoria; this was a historical phenomenon that was to repeat itself in many Italian cities.

The Chiavelli were of German origin, and had settled at Fabriano in the middle of the twelfth century, placing their army at the disposal of the Commune. A family of able politicians, they gradually succeeded in gaining the upper hand, thanks to the intelligence and perseverance of Alberghetto I, Tommaso I and Alberghetto II. Finally, in 1378, Guido Napolitano took possession of the city, winning Papal recognition as its lord, together with the title of Vicar Apostolic. The title was confirmed in his descendant, Chiavello, who died in 1412, and in the latter's successor, Tommaso IV. In 1435 a plot led to the complete elimination of the Chiavelli, except for those relatives who were out of the city in the pay of Francesco Sforza, and two children who were spared out of pity. Thus the Chiavelli Signoria fell, and was succeeded by Francesco Sforza as gonfalonier of the Roman Church, who immediately forced the revolutionary government to submit to his authority.

The dominion of the Sforza lasted until 1444, when the town, after further dramatic events, passed under the direct control of the Papal States. Nicholas V stayed at Fabriano in 1449 and in 1450, partly to check up on the activities of the so-called "Brethren" (a religious order whose ideas were suspect), who were led by Blessed Giacomo della Marca, a man of great moral strength and profound faith, whose work was not always regarded with a favourable eye by the Roman Curia. The history of Fabriano, whose geographical position makes it a town of some importance, cannot be dealt with adequately in this brief outline. Both what preceded and what followed this period is important, and might well be a subject of careful study, because of the many cultural as well as political implications involved. This historical note merely serves as a starting-point for the real subject of our discussion, which is painting. For there is no doubt that, with the rise of the Chiavelli and their enlightened Signoria, the tradition of painting at Fabriano, and its artistic vitality in general, were at their most dynamic, a fact clearly connected with the town's economic prosperity and political independence.[1]

The first genuine artist to appear, towards the second half of the fourteenth century, was the so-called Master of Campodonico, who carried out the frescoes in the abbey of S. Biagio in Caprile. Modern criticism has regarded this artist with intense admiration, and has sought to define the man and his works in a critical corpus, which, unfortunately,

remains limited.[2] He was a considerable artistic personality, clearly brought up on the art of Assisi, that is to say, on the many examples of Tuscan painting that the Basilica of St. Francis had brought together, and which it continued to accumulate in the course of the century. The *Crucifixion* and the *Annunciation*, both dated 1345, are evidence of a style in which the plastic strength of a fully assimilated adherence to Giotto combines with the influence of Siena. It seems as if the anonymous artist aimed at reconciling two apparently opposed tendencies in a new pictorial vision, in which the indigenous element has inevitably contributed to the formation of a fresh, spontaneous sensibility.

Contemporaneously, the influence of Giotto came to town by another route, through the mediation of artists connected with the school of Rimini. The latter had also been to Tolentino, where they would have seen that masterpiece of fourteenth-century painting in the large chapel of the Basilica of S. Nicolò. In the Gallery of Fabriano there is a large fresco, *Madonna and Child with SS. Lucy, Catherine and Emiliano*, which comes from the church of the Abbey of S. Emiliano (plate 1). It has been rightly maintained to be one of the finest examples of Marchigian painting, and though it stands on a higher artistic level, it is connected with some frescoes in the church of S. Agostino. The latter have been associated with an artist who, on Salmi's suggestion, has been called the Master of the Coronation of Urbino, after the painting that has served as the basis for his identification. The critics, who in recent years have shown particular interest in the wonderful fresco from S. Emiliano, are divided into two camps: one, led by Toesca, is inclined to see in the unknown author of this work, a Fabrianese painter connected with the Riminese school, but not unaffected by other direct Tuscan influences; the other maintains that the work is to be attributed to an early period of the Master of the Coronation, of whose art it is the finest example. Certainly, it is by no means easy to connect the very high degree of abstraction attained by the author of this fresco, whose style remains open to formal solutions of a very sensitive kind, with the more modest painter of the Urbino Coronation. In the absence of any real certainty, it is better to keep an open mind and to place our trust in philological and stylistic research, the only instruments that can lead to definite conclusions. Therefore, it is better to call the author of this splendid fresco by the name most appropriate to him until the contrary can be proved, that is, the Master of the Maestà of S. Emiliano.[3]

As we can see, the world of painting at Fabriano towards the middle of the fourteenth century was anything but an artistic backwater. On the contrary, it was a place where painters stayed and met other painters, just as in many other towns in the Marches.

The first historically well-defined artist appeared at a time when these tendencies were flowering, and as the evident result of their interaction with others. To a certain extent this artist may be considered the founder of the Fabriano school of painting. His name is Allegretto Nuzi and he was born at Fabriano about 1320. He went to Florence, where he was enrolled in the guild of painters in 1346. His importance is due to the various elements that emerge in his paintings, where Tuscan influences (particularly Sienese) combine with local characteristics. Moreover, he worked for a long time in his native town, carrying out polyptychs and frescoes for a number of churches. Many of his works have left Italy, while others are to be found in the Gallery of Fabriano, at Urbino, at San Severino, and in the Vatican Gallery.

This is not the place to embark on a profound study of his personality or to trace the development of his style. However, we must bear in mind that tradition points to him as the direct master of Gentile, who will be the object of our attention, and whose origins will have to be gone into in greater detail. But apart from the question of a direct apprenticeship, we ought to examine whether Allegretto's painting has any of those characteristics—even though they may be expressed very differently because of the different cultural situation—

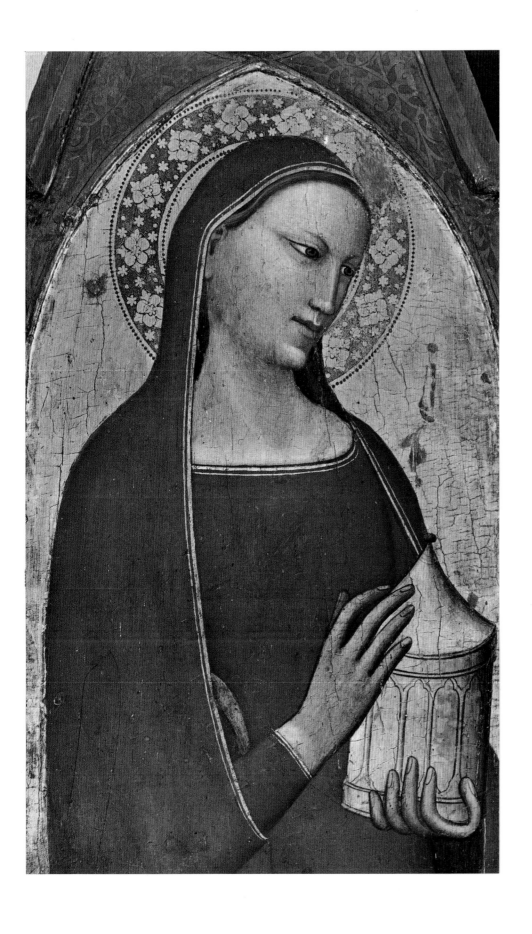

I. Allegretto Nuzi: *St. Mary Magdalen.*
Detail from a polyptych. Fabriano, Pinacoteca Civica

which later formed the fertile *humus*, the vital substance of the great Fabrianese master's art. As a matter of fact, Allegretto Nuzi, extolled by tradition but decried by the critics, possessed a narrative style and an elegance in the solution of certain formal problems that justify the fame he enjoyed in his own day, and the great industry that characterized his life. He is a kind of Tommaso da Modena of Central Italy. That is to say, he differs from Sienese painting, which was undoubtedly an influence in his work, but also refused to follow Florentine culture. He developed a narrative style that is particularly effective psychologically, while strictly adhering to principles of composure and balance. He was also able to articulate spatial values, owing to his sensitivity to colour, which he expresses by balancing one tone or colour against another, in the spirit of one who searches after rhythmic harmony and an elegance free from rarefied preciosities. Moreover, he depicts humanity, surprised in its most true-to-life attitudes and its most genuine expressions, qualities that cannot go unacknowledged. In brief, Allegretto Nuzi, especially in the frescoes of *Scenes from the Life of St. Lawrence*, and in the gracious, elegant figures of saints on the panels in the Gallery of Fabriano (plate I), is an isolated figure in the history of art in the Trecento. Yet he it was who gave the first impulse to the formation of the fifteenth-century school of Fabriano, of which he may be rightly considered the precursor.[4]

Francescuccio di Cecco Ghissi, by whom there are a number of panels (at Fabriano, at Fermo, in the Vatican Gallery etc.), all dealing with the same subject, the *Madonna of Humility*, is undoubtedly greatly inferior to Nuzi. He is a pleasant painter, but repeats in a monotonous fashion a theme that had already been dealt with by Allegretto, to whom he is in every way inferior, because of his lack both of creative energy and sensitivity to colour, that is, of that compositional originality which constituted Nuzi's particular characteristic.

Hence when Gentile da Fabriano appeared on the scene, he did not find himself in a town devoid of artistic antecedents. Moreover, he had the opportunity of seeing any number of works of art. He could even have become familiar with them, so close were they to him. Such works were the frescoes in the large chapel of S. Nicola at Tolentino, with its various manifestations of the Riminese school (where one must look for painters from Fabriano too), not to mention Assisi, where the Florentine and Sienese schools, Cimabue and Giotto, Simone Martini and the Lorenzetti had created their stupendous, unique symposium of inspired ideas, experiences and inventions. If we consider, therefore, the contemporary art of his own town, together with the incentives to creative activity that surrounded him on all sides, it becomes immediately clear that Gentile was already able to find, in the environment that formed him in his youth, sufficient cultural material to give him the necessary open-mindeness to pursue further experiments of his own. If we also take into consideration the particular cultural conditions that prevailed at Fabriano at the time, and the possibility of relations between the lords of the town and the northern countries, we might find further evidence for the splendid, but not inexplicable, appearance of that painter of genius, Gentile da Fabriano.

### Gentile da Fabriano

It is not known when Gentile, the son of Nicola Giovanni Massi, was born. The careful researches of a Fabrianese scholar, Romualdo Sassi, who has done so much to further our knowledge of the cultural world of Fabriano in the fifteenth century, have failed to establish when the artist began his activity. Sassi places Gentile's birth around 1370, but there is no evidence to make this a certainty. Little is known about his youth, and the first we hear of him is that he was in Venice in January 1409, carrying out an altarpiece, which has now been lost. As he was paid more than a well-known Venetian painter, Nicolò di Pietro,

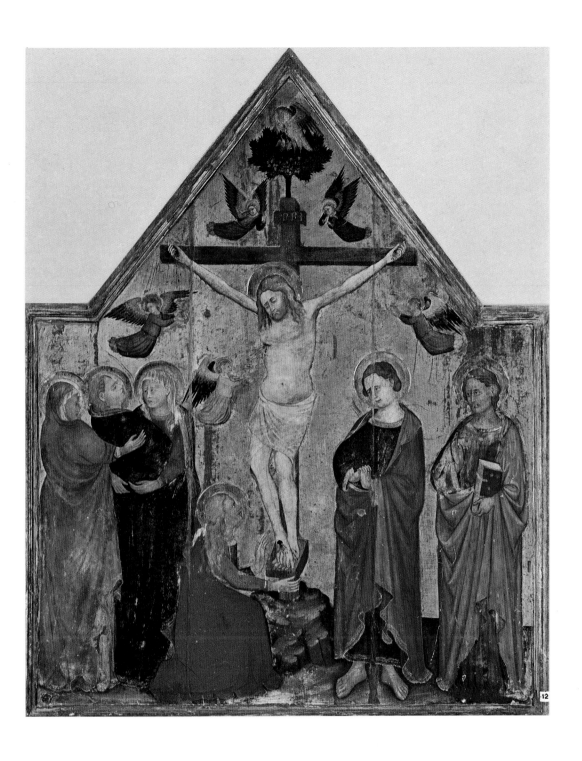

II. Anonymous Painter from Fabriano, 14th-15th century: *Crucifixion*.
Fabriano, Pinacoteca Civica

he must already have been famous. In 1410, again in Venice, he was enrolled among the Brethren of the School of S. Cristoforo dei Mercanti, and lived at S. Sofia. Since a number of years' residence in the city were required before one could be enrolled in a school, Gentile arrived in the city a few years earlier. The most famous work painted during his stay in Venice was the fresco in the Sala del Maggior Consiglio in the Doge's Palace, which depicted the battle between the Venetians and Otto III. This painting, now lost, is mentioned in the documents as being of particular importance, and was clearly fundamental to the development of Venetian painting. Moreover, it represented a meeting-point between the painting of the Marches, Venice and the Po valley, for by the side of Gentile, working as his young assistant, was Pisanello himself.

In 1414 Gentile was at Brescia, carrying out frescoes in the family chapel of the Malatesta, a work he completed in 1419. In the same year, he was given a safe-conduct pass for Rome, where he had been invited by Pope Martin V. However, his journey was interrupted at Florence, where the Pope had been prevented from returning to Rome by the political situation. In 1420 Gentile returned to his native town as appears from a request made to Tommaso Chiavelli on 23 March of that year. But he was certainly again in Florence in 1422, since he is mentioned among its doctors and apothecaries.

This was a period of great activity, which culminated in a number of works of prime importance, among them the *Adoration of the Magi* (plates IV, V, 8–12), signed and carried out in 1423, following a commission from Palla Strozzi.

Two years later, in 1425, Gentile completed the famous polyptych commissioned by the Quaratesi family for the church of S. Nicolò d'Oltrarno. The polyptych is now dismembered and divided among various galleries (plates 17–23). In the same period, moreover, the painter widened the sphere of his activity. After painting the *Madonna dei Notai* at Siena, he went to Orvieto and painted the *Madonna and Child* fresco in the cathedral, where it can still be seen. Two years later he was in Rome, where he painted frescoes in the church of St. John Lateran; these were destroyed in the seventeenth century, when Borromini rebuilt the shell of the Basilica, completely altering the Early Christian structure in the process. In the course of this intensely active period, Gentile, besides other works, painted in S. Francesca Romana a fresco of the *Madonna and Child*, which work has also been destroyed. He died in Rome between August and October 1427.

The problem of Gentile's formation has always been of great interest to the critics, and it has generally been solved by emphasizing that he was brusquely uprooted from the human environment in which he was born. His experiences and the influences he came under were always stimulating and useful; and yet, the land that formed him always remained the fundamental element in his art, since it not only served as a guide in his contacts with other painters, but also determined his way of life.

The chronology of Gentile's works, especially that of his formative period, is extremely difficult to reconstruct, as so many of them have been lost.

Amico Ricci (1834) records a number of Gentile's frescoes in the cathedral of San Severino. These must have been painted in his youth, since his return to his native town in 1420 (if it took place) did not last long. The panel of the *Madonna and Child* (plate 3) comes from Fabriano, and the polyptych with the *Coronation of the Virgin* at its centre (now at the Brera) from the Abbey of Val Romita (plates III, 5, 6). Finally, another painting from Fabriano is *St. Francis receiving the Stigmata* (plate 7): this was formerly in the Fornari Collection at Fabriano, but now belongs to the Carminati Collection at Crenna di Gallarate, in the province of Varese. It should also be remembered that at Fabriano there are many paintings influenced by Gentile, and that the flowering of International Gothic throughout the region was one of the greatest in the whole of Italy, its various streams combining to form a style

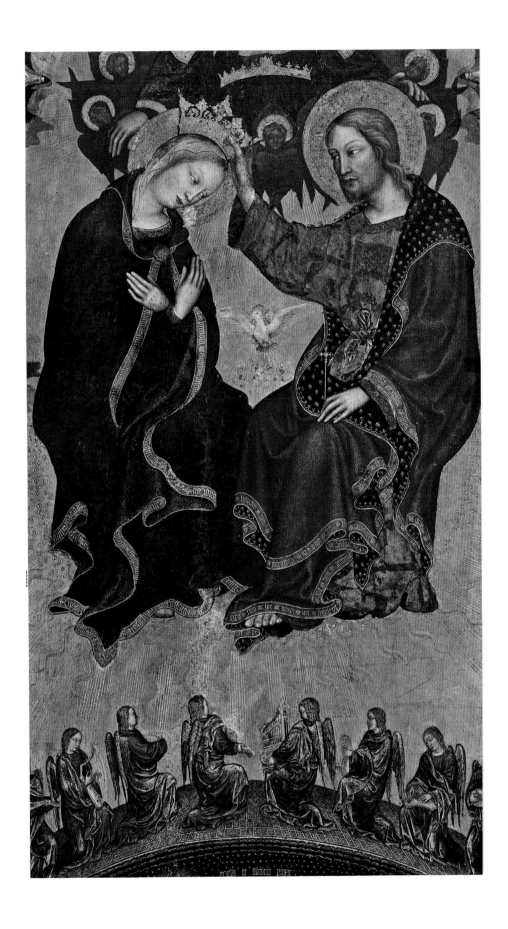

III. Gentile da Fabriano: *The Coronation of the Virgin*. Detail from plate 5.
Milan, Brera

upon which Gentile's work did not fail to exercise an influence. By this, we do not mean to say that the Fabrianese master did not belong to a far greater current, the same current that was sweeping the whole of Western Europe. But it would probably be a mistake to ignore the cultural conditions in which he found himself, and of which he is the finest interpreter. If, as we have said above, the chronology of his early works is uncertain, one thing is quite clear: that they come from Fabriano and its environs. It is improbable, therefore, that his artistic formation took place outside his home town, in northern Italy that is, since it is only after his stay in Venice that we find documents and records regarding his activity in the area of the Po, while there is not a single work or document to prove that he spent any part of his youth in Lombardy. If, therefore, certain paintings seem to lean towards a Lombard style—I am referring to the Berlin altarpiece—this cannot prove that the artist did his apprenticeship in the north; if anything it shows that he was acquainted with Lombard art, possibly through miniatures. But that the artist was searching for a more authentic mode of expression is borne out by the Val Romita polyptych (plates III, 5, 6)—another early work, according to current opinion. Here, the Sienese influence is far more evident than the Lombard, which only goes to show that his contacts lay westward rather than to the north. One must not forget that only a day's walk separates Fabriano from Assisi, where Simone Martini had left his famous frescoes, the *Scenes from the Life of St. Martin*. Gentile probably meditated upon these works more than we think, distilling from them a compositional style which is at once calm and refined, and which remained the fundamental element in his art.

Though Gentile left his native land as a young man—anticipating Raphael's experience to a certain extent—his painting was, nevertheless, of fundamental importance for his own town and region, for he helped to establish International Gothic in the Marches, where it became widespread, and where other painters of note also helped to make it predominant. Moreover, the influence of Gentile on Venetian painting is now an accepted fact.

It has been noted above that Jacobello del Fiore, who arrived in the Marches practising a style still characterized by an almost icon-like solemnity, changed after 1410. Evidence of this change can be seen in the little panels of S. Lycia at Fermo (plates VI, VII, 26, 27). These panels—and one may observe how criticism, even when it is mistaken, can be very significant in the suggestions it implies—were first attributed to Gentile himself or to his school. The definitive attribution of these works to Jacobello is the most sensational proof of the influence exercised by Gentile on this Venetian painter, who was the pupil, therefore, and not the master of the Fabrianese artist. One has only to follow Jacobello, from his first works in the Marches (e.g. the 1407 triptych formerly at Montegranaro di Pesaro) to his later ones, to understand the influence Gentile had upon him, just as he influenced Nicolò di Pietro and Giambono, and perhaps even Jacopo Bellini himself. A complete analysis of Gentile, especially after his encounter with Tuscan art, goes beyond the scope of this book. Our main concern has been to face the question of his origins, taking into account the local factor as well, since any discussion that overlooks the historical and cultural situation of the Marches at the dawn of the fifteenth century, would only undermine all logical research into a world which, though it was later to change, reached at that time a very remarkable level of civilization.[5]

## Catalogue of works
[*see plates III–V, 3–23*].

Berlin-Dahlem, Gemäldegalerie, *Madonna and Child with SS. Nicholas, Catherine and Donor*. This comes from the church of S. Nicolò di Fabriano and was seen by Ricci in Rome in 1829 (1834, p. 155).
Crenna di Gallarate (Varese), Carminati Coll., *St. Francis receiving the Stigmata*. From the Seminary of Fabriano, and probably same as that mentioned by Ricci as belonging to Buffera (*op. cit.*, p. 154).

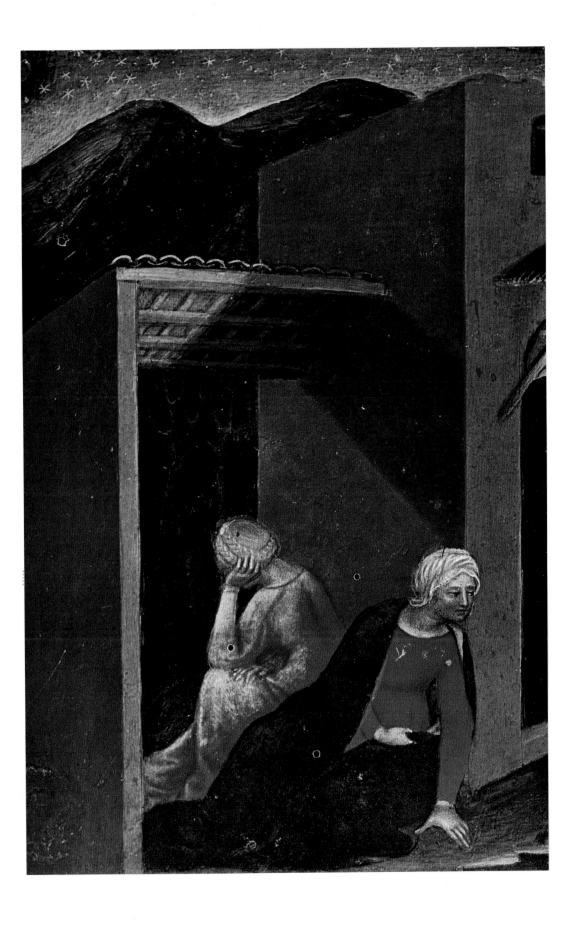

IV. Gentile da Fabriano: *Watching Shepherdesses*. Detail from plate 12. Florence, Uffizi

Florence, Uffizi, *Adoration of the Magi* (1423).
Florence, Uffizi, *SS. Magdalen, Nicholas, John the Baptist, and George*. Lateral panels of the Quaratesi polyptych.
Florence, Berenson Coll., *Madonna and Child*.
Hampton Court Palace, Royal Coll., *Madonna and Child*. Central panel of the Quaratesi polyptych.
Milan, Brera, *Val Romita Polyptych*.
New Haven, Yale University Art Gallery, Jarves Coll., *Madonna and Child*.
New York, Metropolitan Museum of Art, *Madonna and Child with music-making Angels*.
New York, Frick Coll., *Madonna Enthroned and Child with kneeling Saints*. Formerly in the Herbert Coll. (London), then in the Paolini Coll. (Rome), until sold to New York 1924.
Orvieto Cathedral, *Madonna and Child*. Fresco.
Paris, Heugel Coll., *Coronation of the Virgin*. Perhaps from the Buffera Coll. of Fabriano (Ricci, 1834, p. 154).
Paris, Louvre, *Presentation in the Temple* (right half of the predella of the *Adoration of the Magi*).
Perugia, National Gallery, *Madonna and Child with music-making Angels*.
Pisa, Civic Museum, *Madonna Adoring Child*.
Rome, Vatican Gallery (on loan), *Annunciation*.
Rome, Vatican Gallery, *Scenes from the Life of St. Nicholas*. Parts of the predella of the Quaratesi polyptych.
Velletri, Museo Capitolare, *Madonna and Child with two Angels*.
Washington, National Gallery of Art (Kress Coll.), *Madonna and Child with two Angels* (formerly at Tulsa).
Washington, National Gallery of Art (Kress Coll.), *Pilgrims at the tomb of St. Nicholas* (lateral panel of the predella of the Quaratesi polyptych).
Washington, National Gallery of Art (Goldman Coll.), *Madonna and Child*.

## The Master of Staffolo

In 1947, Santangelo chose this temporary name for a minor painter who was certainly brought up, if not born, at Fabriano. In the church of S. Francesco, in the little village of Staffolo, this artist has left a polyptych, painted in an International Gothic style, in which there are undeniable traces of Gentile's influence, together with others, which probably derive from the works of the Salimbeni brothers. Zeri, taking up the question that Santangelo had broached, also credited (1948) this master with the triptych in the Gallery of Fabriano, which represents the Madonna adoring the Child in the cradle (plate 25). This anonymous work had been previously assigned to a hypothetical "Master of the Cradle", to whom other works were attributed, more on iconographical than stylistic grounds, so that a fictitious artist came into being. Zeri has rightly demolished this fabrication, at the same time helping us to see more clearly the figure of the Master of Staffolo, who can be shown to have really existed through a group of paintings which bear the mark of a single personality.

The Master of Staffolo took up the style of Gentile, and is probably connected also with the very first works of Lorenzo Salimbeni. He was certainly in contact with Pietro di Domenico of Montepulciano, but he also anticipates certain stylistic and chromatic characteristics proper to Francesco di Gentile. This would confirm his Fabrianese origin, as does the presence of some of his works in the district around Fabriano.[6]

### Catalogue of works
[*see plate* 25].

Albacina, Parish Church, *Triptych with Madonna, the Child, St. Venantius, and St. Marianus*.
Claremont, Cal., Pomona College, Kress Coll., *Madonna and Child with SS. Lucy and Eligius*.
Domo (Serra S. Quirico), Parish Church, Triptych: *Madonna and Child with Bishop Saint and Martyr Saint*.
Fabriano, Pinacoteca Civica, *Madonna and Child; SS. John the Baptist and Catherine* (formerly attributed to the Master of the Cradle).
Fabriano, Church of the "Buon Gesù", *Madonna and Child with St. Bernardino* (banner).
Matelica, Convent of the Magdalen, *Madonna Adoring Child*.
Naples, Museo di Capodimonte, *St. Eleutherius and Worshippers*.
Rome, Museo di Palazzo Venezia, *Madonna of Mercy; SS. John the Baptist and Sebastian* (banner).
Staffolo, Church of St. Francesco, *Polyptych*.

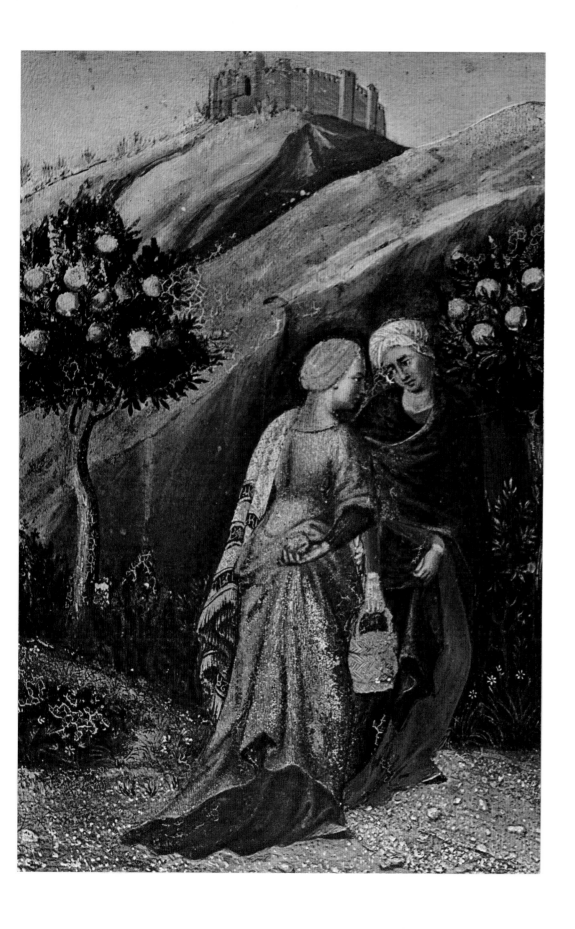

V. Gentile da Fabriano: *Two Ladies*. Detail from plate 12. Florence, Uffizi

## Francesco di Gentile

This Fabrianese artist, one of the most mysterious and elusive in the Marches, was active in the second half of the fifteenth century, and his style, though eclectic, is remarkable. There is some doubt, however, whether he was in fact as eclectic as the many works attributed to him would have him appear, for many of these—stylistically different from each other—are not his, in all probability.

Wrongly considered the son of Gentile da Fabriano, he was regarded by Berenson as the pupil of Antonio da Fabriano, though there is no evidence to support this belief. There are very few signed works of his, but enough to help us reconstruct the components of his style. We have no dates regarding his activity, and the only one we did have, 1497, was connected with a number of frescoes in the church of S. Leonardo at Albacina, but which no longer exist.

Francesco di Gentile's origins are, perhaps, to be traced to the Master of Staffolo, with whom there is no lack of stylistic affinity of a late International Gothic kind. Only later, perhaps, did the artist come into contact with Antonio da Fabriano's work, but was then attracted to the painters of Venetian origin who were working in the region of the Marches. As things stand at the moment, it is quite impossible to attempt an objective reconstruction of Francesco's artistic personality. But one thing is clear: he followed the style of Crivelli, whom he could have known and understood through the works carried out by the Venetian at Fabriano immediately after 1490. Evidence of this is the signed *Portrait of a Young Man* (plate 30; Bergamo, Coll. Pesenti), where the Crivellesque elements are clearly distinguishable. It is evident that his openly Renaissance and Paduan development began after he had seen the works of Crivelli. Berenson attempted to compile a catalogue of his works, in which he also included the Saints on the side columns of Luca Signorelli's altarpiece in the church of S. Medardo at Arcevia. Berenson's catalogue is given below, though the reader is warned that not all the great scholar's attributions are to be accepted, but they may serve as the basis for a critical re-examination of the artist.[7]

Catalogue of works
[*see plates* 30, 31, 33–37].

Arcevia (Ancona), Collegiate Church of S. Medardo, *Six Saints* in (frame of Luca Signorelli's altarpiece).

Assisi, F. M. Perkins Coll., *Triptych: Madonna and Child with two angels; Christ at the Column, St. John the Baptist.*

Assisi, F. M. Perkins Coll., *Pietà; St. Sebastian and Flagellants.* (Processional banner).

Baltimore, Walters Art Gallery, *Ecce Homo* (?).

Baltimore, Walters Art Gallery, *Madonna and Child with Infant Baptist and Angels* (?).

Beffi (Aquila), Madonna del Ponte, *Triptych: Madonna and Child Enthroned with two Angels; Birth, Death, and Coronation of the Virgin* (?).

Bergamo, Pesenti Coll., *Portrait of a Youth.*

Bracciano, Castello, *Visitation.*

Derby, A. W. Pugin Coll. (ex), *Fragments of Polyptych: Madonna and Child with Angels; SS. Jerome and John of Prato; SS. Clement, Sebastian, and Donor; three predella panels representing the Nativity, the Crucifixion and the Resurrection* (work dated 1462, added to Berenson's lists by L. Vertova, ed. Phaidon, 1968).

Florence, Berenson Coll., *Annunciation* (restored).

Gotha, Museum (formerly), *Portrait* (?).

Kilburn (London), Church of St. Augustine, *Trinity.*

Lille, Musée des Beaux-Arts, *Bust of Christ; Small St. Sebastian.*

Matelica, Church of S. Francesco, *Triptych, Madonna and Child Enthroned, with two Angels; SS. Francis and Bernardino; in frame, the Annunciation and four small Saints; on the predella, two Donors and four scenes from the life of St. Bernardino.*

Matelica, Piersanti Museum, *Triptych with the Crucifixion, the Nativity, and the Adoration of the Magi; ib. Crucifixion with predella representing eight stories about the true Cross.*

Melchett Court (Romsey, Hants.), Melchett Coll. (formerly), *Ecce Homo.*

Milan, Brera, *Madonna in Glory; St. Sebastian with SS. Anthony Abbot and Dominic; in the pinnacle, Baptism of Christ.* (Processional Banner).

VI. Jacobello del Fiore. *St. Lucy dragged by oxen*. Fermo, Pinacoteca Civica

Nevers, Musée, *Panel from the frame of an altarpiece representing St. John the Baptist.*
Paris, Louvre, Campana Coll. 270 (on loan at Valenciennes), *Panel of a polyptych: St. Nicholas of Tolentino.*
Perugia, National Gallery: *Annunciation with Eternal in pinnacle; Madonna and Child with Angels and Dead Christ in pinnacle.* (Processional banner).
Philadelphia, Johnson Coll., *Madonna and Child with Pomegranate.*
Rome, National Gallery, *Angels in Adoration.*
Rome, Museo di Palazzo Venezia, *Bust of St. John the Baptist.*
Rome, Vatican Gallery, *Madonna with the Butterfly.*
Washington, Dumbarton Oaks, *Ecce Homo.*
Zagreb, Strossmayer Gallery, *Ecce Homo and Donor.*
Location Unknown: *Right-hand panel of a triptych; St. Bernardino.*

## Antonio da Fabriano

Our information regarding Antonio di Agostino di Ser Giovanni da Fabriano runs from 1451, date of the St. Jerome (formerly in the Fornari Collection, and now in the Walters Art Gallery; plates 38–39), to 1489, when his name appears in a local document. The artist led a very simple life, as far as one can see from the few documents concerning him, and spent his time at Fabriano and in the little villages and towns roundabout. In 1452, he was engaged in painting the Crucifix of Matelica, now in the Piersanti Museum (plates 42–43). The records at Fabriano show that "Magister Anthonius Pictor" was a member of the Council of Credence in 1457, that in 1473 he paid his taxes, and that finally, in 1484, he was Prior of the above-mentioned Council. In May 1485, he petitioned the Commune for a grant for his son, Agostino, who was evidently outside the town. The records also show that the artist was a wool trader, and that in 1489 he was dealing in cattle. The document referring to this latter activity provides the last information we have of him. Antonio had probably died by 1491, since his son Agostino paid 10 "bolognini" that year for a "Mass for his deceased".

Other records at Fabriano testify that Antonio visited Sassoferrato and Genga, small centres close to his home town. But we know of no events in his life to justify certain influences in his painting which are alien to local art, but which are clearly present and acknowledged by modern critics.

Of Gentile, the greatest local painter active at the beginning of the century, there is no trace in Antonio's development. Moreover, he revealed his partiality for Renaissance methods very early in his career. Reference has frequently been made to the Flemish nature of his work, especially that of his youth, and Zeri has recently defined his influence more precisely by indicating southern Italy or Sicily as the places where the artist might have served his apprenticeship. This is because Zeri sees the Flemish element mixed with compositional characteristics of a Sicilian-Catalan origin, as in the *Death of the Virgin* in the Gallery of Fabriano (plate 45). This painting follows a pattern frequently found in the Spanish *retablos* and which is present in the *Madonna* of Antonio's banner at Genga (1948, p. 164)—curiously inspired by a prototype of Antonello da Messina. These influences, modified by the artist in a decidedly Renaissance manner, suggest other elements of Tuscan origin. But van Marle has rightly stated that the Flemish character of the artist's work cannot be a result of the presence in Urbino of northern painters such as Justus of Ghent. Nor can it be due to the influence of the Spaniard, Pedro Berruguete, also active in the same town, since both these foreign artists did not arrive in Urbino until twenty years after Antonio had completed his first works.

The uncertainty that surrounds the figure of Antonio da Fabriano has led to his being credited in the past with paintings that are not by him at all. Zeri made a fundamental contribution to the solution when he denied that the polyptych in the church of S. Croce at

VII. Jacobello del Fiore: *St. Lucy in the Burning Bush*. Fermo, Pinacoteca Civica

Sassoferrato (plate 124) was his, assigning it to its real author, Giovanni Antonio da Pesaro, and thus restoring the nature and coherence of Antonio's artistic personality.

Other facts unearthed by recent research concern the date of the Genga triptych (1474), and that of the frescoes in the upper hall of the former convent of S. Domenico at Fabriano. The latter were certainly painted after 1472, since this was the date which, until a short while ago, could be read in one of the rafters of the roof. This is also an indirect confirmation of the date of the frescoes in the lower hall; the inscription, which was still seen by Cavalcaselle, but is now lost, said "1480, die Februari". The paintings in the library, which represent a dominating figure of Christ the Saviour in the foreground against a landscape receding into the distance, as well as Saints and Blesseds of the Dominican Order wrapped in their studies, are in a very precarious state of conservation, but could be saved if attended to in time. At the very top, there is a Madonna and Child in monochrome, clearly influenced by the Venetian school. In the refectory below there is a painting of the Crucifixion. These frescoes constitute the largest group of works we have of the Fabrianese master, and should, therefore, be preserved and kept under far better conditions than those in which they are at the moment.

Antonio is an artist who merits careful study, since he is undoubtedly one of the most vital personalities in the painting of the Marches in the fifteenth century. His very early adherence to the Renaissance, his contact with the art of Antonello, his domineering personality, often expressed in a rough yet authentic manner, make him an isolated case among the artists of the time. That he was no stranger to Venetian culture is shown by the above-mentioned frescoes in the convent of Fabriano, where the *Madonna and Child in a mandorla* is an iconographic derivation from some Vivarinesque prototype. Distinctly Venetian is also the *Madonna* in the Museum of Matelica (plate VIII), where there are traces of Jacopo Bellini's influence. Antonio da Fabriano, whose style is noticeably closer to the Renaissance than that of Francesco di Gentile, who was born almost at the same time, represents one particular aspect of the lively school of Fabriano, and moreover he remained independent of Tuscan or Umbrian influences. His strength really lay in his faithful adherence to a form of expression based on a plastic formal structure which never yielded to the compromises of imitation nor ever declined to the level of provincial art.[8]

Catalogue of works
[*see plates VIII*, 38–45].

Arcevia (Ancona), Collegiate Church of S. Medardo, *Annunciation* (in frame of Signorelli's altarpiece).
Baltimore, Walters Art Gallery, *St. Jerome in his Study* (1451).
Budapest, Count Julius Andrassy (formerly), *Madonna and Child Enthroned, two Angels, SS. Donino and Peter Martyr* (1459?).
Cerreto d'Esi, Parish Church, fragments of Polyptych, *St. Mary Magdalen, St. Francis; an Angel and the Virgin Annunciate*.
Fabriano, Convent of St. Dominic (or St. Lucy), Refectory, *Fresco: Christ on the Cross with SS. (Dominicans and Monks), St. Lucy and St. Catherine of Siena in the Niches* (1480); ib., Upper Room, Library, *Christ the Redeemer, Landscape, Dominican Saints, Madonna and Child* (after 1472).
Fabriano, Pinacoteca Civica, *Death of the Virgin*; ib., *Madonna and Child with SS. Anthony Abbot and James, and Donor* (detached fresco); *Madonna and Child with SS. Christopher, Michael and Andrew* (1457), fresco taken from the Casa Bigonzetti Baravelli.
Genga (Ancona), Church of S. Clemente, *Triptych: Madonna and Child, Angels, St. Clement, St. John the Baptist. In the predella, half-length portraits of Apostles* (1474); ib., *St. Jerome and Donor;* ib., Rectory, *Banner with Madonna Enthroned and Eternal; St. Clement Enthroned with Flagellants and Donor*.
Gualdo Tadino, Municipal Gallery, *Triptych: St. Anne and the young Virgin, St. Joachim and St. Joseph*.
Matelica, Piersanti Museum, *Crucifix* (1452); ib., *Madonna and Child*.
Ponce, Puerto Rico, Museo de Arte, *Portrait of Prelate*.
Richmond (Virginia), Museum of Fine Arts, *St. Clement* (fragment of a missing polyptych).

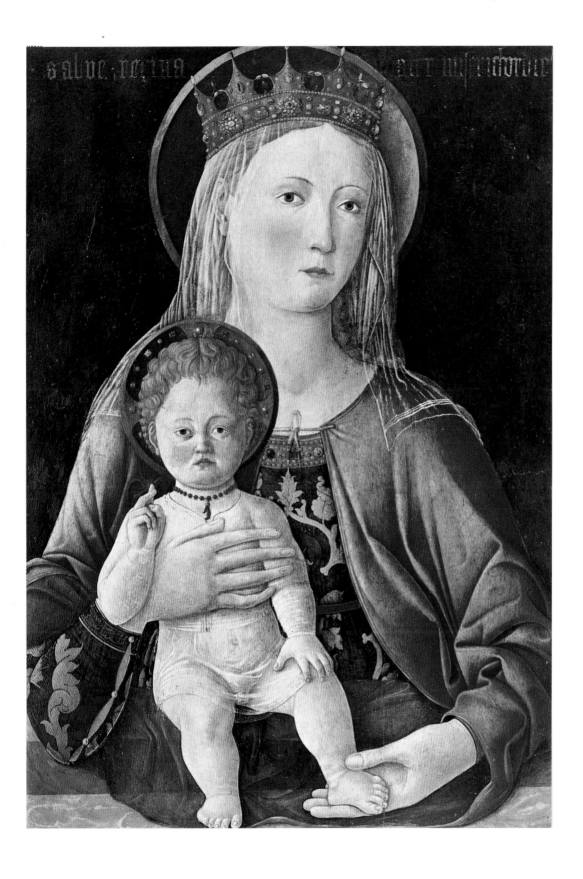

VIII. Antonio da Fabriano: *Virgin and Child*. Matelica, Museo Piersanti

# NOTES

1.  There is a great deal of literature on the history and politics of Fabriano. See the detailed bibliography compiled by B. Molajoli in *Guida Artistica di Fabriano*, ed. 1968.

2.  See the various studies on the subject and particularly: P. Toesca, *Storia dell'arte italiana, il Trecento*, Turin, 1951; A. Marabotti Marabottini, *Allegretto Nuzi* in "Rivista d'Arte", 1953; F. Zeri, *Un unicum su tavola del Maestro di Campodonico* in "Bollettino d'Arte", IV, 1963; C. Volpe, *La pittura riminese del Trecento*, Milan, 1965; G. Marchini, *Mostra di affreschi staccati*, Urbino, 1964; (Catalogue) *L'Europe Gothique*, Paris, 1968 (exhibition held at the Louvre); B. Molajoli, *Guida Artistica di Fabriano*, 2nd ed., 1968 (for further bibliography).

3.  The artistic personality of this unknown master has been examined by Salmi in his study devoted to *La Scuola di Rimini*, published in the review of the Institute of Archeology and the History of Art, III. See also P. Toesca, *Il Trecento*, 1951; P. Zeri, *Un affresco del Maestro dell'Incoronazione di Urbino* in "Proporzioni", 1950; G. Vitalini Sacconi, *La scuola camerinese*, Trieste, 1968; C. Volpe, *La Pittura Riminese del Trecento*, Milan, 1965.

4.  For Allegretto Nuzi, see the above-mentioned article (1953) by Marabotti Marabottini, as well as the bibliography in the 1968 edition of Molajoli's Guide to Fabriano.

5.  The problem of Gentile's formation has been examined many times, but with different results. By far the most penetrating study is that of Longhi in his essay on *Fatti di Masolino e di Masaccio* in "La Critica d'Arte", 1940. More recent criticism (v. also L. Grassi, *Gentile da Fabriano*, Milan,1953) inclines to the view that Gentile was trained in Padua, which would justify his adoption and personal interpretation of the courtly Gothic style.
The same idea has been pursued by other scholars, who still tend to see in Lombardy, and the whole of the Po valley in general, the centre of diffusion for the courtly Gothic in Italy. Palluchini, however, tends to emphasize the importance of the Venetian influence, which must have had a part in Gentile's formation, given the presence in the region of works by Niccolò di Pietro and Jacobello. But as we have already pointed out, the question must be turned upside down, in the sense that it was Gentile who influenced his colleagues. For this, see my article *La Pittura del Quattrocento nelle Marche e i suoi vari Rapporti con quella Veneta*, which appeared in "Umanesimo Europeo e Umanesimo Veneziano", Florence, 1963. The same article also stresses the need for a critical reappraisal of Cavalcaselle's old hypothesis (1864) regarding Gentile's Umbrian formation. This theory has been accepted by Longhi, at least in part, and he suggests in the above-mentioned essay that Gentile was influenced by the painters and miniaturists of Orvieto, such as Ugolino di Prete Ilario. Personally, I am still inclined to see a close connection between Gentile and the frescoes of Simone Martini, following a suggestion made by Pietro Toesca in the lectures he gave on International Gothic at Rome University during the academic year 1935–36. See also the doctoral thesis on the *Rapporti tra Gentile da Fabriano e Jacobello del Fiore* presented by Ileana Chiappini at the University of Urbino, 1967–68.
There is no doubt that Jacobello del Fiore's style underwent a change from the time of his first works in the Marches, such as the Montegranaro triptych, in which the figures are still flat, stiff and austere, to that when he painted the little panels of Fermo representing *Scenes from the Life of St. Lucy*, which are conspicuous for refinement, fluidity of movement, delicacy of colours, and treatment of light. Nor was the iconographical element of the grassy lawns, which only appears later in Jacobello del Fiore, imported into the Marches, for it was widely adopted there, and can already be seen in Lorenzo Salimbeni's famous triptych (January 1400) in the Gallery of San Severino. Carlo da Camerino also makes wide use of grassy lawns in his *St. Francis receiving the Stigmata*. We may conclude that, since Lorenzo Salimbeni came to the region long before Jacobello, the latter learnt the use of this device in the Marches. Moreover, the diffusion of Gentile's influence in Venetian territory goes to show how much the art of the region owed to the Fabrianese master. This is borne out by the fresco fragment in the Civic Gallery of Treviso representing the *Madonna and Child*, which is clearly modelled on Gentile, by the panel of the *Madonna of Humility* in the Poldi Pezzoli Museum, Milan, attributed to a Venetian master influenced by Gentile, and by Jacobello del Fiore's *Madonna and Child* in the Correr Museum, which is clearly connected to the art of Giambono, an unmistakable follower of Gentile. Finally, the famous panels representing *Scenes from the Life of St. Benedict*—which have occupied and preoccupied the critics so much—must also be connected with Gentile's widespread influence in Venice in the period around 1420 (see the reconstruction of the critical history of these panels in L. Magagnato, *Da Altichiero a Pisanello*, catalogue of the exhibition held at Verona, Venice, 1958). For the Correr Madonna, see I. Chiappini, *Per una datazione tarda della Madonna Correr di Jacobello del Fiore* in "Bollettino dei Musei Civici Veneziani", 1968, IV. On the other hand, evidence of the way in which Gentile's influence penetrated and endured in the Marches is provided by the Arzilla *Polyptych*, a late work of 1470.
A further example of the widespread influence of Gentile's style can be found at S. Ginesio in the church of Sant'Agostino: *St. Anthony healing the foot of a Young Man*. In the same church, the painting illustrating the *Battle between the people of S. Ginesio and of Fermo* reveals, in its descriptive intensity, influences and suggestions swinging from Jacobello to Gentile. The recent restorations carried out by the Urbino Superintendence have clearly revealed the qualities of this work which still remains a stylistic mystery.

6.  The little triptych in the Gallery of Fabriano is described by Serra (*Inventario degli oggetti d'arte, Provincie di Ancona ed Ascoli Piceno*, Rome, 1936, p. 68) as "a work of the Fabrianese school dependent on Gentile da Fabriano, 15th century", in accordance with the opinion of previous scholars. Later, the name of "Master of the Cradle" was coined, and connected with other iconographically similar works, all of which were clearly derived from an earlier model of Gentile's. According to Zeri, the Master of Staffolo should always be kept in the shadow of Pietro di Domenico da Montepulciano, a little-known Tuscan painter who worked in the Marches in the first decades of the century. However, we must not exclude the possibility that he was in some way connected with the Salimbeni brothers, though his debt to Gentile is paramount in any case. The list of works that follows is based on the suggestions of Santangelo (1947), Zeri (1948), and

finally, Molajoli (1968). The Matelica *Madonna* reveals a personality close to that of the Master of Staffolo, but at a higher level. This is a further proof of how difficult it still is to understand the pictorial taste diffused by Gentile throughout the region.

7. Molajoli rightly observes that the artist's works "denote an eclecticism not dissimilar in substance, though very different in its results and developments, from that already noticed in Antonio da Fabriano—an initial formation in the traditions of local painting with a marked tendency towards art of a Flemish character, to which were added at an ever deeper level elements from Venetian painting, and from Crivelli in particular... eclectic without a doubt, as has been rightly affirmed, and, therefore, always capable of disconcerting changes of style. But it seems to us difficult to demonstrate in a critically valid manner that these changes can be so brusque, as to justify our crediting the artist with the pronounced imitation of Pinturicchio in the *Madonna* of Baltimore, with the 'Lippesque' style of the *Madonna* in Philadelphia, and with the excessive subservience towards Flemish painting in the other *Madonna* in the same Collection." (id., p. 35) A painting of the *Madonna and Child with SS. Augustine and Catherine* has recently been attributed to Francesco da Gentile. Although this exquisite work seems to belong to the figurative culture of the Marches, its attribution to this painter has not been definitely proved. (See *Antologia di Dipinti di Cinque Secoli*, edited by Gilberto Algrandi, Palazzo Serbelloni, May 1971, Milan.)

8. Archival research into the figure of Antonio da Fabriano was carried out by Sassi, who returned to the subject on three occasions: *Documenti di Pittori Fabrianesi* in "Rassegna Marchigiana", 1924; id., in "Rassegna Marchigiana", 1925; id., *La Famiglia del Pittore Antonio da Fabriano* in "Rassegna Marchigiana", 1927. The name of Antonio da Fabriano was already known to Lanzi and Amico Ricci. The latter wrongly considered him a pupil of Gentile, while he exalted his artistic personality in his *Memorie Storiche* (1834, I, pp. 175-179). Moreover, Ricci mentions the *St. Jerome*, dated 1451, which he saw in the Faustini Collection at Fabriano, and which is now in the Walters Art Gallery of Baltimore. Referring to the Genga triptych, he writes: "This is a panel that does honour to our artist and places him among those who were making every effort to bring the arts to ever greater perfection". He adds that another work of merit is "a little banner which Antonio likewise painted for the same church, with the Virgin painted on one side, and St. Lucy on the other. At the feet of the saint kneel many members of the confraternity, who have been painted from real life." (id., p. 177) There are more recent studies on Antonio: Colasanti (1907, p. 416), L. Venturi (1914, pp. 173-175), F. M. Perkins (1906, p. 51), M. Salmi (1923, p. 58), B. Molajoli (1927, p. 267), L. Serra (1934), R. van Marle, XV, 1934; Serra in *Inventario degli Oggetti d'Arte etc., Le Province di Ancona e Ascoli Piceno*, Rome, 1936. A fundamental contribution to our knowledge of the artist was made by Zeri in his article on Giovanni Antonio da Pesaro in "Proporzioni", 1948, pp. 164-65. Further contributions have been made under the entry *Antonio da Fabriano* in P. Zampetti, *Carlo Crivelli e i Crivelleschi*, Exhibition Catalogue, Venice, 1961, and by B. Molajoli, *Guida di Fabriano*, ed. 1968.

It is hoped that the frescoes in the former convent of S. Domenico, which are so important for our further knowledge of Maestro Antonio, will be restored as soon as possible. The recent collapse of parts of the library roof has made the problem an urgent one. The building is in the course of being restored at the moment, and we hope that this will lead to a general restoration of the whole of the historic monument, which contains one of the town's masterpieces of Gothic painting and one of the most precious records for the history of local art. The recovery of Antonio da Fabriano's frescoes would be one of the most positive results of this necessary protective action.

The *Madonna and Child* in the Museum of Matelica has been attributed to Antonio by Lionello Venturi (1915) and by subsequent writers, but Zeri has recently eliminated it from his list. Longhi too, ("Paragone", 1962, p. 20) rejects the attribution, declaring that "in my opinion, the greatest links are with the early works of Giovanni Bellini". Though one cannot be wholly certain, I think that in spite of these objections, the panel must still be regarded as the work of Maestro Antonio, at least until one discovers its real author, who must have been a local artist very much under the influence of the Venetians. The austerity of its layout and the plasticity of its figures certainly recall the later works of Antonio. On Antonio's contact with southern Italian influences and his possible visit to Naples, see Giovanni Urbani in *Bollettino d'Arte*, 1953.

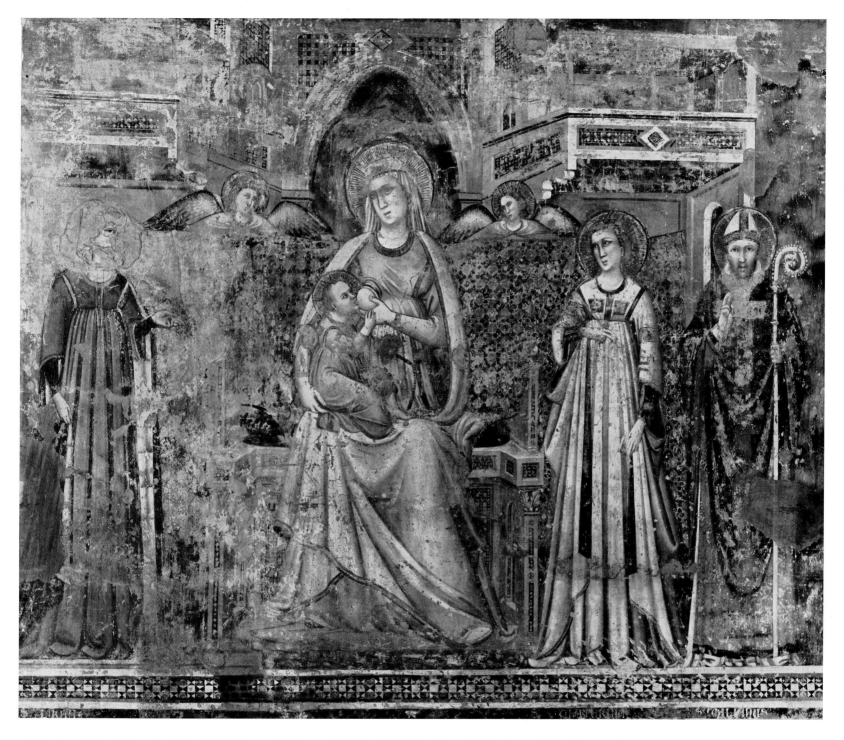

1. Master of the Maestà of Sant'Emiliano: *Virgin and Child with Saints Lucy, Catherine and Emiliano*. Fabriano, Pinacoteca Civica.

2. Allegretto Nuzi: *Triptych: The Coronation of the Virgin with Angels and Saints*. Southampton, Art Gallery.

3-4. Gentile da Fabriano: *Virgin and Child with Saints Nicholas and Catherine and a donor*. Berlin-Dahlem, Gemäldegalerie.

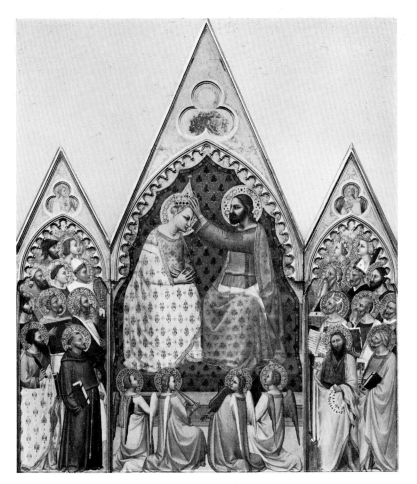

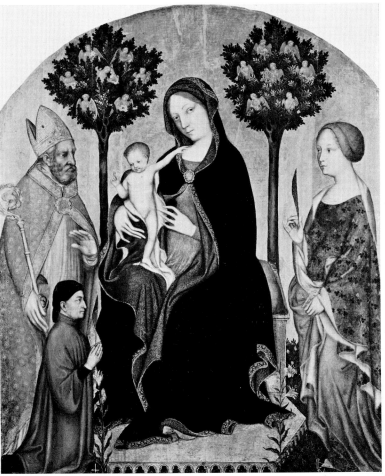

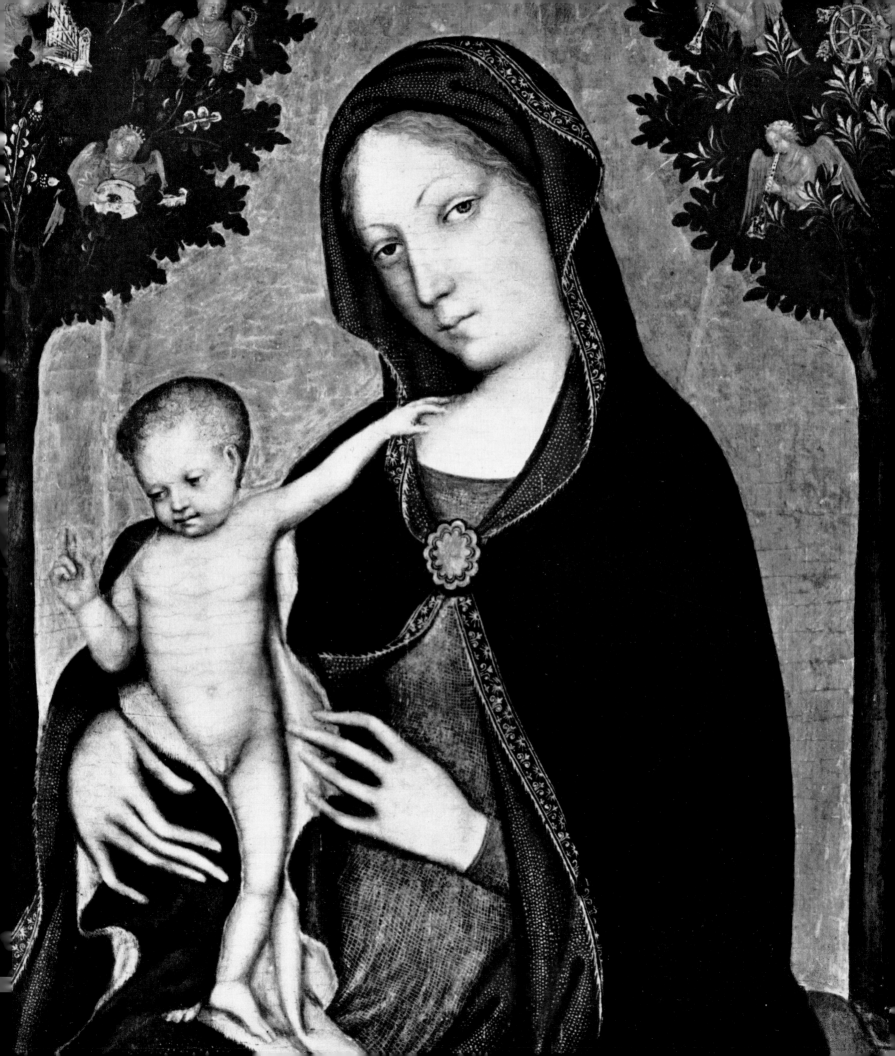

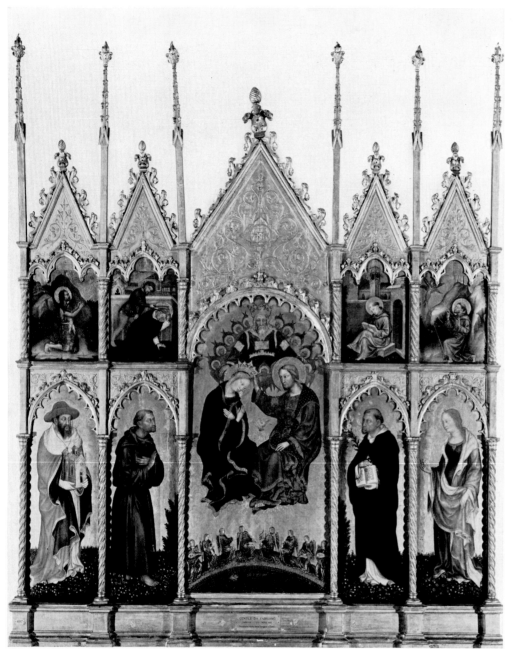

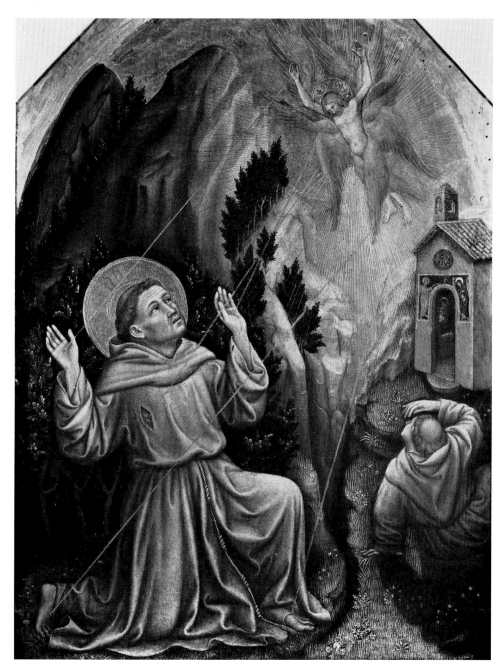

5. Gentile da Fabriano: *Polyptych from Val Romita*. Milan, Brera.

6. *Saint Mary Magdalen*. Detail from plate 5.

7. Gentile da Fabriano: *Saint Francis receiving the stigmata*. Crenna di Gallarate (Varese), Carminati Collection.

8-9. *Angel and Virgin of the Annunciation.* Details from plate 12.

10. *The Nativity.* Detail from plate 12.

11. *The Flight into Egypt.* Detail from plate 12.

12. Gentile da Fabriano: *The Adoration of the Magi.* Florence, Uffizi.

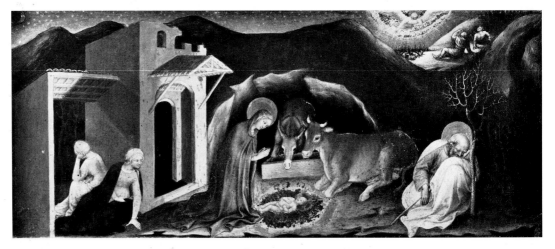
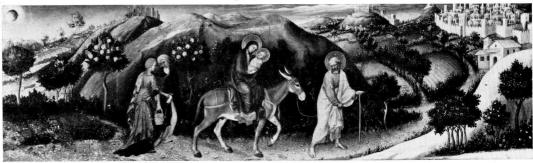

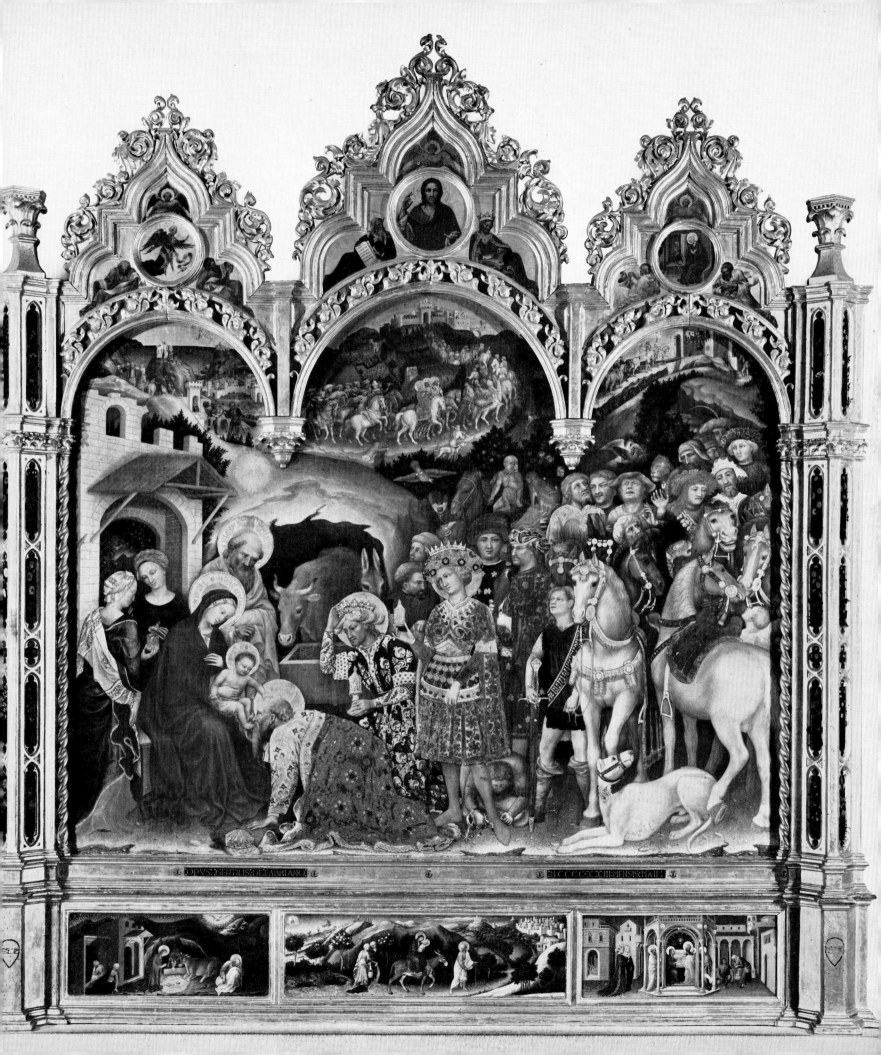

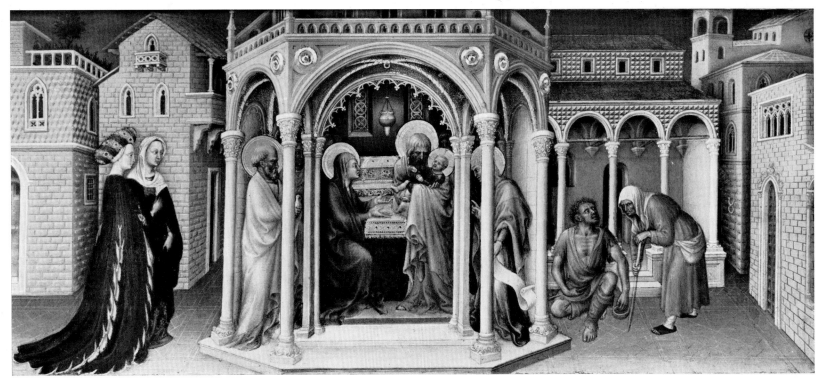

13-14. Gentile da Fabriano: *The Presentation in the Temple*. Detail from the predella of the *Adoration of the Magi*. Paris, Louvre.

15. Gentile da Fabriano: *The Adoration of the Magi*. Detail from plate 12.

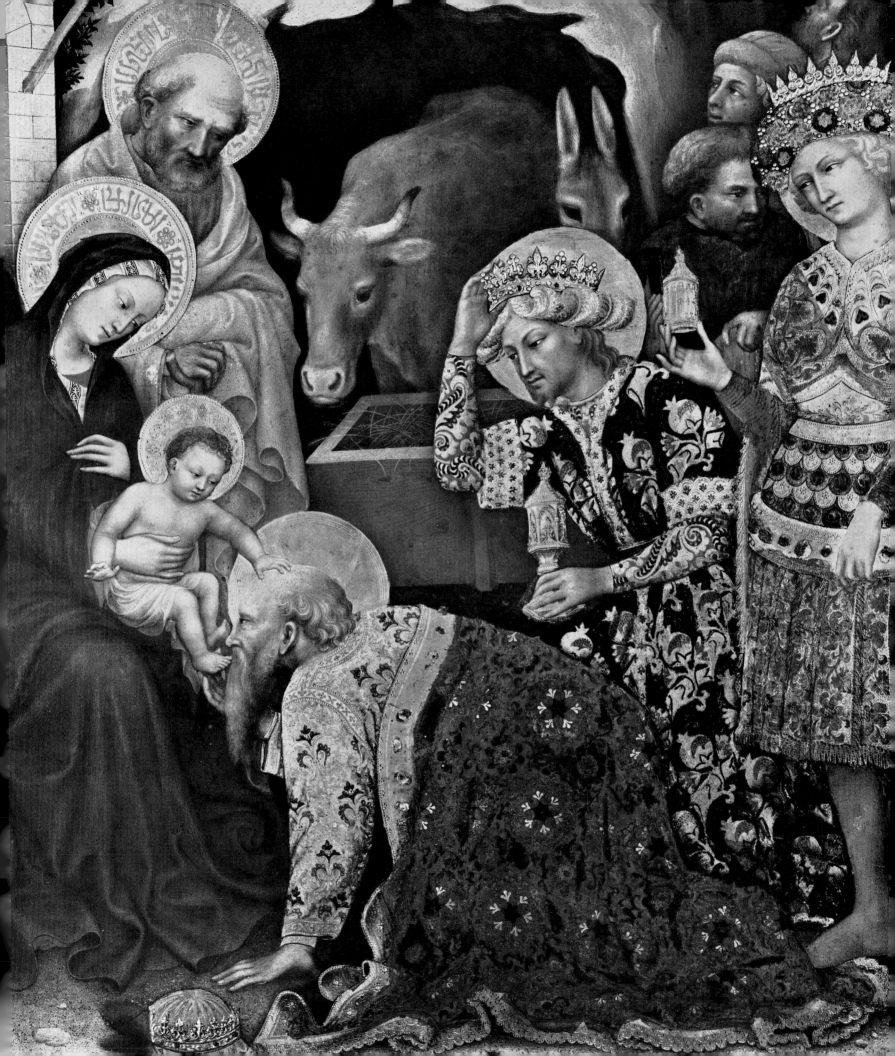

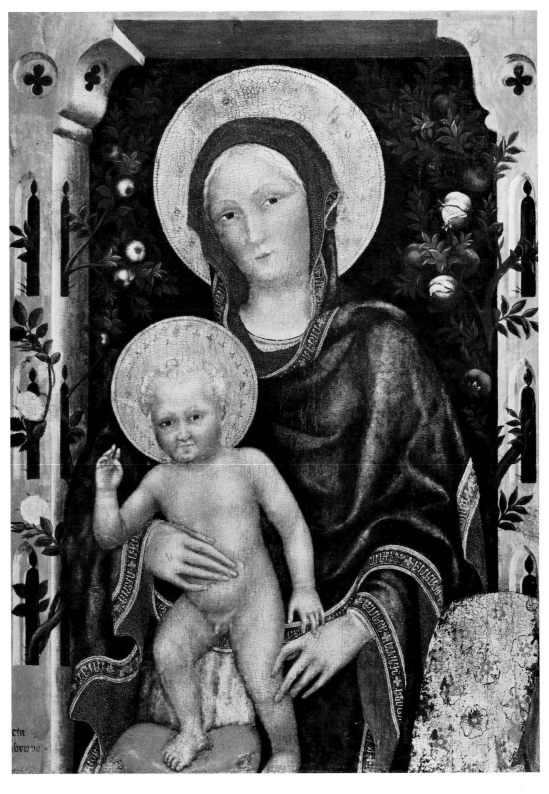

16. Gentile da Fabriano: *Virgin and Child*. New Haven, Yale University Art Gallery, Jarves Collection.

17. Gentile da Fabriano: *Virgin and Child*. Centre panel of the Quaratesi Polyptych. Hampton Court Palace, Royal Collection.

18-19. Gentile da Fabriano: *Saints Mary Magdalen*, *Nicholas*, *John Baptist and George*. Details from the Quaratesi Polyptych. Florence, Uffizi.

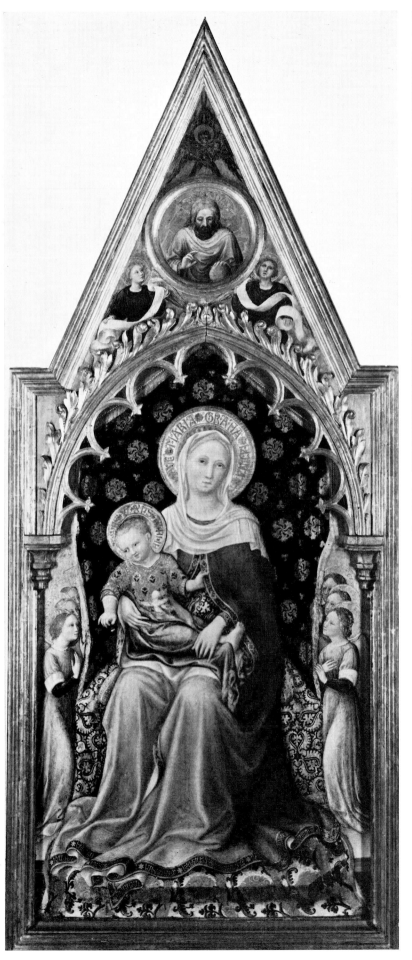

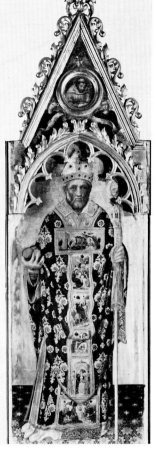
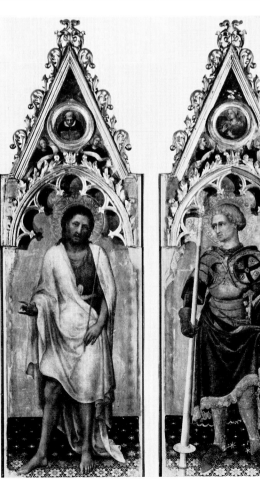

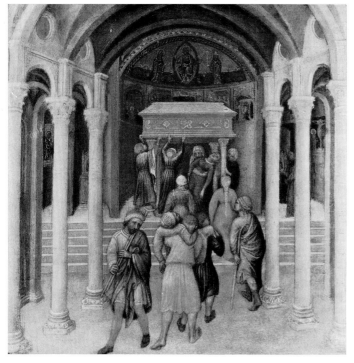

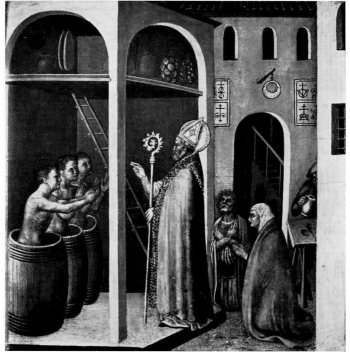

20. Gentile da Fabriano: *Pilgrims at the tomb of Saint Nicholas of Bari*. Detail from the predella of the Quaratesi Polyptych. Washington, National Gallery of Art (Samuel H. Kress Collection).

21. Gentile da Fabriano: *Saint Nicholas of Bari restores three dead youths to life*. Detail from the predella of the Quaratesi Polyptych. Rome, Pinacoteca Vaticana.

22. Gentile da Fabriano: *The Birth of Saint Nicholas*. Detail from the predella of the Quaratesi Polyptych. Rome, Pinacoteca Vaticana.

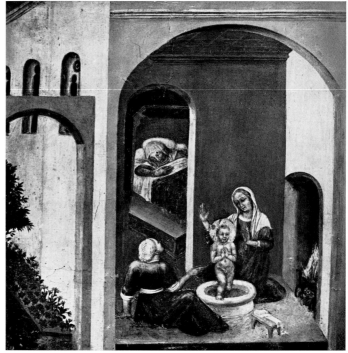

23. Gentile da Fabriano: *Saint Nicholas of Bari saving a ship at sea*. Detail from the predella of the Quaratesi Polyptych. Rome, Pinacoteca Vaticana.

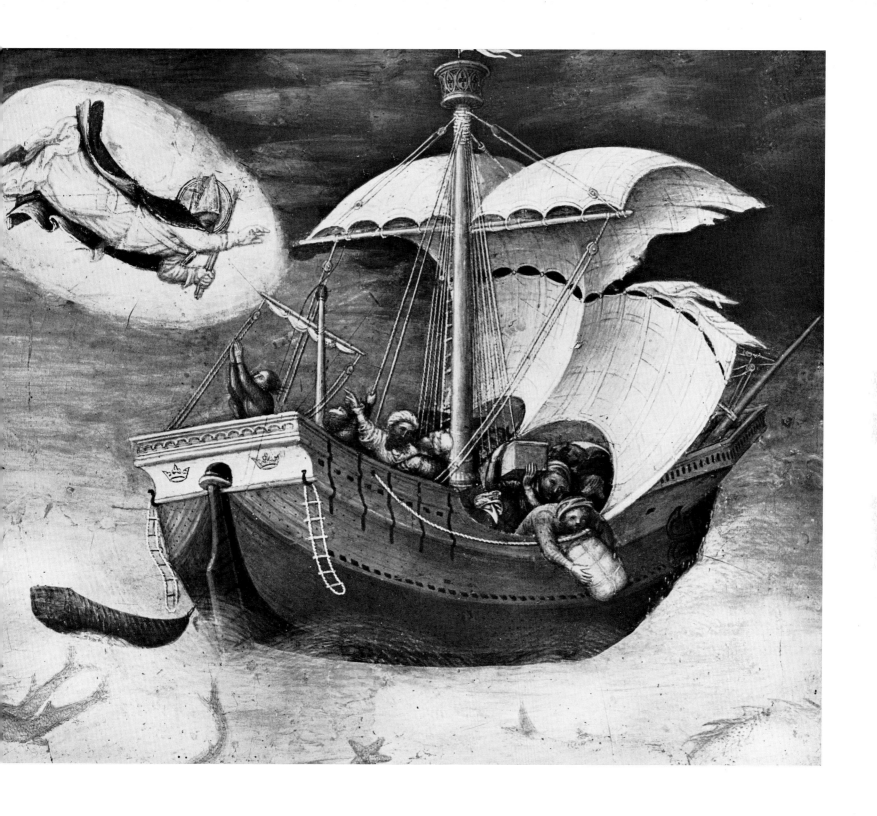

24. Jacobello del Fiore: *Madonna of Mercy with Saints James and Anthony Abbot.* Switzerland, private collection.

25. Master of Staffolo: *Virgin and Child with Saints John Baptist and Catherine.* Fabriano, Pinacoteca Civica.

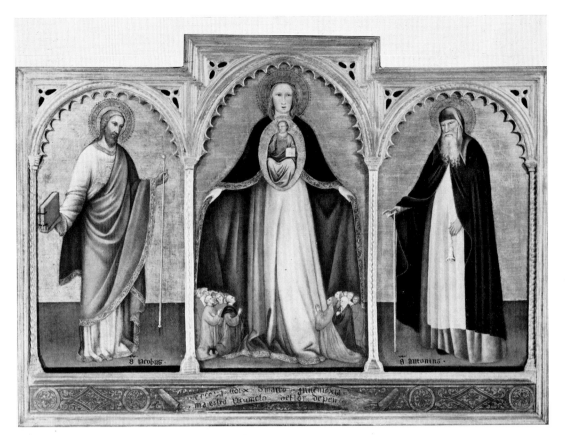

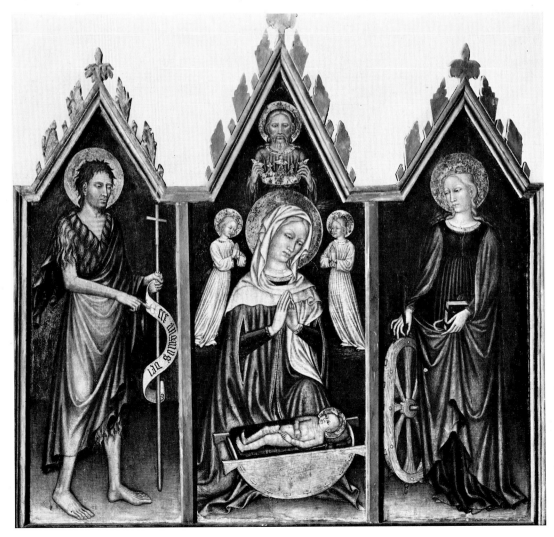

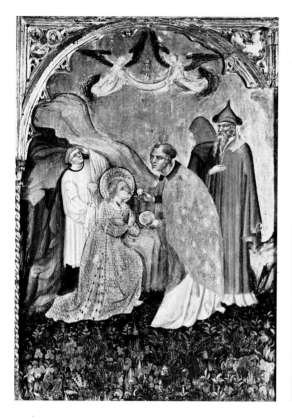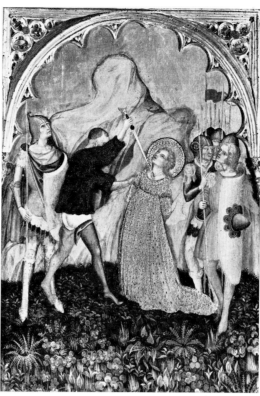

26-27. Jacobello del Fiore: *Communion and Martyrdom of Saint Lucy*. Fermo, Pinacoteca Civica.

28. Follower of Gentile da Fabriano: *Triptych: Virgin adoring the Child, with two Saints*. Pesaro, Pinacoteca Civica.

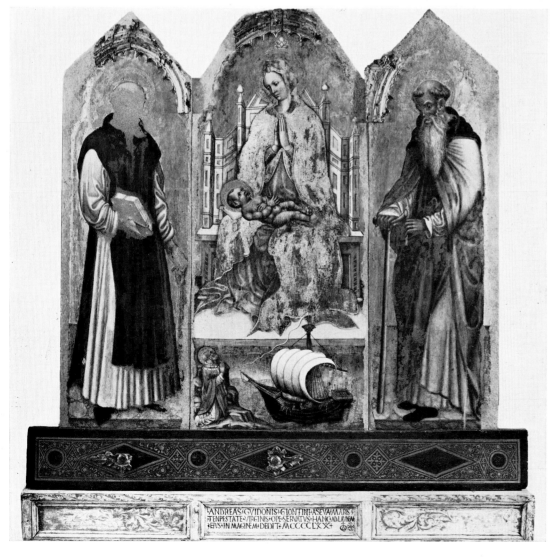

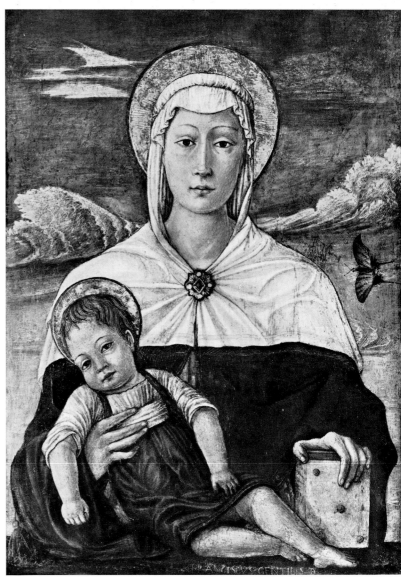

29. Anonymous Master, c. 1400-1450: *Battle between the people of S. Ginesio and of Fermo* (detail). S. Ginesio, church of Sant'Agostino.

30. Francesco di Gentile: *Virgin and Child with the Butterfly*. Rome, Pinacoteca Vaticana.

31. Francesco di Gentile: *Portrait of a young man*. Bergamo, Pesenti Collection.

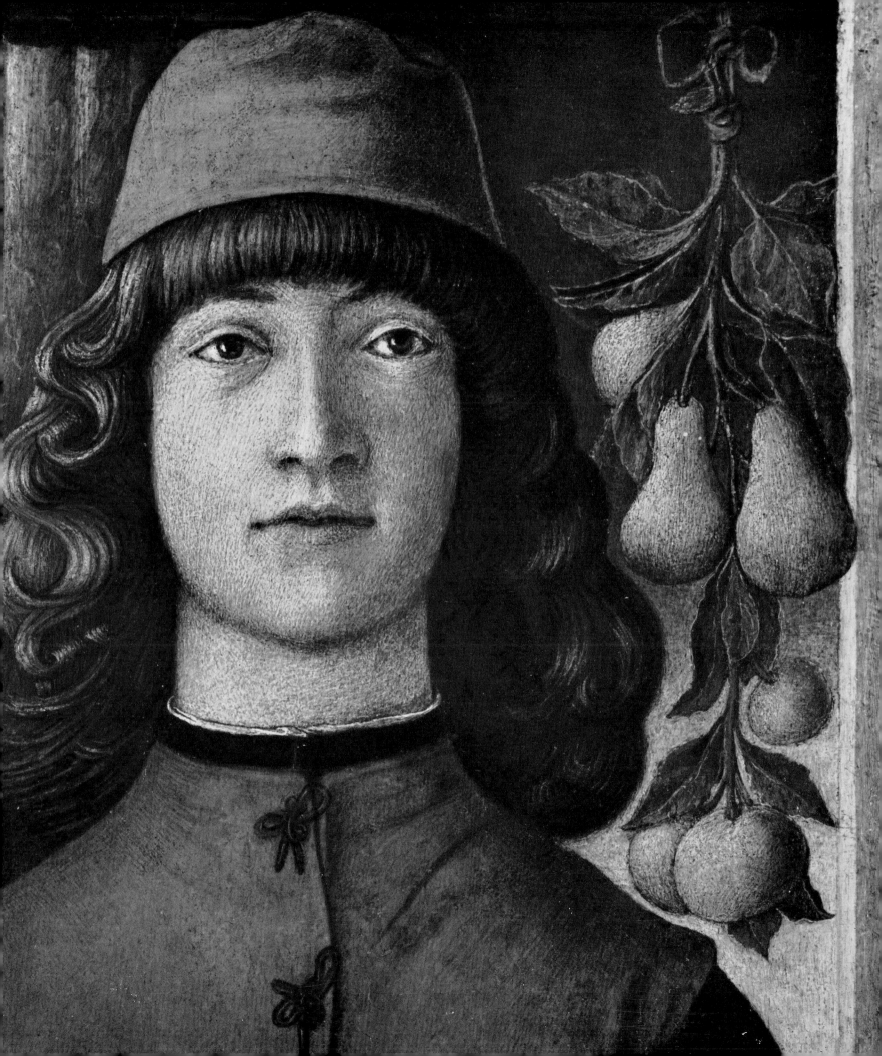

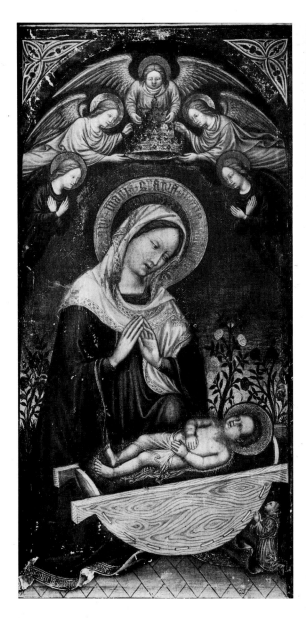

32. Master of Staffolo (?): *Virgin adoring the Child*. Matelica, Convent of the Magdalen.

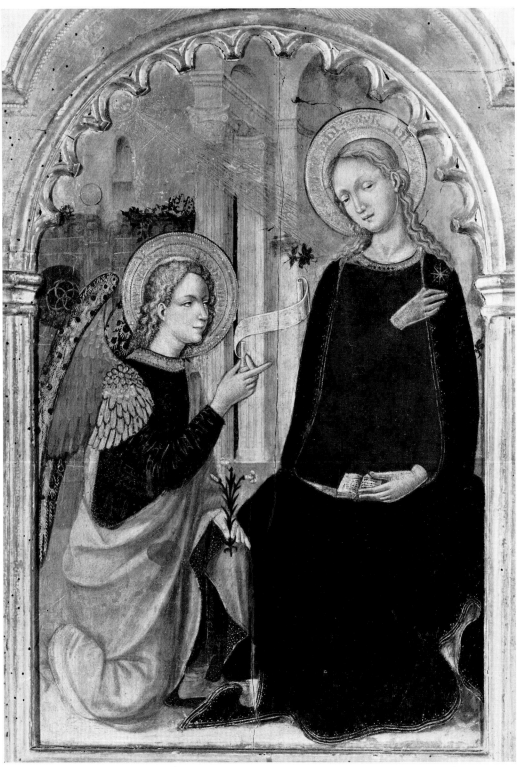

33. Francesco di Gentile: *The Annunciation*. Perugia, Galleria Nazionale.

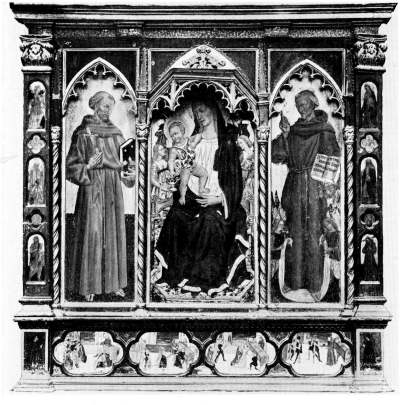

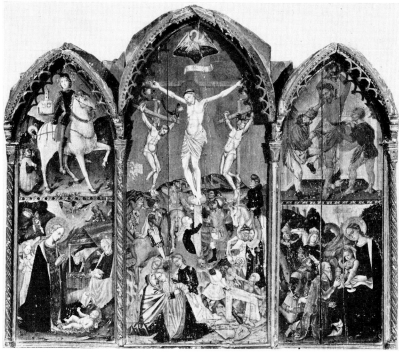

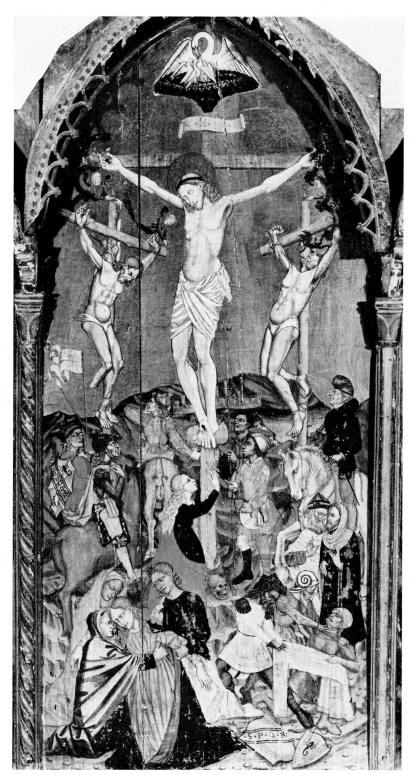

34. Francesco di Gentile: *Triptych: Madonna enthroned and Saints.*
Matelica, Church of S. Francesco.

35-35*a*.Francesco di Gentile: *Triptych: The Crucifixion, the Nativity and the Adoration of the Magi.* Matelica, Museo Piersanti.

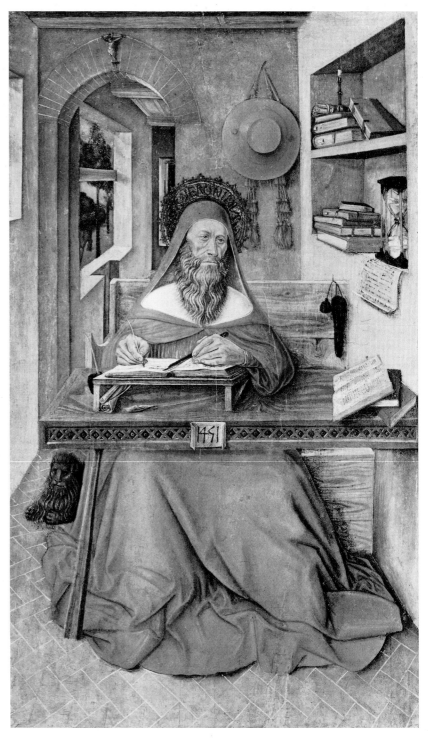

36-37. Francesco di Gentile: *Adoring Angels*. Rome, Galleria Nazionale.

38-39. Antonio da Fabriano: *Saint Jerome*. Baltimore, Walters Art Gallery.

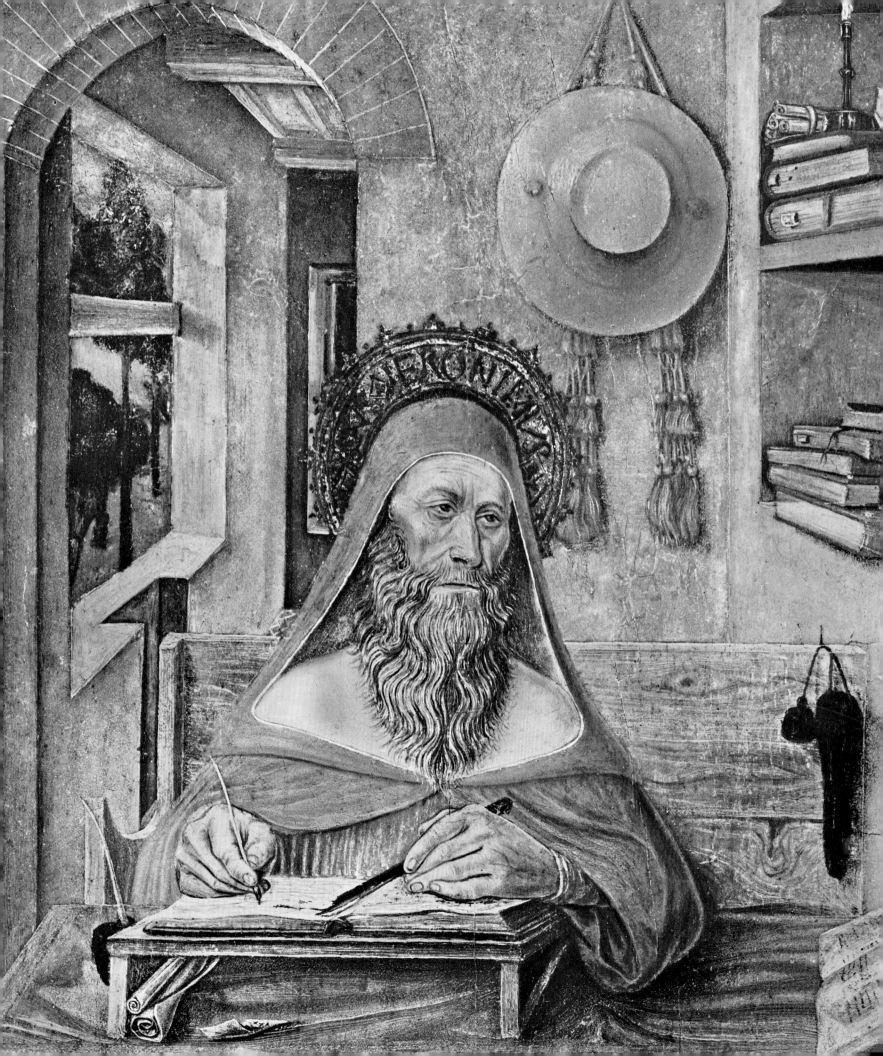

40. Antonio da Fabriano: *Portrait of a monk*. Ponce, Puerto Rico, Museo de Arte (Samuel H. Kress Collection).

41. Antonio da Fabriano: *Triptych*. Genga, Church of S. Clemente.

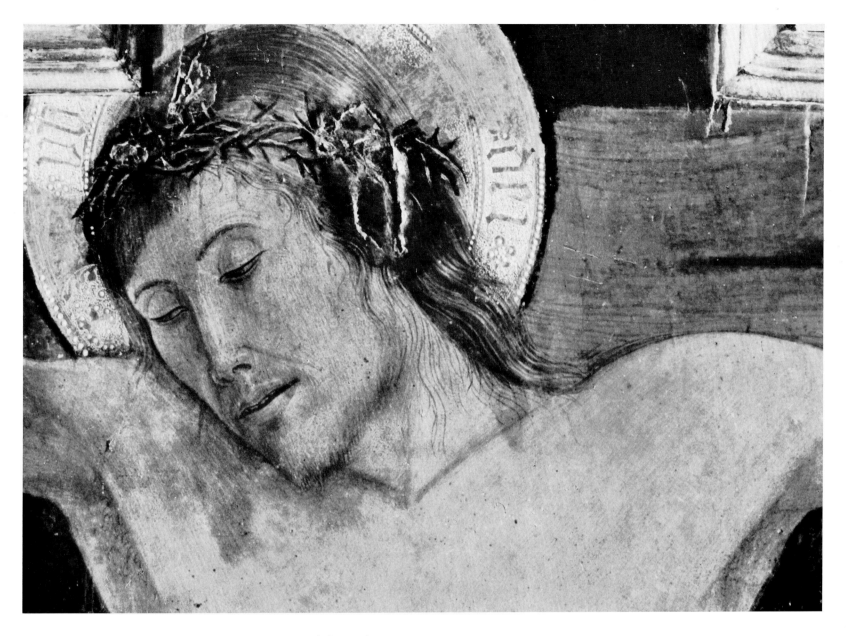

42.  Antonio da Fabriano: *Christ on the Cross*. Detail from plate 43.

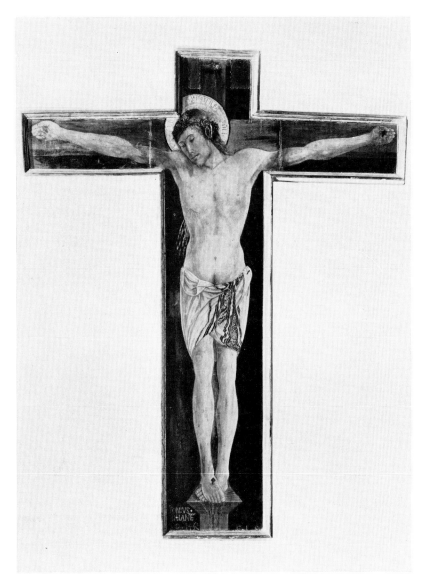

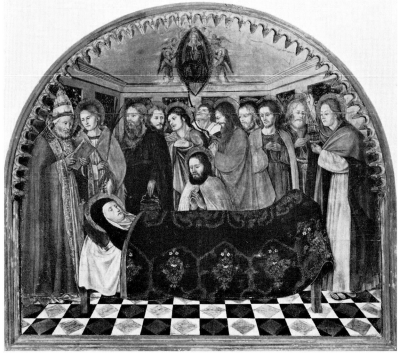

43. Antonio da Fabriano: *Christ on the Cross*. Matelica, Museo Piersanti.

44. Antonio da Fabriano: *Triptych*. Gualdo Tadino, Pinacoteca Comunale.

45. Antonio da Fabriano: *The Death of the Virgin*. Fabriano, Pinacoteca Civica.

The town of Camerino, now known above all as the seat of a small university, was formerly of considerable political and, consequently, cultural importance. Its early history is not within the scope of our discussion. During the fourteenth century, the De Varano family was engaged in the gradual establishment of its Signoria, which was later to become the most powerful in the southern Marches, in spite of continual struggles, such as that against Carlo Malatesta. The subsequent history of this family, and of the town itself, is characterized by dramatic and sometimes tragic events, such as the murder of Giovanni Da Varano in 1433, and the brief period of Republican rule that followed the massacre of Gentil Pandolfo and two other members of the family in July, 1434. This was probably work of Francesco Sforza, whose object was the conquest of the Marches. He did at least restore real freedom to Camerino, for on this occasion, the town took the statutes of Siena as the basis for its own future government. The Republic lasted as long as the local political situation remained favourable to Francesco Sforza, that is until 1443, when he was forced to return north, pursued by Nicolò Piccinino, leader of the papal forces and those of Alfondo of Aragon. In December of the same year Giulio Cesare and Rodolfo da Varano were returned to power. The two cousins had escaped the slaughter of 1433 together with Elisabetta Malatesta, the wife of Pier Gentile, who had been decapitated at Recanati on the 6 September of that year. The little duchy received new life, thanks to the wise policy of Elisabetta, who prepared the cousins for the future government the town, while developing friendly relations with the Duke of Milan, Federico da Montefeltro, and the Roman Church.

In 1448 the Duchess retired to a convent, leaving the two cousins to govern the little State. Rodolfo died in 1464, and power remained in the hands of Giulio Cesare, who was a man of great wisdom, an excellent politician, and a courageous general. His love of art and his refined taste led him to change Camerino considerably, and to build, amongst other things, the Ducal Palace, which, for its architectural beauty and the elegance of its decorations, must have been a unique example of its kind. With the accession of Alexander VI to the papal throne, Camerino suffered the same misfortunes that overtook the other States of central Italy. Cesare Borgia, after occupying the duchy of Urbino, invaded that of Camerino. On the 9 October, the old duke was murdered in the fortress of Pergola, where he had been imprisoned. This was followed by the murder of his three sons, Annibale, Venanzio and Pirro, who, in the meanwhile, had been taken to the Torre di Cattolica.

After the death of Alexander VI in 1503, the Da Varano were able to regain possession of their territory under Giovanni Maria, who married Caterina Cybo. In 1515 the Signoria of Camerino was officially granted the status of a Duchy by Leo X, and the town enjoyed

what was truly to be one of the most splendid creative periods of its history.

This brief sketch will serve to demonstrate how very lively a centre Camerino was in the fifteenth century. Even in the field of learning it produced important figures, some of them humanists, such as Muzio and Favorino, as well as historians and men of letters. A female member of the Da Varano family, Costanza Da Varano, left writings in Latin and Italian, although she died at the early age of twenty-one.

There is little evidence now of this great political and cultural ferment, because the town, unlike Urbino, which has remained intact, has undergone a profound change. The reasons are to be sought, above all, in the decadence into which the town fell under the rule of the Popes (a fate common to the whole region); secondly, in the earth-quakes by which it was ravaged, particularly in the eighteenth century; and finally, in the use of sand-stone, which, exposed to the erosion of the atmosphere, has gradually crumbled to such a point, that the town's buildings have changed in appearance. A particularly unhappy fate has been reserved for the Ducal Palace, which was rebuilt by Giulio Cesare about 1490. Its structure is now greatly altered, and it has been encased in brick to ensure stability. This is doubly sad, because it has changed beyond recognition what must have been one of the most beautiful of all Renaissance courtyards. Baccio Pontelli was perhaps responsible for its architectural lines, while its decorations (only recently uncovered in part) must certainly be attributed to Carlo Crivelli, who was active at Camerino about 1490, as his works in the Brera Gallery of Milan prove.[1] The first artist from Camerino to appear in the records is Cola di Pietro, mentioned by Pirri (1917) as the author of some of the frescoes in the church of S. Maria in Vallo di Nera (Perugia). This painter's work has been studied by Gnoli, van Marle, and other scholars. Vitalini Sacconi, who devotes a chapter to Cola in his book on the school of Camerino, has reconstructed his oeuvre on the basis of precise stylistic criticism, and has grouped together a number of works, among them the great *Crucifixion* in the refectory of the Convento delle Clarisse at Camerino. This fresco, previously described by Aringoli (1928), has also been studied by Marchini, who has noticed its Giottesque and Sienese influences, as well as elements of northern derivation, which are particularly evident in the keen, pungent, narrative style of the subsidiary episodes. Marchini concludes that the fresco is by "an artist of local extraction, capable of throwing further light on the origins of the school of Camerino".[2] Vitalini Sacconi also attributed to the painter the frescoes in the church of the Abbey of Ponte La Trave, where, in a vast Crucifixion covering the left wall of the presbytery, one can find stylistic elements rather similar to those of the Master of Campodonico and at the same time connected with the art of Pietro Lorenzetti. These frescoes undoubtedly share stylistic affinities, together with the *Crucifixion* which forms the central part of a polyptych in the Civic Gallery of Camerino, also attributed by Sacconi to Cola di Pietro. If it is his, then one must also attribute to him another fresco of the Crucifixion in the apse of a now roofless, dilapidated country church near Bolognola. This unknown work clearly belongs to the same master, whose style is conspicuous for its etiolated stylization, which elongates his figures in the search for an unmistakable Sienese elegance. Particularly significant is the slender body of the Christ on the panel in the Camerino Gallery This is the work of a very refined painter, wholly involved in subtle problems of forms, and whose art is perhaps based on close study of manuscript illumination.

It is difficult however, to credit one single artist with works that differ both in style and influence, such as the Apostles in the parish church of Pievetorina, for example, or the great *Death of the Virgin* in the church of S. Maria at Vallo di Nera, where the compositional rhythm, the symmetrical arrangement of the figures, and the peculiar iconic effect of the whole, point to a cultural background totally at variance with the artistic personality of the author of the Camerino *Crucifixion*. Here, there is movement and interplay between

the pictorial masses, and its style was certainly not forgotten when the Salimbeni brothers painted the Oratory of S. Giovanni at Urbino. In brief, it is a fresco that opens out to the future, whereas the frescoes denote almost too strong a link with tradition. Therefore if Cola di Pietro is really the author of the above-mentioned frescoes of the Valle Nerina, then he cannot have carried out the frescoes in the church of Ponte La Trave and the works already mentioned at Camerino. In any case, it is perfectly clear that an artistic tradition sensitive to the most genuine feelings of the time existed at Camerino at the end of the fourteenth century. One might say that here, as at Fabriano, figurative art was already "at home", and in a particularly open and alert way. Moreover, a desire for knowledge motivated here a search for the means to express itself fully just as soon as a painter of real calibre appeared on the scene. For it was no coincidence that Camerino was in political contact with Florence, Venice, Siena and other places.

## Carlo da Camerino

In 1935, on the occasion of the exhibition of fourteenth-century Riminese painting, a painted cross belonging to the church of S. Michele Arcangelo of Macerata Feltria—a little town at the foot of the Carpegna, between the Marches and the Romagna—was restored and included in the exhibition. The painting, believed to be the work of a local master, revealed in the course of its restoration the name of its author and date. This was a very late one in comparison with the intense, lively, but brief flowering of the school of Rimini: "Hoc opus factum fuit anno domini MCCCLXXXXVI a lu... deci... Carolus da Camerino pinxit". Brandi wrote in the exhibition catalogue that "Carlo da Camerino, now revealed, even though he does seem like an Arcangelo di Cola (also from Camerino) before his time, is still so Riminese as to remind a new century of the fact".[3] This was clearly a hasty and contradictory judgement, an attempt to justify the inclusion of a painter who had no business to be represented in the exhibition, for if there was ever an artist free from all Riminese influence, that artist was Arcangelo di Cola, and any grouping of the two together is purely arbitrary. But Brandi's discovery proved to be a happy chance, and was to bear fruit later.

In 1948 Zeri published a brief article on the painter, attributing to him a second work, the *Annunciation* in the Gallery of Urbino (plates IX, 46), which also came from Macerata Feltria, where it had been exhibited in the town hall until 1918.

Zeri, by means of a stylistic examination of the two works—the signed *Crucifixion* and the *Annunciation*—demonstrated that they were by the same artist, rightly pointing out that the artist's antecedents were to be sought, not so much within the orbit of Riminese painting (in spite of some concession to the decorative style in the use of the gold ground of the panel), as in the frescoes by Giotto, Simone Martini and Pietro Lorenzetti at Assisi, that is, in that pictorial symposium at which the different currents of painting in the Marches, from the Master of Campodonico to Carlo da Camerino, looked so intensely, if not exclusively. Carlo da Camerino was also interested in the Bolognese painters, who were active in the Marches along the Adriatic coast, from the Romagna to Ancona and beyond. He must have worked in this area for a long time, as nearly all his works are in the northern parts of the region. Again, in 1948, Philip Pouncey recognized the hand of Carlo in two panels with Angels and Saints, which had been previously attributed to a nonexistent "school of Ancona", and which had formed the wings of a triptych now lost or dismembered. This attribution is to be accepted and placed in relation to the *Crucifixion* of Macerata Feltria. In 1950, Zeri credited the painter with six other works, three in the Gallery of Ancona, and three in the Museums of Stockholm, Cleveland and Baltimore. This makes a considerable

number, even if the grouping of all these works (especially those of Ancona) in the oeuvre of a single artist does raise certain stylistic problems.

The reconstruction of Carlo's artistic personality is a difficult task, but the mere fact that we can reach certain conclusions and gather together a number of indicative elements is an essential step forward in getting to know something about the still very intricate problem of the formation of the Marchigian schools of painting at the beginning of the fifteenth century. Carlo was undoubtedly an eclectic painter, but he succeeded in shaking off a certain compositional rigidity of fourteenth-century painting in his sometimes tender search for concrete representation. His art is characterized by the alternation of a lyrical abandon tied to an almost abstract linearity—as in the *Annunciation* of Urbino—with other forms so much more solid and firm in their popular solemnity, as in the *Death of the Virgin* in the Gallery of Ancona. Taking the *Crucifixion* of Macerata Feltria as our sure point of departure, since it is signed and dated (1396), we must try and date the artist's other works with reference to it. The *Death of the Virgin*, with its many Bolognese allusions (in fact, it has been assigned to Andrea da Bologna, an attribution still maintained by Longhi I believe), must be an earlier work, because of its formal uncertainties and the presence of elements which may even derive from the Master of Campodonico himself. Other pictures, however, such as that of the Eternal with the soul of the Madonna in His arms, are again of Bolognese origin; this picture is also connected with the corresponding figure above the *Crucifixion* of Macerata Feltria. The Ancona *Circumcision* is a much later work; its decorative style is so typical of the florid Gothic, which is as evident in the slender little columns supporting the Temple, as it is in the Angels in the pinnacles above.

Another panel that might be connected with this work, and which is still unattributed, represents the Madonna and Child set within an architectural structure supported by the very slenderest of columns (plate 50). The upper part of this structure takes on the form of a cupola, which partly recalls that of S. Maria del Fiore. Six Angels hold the thin stems of the columns as if they were the poles of a canopy in a procession. Others, on the tops of the columns, lose the rigid statuary poses and move with their little wings outstretched, the sashes round their waists fluttering in the wind. The colours are rather severe and incline towards tones of brown, as in the Ancona *Circumcision*, seeming almost to anticipate a taste peculiar to the Fabrianese artist, Francesco di Gentile. This panel must therefore represent the very last period of Carlo's paintings. Zeri even attributed to him—and probably rightly so—the hieratic Madonna which was once a part of a fresco in Convent of S. Domenico and which is now in the Ancona Gallery. This fragment has also been attributed to various painters of the International Gothic style. Here Carlo appears as the practitioner of a refined style, with so carefully gauged a sense of rhythm, as to place him upon a rather higher stylistic level than that attained in the so much more pouplar *Death of the Virgin* in the same gallery. I would not hesitate to group the latter with the *Cruicfixion with four Saints and the kneeling Magdalen* in the Strossmayer Gallery of Zagreb. Previously attributed to the school of Ancona, this painting has been given to Lorenzo Salimbeni in the Gallery's latest catalogue. But everything suggests that it is a work of Carlo's, perhaps even earlier in date than the Macerata Feltria *Crucifixion*. If it is so, then one will have to assume a more complex chronological evolution of his art to replace that based upon the over-generalized formula of eclecticism, which may just conceal our own incapacity to perceive developments in his painting brought about by historical and environmental factors. It is difficult to establish these developments now, since we know so little of what went on in the artistic world of the time and have only one signed and dated work, the *Crucifixion* of Macerata Feltria. However, the likeliest theory is that Carlo, after beginning in a style modelled on the art of Bologna, turned to Sienese painting, adopting a style similar perhaps to that of the early Gentile.

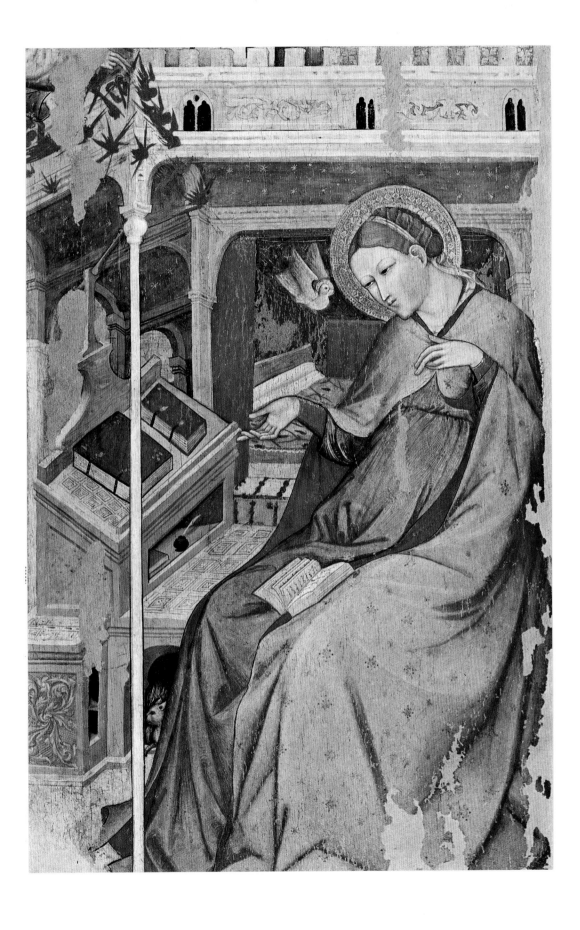

IX. Carlo da Camerino: *Virgin Annunciate*. Urbino, National Gallery

Hence the stylistic contradictions, which, in fact, reveal the development of a more subtle, refined sensibility, such as we see in the *Annunciation* of Urbino and other works done in the International Gothic manner, until we come to the panel of *St. Francis receiving the Stigmata*. Here, the traces of Gentile combine with other elements, such as the flower-dotted lawn which anticipate, or perhaps testify to mutual contacts with, the art of Jacobello del Fiore.[4]

## Catalogue of works
[*see plates IX*, 46–50].

Ancona, Pinacoteca Civica, *Death of the Virgin* (?); ib., *Circumcision*; ib., *Crowned Virgin* (fragment of fresco).
Baltimore, Walters Art Gallery, *Triptych, Madonna and Child with SS. Peter, Paul, John the Baptist and Francis*.
Bassano, Private Coll., *Madonna and Child Enthroned with Angels* (?).
Cambridge, Fitzwilliam Museum, *Two lateral panels of triptych representing Angels in Adoration and SS. Peter and Paul, John the Evangelist and Andrew respectively*.
Cleveland, Museum of Art, *Madonna and Child adored by Angels with Eve and the Serpent in the lower half*.
Falerone, Town Hall, *St. Francis receiving the Stigmata*.
Macerata Feltria, Church of St. Michael the Archangel, *Painted Cross with Risen Christ, Madonna, St. John the Baptist and praying Franciscan* (signed and dated 1396).
Mondavio, Town Hall, *Madonna and Child Enthroned, and in the pinnacle, Christ on the Cross between Madonna and St. John*.
Rome, Vatican Gallery, *Six little panels representing the Works of Mercy*.
Stockholm, National Museum, *Coronation of the Virgin and Eternal surrounded by angelic Choir*.
Urbino, National Gallery, *Annunciation*.
Zagreb, Strossmayer Gallery, *Christ on the Cross surrounded by female Martyr Saint, Madonna, St. John the Evangelist, St. Anthony Abbot, and St. Mary Madgalen at the foot of the Cross* (?).

## Olivuccio di Ceccarello

According to Amico Ricci, Filippo Maria Visconti ordered a painter called Olivuccio di Ceccarello, in 1429, to carry out an *Adoration of the Magi* for the Holy House of Loreto, for the agreed sum of 50 gold florins.

In the document the artist's name appears as "Magister Alegutius Cicarelli de Ancona", but further research by Giannandrea (based also on discoveries made by Feliciangeli in the archives) led to the conclusion that the artist was not really from Ancona, but from Camerino. Thus it was discovered that he was primarily active in the district of Ancona, where, amongst other things, he painted in the church of S. Francesco alle Scale in 1434, and then in the church of S. Martino at Sirolo, for which he finished a *Crucifixion* and *Six scenes from the Life of S. Nicolò* in the following year. The artist died in 1438, and was buried in the above-mentioned church of S. Francesco.

It is clear that Olivuccio must have been an artist of considerable reputation for the Duke of Milan to turn to him, for a painting that was to be donated to the House of Loreto. Moreover, follower as he was of the International Gothic in art, Visconti would not have entrusted the work to an artist whose work was out-of-date. The document provides precious evidence of the cultural relations between Lombardy and the Marches, and may also help to account for the flowering of the courtly Gothic style in the region and of the way it took root there, to the point that it even became popular.[5]

Since the works mentioned in the documents have been lost, only Olivuccio's name remains, but no concrete evidence of his activity. Giannandrea suggested long ago that a panel representing *S. Primiano*—an anonymous work, attributed by the critics to the Umbrian or Sienese school—may be an example of Olivuccio's work. Sixty years passed before this suggestion was taken up again. In comparing the styles of Arcangelo di Cola and Carlo, Zeri claims that the two artists must have been in contact with each other. However, he goes on to say that relationship cannot be defined with any greater accuracy, since "information is still lacking regarding the third artist from Camerino who was present

at the time, and who worked almost exclusively in the commercial centre of the Marches (Ancona); that is to say, that Olivuccio di Ceccarelli, whose characteristics we can only suspect are traceable in a small group of works very similar to Carlo's". The scholar adds that first among these works is the majestic *Madonna Enthroned*, formerly in the cathedral of Ancona, but now almost completely destroyed by the bombardments that hit S. Ciriaco in the Second World War.[6] Vitalini Sacconi has rightly drawn together the threads of the argument, to begin the reconstruction of the artistic personality of a painter who has remained in the dark so long. Undoubtedly the work that best fits in with the style of Camerino is the *Madonna Enthroned with Child at the Breast*, a painting that really stands halfway between that of Carlo and the best known work of Arcangelo. The solemn, hieratic figure of the Virgin seems to contrast with some of the decorative refinements of the whole, but it remains substantially faithful to a typically local tradition, which can also be found in the stupendous wood sculpture of the Renaissance at its zenith, that is, towards the end of the century. The style of *St. Primiano* is less refined, but its hieratical solemnity connects it with the Madonna, and it is possible that the same source inspired both works, probably on two separate occasions. It is easy to imagine that Olivuccio—if he really is its author—may have felt the influence of Carlo, or even of Arcangelo di Cola, when he painted the *Madonna*.

Vitalini Sacconi also attributes to the artist the fragment of a fresco in the church of the Minori Riformati at Massa Fermana, another work closely related to this group; the attribution may be accepted therefore, if only as pointing to a common stylistic current. But the *Madonna* of the Baravelli Palace at Fabriano, also attributed to Olivuccio, seems to derive rather from the style of Giovanni Antonio of Pesaro,[7] who may be the author, at least in part, of the frescoes in the cemetery chapel of Castelferretti. After further study, these Anconese frescoes may cast light on the relationship between the schools of Camerino and the Adriatic coast.

## *Arcangelo di Cola*

This artist—undoubtedly one of the leaders of central Italian painting during the first decades of the fifteenth century—has still not been restored to his rightful place after centuries of neglect and error. But this task, as we shall see, is a rather arduous one, because of the complex cultural situation in which the artist found himself, especially during his stay in Florence. Was he trained in his native region or elsewhere? This problem concerns the whole International Gothic movement in the Marches.

The information we have regarding Arcangelo is slight, and covers only a very brief period of time. But one must stick to it as the basis for any conjecture. It runs from 1416 to 1429. On 19 October 1416 Arcangelo appears at Città di Castello, where he was paid for a *Magdalen* he had painted in the Sala del Maggior Consiglio of the town hall. In 1420 he was in Florence, where he rented a house for a period that was to begin on 1 November ("to begin on the coming All Saints"). On 27 September of that same year, he was accepted into the Guild of Doctors and Apothecaries; in the relative document he is called "Agnolo di Cola di Vanni, da Camerino". Evidently he must have been in the city for some time, and was, therefore, known for his work as a painter. In 1421, again at Florence, he joined the company of St. Luke, and in the same year, on the commission of Ilarione de Bardi, he agreed to paint a panel (perhaps a polyptych) for the church of S. Lucia de' Magnoli, a work now lost. At the same time he was commissioned to do a second panel for the parish church of Empoli, a work that was never carried out, as we learn from the fact that he returned the money he had received in advance. The refund was undertaken by a certain Michele Agnolo, painter, who was perhaps an assistant of Arcangelo's.

On 18 February 1422, the artist received from Martin V a safe-conduct pass to move freely about Italy. "Since Our beloved son Arcangelo di Cola of Camerino, who will show these letters, must go to various places in Italy on Our business and that of the Roman Church, We desire that he enjoy every safety on his outward journey, during his stay and on his return journey. We therefore pray and earnestly exhort you, and all Our subjects and soldiers, ordering that you in no way harm or offend, and that in so far as it is within your power, you will prevent all others from so harming or offending the said Arcangelo, whom We so benevolently recommend, as well as his companions, members of his household, horses, baggage, packs, equipment, and all whatsoever he shall carry with him." Thus reads the translation of the pass sent by the Pope to Arcangelo, which can be seen in the Vatican register 353 C. 219. The document continues with further exhortations, that the painter is not to pay custom duties or tolls, and that he and his following are to be given every assistance if ever they should require it. All this clearly shows how much the Pope cared about the painter, at a time when travelling was no easy matter, and how much his care extended to the little "court" around him, of which we are given a glimpse in the document ("companions, members of his household, horses" etc.). A poor painter would not have been able to afford to travel with so expensive a retinue. Therefore, Arcangelo must have been well-known; and especially so, if he was able to get persons at so high a level to act on his behalf.

There is no further information about him from Florence, save that regarding the painting for the church of S. Lucia de' Magnoli, and the refunding of the sum received for the Empoli altarpiece that was never carried out.

In 1425 the artist appears in his native district, since a triptych dated with that year once hung in the church of Monastero dell'Isola in the surroundings of Camerino. This work, fundamental for our knowledge of his style at that time, was unfortunately destroyed by a fire in September 1899. It seems that Arcangelo was again in Florence in 1427, for it appears that he was indebted to Pietro Battiloro in that year. In 1428 he was at Camerino, where he witnessed the testament of Nicolina Da Varano, widow of Braccio da Montone. On 30 July of the following year, he was also at Camerino and supervised the installation of the choir-stalls in the church of S. Domenico. After this date there is no mention of him in the documents.

The information without the works, although useful, would seem to have no meaning. But though meagre, the documents are extremely important, for they show that Arcangelo was an artist fully alive to the tastes of his time. And in a city like Florence, where the appearance of the revolutionary figure of Masaccio had produced one of the greatest cultural crises of all time, this meant a great deal. It is well to pay attention to the dates that follow each other so rapidly, and to the closely-knit sequence of events. Arcangelo was in Florence in 1420. Two years later, the most famous exponent of International Gothic, Gentile, returned to Florence after his wonderful period of activity in Venice and Brescia. Masolino's *Madonna* of 1423, formerly in Bremen, shows the Tuscan painter to be fully immersed in the same Gothic culture. The famous frescoes of the Brancacci chapel in the church of the Carmine, most probably begun in 1424–25, mark the beginning of the new era of Masaccio. The panel of *St. Anne with the Virgin and Child* (Uffizi) was painted in the same period, and, as Longhi has ably demonstrated, was the fruit of the collaboration, already in course at the Carmine, between Masaccio and Masolino, two similar artists, who were, nevertheless, representatives of two quite different worlds.

How much the presence of the two artists from the Marches counted in Florentine art during those years is difficult to say, but it is clear that they brought with them a refined style, which had reached the apogee of its sophisticated and decadent splendour. The sudden

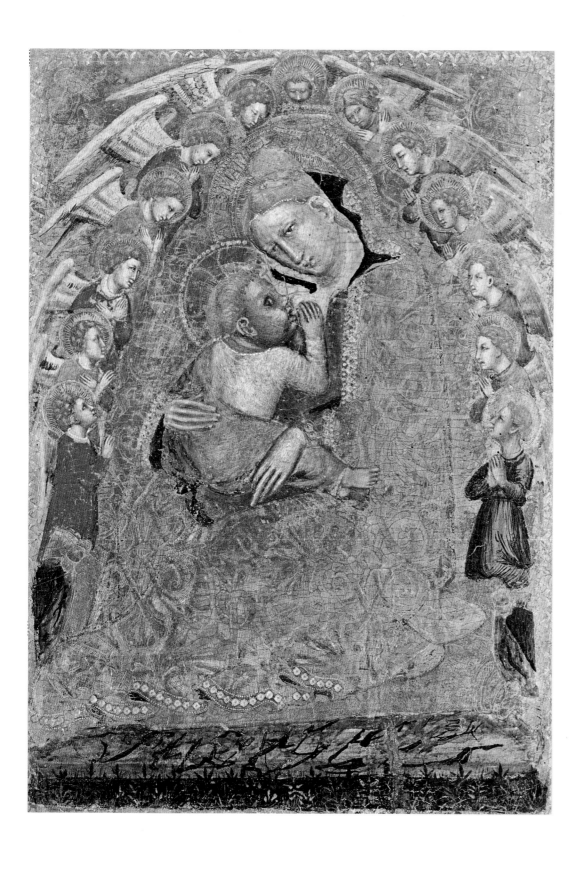

X. Arcangelo di Cola: *Madonna of Humility*. Ancona, Pinacoteca Civica

advent of Masaccio not only surprised the artists who were strangers in the city, but the Florentines themselves. It is unthinkable, therefore, that the powerful, intransigent personality of Masaccio might have been influenced by Arcangelo; the opposite is more likely. In fact, the peculiar solidity of the *Madonna Enthroned and Angels* at Bibbiena—one of the few works of his still extant—is the result of a new element which is in conflict with the linearity typical of the courtly Gothic, and which we find in other paintings by Arcangelo. Moreover, as Longhi has pointed out, the Child's gesture, in putting a grapestone into its mouth, is taken from Masaccio's polyptych for the church of the Carmini at Pisa. But there is clearly nothing in Masaccio that can be derived from the work of Arcangelo or that of Gentile. The influence exercised by the young revolutionary painter on Arcangelo may help in establishing earlier dates for other works which clearly precede this later style, until we come to the *Madonna of Humility* in the Gallery of Ancona (plate X), which has only recently been attributed to the artist by Zeri. Arcangelo, therefore, began in a style tied, like that of so many other Marchigian artists of his time, to fourteenth-century Sienese painting, and similar to that of Carlo da Camerino. The latter however, must have preceded him in the acceptance of International Gothic, while Arcangelo's style clearly marked by certain naturalistic traits, derived from the presence of Bolognese influences in the local artistic ambient. At this point, one really must ask oneself what the relationship was between Gentile and Arcangelo; for there is no doubt that the two artists knew each other and probably worked side by side. Moreover, we may take the fact that the Pope held both of them in great esteem as indirect proof of this. One only has to look at some of Arcangelo's works of certain attribution to realize how well they did know each other. *The Enthroned Madonna and Child* in Rotterdam (plate 58)—as Vitalini Sacconi has rightly pointed out—is connected, by virtue of the way in which the veil is folded around the neck of the Madonna, with the fresco in the church of S. Marco at Osimo (plate XI), and in both works Arcangelo clearly attempted to follow the art of Gentile.[8] Gentile must also be mentioned with reference to the refined Madonna of the Frick triptych in New York (plate 52). It follows that, since Arcangelo arrived in Florence before Gentile, the two artists must have met each other much earlier, perhaps even before Gentile set out for Venice. According to Amico Ricci Gentile also worked at San Severino, and most certainly in his youth. It is easy to imagine that the two artists—who were born at approximately the same time—met at San Severino or at some place in the neigbourhood. In that same town, another artist stood on the threshold of a brilliant career: Lorenzo Salimbeni. Thus the leading figures of what we may call the Marches' pictorial triangle had the opportunity of meeting each other at the very end of the fourteenth century or at the beginning of the fifteenth, that is to say, at a very early phase in the diffusion of the International Gothic style. These artists then left for different parts of Italy, and worked elsewhere. But it is well to remember that their origins are to be sought in the fruitful encounters that took place on their native soil.

Arcangelo di Cola returned to Camerino towards the end of his life, when, in my opinion, he painted the Osimo fresco (plate XI), which Longhi holds to be an early work. But it seems to me that it is precisely in this painting—in its structural grandeur and in the treatment of the Virgin's face which recalls the panel of St. Anne by Masaccio and Masolino—that we see the results of a great, but misunderstood lesson in art. For what happened to other artists, and to Masolino in particular, also happened to Arcangelo: once beyond the influence of Masaccio's personality, they yielded to their nostalgia for the courtly style, while continuing to apply technical novelties, without really understanding the intimate nature of what had inspired them. That main stream of typically Marchigian and Camerinese painting which sprang from a "contamination" between old and new, and which was to result in a number of refined, sophisticated artistic styles, originated

XI. Arcangelo di Cola: *Virgin and Child Enthroned*. Osimo, church of S. Marco

in the work of Arcangelo di Cola. For he was one of the artists most open to the various currents of his time, though the sudden advent of the great Tuscan took him by surprise, finding him without either the formal means or the necessary artistic ability to adapt himself to the new directions in which art was moving, directions which were alien to his cultural background.[9]

## Catalogue of works
[*see plates X–XII, 51–58*].

Ancona, Pinacoteca Civica, *Madonna of Humility*.
Bergen, Billedgalleri, *Madonna and Child with Jasmine Blossom*.
Bibbiena, Church of SS. Ippolito e Donato, *Madonna and Child Enthroned with six Angels*.
Camerino, Pinacoteca, *Madonna and Child Enthroned with two Angels*.
Modena, Galleria Estense, *Predella: St. Catherine on the Rack; Deposition; the Funeral of St. Zenobius; St. Andrew tied to the Cross; St. John immersed in a Vat of Oil*.
Munich, Walter Schnackenberg Coll. (formerly), *Madonna of Humility*.
New Haven (Conn.), Yale University Art Gallery, *Madonna and Child Enthroned and four Saints* (fragment.)
New York, Frick Coll., *Madonna Enthroned and Child with six Angels; Crucifixion* (signed diptych).
Osimo, Church of S. Marco, *Madonna and Child Enthroned with SS. Dominic and Peter Martyr* (fresco).
Osimo, Convent of St. Nicholas, *SS. Gregory and Luke*.
Philadelphia, John G. Johnson Coll., *Four panels of a predella: Visitation, Nativity, Adoration of the Magi, Flight into Egypt* (also attributed to Paolo Schiavo).
Pioraco (Macerata), Church of the Crucified, *Madonna and Child with two Angels in Adoration* (frescoes in the chapel).
Prague, Narodni Galerie, *SS. Zenobius, Andrew, John the Evangelist and Catherine*.
Rotterdam, Boymans Museum, *Madonna and Child with Angels* (?).
Venice, Vittorio Cini Coll., *Tabernacle: Madonna and Child Enthroned, and on the sides, St. Francis receiving the Stigmata, SS. Anthony Abbot and Bartholomew; Crucifixion, St. Christopher*.
Venice, Cini Coll., *Panel of a predella: Martyrdom of St. Lawrence* (probably a fragment of the lost altarpiece of the church of S. Lucia dei Magnoli in Florence).
Location Unknown, *Archangel Gabriel; Virgin Annunciate*.

## *Giovanni Boccati*

After leaving his native Camerino, Giovanni di Pier Matteo arrived in Perugia in 1445. In that year, he applied to the Priors of the town for citizenship, and declared that he had come to the town six month previously in order to practise the art of painting, and that he intended to stay there. The application was granted, after a number of considerations were taken into account, from which we learn that Master Giovanni was "in arte pictoria expertissimus". Bearing this in mind, and relating it to the last date we have regarding the painter, that is, 1480, one must suppose that he was born about 1410. In fact, a later date, such as 1420 or after, hardly seems reconcilable with the document of 1445, which implies that the painter was already well established, and therefore not younger than thirty years of age. Hence it must be that, when the artist arrived at Perugia, he was already well known, and could therefore be described in the document as being "most expert". The first signed work we have of his is the *Madonna of the Bower*, now in the Gallery of Perugia (plates XIII, 59, 60). The painting denotes considerable experience, and the hand is of an artist who has fully realized the potential of his creative abilities. Two years later, on 23 January 1448, Boccati appears at Padua as "Magister Johannes q.m. Petri Mathej de Camarino pictor abitator Padue in contrada Santi Egidi".

Since the artist's presence at Perugia is also recorded in 1446 (when he sold "a painted altar panel" to the Brotherhood of the Disciplined of St. Dominic for 250 florins) his journey to Padua must have taken place between 1446 and the January of 1448, so that it seems he went there some time in 1447.

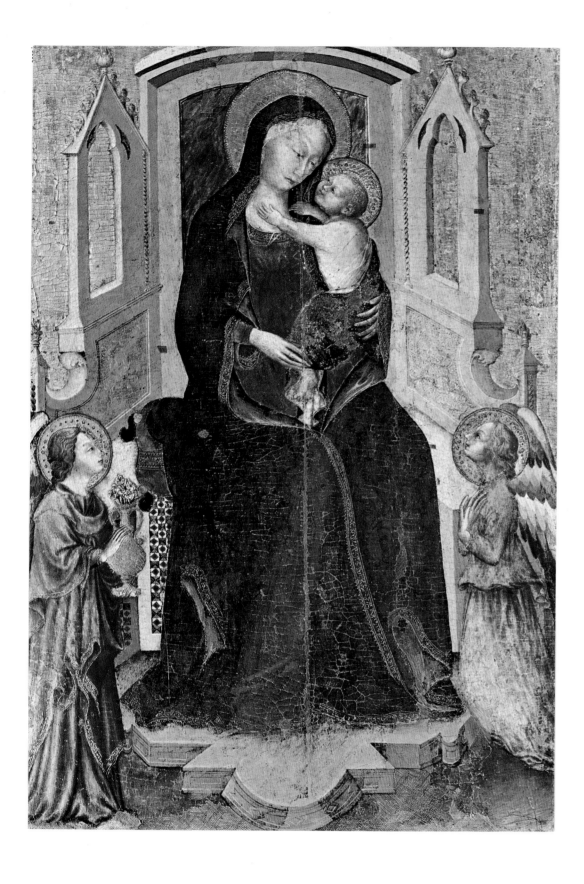

XII. Arcangelo di Cola: *Virgin and Child with two Angels*. Camerino, Pinacoteca Civica

He certainly spent some time at Padua, but he must have returned to his native town in 1450, for in March of the following year he had already left it again, and is to be found in Florence, together with Giovanni Angelo. The latter was another painter from Camerino, who was unknown until only a short time ago, but whom Zeri has recently identified as the author of the famous Barberini Panels. In a letter to Giovanni Angelo, his father-in-law reminds him that when he left Camerino, together with "Giovanni Boccaccio" (Boccati, of course), he had, together with his friend, promised to make a lot of money, which did not seem to be borne out by events. His father-in-law complains, and asks him to return home, on behalf of the Duchess too. The letter is addressed to "Giovanni painter from Camerino in the house of Cosimo in Florence", which clearly shows how greatly they were esteemed, since they were guests in the house of a patron of the arts such as Cosimo de Medici. It also shows that the two artists were working together, though there is no definite information as to the origins of their partnership. Zeri, however, interprets the Sequence of Boccati's movements in another way. According to him the letter is evidence that the artists left Camerino together, that they went first to Perugia, and then to Florence, where Giovanni Angelo stopped at the court of the Medici, whereas Boccati, after a brief sojourn, proceeded as far as Padua. If we interpret the information in this way, at least it gives some indication, approximate though it may be, as to when Boccati returned from Padua. For there is no further documentary reference to him until 1465, when he reappears as a witness in his native town. But he must have already been there for some time, for in 1463 he signed the *Coronation on the Virgin* for the church of Castel Santa Maria. He must have returned to Camerino only a short while before, since from this moment on there is a sudden abundance of information regarding his presence there. In 1468, for example, he signed the polyptych (plates XIV, 65–68) for the parish church of Belforte sul Chienti (not very far from Tolentino), and two other documents refer to his presence there.

It is probable that he was at Perugia again in 1480, for in that year he was paid for two panels he had done for the churches of S. Benedetto and S. Salvatore di Pozzaglie in the surrounding district. Besides this, he had already painted an altarpiece for Orvieto in 1473. We may suppose, therefore, that he returned to Perugia towards the end of his life. However, the last reference to him concerns the two Perugia altarpieces. One must suppose that the artist died about this time. These are the facts which indicate (in all their obscurity) two fundamental periods in the life of Giovanni Boccati: his formative period, and that which falls between his stay in Padua and his reappearance in Camerino in 1463, approximately thirteen years in all, in the course of which it is not known where the artist may have been. This gap is only partially filled by his documented visit to Urbino, where he painted, in one of the rooms of the Jole apartment in the Ducal Palace, frescoes of illustrious men and other motifs of a decorative nature. But according to Zeri, these frescoes must have been done about 1475, after his recorded return to Camerino. This obviously complicates matters even further, since the gap widens—if one accepts Zeri's interpretation of the letter addressed to Giovanni Angelo—from 1448 to 1463. Nor is it conceivable that the artist remained at Padua all this time, without leaving some evidence of so long a stay. Therefore, one must base the reconstruction of his artistic personality on his dated works, and try to trace his development by means of the stylistic changes that gradually appear in them.

*The Madonna of the Bower* of 1447 (plates XIII, 59–60) is the work of an artist already integrated in the Renaissance style, and above all, very much aware of the significance of Domenico Veneziano. The latter had been in Perugia ten years earlier, and had left behind an artistic heritage the fruits of which were later reaped by a number of great masters, the greatest of whom was Piero della Francesca. The *Madonna of the Bower* shows how much attention Boccati had paid to the Venetian painter, and how much he had assimilated of

his style and even of his iconographical characteristics. Zeri has rightly drawn attention to the Flemish elements in Boccati's repertory, and in particular those that derive from Van Eyck. Following up an old suggestion of Longhi's that Domenico Veneziano himself may not have been unaware of northern painting, Zeri believes that Boccati came into contact with the characteristics of Flemish painting through looking at the works of Domenico Veneziano which are now lost.

Fate has not been kind to the works of this artist, of whom we have only a few precious examples. Zeri has studied a number of Boccati's *Crucifixions*, in particular the two in Venice, the one in the Ca d'Oro (signed), and the other in the Cini Collection (plates 62, 63), and has come to the conclusion that there is an un-Italian narrative technique present in them. The crosses, he observes, "point upwards out of the stony hills, gathering together beneath them groups of horsemen and followers, and breaking them up into tightly-knit, almost tumultuous sequences of episodes". Moreover, the views expand to reveal vast landscapes, full of precise details taken from a closely observed countryside, details that suggest a direct or indirect knowledge of the *Crucifixion* of Jan van Eyck's diptych, formerly in the Hermitage of Leningrad, and now in New York. Since, in the predella of the *Madonna of the Bower*, there is a Crucifixion very similar to the ones in Venice, it is better to regard the latter as belonging to Boccati's early period. They may even precede the *Madonna of the Bower*, which, as we have said, dates from 1447. These Flemish elements must undoubtedly be acknowledged, and Zeri has shown exceptional intuition in establishing the painter's indebtedness to Domenico Veneziano, through his examination of the Camerinese artist's *Crucifixions*. Evidently, Boccati analysed, with care and curiosity, the most revolutionary changes that caught his eye. However, it is well to remember that the artist came from a region where certain characteristics of the International Gothic style had become widespread. Salimbeni's frescoes at San Severino are full of a taste for narrative, and the artistic personality of Gentile da Fabriano had a profound effect on Marchigian art. How sensitive Gentile was to the analytical description of the most minute, distant details, can be seen in the *Adoration of the Magi* in the Uffizi (plate 12). Zeri therefore suggests that the *Adoration of the Magi* in Helsinki (plate 61), a very precious work of Boccati's, is a kind of revised version of Gentile's painting, and uses it as proof that Boccati was in Florence together with his fellow countryman Giovanni Angelo, in confirmation of the letter referred to above. However, Boccati's style in the Helsinki panel is less of a Renaissance one than that in the *Madonna of the Bower*, and it would seem that this *Adoration* was painted before the artist's stay in Perugia, and was the fruit of his artistic experiences in his native town. It follows that the *Crucifixions*, too, may be works of his early period, of which there would be no trace otherwise. The hold that his early training in late, or courtly Gothic had over him, was never to allow Boccati to accept the ways of the Renaissance with the same zeal as shown by those who were capable of understanding the true essence of the Renaissance, that is, as something that formed a vital part of the personality. In fact, as Zeri rightly observes, Boccati belongs to "an area of pseudo-Renaissance culture, intimately connected with the Gothic world and quite incapable of understanding the scientific, Renaissance character of a Domenico Veneziano".[10] It would be a mistake however, to judge Boccati on the basis of what he is not, instead of trying to see what he really is. Zeri's comments on the empirical nature of Boccati's perspective are very much to the point however, and he demonstrates how Boccati did not feel perspective as a unifying factor, "but leaves all the rest to adjust itself, with a kind of fortuitousness from which the principle of interdependence is entirely absent".

Boccati cannot be considered a Renaissance painter then, but rather an isolated figure in whom the Renaissance element disappears beneath an innate taste for narrative and

fable. Only a conjecture of this kind can explain the peculiar stylistic involution we find in the great Belforte polyptych (plates XIV, 65–68), painted in 1468, certain parts of which still seem to look back nostalgically at earlier examples of the courtly Gothic. In the *Madonna of Ajaccio* (plate 71), Boccati seems to have had the example of Piero della Francesca directly before his eyes, but even this influence is only superficial, and the artist only makes use of it in forming a style that is typically and unmistakably his own. This is the reason why—unlike the case of Gerolamo di Giovanni—his visit to Padua left no trace in his painting. In the frescoes of Urbino, which were almost certainly carried out after 1450—if not in 1475, as suggested by Zeri—we also find the artist still tied to the world of fable, devoid of the least touch of Renaissance clarity and precision. And yet, that world dominated by the genius of Luciano Laurana and Piero della Francesca should have captured the imagination of a painter in search of inspiration and lacking in artistic personality. Boccati did not overlook the artistic discoveries of the Renaissance, but interpreted them in the spirit of narrative and fantasy. The embracement scene in the predella of the Belforte polyptych (plate XIV) takes place within an architectural setting which vividly recalls that in the *Annunciation* in the Washington National Gallery (plate 73), attributed to the Master of the Barberini Panels and identified by Zeri as the work of Giovanni Antonio. By a certain stretch of the imagination, one could even take Giovanni Boccati for the Master of the Barberini Panels. But it is precisely the greater vigour of the Washington panel, a typically Florentine quality, that indicates how completely absorbed its author was in the new art, even though it still has a touch of graciousness and gentility in the figures, modelled as they are on those of Lippi. But the sky that disappears beyond the trees is just as cold, and similarly covered with those typically Camerinese clouds of "dry ice", yet another confirmation of the affinity between the Master of the Barberini Panels and Giovanni Boccati.

In conclusion, Boccati's development up to its last, final involution, has become very much easier to follow than might have been imagined only a short time ago. And this serves only to enhance his figure as an artist, since we find him tied to an extremely difficult, yet valid, artistic form of expression, as we have said before. Though he may expose himself to the charges of injudicious critics—in our case, those who blame Boccati for not being a Renaissance artist—perhaps his greatest merit lies in this wonderful equilibrium, in the way he preserved his creative instinct, almost like some Sienese painter of his day.[11]

## Catalogue of works
[*see plates XIII, XIV, 59–71*].

Ajaccio, Musée Fesch, *Madonna Enthroned and Child between music-making Angels and Putti.*

Belforte del Chienti (Macerata), Parish Church of St. Eustace, *Polyptych: Madonna Enthroned between SS. Eustace, Peter, James and Venantius; Crucifixion and other Saints in upper register; Scenes from the Life of St. Eustace and figures of SS. John the Evangelist, Jerome and Matthew on the predella.*

Other figures of Saints in the side pilasters signed Op. Johannis Boccati Pictoris de Cam.o (1468).

Budapest, Museum of Fine Arts, *Altarpiece from the Chapel of S. Savino at Orvieto: Madonna and Child Enthroned with SS. Juvenal, Sabinus, Augustine and Jerome* (1473).

Castel Santa Maria (Castel Raimondo, Macerata), Chiesa dell'Assunta, *Coronation of the Virgin with Angels, SS. Venantius and Sebastian* (1463).

Esztergom (Hungary), Diocesan Museum, *Crucifixion.*

Esztergom (Hungary), Diocesan Museum, *Two round paintings with the heads of Saints* (the Museum attributes them to Domenico Veneziano).

Florence, Berenson Coll., *Madonna and Child with angels; Marriage of the Virgin.*

Helsinki, Ateneum, *Adoration of the Magi.*

London, Thomas Barlow Coll. (formerly), *Two panels of a predella: Totila's Feast and the Death of Savinus* (probably part of the Orvieto altarpiece).

Milan, Gallery Finarte (1971), *Legend of St. Savino* (Panel from predella of the Orvieto altarpiece).

Nemi, (Fiordimonte, Macerata), Parish Church, *Triptych: Madonna and Child, with Angels between SS. Matthew and Prisco.*

XIII. Giovanni Boccati: *Saints and Angels*. Detail from plate 59.
Perugia, Galleria Nazionale

New York (formerly Paolini Coll.), *Madonna and child with Music-making angels*.

Oberlin (Ohio), Allen Memorial Art Museum (Kress Coll.), *SS. John the Baptist and Sebastian* (parts of a dismembered polyptych).

Palermo, Chiaramonte Bordonaro Coll., *Madonna and sleeping Child with four Putti*.

Paris, Martin Le Roy Coll. (formerly), *Two Angels holding Candles* (fragments of a polyptych).

Perugia, National Gallery, *Madonna dell'Orchestra*.

Perugia, National Gallery, *Madonna and four Putti*.

Perugia, National Gallery, *Madonna of Mercy*.

Perugia, National Gallery, *Madonna of the Bower* (signed and dated 1447).

Perugia, National Gallery, *Deposition* (from the church of Sant'Agata, signed and dated 1479).

Poznan, National Museum (formerly Mielzynski Coll.), *Madonna and Child with three Angels*.

Princeton (N. J.), Art Museum (formerly in the Caccialupi Coll., then in the Nevin, then in the Platt), *Madonna and Child with two Angels* (damaged, particularly in its central part).

Rome, Vatican Library, *St. Venantius*, drawing (perhaps a sketch for the saint in the Belforte polyptych).

Rome, Colonna Gallery, *Three panels of a predella*.

Rome, Vatican Gallery, *Two panels of a dismembered polyptych: SS. John of Prato and George, SS. Anthony of Padua and Clare*.

Rome, formerly Nevin Coll., *Madonna and Child Enthroned with six Angels*.

Sentino (Camerino), Parish Church, *Fragmentary Frescoes with figures of Saints* (?).

Seppio (Camerino), Church of S. Maria, *Triptych of the Madonna of Sorrows: Madonna adoring Child, with the Donor, Amedeo de Mirabella, Rector of the Church. On the right St. Sebastian, on the left St. Vincent Martyr* (the latter is destroyed); signed and dated 15 August 1466.

Turin, Sabauda Gallery (Gualino Coll.), *Crucifixion*.

Venice, Ca' d'Oro, *Crucifixion*.

Venice, Cini Coll., *Crucifixion*.

Location Unknown, *Dead Christ*.

## Giovanni Angelo di Antonio (*Master of the Barberini Panels*)

Until 1961, the name of Giovanni Angelo was connected solely with three letters that go back to 1451. (He is also mentioned in two documents of 1460, in which he is referred to as "Magister Joannes Antonii de Camerino et contrata Medii pictor").

The first letter is signed by "Ansovino di Maestro Petri", merchant of Camerino, who writes to the painter, addressing his letter to the house of Cosimo in Florence, that is, care of the Medici family, who were the lords of the city. Ansovino was the painter's father-in-law, and the letter was written with the purpose of persuading him to return home. The old merchant points out that "Madonna", that is, the Duchess of Camerino, is also anxious for him to return soon. The same letter reveals that Giovanni Angelo had left Camerino together with Boccati, though there is no precise indication as to when the departure took place. Anyway, it is clear that the two artists were bound by ties of friendship, and, therefore, by a certain artistic affinity as well. It is possible that they stopped at Perugia, where Boccati's presence is signalled in 1445, and that only later did they proceed, or perhaps just Giovanni Angelo by himself, to Florence. What makes this information important is that it shows that the Camerinese painter frequented the most refined and elegant circles of Florence of the time, and that he was the friend of Cosimo's son, Giovanni Medici. On receiving his father-in-law's letter, the artist suddenly decided to return to Camerino. Later, since Giovanni Medici was taking the waters at Petriolo di Firenze, Giovanni Angelo wrote to the young nobleman from Siena, that is, when he was already on his way, apologizing for his departure. He then wrote a second letter to the prince on a very important and delicate question, inviting him to consider the possibility of marrying the daughter of Battista Chiavelli, lord of Fabriano, who was a distant maternal cousin of the Da Varano, lords of Camerino. The girl is about thirteen years old, writes the artist, full of virtue and extraordinarily beautiful. He ends by recalling that he owes the prince a small sum of money, promising to pay it back on the very next occasion. The signature is phrased in the following way:

"Johani Angelo d'Antonio depintore da Camerino qual sonava di lioto". One can see that the painter must have been carrying out an official mission entrusted to him by the Chiavelli and Da Varano families. And if the two noble families of the Marches turned to the painter, it was because they knew of his close relations with the prince. A tone of familiarity characterizes the whole of the letter, particularly that curious signature ("who played the lute"), which seems to evoke the memories of happy evenings spent together.

It is very strange that this artist could have sunk into such oblivion that nothing more was known of him than that is contained in these letters and the few other documents in which he is mentioned.[12]

In 1961, Zeri, by means of an exemplary philological reconstruction, succeeded in demonstrating that the unknown author of the Barberini Panels was none other than Giovanni Angelo di Antonio of Camerino. The Barberini Panels had been one of the most controversial problems of fifteenth-century Italian painting, and in vain had the best critics of the last decades of the nineteenth and the first half of this century sought to identify their author. The two panels representing *The Nativity of Virgin* (plates 74, 75) and *The Presentation in the Temple* came from the Barberini Gallery and were sold in 1935, when authorization was given for them to be sold separately. One is now in the Metropolitan Museum of New York, and the other in the Boston Museum of Fine Arts. After surveying the development of critical opinion conceiving the panels (which have always been related to the painting of the Marches), Zeri followed up Offner's critical study of them. In 1939, Offner had tried to group together a number of paintings sharing stylistic characteristics similar to the two panels, with the purpose of constructing a small corpus of works, whose author he then called the Master of the Barberini Panels, following a suggestion of Adolfo Venturi's. Offner—solely on the basis of stylistic data—attributed four works to the artist: an *Annunciation*, formerly in Florence and now in the Washington National Gallery (plate 73), and, in the following order, the *Crucifixion* in the Cini Collection in Venice (plate 72) and the two panels mentioned above. This order was based on a number of considerations, which can be briefly summarized in the following points: 1) the Washington *Annunciation* is the earliest of the four works, and must have been done about 1447, given its connections with Lippi's *Coronation*, which was finished in 1447 (the angel in the *Annunciation* repeats the Virgin in the *Coronation*). Moreover, there are traces of Domenico Veneziano in the *Annunciation*. both in the relationship between figures and architecture, and in the particular clarity of the light, which recalls Domenico's works in Florence and particularly the altarpiece from S. Lucia dei Magnoli (Uffizi) of 1448. 2) There is no doubt that the painter of the Washington *Annunciation* is the same who carried out the Barberini Panels. However, these panels must have been done very much later, about 1470, and at Urbino, since they clearly show signs of contact with the artistic world of that court, and the emblematic eagle of the house of Montefeltro appears on the architecture in the New York *Nativity*. It may be added in passing, that the provenance from Urbino is also made possible by the fact that the Barberini took many works of art away with them after the death of the last duke in 1631. Offner places the Cini *Crucifixion* in the period between the *Annunciation* and the two Barberini Panels, pointing out its Lippesque elements, which he also finds in the later Barberini Panels. His final conclusion is that the anonymous painter, after undergoing the influence of Domenico Veneziano in his youth, fell under that of Lippi, whom he met in Florence. After leaving Florence, he went to some place in the provinces, where he came under the influence of Piero della Francesca, and that of Lippi again at Spoleto. Finally, he went to Urbino, where he painted the famous panels.

In 1953, following up the work done by Offner, Zeri proposed that the following pictures be added to the four already identified: 1) *St. John the Baptist* in the Apostolic Palace of

Loreto (attributed to Marco Zoppo by Berenson, and to Ludovico Urbani by Longhi); 2) *St. Peter* (Milan, Brera); 3) *St. Francis of Assisi* (Milan, Ambrosiana Gallery), like the Brera panel, also attributed to Nicola di Maestro Antonio, the two works appearing to be parts of the same polyptych; 4) *The Annunciation* (Munich).

In 1961 Zeri returned to the subject, and after carrying out a stylistic examination of the eight works, came to the conclusion that their author could only have been someone very much like Giovanni Boccati. For, he argues, the stylistic characteristics which go to make up the culture that gave birth to these paintings recall precisely that world in which Boccati was formed. Zeri's subtle, acute study, which is supported by philological and historical evidence, as well as information about various artistic circles, is wholly convincing. Indeed, its critical and logical thoroughness leaves no doubt. He even maintains that the famous *Alcove of Federico da Montefeltro*, still preserved in a room of the Jole apartment in the Ducal Palace of Urbino, was also done by Giovanni Antonio, and suggests that the Barberini Panels were originally inside the alcove itself.

In 1962, unconvinced by Zeri's arguments, Parronchi claimed that the Barberini panels were the work of no less a person than Leon Battista Alberti. This attribution was in line with that of Pasquale Rotondi, who already in 1950 had given them to Bramante. Both these suggestions where prompted by the way in which the architecture and the surroundings predominate over the figures in the two panels. Finally, in his book on the painting of Camerino, Vitalini Sacconi too seems unwilling to accept Zeri's reconstruction, for "the ingenious arguments in which the thesis abounds, though they succeed in giving a certain insistency to the theory that is put forward, are not sufficient to command objective conviction".[13]

And yet, if one were to make any comment on Zeri's study, it would be that he has worked *ad abundantiam*. The arguments that form the basis of his study—which is a mass of threads all drawn together into a single core—are valid, but would have been redundant, if he had emphasized the close connection between Giovanni Boccati and the Master of the Barberini Panels. The Virgin in the Washington *Annunciation* certainly follows Lippi in iconography and pose, but is extraordinarily close to Boccati in the colours, and in the tender and self-absorbed expression. The affinity between the face of St. Venantius in Boccati's Belforte polyptych and that of the Virgin in the Washington *Annunciation* is quite astonishing. And what about the *Crucifixion* in the Cini Collection (plate 72)? Look at the overcast sky, with those twisted, almost numb-looking clouds, the colour of ice. They are the same as in the Washington *Annunciation*, and reappear in the works of Boccati, in the predella of the Belforte polyptych for example (plate 68). Even the grooved rocks of the Cini *Crucifixion* resemble those that Boccati painted as the base for the town of Camerino, which St. Venantius holds in his left hand (plate 67). But there is no point in continuing further. The fact remains that the painting of Camerino has been enriched by yet another name, a name which up to only a short time ago was nothing more than a memory. We can now see that it belongs to a painter with a well-defined artistic personality of his own, who takes his place in the complex cultural world of local civilization in the early Renaissance.[14]

Catalogue of works
[*see plates 72-75*].

Boston, Museum of Fine Arts, *Presentation*.
Loreto, Apostolic Palace, *St. John the Baptist*.
Milan, Ambrosiana Gallery, *St. Francis of Assisi*.
Milan, Brera, *St. Peter*.
Munich, Alte Pinakothek, *Annunciation*.

XIV. Giovanni Boccati: *The Embracement*. Detail from the predella
of the polyptych (plate 68). Belforte del Chienti, Parish church of S. Eustacchio

New York, Metropolitan Museum, *Nativity of the Virgin*.
Urbino, Ducal Palace, *Decorations of Federico da Montefeltro's Alcove*.
Venice, Cini Coll., *Christ on the Cross*.
Washington, National Gallery of Art (Kress Coll.), *Annunciation*.

## Gerolamo di Giovanni

It was Berenson (1907) who pioneered the critical study of Gerolamo di Giovanni, an artist whose importance has been increasingly recognized, so that he is now considered the greatest representative of that current in the painting of the Marches which had its centre at Camerino. The school of Camerino was rich in artistic tendencies, and, in turn, was subject to many influences: it absorbed the lessons of Umbria and Tuscany, nourished itself on Venetian-Paduan examples, and developed a style, which, though the fruit of a "contamination", gave birth to many works of art.

There is little information regarding Gerolamo's life, but sufficient to reconstruct his artistic career. He was at Camerino in 1449, the date of a fresco formerly in the church of S. Agostino and later detached and placed in the Municipal Art Gallery (plate 76). The following year he appears in Padua, where he was enrolled in the local guild of painters. It is not known how long he stayed in this city, but it was probably for a long time. It must be remembered that Giovanni Boccati had been there before him, but whereas the latter was to absorb little of the city's culture, Gerolamo was very much influenced by it. He appears at Camerino in 1462, when he dated a fresco in the church of S. Francesco (plate 90). The following year he signed and dated the gonfalone of Tedico, which represents the Madonna of Mercy, now in the Gallery of Camerino (plate 85). Finally, in 1473, he signed the polyptych in the church of S. Maria del Pozzo at Monte S. Martino (plate 91): "Jeronimus Joanni de Camerino pinxit MCCCCLXXIII".

The last works connected with the painter, though they may be by one of his followers are a few dilapidated frescoes in the church of S. Margherita at Acquacanina near Camerino.

No further information exists, so that the only certain dates we have run from 1449 to 1473. There are three signed and dated works in all; another three which are generally attributed to him are also dated. All critical discussion of the painter must be based on these works, but his documented presence at Padua also deserves serious consideration.

Berensons' essay of 1907 came at a most opportune moment, at the end of a period of renewed interest in Gerolamo. This interest had been aroused by the exhibitions at Macerata in 1905 and at Perugia in 1907. Berenson—like Perkins and van Marle—placed great emphasis on the relations between Gerolamo and Boccati, and even claimed that Gerolamo was Boccati's pupil. Other scholars, such as Lionello Venturi, Colasanti, and Serra find the art of Florence to be the decisive influence in Gerolamo's work. But Berenson also pointed to the Paduan element in his painting, and even suggested that he might have come into contact with the school of Murano. On the other hand, he ruled out the possibility that Crivelli might have exercised any influence on him, preferring to associate him with Vivarini. Even in the last editions of his *Lists*, Berenson still affirmed that Gerolamo was probably a pupil of Boccati and that he developed under the shadow of Vivarini and then under the influence of the various Umbrian followers of Benozzo and Piero della Francesca.

Longhi took up a very much more definite and, one may say, revolutionary stand-point for in 1926 he went so far as to attribute to Gerolamo one of the frescoes in the Ovetari chapel in the church of the Eremitani at Padua.

Longhi's views were not very favourably received by subsequent critics, and in the Mantegna Exhibition of 1961 Gerolamo di Giovanni was not included among those "desperadoes" who, towards the middle of the century, stirred up the calm waters of contemporary

Venetian painting in Padua. And more recently, only Zeri has accepted Longhi's suggestion, though he emphasizes the basic influence of Piero della Francesca on Gerolamo, whom Longhi had, in fact, called a "good follower of Piero".[15] However, he was not just a "good follower" of Piero's but a precious one, and in way that suggests a direct contact between the two, and rules out all possibility that Gerolamo turned to the manner of Arcangelo di Cola, or of Giovanni Boccati himself. That is to say, Piero's artistic personality took such an immediate, strong hold of Gerolamo, whose temperament soon showed itself to be a firm and independent one, that it rendered him immune to further stylistic influences. The dates speak for themselves. In the fresco of 1449, the tender, complacent, digressive style so typical of Boccati gives way to a strict, concise, authentic method of composition (plate 76). It is true that the foliage beyond the wall is redolent of the courtly Gothic, while the throne upon which the Madonna is seated—as Vitalini Sacconi points out—recalls that of Arcangelo's *Madonna* of the church of S. Marco at Osimo. But it is the inner essence that has changed. The severe figure of St. Antony Abbot (still in a fairly good state of preservation) is wholly tied to the style of Piero; so is his mantle, bathed in the light that comes from right. The same light throws the shadows of the Madonna and Child against the semicircular back of the throne (as if to demonstrate the existence of a real space, in a manner worthy of an eighteenth-century view painter), which rises in the form of a shell-shaped bowl. The whole composition is set within the context of a very precise, almost emphatic perspective, which looks as if it has been carried out by a neophyte determined to achieve his purpose at all costs. If we pass from this painting to Gerolamo's next signed and dated picture, the banner of Tedico (plate 85), we see his style did not undergo any profound change in the long interval of about fourteen years that separates the two works. He has continued unwaveringly in the same direction, which has led him to an ever greater degree of abstraction. What surprises one is the triptych in the church of S. Maria del Pozzo at Monte San Martino (plate 91), signed exactly ten years later, in 1473. Here the artist appears to have worked in a narrative style which really does recall that of Boccati—one has only to look at the four angels behind the Madonna and Child—and which also contains Vivarinesque elements, e.g. in the austere figure of St. Michael the Archangel (painted after the manner of Bartolomeo) in the upper register. Nor can we discount the influence of Carlo Crivelli, who was later to meet Gerolamo again, after they had met, almost certainly, in Padua, when both were still young men.

There is no need to point out how anachronistic are the decorative elements of a late Gothic, Venetian variety which reappear in the triptych, after the artist had proved himself to be an able exponent of the rigorous rules of Renaissance painting for over twenty years. In short, we can only conclude that by 1473, Gerolamo di Giovanni was probably confined within his own artistic surroundings and, shut off from all vivifying influences, had ended by capitulating to the local "reactionaries". A contributory factor were the "ambiguous" polyptychs of Bartolomeo Vivarini, which had spread throughout the region, and to which Antonio (who was still full of Gothic feeling) had also contributed; so had his son, Alvise, who, in 1475, was putting the finishing touches to his polyptych at Montefiorentino in the upper Marches, a work in which the austere Paduan style blends easily with the refined Gothic craftsmanship of the supporting woodwork. Hence we must look at the problem in a quite different light, and conclude that, if Gerolamo was influenced by Boccati, it was in the final phase of his career, but certainly not in his youth. The two painters probably met each other after their return to Camerino, their long journeys over. In fact, Boccati reappeared there in 1463. But there is no trace of his influence in the banner of Tedico, which dates from 1463, so that they must have met at a later date. Even the Venetian influence —that of Vivarini—must be traced to a later date than this.

It is possible that some of Gerolamo's Crucifixions too, such as the fresco in the apse of the parish church of Raggiano (Camerino), are not early works, but were painted at the time when he fell back upon a local tradition indebted to the art of Boccati. On the other hand, I would attribute to his youth a number of frescoes clearly carried out in the spirit of Piero della Francesca. These bear no sign of those touches of Lippi that we find in his later works, such as the fresco of the *Madonna and Saints* from the church of S. Francesco at Camerino. For example, the poor shreds that remain of the mural painting in the secluded church of Val Caldara (Montecavallo), on the hills near Camerino, come closer to the spirit of Piero della Francesca than the works of any other artist, and in a way that not even Gerolamo himself was to repeat. Therefore, Gerolamo must have been near him in his youth.

I am also tempted to place in this period, or just a little after it, the paintings in the Bolognola chapel in the Villa of Malvezzi (plates 87–89). The *Madonna* in the centre is clearly related to the one painted by Carlo Crivelli in 1470, fragments of which are now in the Gallery of Macerata (plate 136).

What happened to Crivelli's style after his first contact with the art of the Marches? It reveals a sudden change from its characteristic violence and dynamism, becoming more open and monumental, as we see best of all in the Montefiore polyptych (plate 141). His world is no longer unreal, fantastic and wooden, but is imbued with a greater humanity, which is evidently the result of a maturation brought about by some new artistic experience. Hence it seems not rash to suggest that Crivelli may have approached the art of Piero della Francesca through the works of Gerolamo di Giovanni. The evidence for this is provided by the two *Madonnas* of Bolognola and Macerata (plates 89, 136), which are inseparably linked, the one being dependent on the other. And since Gerolamo's irremediable decadence reveals itself in the digressive, popular style of the Monte S. Martino polyptych, which dates from 1473 (plate 91), it is inconceivable that the Bolognola *Madonna* could have been contemporary with it or date from after 1470. It follows that it was Crivelli, who, in the years immediately following his arrival in the Marches, looked at the very early works of Gerolamo, that is to say, at perhaps the most spontaneous and most genuine compositions Gerolamo ever carried out.

A change took place in Gerolamo's style, in the direction of the Paduan school, when he painted the *Pietà* with the *Annunciation* (plate 79) beneath it. The picture, which came from the church of Sperimento near Camerino, is now in the municipal Gallery. It is one of the finest examples of Gerolamo's art, and perhaps one of the most representative of that complex Renaissance civilization that sprang up at the court of the Da Varano at Camerino. Mantegnesque elements are evident for everything in the *Annunciation* recalls the Oveteri chapel, both the way in which the perspective gives the buildings that effect of soaring upwards, as well as the cold colours which give the painting what one might call a metaphysical consistency. Zeri rightly emphasizes Gerolamo's fierce attachment to the Paduan school, and repeats Longhi's suggestion regarding Gerolamo's presence among the artists engaged in the work at the church of the Eremitani. As we have mentioned above, Longhi attributes the scene of *The Departure of St. Christopher* (plate 78) to Gerolamo. The same fresco has been attributed to Marco Zoppo by Cavalcaselle, and to Ansovino da Forlì by Schmarsow, two attributions that are clearly unacceptable, whereas Longhi's intuition has opened up a series of problems which no other scholar, apart from Zeri, has been capable of following up. The Mantegna Exhibition of 1961 would have provided the opportunity for a decisive examination of the relations between Camerino and Padua. Instead, it was completely avoided, and the fresco in question (a sorry-looking fragment, although patiently put together after the disaster of 1944, which practically destroyed the most famous examples of Quattrocento fresco painting in northern Italy) was exhibited without definite attribution. As if that

XV. Gerolamo di Giovanni: *Crucifixion*. Sarnano, church of S. Maria di Piazza

were not enough, the problem that Longhi had broached was not even taken into consideration. And yet the very early date of the fresco (1450), plus a number of characteristics that so clearly recall the culture of the Marches at the time, might have proved decisive in linking the presence of Gerolamo in Padua, and his contact with the Renaissance art of Piero della Francesca, with that group of progressive artists who had gathered together in the same city.

A comparison of the Paduan fresco with those works of Gerolamo that date from the period immediately after his stay in the city, shows clearly how much he was influenced by the Paduan school. But it must also be pointed out that there are unmistakable traces of the Urbino school in the Camerino *Annunciation* (plate 79). For example, the great arch decorated with rosettes on the left, the little room with its slabs of marble divided by transennae and beams as well as the coffered vault all recall architectural features of the Ducal Palace, such as the loggia on the "façade of the little towers", and the chapel of the "sanctuary" which Federico da Montefeltro had built beneath his "little study", as if to give moral support to his place of meditation and intellectual activity.

But Gerolamo's rendering of architectural details from Urbino takes on an almost surrealistic aspect, since it lacks that spatial equilibrium which was the highest expression of the civilization of the Montefeltro.

The following works show that Gerolamo was engaged in a continual search, as if he abandoned himself to the nostalgic appeal of an unattainable, abstract world. This is the only way one can attempt to understand the banner of Tedico (plate 85), where we find the same metaphysical abstraction as in certain examples of contemporary wood sculpture (upon which Luciano Laurana did not fail to have an influence). This abstraction was to find its finest, and ambiguous expression in the polyptych from Gualdo Tadino, now at the Brera. Here the compromise between a die-hard tradition and the impulse towards abstraction derived from the style of Piero della Francesca reaches its extreme point of refinement. It may be considered as Gerolamo di Giovanni's masterpiece. It was impossible to go further. Things changed after this until Gerolamo becomes almost unrecognizable, as in the Monte S. Martino polyptych (plate 91), where the elements taken from Vivarini and those of the courtly Gothic are so confusing that the author would be indistinguishable were it not for the fact that, fortunately enough, the work is signed. With it we can group others, which, for odd reasons, some scholars still refuse to attribute to him, although they constitute the largest body of evidence concerning Gerolamo's last period. Taken as a whole, his stylistic development is one of the most extraordinary to be found among the pioneers of Renaissance painting in Central Italy.[16]

## Catalogue of works
[*see plates XV*, 76-91].

Balcarres, Coll. of the Earl of Crawford and Balcarres, *Madonna and Child* (attributed to his *bottega*).

Bolognola, Villa Malvezzi, Chapel, *Madonna and Child with Angels, SS. Nicholas of Tolentino, Anthony Abbot, Catherine, Sebastian and the Madonna, St. Lucy.*

Brno, Museum, *Christ on the Cross with the Madonna, St. John the Evangelist, Angels and Donor.*

Camerino, Pinacoteca Civica, *Gonfalone of Tedico: Madonna of Mercy with SS. Venantius and Sebastian* (signed and dated 1463).

Camerino, Pinacoteca Civica, *Annunciation with Donors* (perhaps Giulio Cesare Da Varano with his daughter Camilla); in the lunette: *Pietà with two Franciscan Saints, Angels and self-portrait of the artist.*

Camerino, Pinacoteca Civica, *Madonna and Child with SS. Jerome, John the Baptist, Augustine, Venantius, and the Donor Melchiorre Bandini.* The tatter died in 1473, so that the fresco, which was formerly in the church of S. Agostino, was done prior to this date.

Camerino, Pinacoteca Civica, *Madonna and Child with SS. Anthony of Padua, Anthony Abbot, and two Donors* (1449), fresco detached from the church of S. Agostino.

Camerino, Pinacoteca Civica, *Madonna and Child with SS. Francis, John the Baptist, Anthony Abbot, and Venautius* (1462), fresco detached from the church of S. Francesco.

Camerino, Cathedral, Sacristy, *Triptych with Christ on the Cross, the Virgin, St. John the Evangelist, and Magdalen* (central panel); *St. Michael, St. John the Baptist.*

 Colle Altino, Parish Church, *Crucifixion with Angels and other figures* (1491), fresco on the wall of the apse.
Colle Altino, Parish Church, *Madonna and Child*, fresco over the altar to the left.

Fiordimonte, Parish Church of Castello, *Crucifixion, at the foot of the Cross the Madonna and SS. Helen, Ansovino, John the Baptist, Bartholomew, Nicholas of Bari* (1456), fresco in the apse; the upper part is hidden.

 Florence, Bardini Museum, *SS. Peter and Blaise.*

Gagliole (Camerino), Church of S. Maria delle Macchie, *St. Anthony Abbot between SS. Jerome and Roch;* in the pinnacle: *Crucifixion* (early work, carried out perhaps immediately after his stay in Padua).

Gagliole (Camerino), Church of S. Maria delle Macchie, *Madonna and Angels* (late work of the period of the Monte S. Martino polyptych).

Milan, Brera, *Polyptych: Madonna and Child Enthroned, Saints and Crucifixion* (from Gualdo Tadino).

Milan, Brera, *Madonna and Child with SS. John the Baptist and Francis.*

Montecavallo, Church of St. Nicholas of Valcaldara, three figures of Saints: *SS. Venantius, James and Lucy* (remains of frescoes in the transept to the left).

Monte S. Martino (Macerata), Church of S. Maria del Pozzo, *Polyptych* (with Venetian Gothic frame, signed and dated 1473).

New York, Kress Collection (Mrs Rush H. Kress), *Madonna and Child* (attribution doubtful, possibly by Giovanni Angelo di Antonio).

Padua, Church of the Eremitani (formerly), *The Departure of St. Christopher.*

Pioraco (Macerata), Church of the Crucifix, *Crucifixion* (fresco on the left-hand wall).

Raggiano (Camerino), Church of S. Maria, *Crucifixion and mourning Angels* (fresco on the apse wall).

Rome, Museo di Palazzo Venezia, *Madonna and Child with SS. John the Baptist, Fortunatus, Nicholas of Bari, and Michael the Archangel;* above: *Music-making Angels* (from the church of St. Michael the Archangel of Bolognola).

Rome, formerly Del Pero Coll., *Archangel Gabriel and Virgin Annunciate*, two pinnacles, fragments of a dismembered polyptych.

Rome, Private Coll., *Madonna and Child.*

S. Pellegrino di Gualdo Tadino (Perugia), Parish Church, *Polyptych.*

Sarnano (Macerata), Church of S. Maria di Piazza, *Standard: Crucifixion and Annunciation.*

Serrapetrona (Macerata), Parish Church of Castel S. Venanzio: *Crucifixion with Madonna and SS. John the Evangelist and Magdalen* (the figure of St. John has been restored).

Tours, Musée, *St. John the Baptist under Arch with kneeling Donor* (gift from the Campana Coll.).

Urbino, National Gallery, *Crucifixion* (pinnacle of a polyptych from Monte S. Martino now lost).

Valle S. Martino, Parish Church, *The Mass of St. Martin.*

Venice, Cini Coll., panel representing the *Madonna and Child Enthroned and four Angels.*

*Master of Patullo*

In the district of Paganica, near Camerino, there is a farmhouse with a little oratory attached, which originally seems to have served as a summer residence for the bishops of Camerino. In fact, it was originally a Gothic construction, as one can see from the hewn stone and the ogive arch of the entrance. The building is now derelict, and let us hope that it will not be destroyed by time or man, since it is a most rare example of medieval rustic architecture.

The oratory—which was certainly added to the main building, against which it is built—is covered by a series of frescoes,[17] which depict the *Passion of Christ.*

These frescoes are of particular interest, though no critical study based upon an examination of their historical and stylistic elements has been devoted to them as yet. They were commissioned by Ansovino di Angeluccio dei Baranciani, Prior of the Collegiate church of S. Venanzio at Camerino. The scenes of the *Passion* are painted along the walls and in the vault, and extend as far as the bottom wall, whereas the apse is entirely taken up by the *Crucifixion.* Vitalini Sacconi points to the influence of Boccati in these anonymous frescoes, and mentions that of Gerolamo di Giovanni as well, particularly in the Christ of the *Crucifixion.*

This minor painter, whom we shall call the Master of Patullo, after the example of Ponzi, becomes considerably important, if we consider the numerous affinities of his work with the frescoes in the Eremitani in Padua. In fact, everything comes from this source. And

93

though the style is mordant and popular, the whole work unfolds in the light of experiences, which are the direct or indirect result of having seen, or attempting to imitate, what had been done with so much eloquence, restraint and commitment in the church of the Eremitani. There are some general characteristics: for example, the obsession with a perspective that moves from below upwards, the object of which is to set the scene in relation to the spectator's viewpoint. It follows that all the episodes are carried out by means of a geometrical perspective which lengthens the figures and spaces, according to their position in the small area available; some are painted at eye-level, some halfway up the wall, and still others on the ceiling. But this is not all. The scene where Christ is led before Pilate (plate 93) is an evident imitation of Mantegna's fresco in the Eremitani, where St. James is led before the judge, and that of Christ before Caiaphas (plate 95) is another clear example of Paduan influence. One might even say that the little Master of Patullo had, in many ways, followed the episode of *The Departure of St. Christopher* (plate 78) in the Eremitani cycle, a scene that Longhi attributes to Gerolamo di Giovanni. The connection thus established can be accounted for in two ways: either the painter had worked in Padua as Gerolamo di Giovanni's assistant; or he has served his apprenticeship under him, after Gerolamo's return from Padua. In any case, the stylistic affinity with the St. Christopher fresco is such as to confirm its attribution to Gerolamo. In the *Christ before Pilate*, the influence of Mantegna's fresco is so great as to suggest that the artist has a first-hand knowledge of the Paduan frescoes; even a triumphal arch after the fashion of Alberti is included so as to show that the scene took place in a city.

It would be a mistake to call the Master of Patullo a great painter. But he is a spontaneous one, and full of instinctive feeling. This emerges out of an ambiguous cultural background, which in no way impedes its expression, while the artist's eye is turned to earlier works of art, and his own are a mixture of Gothic and Renaissance elements. The holy woman in profile who kneels in the foreground of the *Deposition* (plate XVI), holding Christ's head in her hands, recalls certain fourteenth-century elements in the painting of Assisi; perhaps—who knows?—the direct influence of the Giottesque frescoes in the Eremitani is also at work. On the other hand, the face of the young man who dominates the scene of Christ before Pilate, shows the influence of the Paduan school, after the manner of Mantegna, and something of Gerolamo too. But the artist's colours are wholly based on violent, sometimes sharp contrast of tones. The greens and yellows, the reds and the violets dominate in their various, aggressive tones, but the way in which certain parts of the frescoes are illuminated shows how interested he was in the treatment of light, and how he profited from the examples of Gerolamo di Giovanni and Piero della Francesca.

We do not know of any other works by this interesting painter. But I would attribute to him, tentatively, the frescoes of the *Annunciation* and the *Risen Christ* in the apse of the little church of Valcaldara in the Commune of Montecavallo.[18]

## NOTES

1. For the history of Camerino, see *Guida storica-artistica di Camerino e dintorni*, Terni, 1927. This anonymous work is the result of a collaboration between two local scholars, Domenico Aringoli and Romano Romani. For the painting of Camerino, see Vitalini Sacconi's recent study: *Pittura Marchigiana – la Scuola Camerinese*, Trieste, 1968. This is the first attempt at a serious, fully documented analysis of the critical antecedents of this painting. For Crivelli's presence at Camerino, see P. Zampetti, *Carlo Crivelli*, Milan, 1961.

2. See G. Marchini, *Mostra degli affreschi restaurati*, Urbino, 1964.

3. C. Brandi, *Mostra della pittura riminese del Trecento* (Catalogue), Rimini, 1935.

4. The problem of the relationship between Marchigian and Venetian painting at the beginning of the fifteenth century reappears, therefore, even in the reconstruction of the artistic personality of Carlo da Camerino. For this relationship, see Pallucchini's suggestions in his *La Pittura Veneta del Quattrocento*, Bologna University, 1955–56 (university monograph).

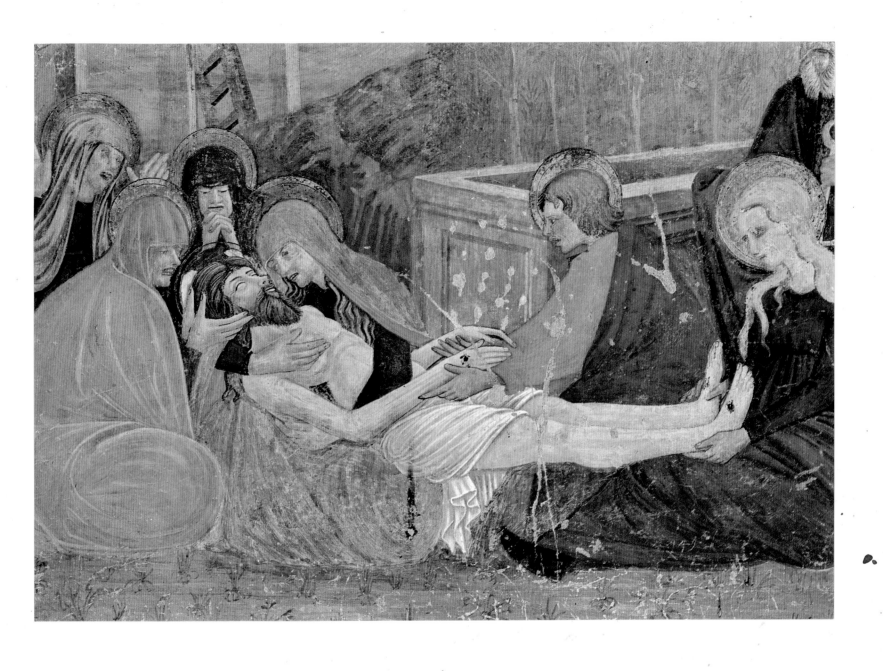

XVI. Master of Patullo: *The Lamentation over the Dead Christ*. Camerino, Pinacoteca Civica

5. It is worth while noting the fact that the Marchigian painters most responsive to the courtly Gothic style were always in contact with the most culturally aware people of the day, who were also involved in the making of contemporary history. It is quite impossible to think that this mysterious Olivuccio remained within the orbit of local painting. Instead, he probably went north, and his contacts with Lombard art, however direct or indirect they may have been, must be at least considered worthy of speculation. His connection with Duke Filippo Maria Visconti cannot be explained in any other way. For the documents relating to the painter, one may consult Giannandrea's still valid study: *Olivuccio di Ceccarello, pittore marchigiano del secolo XV* in "Nuova Rivista Misena", III, 12, 1891 pp. 179–187.

6. Its place has now been taken by the panel of St. Primianus, which was formerly in Santa Maria della Piazza. For the Ancona *Madonna*, see the *Inventario degli Oggetti d'Arte: Province di Ancona ed Ascoli Piceno*, Rome, 1936, p. 7. The painting, done in tempera on a panel, measured 155 × 70 cm, and used to hang on the left-hand wall of the chapel of S. Lorenzo. For the same subject, see also L. Serra, *L'Arte nelle Marche*, I, Pesaro, 1929, p. 313. Finally, it is useful to consult Zeri's article *Arcangelo di Cola: Due Tempere*, in "Paragone", 1950.

7. Regarding this painter, who was so closely tied to the International Gothic style, see the chapter on painting in Urbino.

8. Zeri (1969) prefers to attribute the Rotterdam *Madonna* to a Florentine anonymous master rather than to Arcangelo, to whom he attributes, on the other hand, several unpublished works, mainly in Prague. He believes that the Osimo frescoes were executed by Pietro di Domenico da Montepulciano.

9. The documentary information regarding Arcangelo di Cola has been collected by Vitalini Sacconi on p. 228 of the work already cited. Modern criticism has shown great interest in this artist, without reaching any very useful conclusions. A. Venturi (*Arte*, 1910) suggested that he went to Brescia together with Gentile, but the theory is unacceptable, since the artist was still in central Italy in 1416. There is an interesting article on the subject by U. Procacci, *Il soggiorno fiorentino di Arcangelo di Cola* in "Rivista d'Arte", 1929. For the possible influence of Arcangelo on Masaccio through Masolino, see M. Salmi, *Masaccio*, 1932 (2nd ed., Milan, 1948). The problem has been dealt with very clearly, and in the way accepted above, by Roberto Longhi in *Fatti di Masolino e Masaccio*, "Critica d'Arte", 1940. It has also been dealt with, from the same critical stand-point, by F. Zeri, *Arcangelo di Cola: Due Tempere* in "Paragone", 1952.
The list of works that follows is based on that published by Berenson (*Italian Pictures of the Renaissance - Central Italian and North Italian Schools*, London, 1968).
However, there are a number of works which Berenson and his assistants thought better not to include in their list. In his article *Fatti di Masolino e Masaccio* (p. 185, note 25), Longhi had attributed to Arcangelo di Cola a little panel (formerly in the Aymar Collection) representing a *Madonna Enthroned with Saints*, plus another three Saints in the lower register. This attribution had left me puzzled, until Longhi himself withdrew it in 1950 ("Paragone", 3, p. 49), acknowledging that the painting—part of a triptych—belonged to the Emilian school, "indeed, to Giovanni da Modena himself".
In the same article, Longhi went on to attribute to Arcangelo an *Entombment*, which is clearly a predella panel. He dates it from the very end of the artist's Florentine period, and also sees in it the influence of the Strozzi altarpiece, which Gentile did in 1423. He notes that it even contains certain naturalistic details which testify to Arcangelo's responsiveness to the great changes that were taking place in Florentine art in those years: "Arcangelo di Cola never pronounced himself in favour of the new ideas in so intelligent a way (as this); and it seems that, with the help of this work, we may definitely establish the fact that the most acute phase in his crisis took place about 1424–26".

10. F. Zeri, *Due dipinti, la filologia e un nome*, Turin, 1961, p. 63. He continues: "if it is true that nothing reveals the authentic nature of an artistic personality better than a drawing, then here we have the character and quality of Boccati's art in this sketch of *St. Venantius*, which Degenhart discovered in a codex from Urbino in the Vatican Library: (this sketch) is more closely related, in a general sense, to a Parri Spinelli than to those (and there were very few of them) whom we may definitely call 'Renaissance' Artists". The drawing in question can be found in the Vatican Library, Urb. Lat. 417, f. 123. Degenhart has published it in his *Italienische Zeichnungen des frühen 15. Jahrhunderts*, Basle, 1949, p. 41, note 25. One may add that it is very similar to the figure of St. Venantius in the Belforte triptych, a much later work, carried out at a time whem the painter had lost himself in the precious fables that are closer to Gothic fantasy than to Renaissance precision.

11. Roberto Longhi attributes a number of works to a "member of Boccati's household". But on taking a closer look at the *St. Sebastian* (v. "Paragone", 1962, 15, fig. 61), one seems to be faced with a painter of far less pronounced individuality who may well have been influenced by the direct or indirect knowledge of the works of Carlo Crivelli, or of one of his Marchigian imitators.
If one were to visit the churches in the region, especially those isolated in the hills around Camerino, one would be able to reconstruct a few more "member[s] of Boccati's household", painters who would certainly be closer to him than the one suggested by Longhi appears to be. In the parish church of Sentino in the neighbourhood of Camerino, there are a number of frescoes (at the base of the bell-tower, in the intrados of a side-door leading to the sacristy, on the right-hand side in line with the wall of the presbytery) which are all similar to Boccati's work. The fresco inside the bell-tower representing St. Sebastian might even be attributed to him directly.

12. The texts of the three letters, that of Ansovino, the painter's father-in-law, and the two written by Giovanni Angelo, are given below:
*a*) Letter from Ansovino:
"My dearest son, we have written to you many times but have not received any reply, which astonishes us greatly and leads us to regret that you no longer appear the man we believed you to be, while it seems that you have little care for the necessities of life: so that you would do better to come back and see to your affairs instead of staying away from home. We have written to you so many times that we are at the end of our tether, and if, after this, you do not decide to return, we shall have as little consideration

for you as you have for us. But if you return, you will please us and do yourself service and honour, and once you have settled your affairs here, you may go wherever you want to. Giovanni, we have decided that on your return, if God so wills, you will take your wife and brothers and put the house in order, fitting it up with everything it requires. When you left here, together with Giovanni Boccaccio, you told us that you were going to make a lot of money. But I don't know how much you have made, since from what we have heard, there is no great abundance. As I have told you, do not fail to return as it is in your interests, and you will content those who love you as well as the Duchess, who has told us more than once how much she wishes you were here. She wanted you to accompany Messer Rodolfo in Ferrara, which would have been in your interests. I have nothing more to add. May Christ protect you. Ciociolina wishes to be remembered to you, and all your friends are in good health. Written at Camerino on 17 March. Ansovino di Mastro Petri

Merchant at Camerino etc.

(Archivio di Stato di Firenze, Carteggio Mediceo avanti il Principato, IX, 570), published by B. Feliciangeli, "Arte e Storia", 1910, p. 367.

b) Letter from Giovanni Angelo to Giovanni Medici:

"Magnificent and most honoured Sir, together with all titles due to you. The reason for my writing to you is that I cannot come and see your worship personally. I beg you to accept my apologies, informing you that today I have received two letters from Camerino via Florence from my father-in-law which I herewith enclose, so that when your worship has read them you will understand how very necessary it was for me to return home. And since they have told me that the way is not safe in certain parts of the country around Perugia, some people from Foligno having taken up arms, I have not been to see you, so that I beg you to excuse me as I have said. And once I have settled my affairs I hope in some way, if God preserves us, to return to you in whom I have the firm hope that you will answer to all my needs. I have nothing further to add. May Christ keep you in that state which most pleases you yourself; recommending myself to your worship always.

Siena, 3 april.

Your servant

Giovanni d'Antonio da Camerino".

(Archivio di Stato di Firenze, Carteggio Mediceo avanti il Principato, IX, 558), published by B. Feliciangeli, "Arte e Storia", 1910, p. 368.

c) Letter from Giovanni Angelo to Giovanni Medici:

"Magnificent and most honoured Sir, together with all titles due to you etc. I think that your Magnificence may justly complain of me, since I have not been to visit you for such a long time, as I should have done. But considering all the things I have had to see to and the worries I have had, you will pardon me the same even if I haven't done my duty towards you. I have written this to you many times, but I do not know whether you have received my letters; I think not, because I have not had any reply. I am sending you this by the present courier to tell your Magnificence that if you have not already chosen a wife, considering the great devotion and regard I have for your Magnificence, and should you be looking for a noble bride, there is a young lady who on her father's side is related to the Chiavelli family being the daughter of the late Lord Batista, Lord of Fabriano, and on her other side to the Da Varano family being the daughter of Lady Wilhelmina, an aunt of our magnificent lords. She is a young girl of approximately thirteen years of age and I do not believe that her virtue and excellence have their equal throughout Italy. As for her beauty, it will please you more than any other, and she has a good dowry. Therefore, I beg you to be so kind as to write to me concerning your intentions, for I have the means to settle everything. I also remember that your Magnificence loaned me three ducats, and your brother Piero four when we went to the baths at Petriolo, so that if your Magnificence will write and tell me whom I am to give the money to, I shall give it. Although I am guilty of great ingratitude, I beg you to pardon me, for God knows that I continually bear you in my heart as my benefactors. Recommend me to his Magnificence, your father, and to the Countess, your mother. Camerino, 17 April 1451. The girl is staying at the house of our lords, whose sister she is.

Your humblest servant

Giovanni Angelo d'Antonio

painter from Camerino who

played the lute".

(Archivio di Stato di Firenze, Carteggio Mediceo, published by Gaye, Carteggio, vol. I, p. 161).

This is the right moment for us to return to the discussion regarding the date of the two artists' departure from Camerino. According to Zeri (1961), Boccati and Giovanni Angelo went to Perugia together in 1445, after which, one went on to Padua, and the other to Florence. But the tone of his father-in-law's letter excludes the possibility that Giovanni Angelo had been away from Camerino for over six years. The duchess herself desired the artist to return because she wanted to send him to Ferrara with her son. Boccati guided Giovanni Angelo, who was perhaps younger, and accompanied him to Urbino as well. In this way one can also fill the gap in time regarding Boccati, of whom there would be no further trace otherwise for the period 1445–1468, that is to say, from the works of Perugia to the Belforte triptych.

13. A. Parronchi, *L. B. Alberti Pittore* in the "Burlington Magazine", 1962, 280. He must have gradually been forgotten a long time before. It is probable that the two went to Florence, an idea already put forward by Rotondi, though the latter had attributed the panels to the young Bramante. For this subject, see his article *Bramante Pittore* in "Emporium", 1951, p. 120.

14. In the rural church of Sentino in the countryside around Camerino, the whole wall of the apse is covered with a fresco of the *Crucifixion* (plate 97). The figure of Christ is isolated, hemmed in by the rocks in the foreground, while the landscape spreads out in the distance. Iconographically, if not formally, the painting is similar to the Cini panel, since artists rarely portrayed the figure of Christ isolated, without the two thieves, and without the holy women weeping at the foot of the Cross. The painting has an almost unreal, metaphysical aspect, and the representation of the tragedy of Golgotha is undoubtedly all the more obsessive because of the absence of tears. The work, which needs restoring, is not perhaps of the highest quality, but its present

state does not allow an objective judgement. However, the fact remains that it is connected with the Cini panel, so that its derivation from the school of Camerino is thus confirmed, even if indirectly.

15. See R. Longhi, *Lettere pittoriche a Giuseppe Fiocco sull'Arte del Mantegna* in "Vita Artistica", 1926. Longhi later returned to the subject in his fundamental study of Pietro della Francesca. In the 1962 edition of this work, Gerolamo is called "the oldest and closest follower of the master that we know of" (p. 212). Zeri, for his part, accepts Longhi's attribution, and adds that the part played by Gerolamo within the orbit of the Paduan school is becoming increasingly important (*Due Dipinti, la filologia e un nome*, 1961, p. 77). See also L. Coletti, *Pittura Veneta del '400*, Novara, 1953, pp. XXXV and LXXXI, note 49, according to which the fresco is the result of the collaboration between Gerolamo di Giovanni and Ansovino da Forlì.

16. I have attributed the fresco representing the *Madonna and Child with Angels in Adoration*, previously given to Lorenzo Salimbeni by Serra (1934, p. 278), to Gerolamo di Giovanni (P. Zampetti, *Una chiesa eremitica ed un'antologia pittorica* in "Atti e Memorie etc.", 1964–65). After the fresco had been detached and excellently restored under the supervision of the Superintendence for the Art Galleries of the Marches, it was described by Alberto Rossi in the catalogue of the *Mostra di opere d'arte restaurate*, Urbino, Palazzo Ducale, 1968, p. 42, as a work "that might even suggest one of the many artists active in the area between Camerino and San Severino in the secondo half of the fifteenth century, and who combined the stylistic characteristics of Lorenzo di Alessandro and Urbani with those typical of Boccati and Gerolamo di Giovanni". Vitalini Sacconi (1967) does not mention the fresco, though he touches on the problem indirectly when he attributes to Ludovico Urbani the Colle Altino *Crucifixion*, a wholly similar work, which is connected in my opinion with the Monte San Martino triptych, signed and dated by Gerolamo di Giovanni in 1473. Longhi attributes the *Crucifixion* in the Cini Collection to Ludovico Urbani, though it is accepted here, following Offner and Zeri, as one of the few extant paintings of Giovanni Angelo (Master of the Barberini Panels).
Whether this attribution is acceptable or not, one must not confuse the issue; there is no formal link between this painting and the Colle Altino *Crucifixion*. In fact, Gerolamo di Giovanni's artistic development, from his early adherence to the art of Piero della Francesca to that of Padua, and from that of Padua to his final reversion to the weary lifelessness of his later works, with their servile imitation of certain elements in the Vivarini brothers and Boccati, is fairly clear.

17. The little oratory measures 4,70 × 2,75 metres, and is covered by a barrel vault. It is decorated with frescoes representing the various episodes of the Passion of Christ, each of which bears an inscription in archaic Italian explaining its significance. There are fifteen scenes, beginning with Christ's Entry into Jerusalem, and ending with the Descent to Limbo, and the Resurrection. The most interesting ones, also because of their Paduan influence, are those which represent *Christ before Pilate*, the *Mocking of Christ*, the *Lamentation of the Holy Women*. The following works may be consulted on the subject: C. Ponzi, *Il '400 e il piccolo maestro de "Lu Patullo"* in "L'Appennino Camerte", 14 Nov. 1959; M. Cardona, *Camerino, un secolo e sei pittori*, Camerino, 1965; P. Zampetti, *Una chiesa eremitica ed un'antologia pittorica*, Novara, 1966; C. Ponzi, *Gli affreschi della cappella del Patullo e l'arte camerinese del '400* in "Il Ducato dei Varano", Camerino, 1967; P. Zampetti, *Master of Patullo* in "A Dictionary of Venetian Painters", Leigh-on-Sea, I, 1969; see also what Vitalini Sacconi has to say on the subject in *La Scuola Camerinese*, 1961, p. 209.

18. The frescoes in the church of Patullo have recently been detached and taken to Urbino for restoration. They are now in the final stages of being restored, and reveal throughout the outstanding quality of this painter. It is conceivable that the restoration of the two Valcaldara frescoes may lead to a greater affinity being established between the two groups of frescoes than we are able to detect at the moment. The recovery of a great number of mural paintings (and many, though not all, are cited by Vitalini Sacconi in his perceptive study of the subject) would not only save a pictorial patrimony otherwise destined to disappear, but would also lead to the recognition of certain minor artists who have remained completely unknown so far. In fact, it is clear that much remains to be said about the vast number of mural paintings—many of which are in a pitiful condition—to be found in the churches around Camerino. It is not enough to concentrate attention on the more well-known painters; others, minor ones, ought to emerge to confirm the existence of a true local school, whose activity was widespread in the area. One must photograph, catalogue, compare: the various critical problems will then arise by themselves.
The frescoes of Patullo, now at Urbino, are to be exhibited in the Civic Gallery of Camerino, which has been set up in the former church of S. Francesco.

46. Carlo da Camerino: *The Annunciation*. Urbino, Galleria Nazionale. ▷

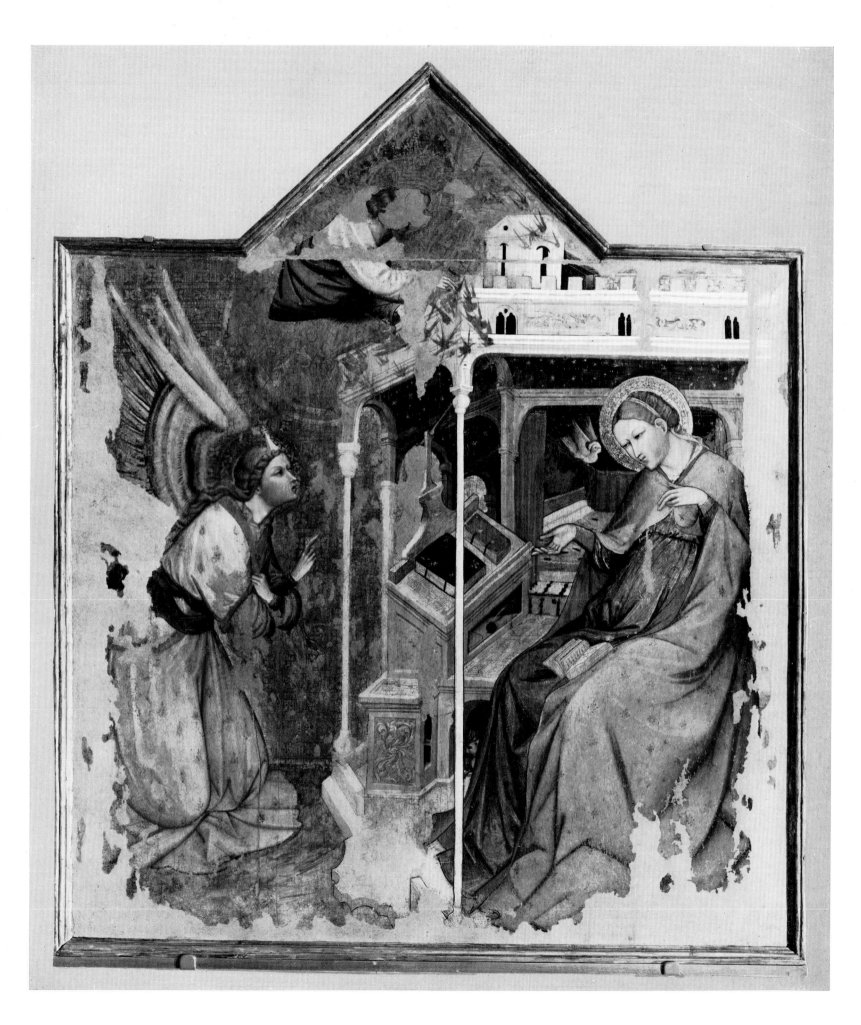

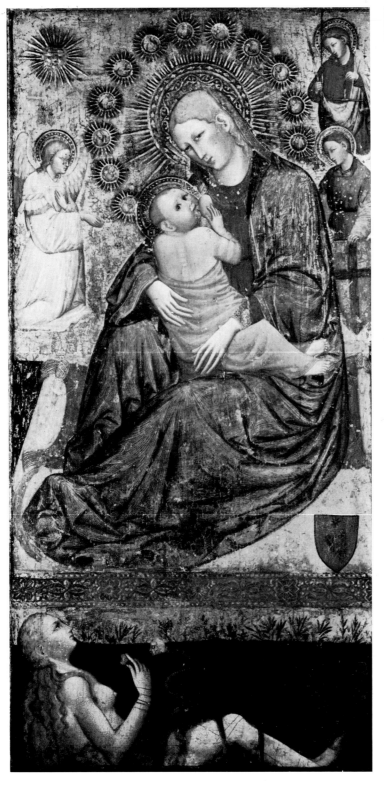

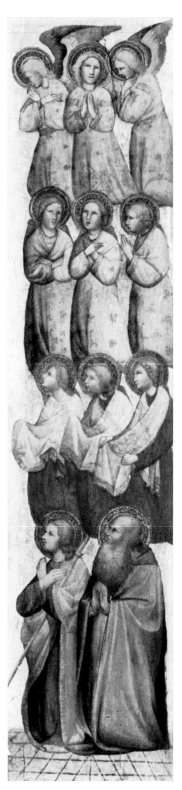

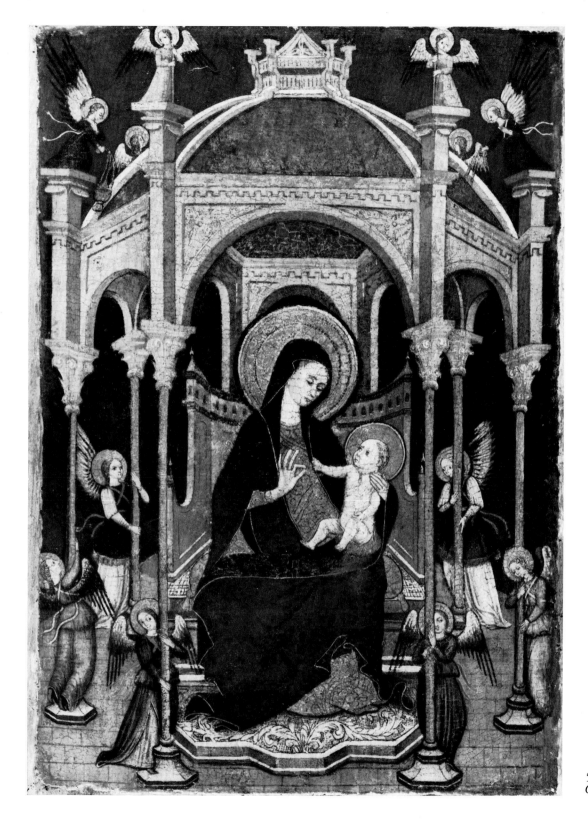

47. Carlo da Camerino: *Virgin and Child with Angels*. Cleveland, Museum of Art.

48-49. Carlo da Camerino: *Angels and Saints*. Cambridge, Fitzwilliam Museum.

50. Carlo da Camerino (?): *Virgin and Child*. Bassano, private collection.

51. Arcangelo di Cola: *Saints Gregory and Luke*. Osimo, Convent of S. Nicolò.

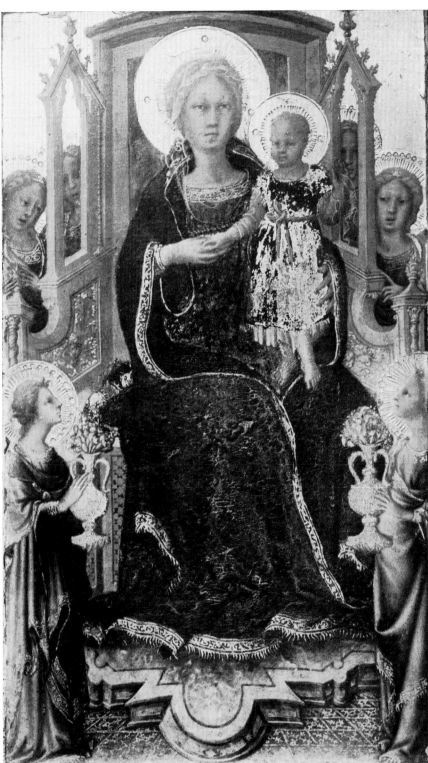

52. Arcangelo. di Cola: *Virgin and Child enthroned*. New York, Frick Collection

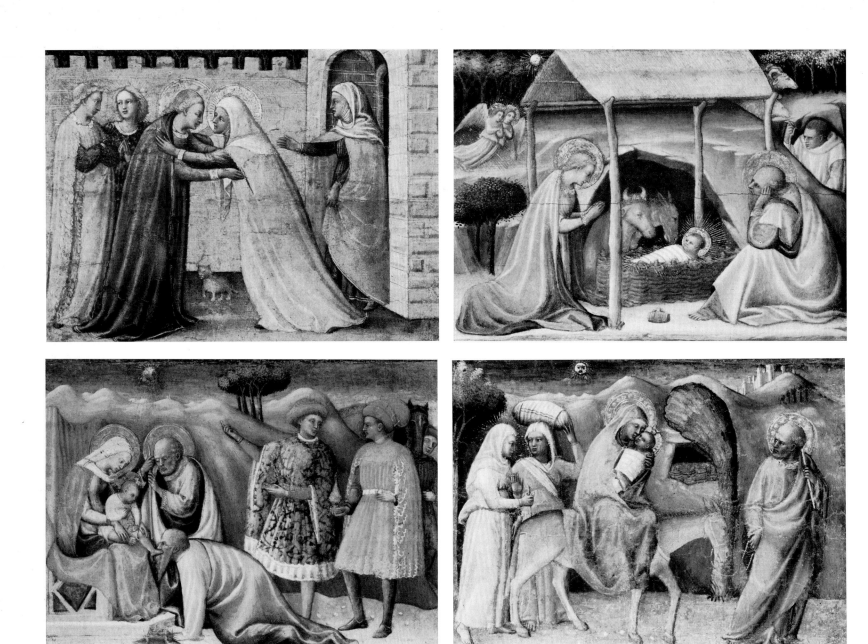

53-56. Arcangelo di Cola: *Predella panels: The Visitation, the Nativity, the Adoration of the Magi, the Flight into Egypt.* Philadelphia, John G. Johnson Collection.

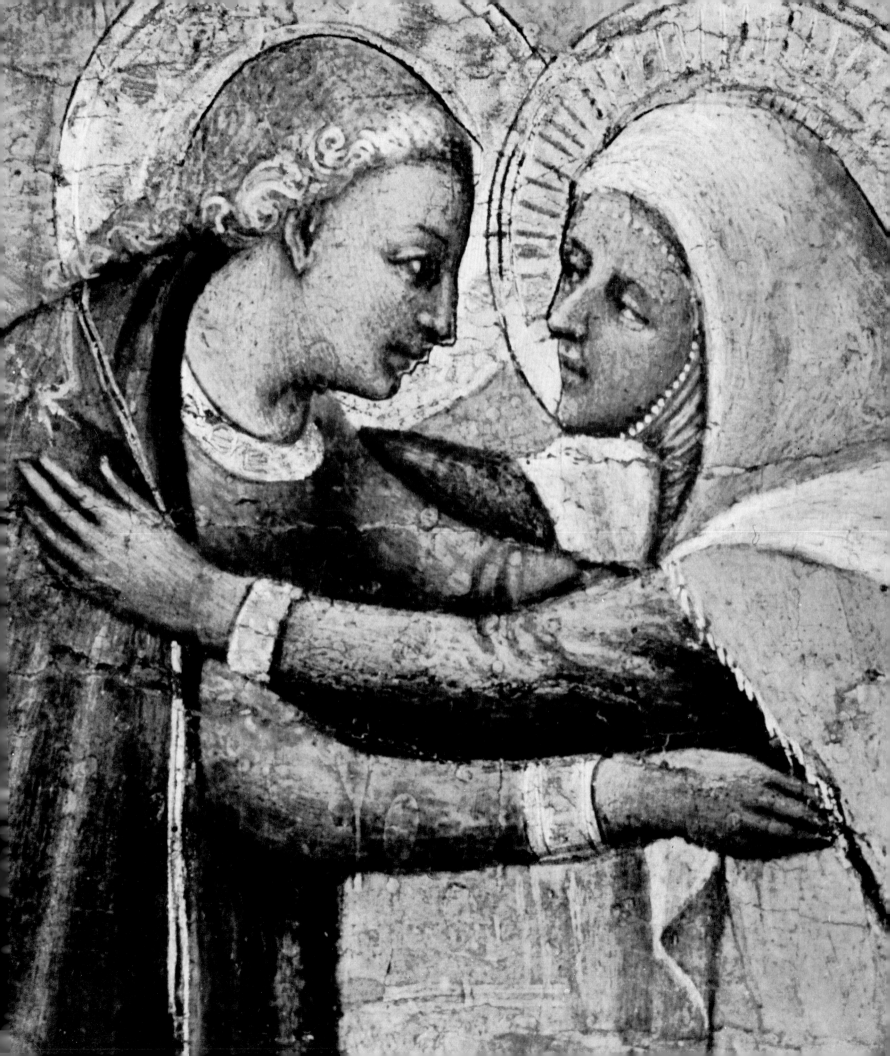

58. Arcangelo di Cola: *Virgin and Child with two Angels*. Rotterdam, Boymans-Van Beuningen Museum.

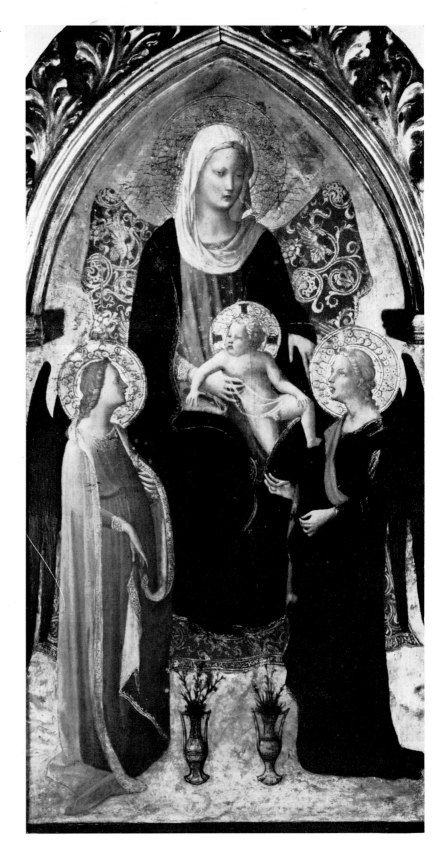

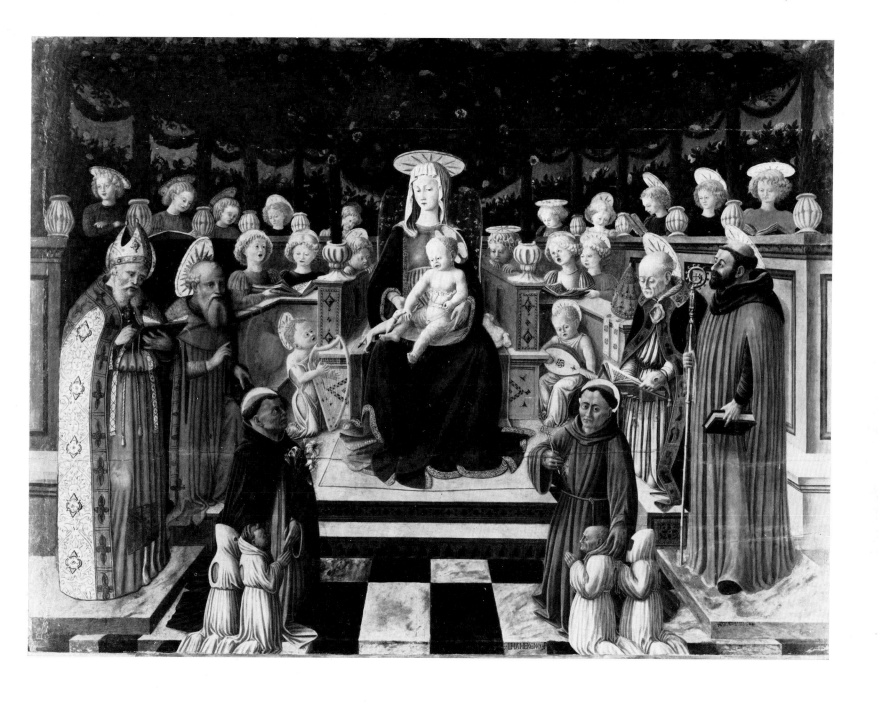

59. Giovanni Boccati: *Virgin and Child with Angels, Saints and donors (Madonna del Pergolato)*. Perugia, Galleria Nazionale.

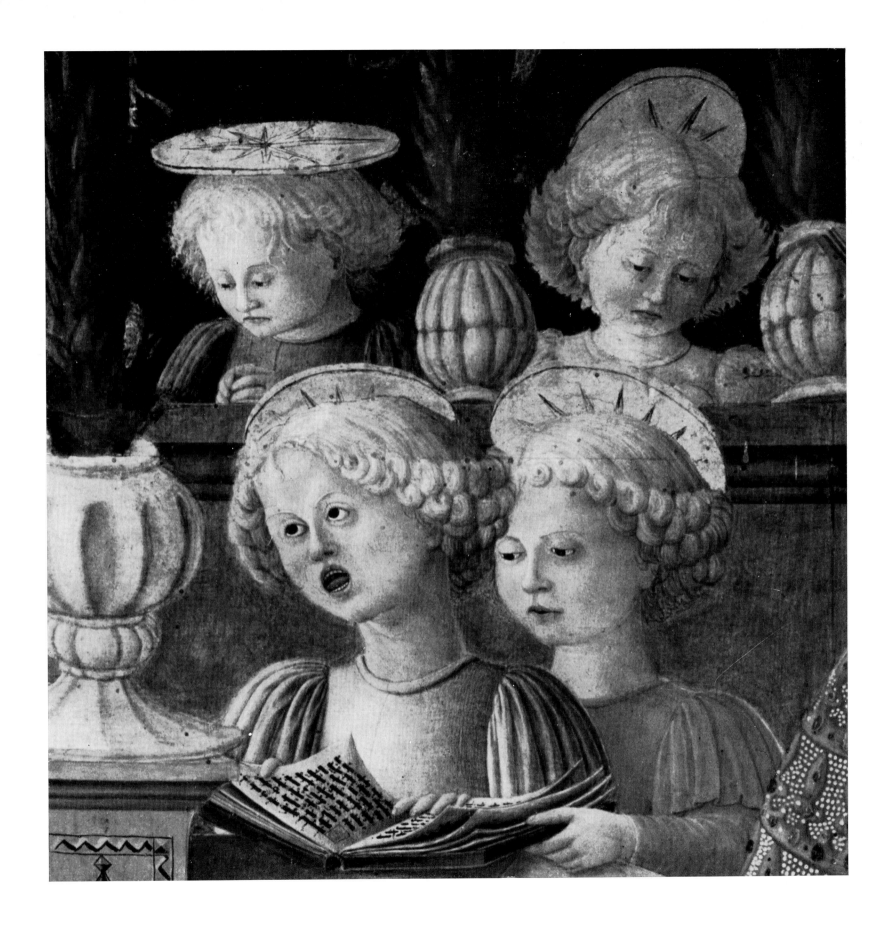

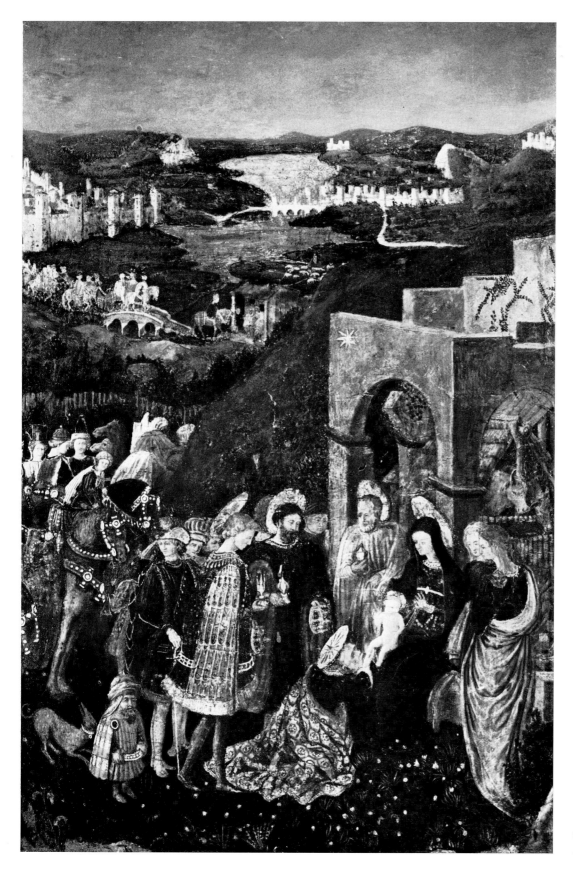

60. Giovanni Boccati: *Angels*. Detail from plate 59.

61. Giovanni Boccati: *The Adoration of the Magi*. Helsinki, Ateneum.

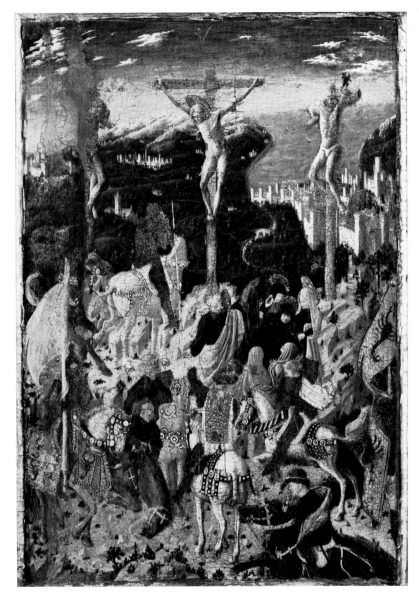

62. Giovanni Boccati: *The Crucifixion*. Venice, Ca' d'Oro.    63. Giovanni Boccati: *The Crucifixion*. Venice, Cini Collection.

64. Giovanni Boccati: *Legend of San Savino*. Milan, Gallery Finarte.

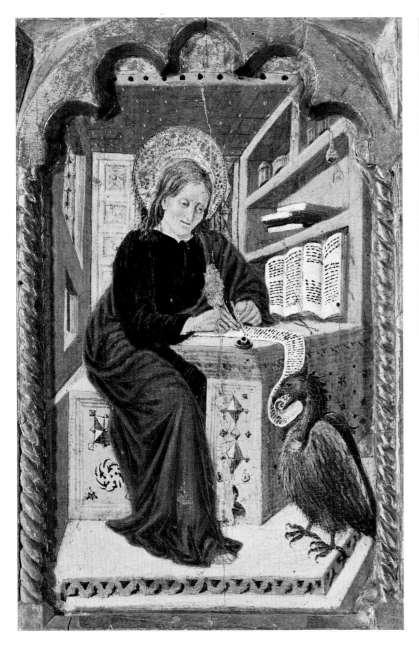

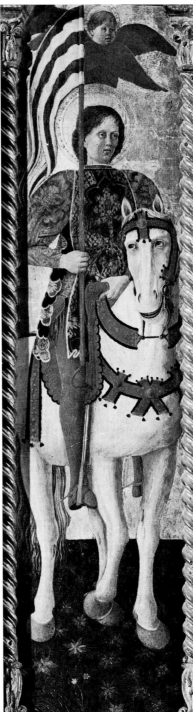

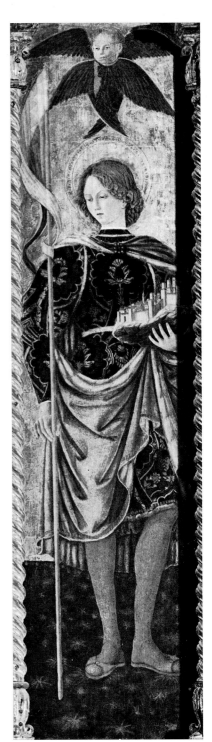

65-67. *Saints John Evangelist, Eustace and Venantius*. Details from plate 68.

68. Giovanni Boccati: *Polyptych*. Belforte del Chienti, Parish Church of Sant'Eustacchio.

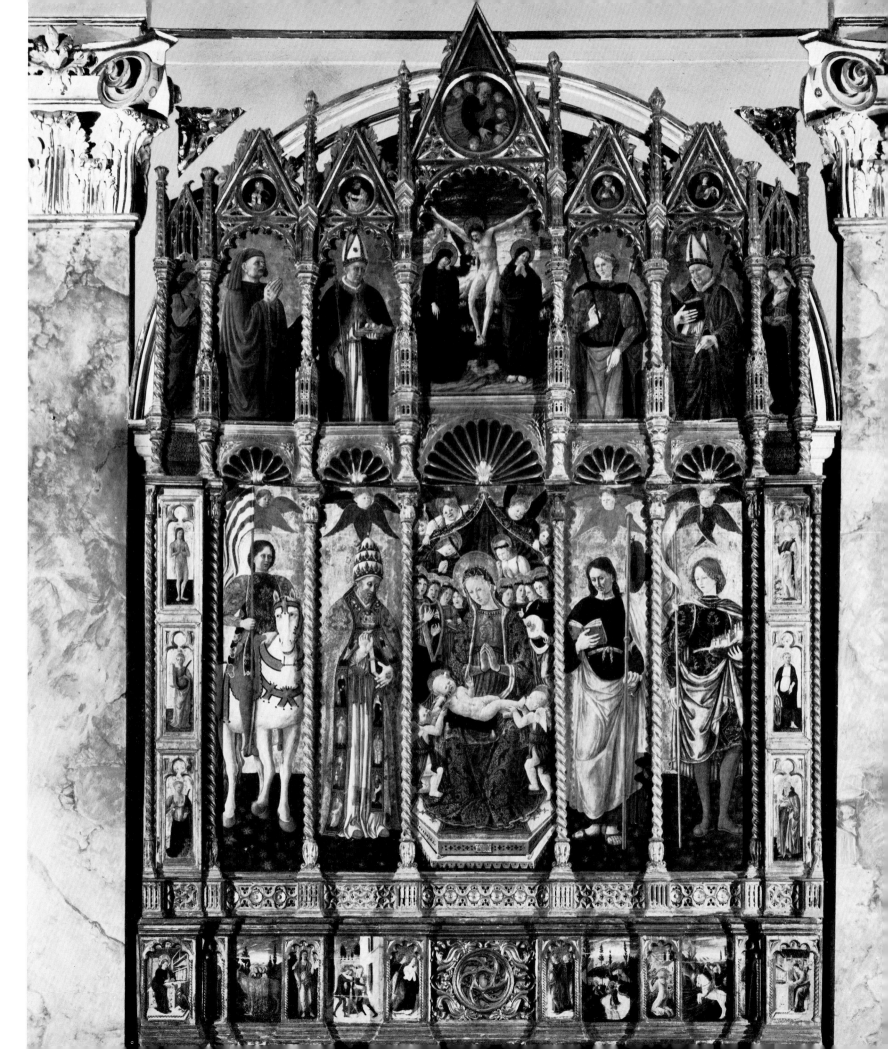

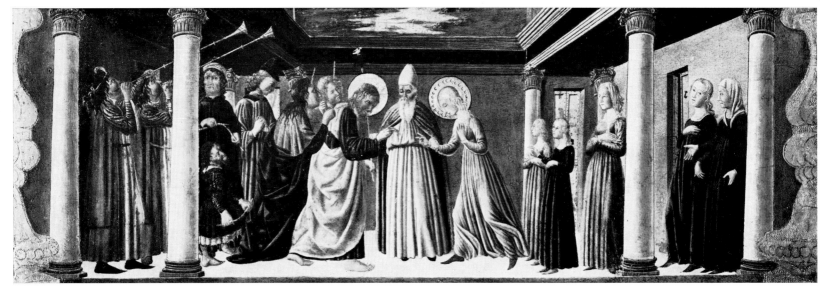

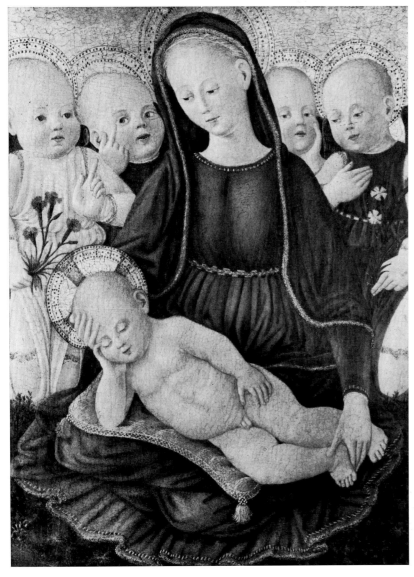

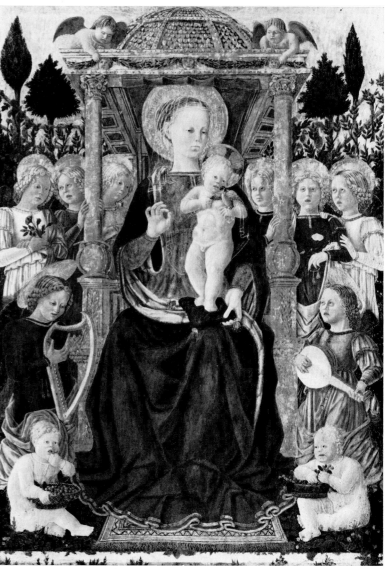

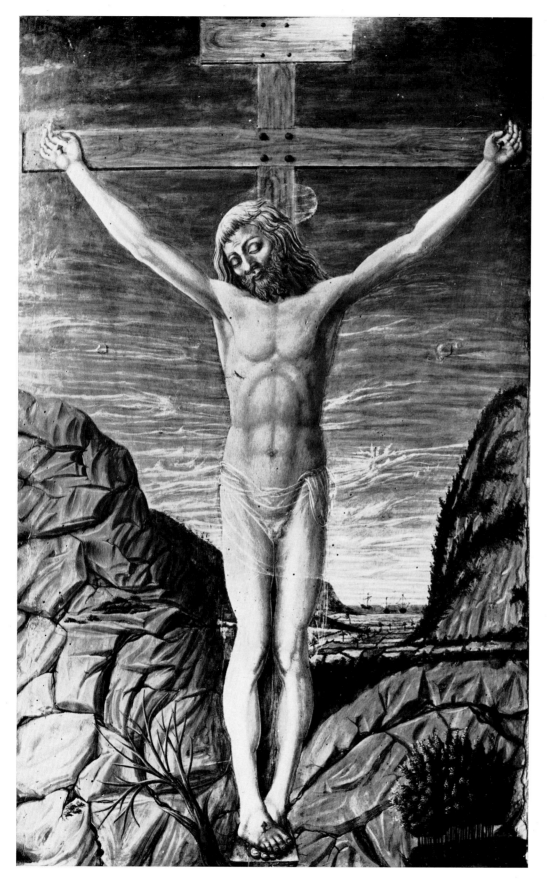

69. Giovanni Boccati: *Predella panel: The Marriage of the Virgin*. Florence, I Tatti, Berenson Collection.

70. Giovanni Boccati: *Virgin and Child*. Palermo, Chiaramonte Bordonaro Collection.

71. Giovanni Boccati: *Virgin and Child enthroned with Angels*. Ajaccio, Musée Fesch.

72. Giovanni Angelo di Antonio: *Christ on the Cross*. Venice, Cini Collection.

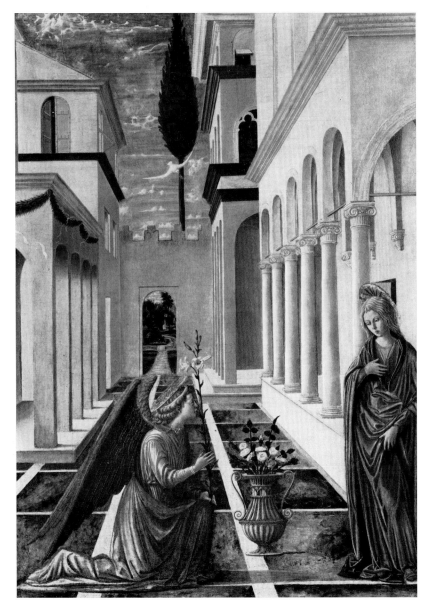

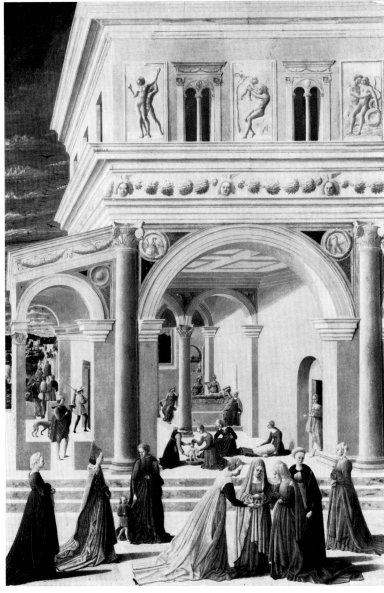

73. Giovanni Angelo di Antonio: *The Annunciation*. Washington, National Gallery of Art (Samuel H. Kress Collection).

74-75. Giovanni Angelo di Antonio: *The Birth of the Virgin*. New York, Metropolitan Museum of Art.

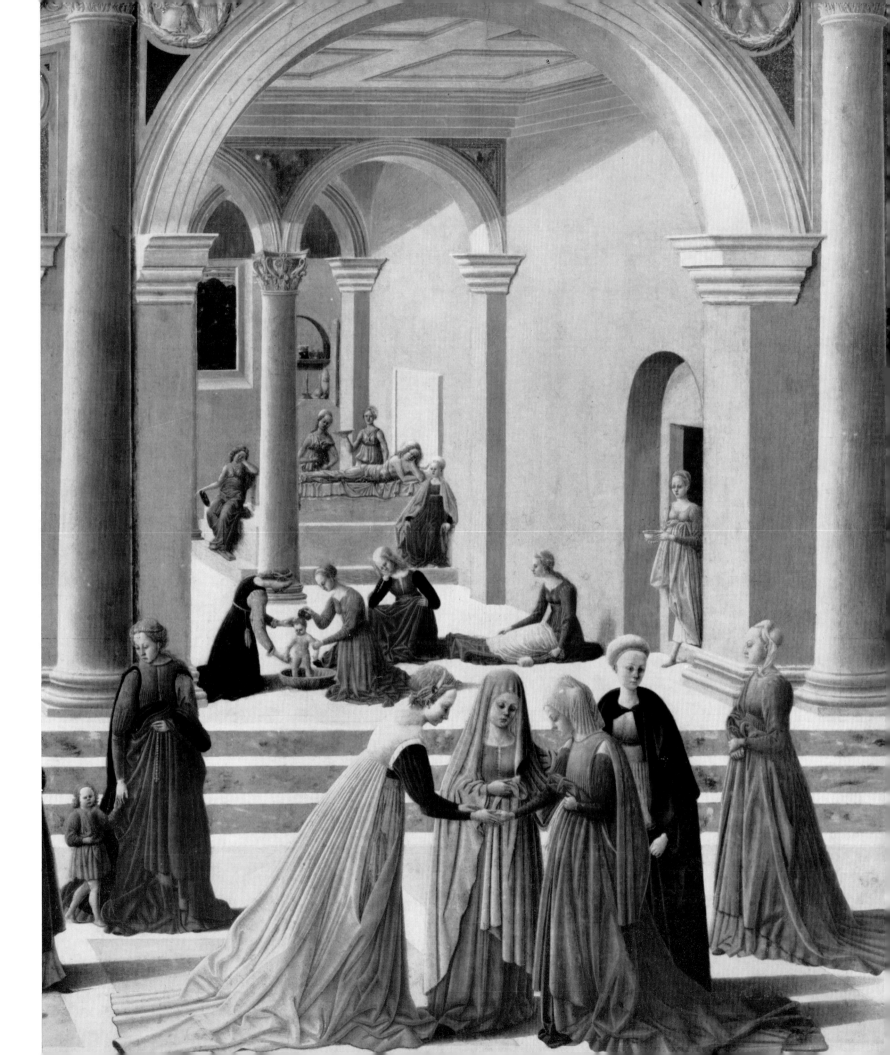

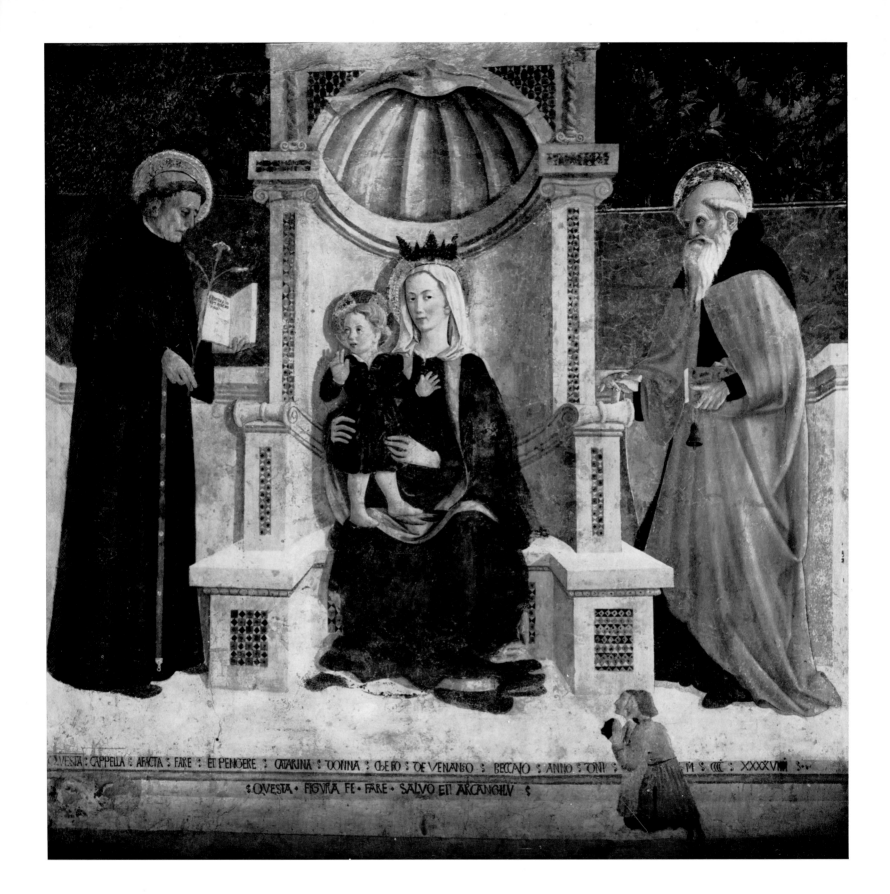

QVESTA : CAPPELLA : AFACTA : FARE : ET PENGERE : CATARINA : DONNA : CHE FO : DE VENANSO : BECCAIO : ANNO : TONI : ... M : CCC : XXXXVIIII : S ·

$ QVESTA · FIGVRA · FE · FARE · SALVO ED ARCANGILV $

76. Gerolamo di Giovanni: *Detached fresco: Virgin and Child with Saints Anthony of Padua and Anthony Abbot*. Camerino, Pinacoteca Civica.

77. Gerolamo di Giovanni: *Saint Lucy*. Montecavallo, Church of Valcaldara.

78. Gerolamo di Giovanni: *The Departure of Saint Christopher*. Formerly Padua, Church of the Eremitani.

79. Gerolamo di Giovanni: *The Annunciation*. Camerino, Pinacoteca Civica.

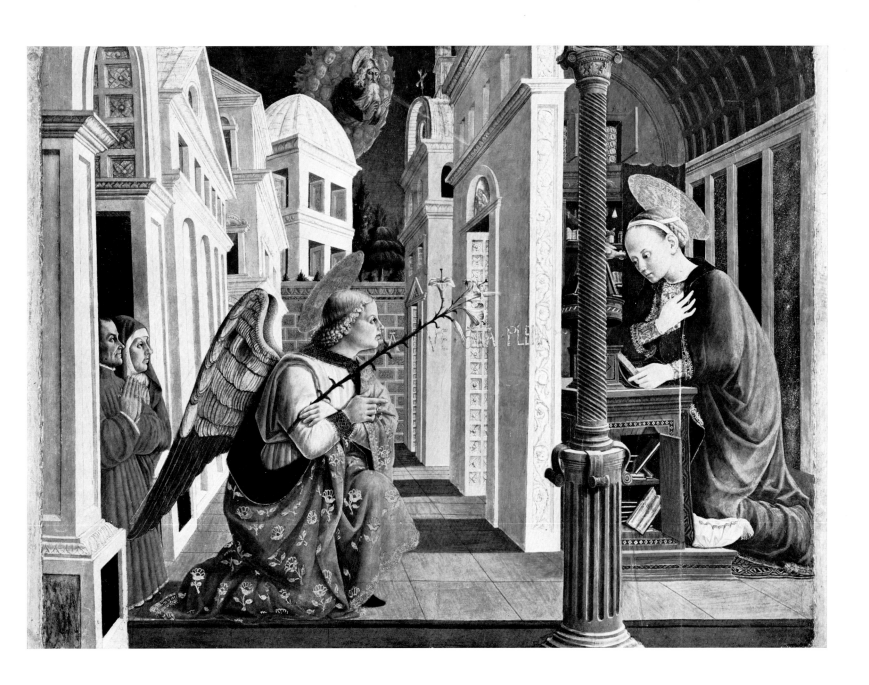

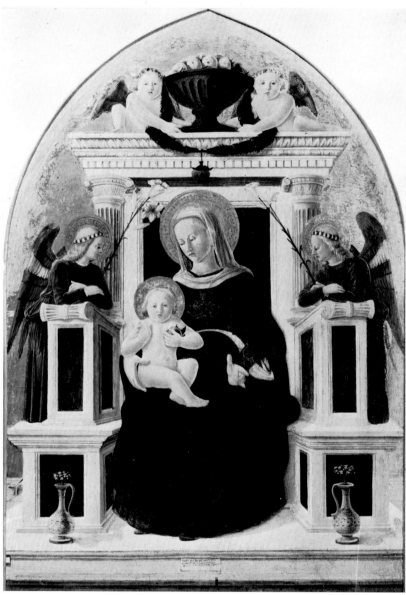

80-81. Gerolamo di Giovanni: *Virgin and Child with Angels*. Venice, Cini Collection.

82. Gerolamo di Giovanni: *Virgin and Child with music-making Angels and Saints*. Rome, Museo di Palazzo Venezia.

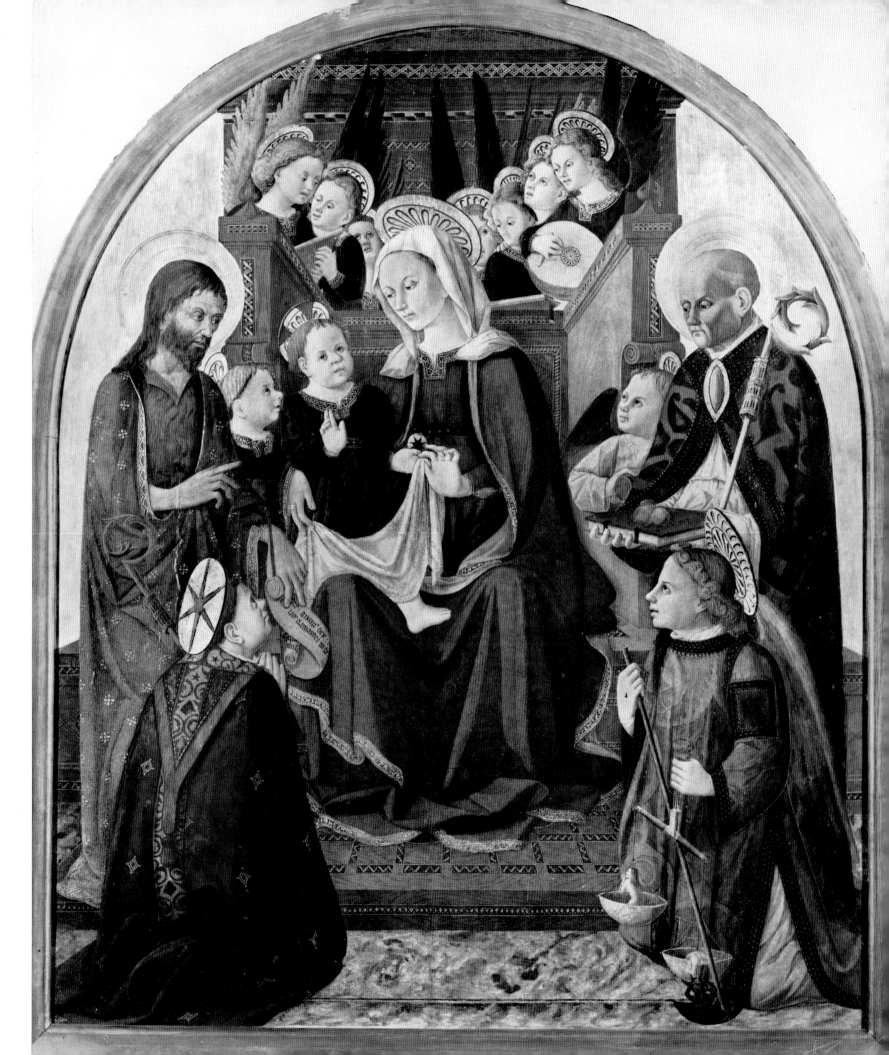

83. Gerolamo di Giovanni: *The Annunciation*. Sarnano, Church of S. Maria di Piazza.

84. Gerolamo di Giovanni: *Polyptych*. Milan, Brera.

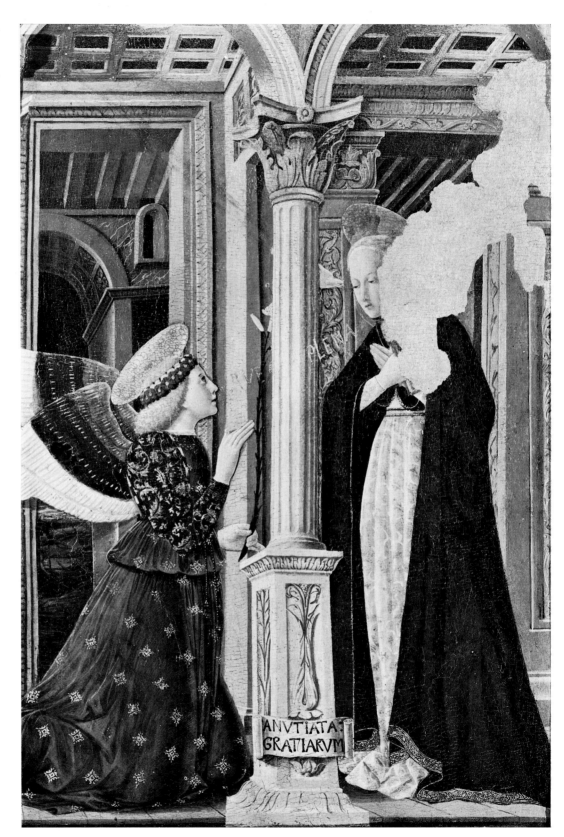

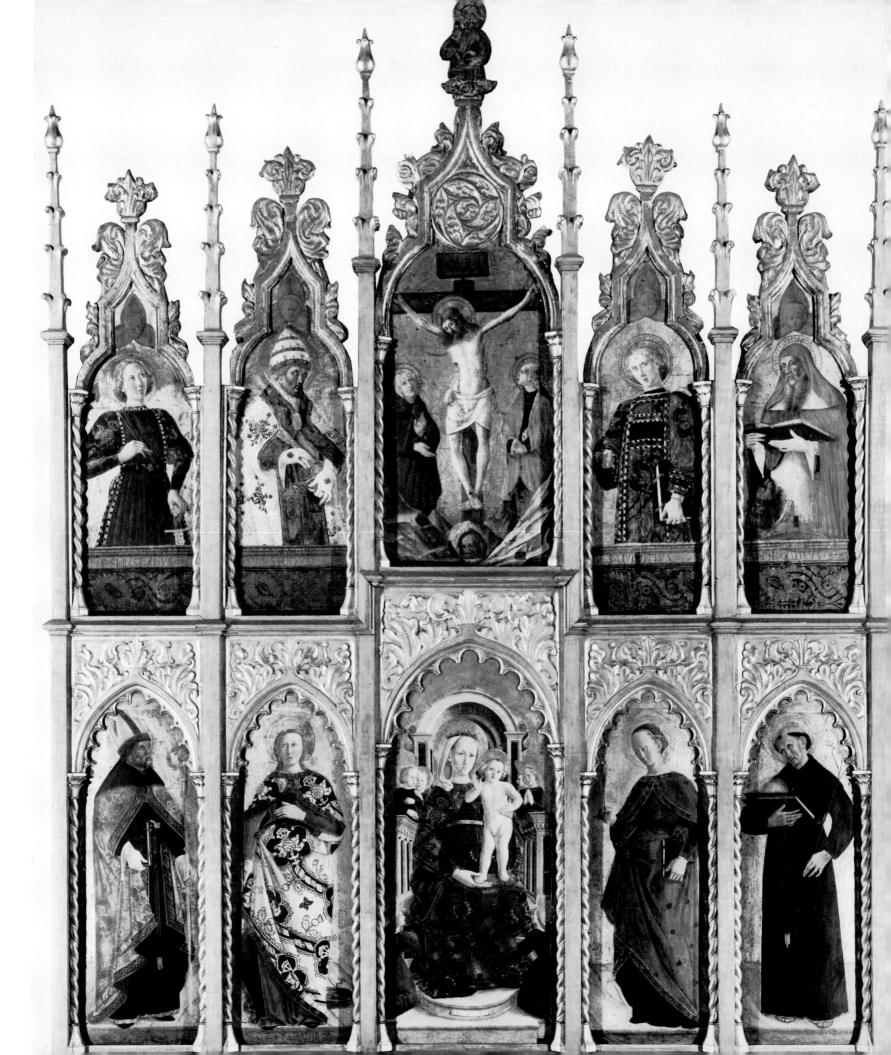

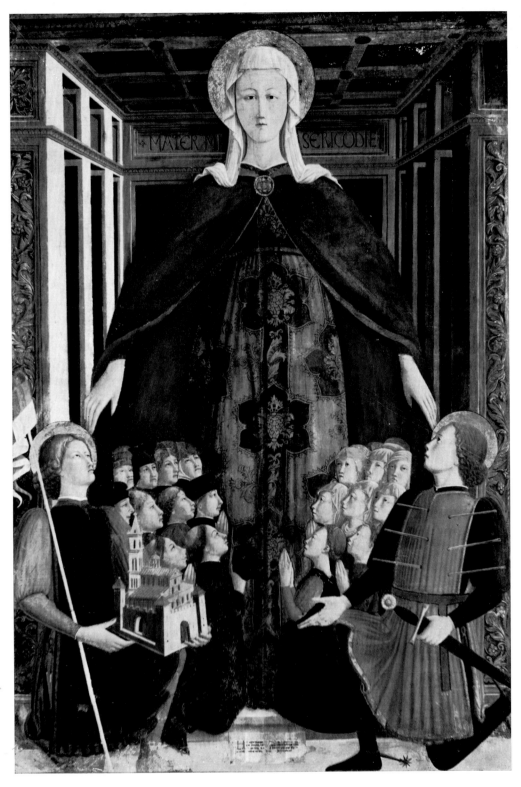

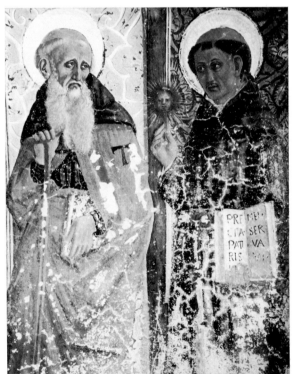

85-86. Gerolamo di Giovanni: *Virgin of Mercy*. Camerino, Pinacoteca Civica.

87. Gerolamo di Giovanni: *Saints Anthony Abbot and Dominic*. Bolognola, Villa Malvezzi.

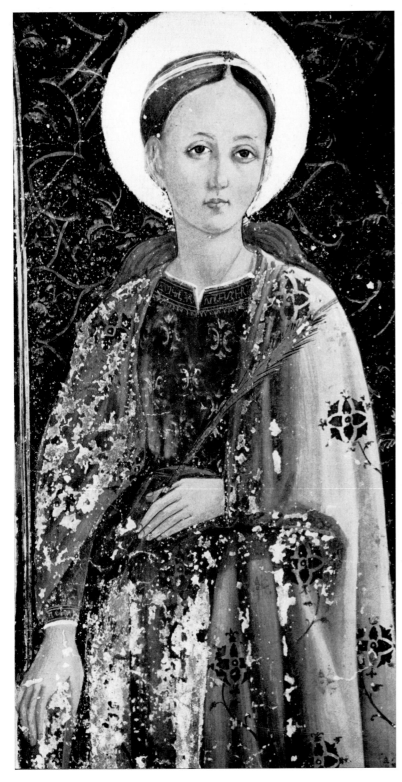

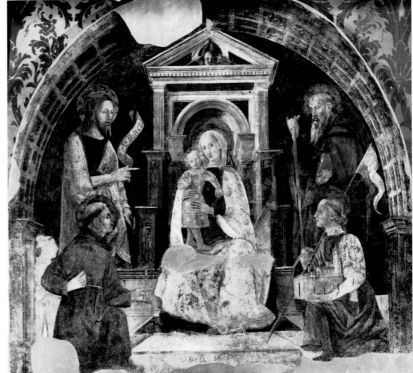

88. Gerolamo di Giovanni: *Saint Catherine*. Bolognola, Villa Malvezzi.

89. Gerolamo di Giovanni: *Virgin and Child with Angels*. Bolognola, Villa Malvezzi.

90. Gerolamo di Giovanni: *Detached fresco: Virgin and Child with Saints*. Camerino, Pinacoteca Civica.

91. Gerolamo di Giovanni: *Polyptych*. Monte San Martino, Church of S. Maria del Pozzo.

92. Lorenzo d'Alessandro (?): *Detail of detached fresco: Angel of the Annunciation.* Gagliole (Camerino), Church of S. Maria delle Macchie.

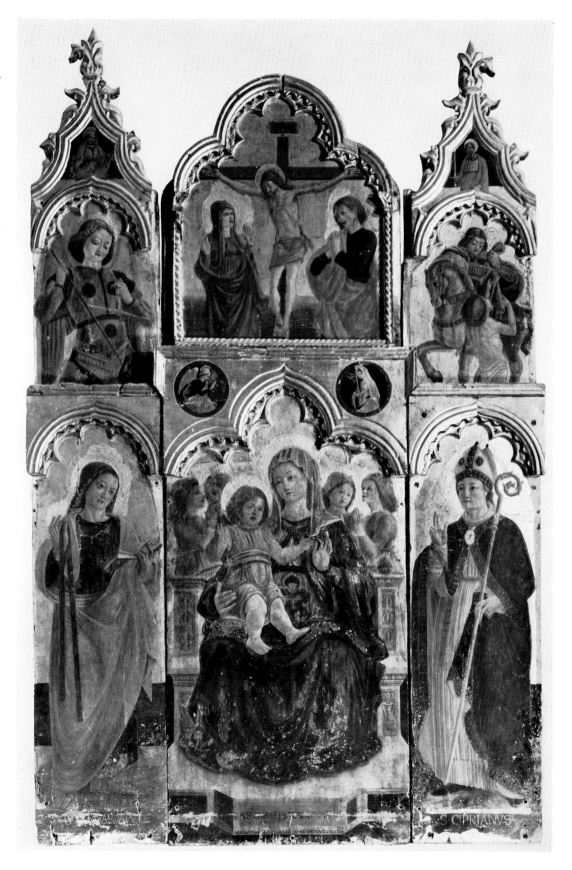

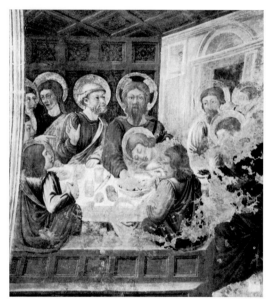

93. Master of Patullo: *Detached fresco: Christ before Pilate*. Camerino, Pinacoteca Civica.

94. Master of Patullo: *Detached fresco: The Last Supper*. Camerino, Pinacoteca Civica.

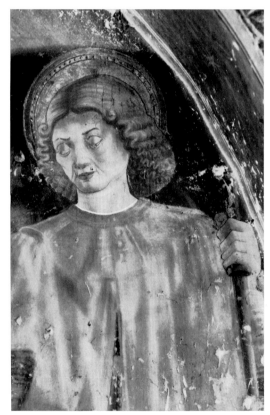

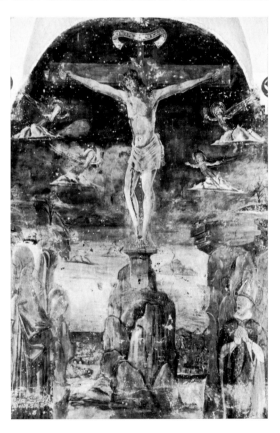

95. Master of Patullo: *Detached fresco: Christ before Caiaphas*. Camerino, Pinacoteca Civica.

96. Gerolamo di Giovanni (?): *Saint Roch*. Gagliole (Camerino), Church of S. Maria delle Macchie.

97. Unknown Painter from Camerino: *Christ on the Cross*. Sentino (Camerino), Parish Church.

San Severino, a town of Roman origin (Septempeda), went through very difficult times during the Middle Ages. A free Ghibelline commune, it was continually at war with the neighbouring towns, changing its allies as the need arose. At the beginning of the fourteenth century, it joined the so-called League of Friends, under the leadership of Gerardo De Tastis, and waged war against Tolentino and Ancona, allies of the Church. In the end the Commune was forced to submit, and the Signoria of the Smeducci became more and more powerful, until the family took control of the town as legates of the Church. Exiled in 1426, the Smeducci attempted to return, but the town (like Camerino) was occupied by Francesco Sforza first in 1433, and again in 1444–45. After the dominion of the Sforza, the town passed under the direct control of the Papacy. From the end of the fourteenth to the end of the fifteenth century, San Severino witnessed the flowering of a notable school of painters faithful to the traditions of International Gothic.

### Lorenzo and Jacopo Salimbeni

The information regarding Lorenzo, who is generally considered the elder and greater of two brothers, is too scanty and inadequate to permit a reconstruction of his artistic development. As for Jacopo, his name is only known because he is mentioned twice as Lorenzo's collaborator in the painting of the Urbino frescoes and of those in the old cathedral of San Severino. The first known work of Lorenzo's is a triptych (or rather, a small altarpiece), of the *Mystic Marriage of St. Catherine, and two other Saints* (plates XVII, 98), painted in 1400, and now in the Gallery of San Severino. On the scroll painted at the foot of the Madonna, the painter declares that he is twenty-six years old. Therefore, he must have been born in 1374.[1] Lorenzo was therefore about the same age as Gentile da Fabriano.

The triptych shows typical characteristics of International Gothic: the ample, delicate folds of the Virgin's dress, the slender, elongated figures, and the flower-dotted lawn on which they stand. An attempt to establish direct traces of Bohemian, or at least northern influence in this work might seem far-fetched. More feasible is the theory advanced by Longhi, but questioned by Fiocco and Grassi, that Lorenzo may have been influenced in his formative years by the work of Zanino di Pietro. This artist was active in the Marches between the end of the fourteenth and the beginning of the fifteenth century, and had painted a polyptych, now dismembered and incomplete,[2] at Valcarecce di Cingoli not very far from San Severino. In 1404, Lorenzo himself painted some frescoes in the sacristy of the church of the Misericordia at San Severino, now mostly destroyed unfortunately, and not

very helpful therefore in the reconstruction of his artistic personality. Recently, in the course of a restoration campaign led by the Superintendence of the Art Galleries of the Marches, a number of frescoes by Lorenzo have been discovered in the crypt of the Collegiate church of S. Ginesio. These represent the *Virgin Enthroned between the Stoning of St. Stephen and St. Ginesio in the guise of a young page playing the lute* (plates XVIII, 99, 100), and a number of scenes from the life of St. Biagio. Near the little window, on the upper part of the wall, a scroll contains the following inscription: *hoc opus fecit Laurentius Salimbeni de S. Severino anno domini MCCCCVI*. To the following year belong a number of frescoes in the sacristy of S. Lorenzo in Doliolo at San Severino. He must also be the author of some fragmentary paintings (among them a *Madonna and Child with an Angel and two Saints as prisoners*, and other subjects) which must have been done at a date very close to that of the Urbino frescoes. Other paintings in the crypt of S. Lorenzo, both on the walls and in the vault, some of them in monochrome, are also connected with the work of the Salimbeni brothers. But the most important cycle they left is the one in the Oratory of S. Giovanni at Urbino (plates XIX–XXIII, 104–120). The fragmentary frescoes in a chapel of the old cathedral of San Severino (plates 101–103), in which both brothers had a hand, might date from a later period still. In any case, it is a late cycle, full of realistic touches. Finally, a fragmentary *Crucifixion* formerly in the apse of the church of S. Domenico at Cingoli[3] must also be included among the authentic works of the two brothers.

They have been credited with other works, which are not always of certain attribution, and which are of little help, therefore, in clarifying their personalities, formation, and cultural background. These include some important frescoes in the chapel of the Trinci Palace at Foligno, which is dominated by the work of Ottaviano Nelli.

The Urbino frescoes are not only the largest work undertaken by the brothers, but also the best preserved, and permit us to examine and evaluate their stylistic characteristics.

To Colasanti goes the credit for having tried to separate the brothers' artistic personalities, and for having obtained important results in this direction. Some later critics have asserted the impossibility of distinguishing between them, affirming that their work constituted an indivisible whole. According to Serra, "one notices not only a clearly unified concept, but uniformity in execution, colours, design, and figures as well, so that a division of the work between the two painters appears artificial". Rotondi, on the other hand, rightly went back to Colasanti's theory, developed it, took note of the stylistic and formal differences between the various parts of the cycle, and once more tried to make a distinction between the two brothers. In fact, Serra's assertion regarding the total unity of the frescoes is not very convincing, while the division suggested by van Marle, who attributed to Jacopo only the decorative and the least important parts and to Lorenzo the most important ones, is equally unacceptable.

It is not difficult to find stylistic differences in the Urbino cycle, which is signed by both brothers. A careful analysis and a comparative examination of the various elements—the quality of the colours, the way in which the human figure is felt and expressed—inevitably lead to the division of the whole, and to the identification of two hands at work. In a study dedicated to these frescoes I attempted something along these lines.[4] But the discovery of other paintings—such as the particularly significant one of the S. Ginesio frescoes—has led to the need for a reappraisal of the problem.

It is necessary, therefore, to take up the discussion where it was left off: "The votive paintings on the left wall, one of which represents *The Madonna and SS. John the Baptist and James*, and the other *The Virgin and SS. Sebastian and John the Baptist*, have generally been neglected (perhaps because of their bad state of preservation), and have always been held to be the work of Lorenzo. But a comparative examination of the two frescoes leads

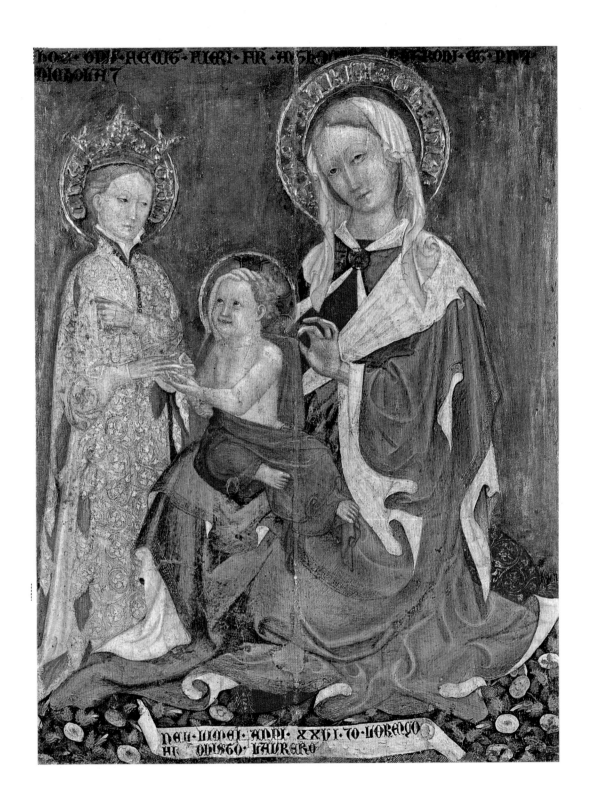

XVII. Lorenzo Salimbeni: *The Mystic Marriage of St. Catherine*. Detail from plate 98.
San Severino Marche, Pinacoteca Civica

to the, I would say obvious, conclusion that, whoever did one, could not have done the other, so great are the differences between them. One of the artists is so closely linked to the schools of northern Italy as to appear a 'friend' of Stefano da Verona. The whole of his painting is carried out at surface level, without the least attempt to create volume or depth; his delicate, refined, elegant style, based upon subtle linear rhythms, has produced an enchanted, abstract world, perfectly summed up in the gesture of the Virgin, whose hands—which seem to move in harmony with some musical rhythm—lift up the thin veil that covers the little, sleeping Child. The red and blue aureole—which is thrown into relief like a jewel by the circle of apostles, and surmounted by the Risen Christ—looks like an enlarged miniature in its attention to detail. The same may be said of the frieze along the upper border, where spiral motifs are woven around the figures of a number of prophets. Thick foliage, spreading out from two slender trunks, emerges from the dark background, and through the leaves peep little, golden angels, painted in the most refined, detailed, precious manner. It is a fitting representation of 'Paradise'.

"The other fresco is conceived very differently. The Madonna is no longer so dreamy and abstract. She sits upon a spacious throne surmounted by a tabernacle, the function of which is to convey the feeling of space. Moreover, there is an evident attempt at episodic narrative, and a wholly human gesture draws mother and child together. This tendency to look carefully and, I would say affectionately at reality, even at certain of its psychological aspects (as we see in the expression of the Madonna, whose lips are parted in a smile) reappears even more clearly in the figure of St. Sebastian, who stands on the left, this side of the step of the throne. (The Saints, the step of the throne, and the throne itself are placed on successive planes, and convey the impression of depth very well.) The figure of the martyr is vigorous and plastic. The artist has tried to give it both volume and humanity, and has succeeded in doing so by simplifying its form and almost shaping it with light and shade. The whole body is in a state of extreme tension, while the face assumes the aspect of a tragic mask, so vividly is the pain expressed."

The analysis of the two votive frescoes, so similar in subject, yet so different in execution, opens up the problem of establishing the differences in the personalities of their authors, since it is quite evident that the two works are inspired by quite different ideals. Mazzini (*Guida di Urbino*, Vicenza, 1962, pp. 61 ff.) insists on the stylistic discrepancies present throughout the Urbino cycle, thus making a further contribution to the final solution of the problem. Marchini's article of 1960, on the other hand, takes a step backwards. Nevertheless, reconsiderations are always useful, and the discovery of the S. Ginesio frescoes may really have set the problem in a new light, in the sense that certain details in the Miracles of St. Biagio are so vividly realistic and emotional as to resemble the fresco we attribute to Jacopo. The affinity between the two works might lead to the question being turned round, and to a revision of the view that would have Lorenzo as the originator of this burst of popular vitality. But, on closer examination, even the sorry remains of the San Ginesio frescoes reveal the presence of two artists at work. For the scene of the martyrdom of St. Stephen, for all its violence, does not attain to the grotesque, expressive, almost caricature-like mime found elsewhere in these frescoes, and the Saint, absorbed within himself, awaits death with devout and meditative serenity. A similar, morally analogous attitude might be found in the group of holy women at the foot of the Cross in the great *Crucifixion* of Urbino (plates XXI, 106). Hence what has been so amply explained above regarding the authorship of two painters, and the way in which the popular, instinctive Jacopo drew closer to the much more meditative art of Lorenzo, is equally valid here.

The *Crucifixion*, which is signed and is therefore the most authentic work we have by the two brothers, affords clear confirmation of their stylistic differences. It is vast and complex;

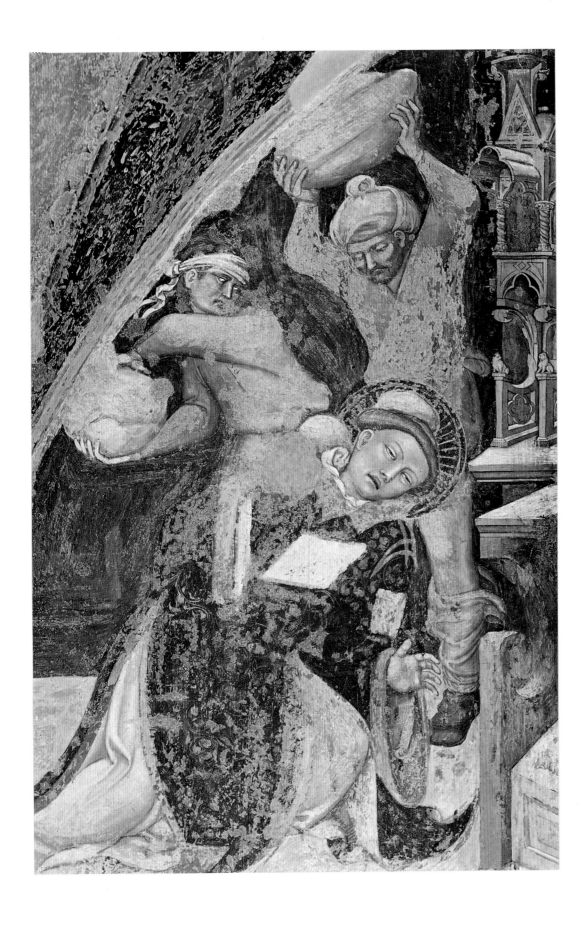

XVIII. Lorenzo Salimbeni: *The Martyrdom of St. Stephen*. Detail from plate 99.
San Ginesio, Crypt of the Collegiata

(plate 104); and, we might add, heterogeneous and digressive. But having said this, one must correct the negative implication of these words by pointing to the vital impact of the whole, and the expressive power of the various episodes.

It would be a mistake to say that the quality of the picture never varies, and one must acknowledge that, besides the differences in quality, there are differences of style. For example, the artist who painted the banal, meaningless heads behind the rocks beneath the central Cross could not have been the same as the one who conceived the stupendous figure of the soldier seen from behind, between the large heads of the two horses, one black, and the other white. Nor could the painter of the Centurion, with his gentle, thoughtful expression, worthy of Gentile, be the same man who succeeded in creating the screaming, mask-like visage of Mary Magdalen, whose long, braided tresses hang down to her waist. In brief, the stylistic contrast is too glaring to be overlooked. Grassi spoke, in analysing this fresco, of a language without syntax. I would prefer to say that one finds here two different languages, supported by two different syntaxes. And I am referring not only to the personalities of Jacopo and Lorenzo, but also to those assistants (for there may have been more than one) who must have helped the brothers to carry out so important a work.

Lorenzo must have done the upper part of the composition, with the mystical pelican, symbol of sacrifice, the flying angels, and the crucified Christ. From his hand also, must come the Virgin and the group of holy women about her, the Centurion, and other figures in the group on the right, though here he must have been helped by others. These parts have been painted in a refined, linear style which tends towards formal preciosity, and are stylistically similar to the first of the two votive frescoes discussed above, the *Madonna of Paradise*, which is undoubtedly the work of Lorenzo. Jacopo must have painted the two thieves, the group on the left, the figures of SS. Mary Magdalen and John the Evangelist, and that of the soldier at the foot of the Cross, as well as some of the armed men at the bottom on the right.

However much the brothers tried to unify their styles, as we shall see, their individual personalities continually rise to the surface, and can be seen in almost every part of the painting. Thus, for example, there is a striking similarity between the St. Sebastian of the votive fresco and the figures of SS. Mary Magdalen and John the Evangelist. I would go further and point to that between St. Sebastian and the good thief, both painted in the same manner, in a roundish form, as if carved out of a cylindrical trunk. And the bad thief too, ably conceived in all his bulky consistency, his body twisted and his feet crossed, hangs in a real space; it is his habitat. His whole structure is one of plasticity and strength, qualities lacking in the figure of Christ, which is painted in a wholly linear, Gothic manner, witness the thin, delicately painted loincloth, with its countless creases, fluttering in the wind.

Above the cross of the good thief, an angel collects his soul, which is represented as a little boy, holding it with a wholly maternal tenderness. On the other side, a devil with a terrifying face and phosphorescent eyes, a thin, feline body and pointed tail, leaps from the cross, out of the bad thief's body; held upside down between the devil's forked fingers, the thief's soul hides its down-turned face in its hands. The scene, which is very vivid, surprisingly effective, and full of character, is undoubtedly Jacopo's work. This can be seen in its movement, which reminds one of the little gesticulating figures in the frieze that decorates the upper part of the votive fresco attributed to Jacopo.

The influence of Giovanni da Modena, and of his great painting of Hell in the Bolognini chapel in particular, is fairly evident in this fresco. But one must add that it is a general one, and that our artist shows a freedom of interpretation and a search for movement that are absent from the paintings of San Petronio. These reveal a tendency to stiffen the figures, to arrest them in a terrifying, but abstract vision, in which the artist takes pleasure in resolv-

XIX. Lorenzo Salimbeni: *The Madonna of Paradise*. Urbino, Oratorio di San Giovanni

ing the single episodes in grotesque and sometimes caricature-like detail. Jacopo Salimbeni, on the other hand, seems to be striving for something else: his figures are animated, their gestures exasperated, inspired by a vision truly tragic and full of human content.

Jacopo's personality is again evident in the two spiral columns which frame the painting on both sides and which are covered with scenes painted *a sanguigna*, more like drawings than paintings. Here battle scenes alternate with single figures in the act of twisting themselves among the spirals, which are shown at different levels and in different perspectives. The horsemen, fighting, falling, dying, and their horses, sometimes pawing, at others rolling on the ground or charging into battle, have been done with extraordinary vividness, and by a precise, energetic hand. As good old De Sanctis would have said, a "universe" in itself. Moreover, it is surprising to find in 1416 such skill in the use of perspective, and such a constant, keen search for new forms of representation. When one thinks of the wholly marginal, secondary function of these columns, it is astonishing to think that the painter worked on them with such evident persistence, and with so much creative application.

Lorenzo's art, on the other hand, finds its best expression in the group of holy women, where that linear style, already referred to above in our discussion of the first of the two votive frescoes, reappears so delightfully. Here too, the artist makes use of the drapery, not to give substance to the figure, but to create a surface harmony, and the whole group, which is almost detached from the rest of the composition, forms a self-contained whole. Even the colours—here soft and tenuous and merging one into another, elsewhere harsher, more uniform and strongly contrasting—reflect the different personalities of the two brothers, and their different aims. For whereas Lorenzo uses them only to create subtle harmonies of a decorative purpose, Jacopo uses them to give volume and power to his compositions.

It is not possible to discuss in detail the various *Scenes from the Life of St. John the Baptist*, which occupy the right-hand wall (plates XXII, XXIII, 107–120). Here, there is a greater stylistic uniformity, and the two brothers' styles seem to combine into one. Some scenes—such as that of the *Baptism* (plate XXII)—are among the finest examples of the courtly Gothic.

I do not claim any finality for this attempt to distinguish between the artistic personalities of the Salimbeni brothers. The problem is complicated and requires further examination.

Nor, following in the wake of Colasanti and Rotondi, shall I take advantage of the opportunity to attribute the most beautiful, most "Gothic" parts of the paintings to Lorenzo, with the sole purpose of relegating Jacopo to the secondary role of a clumsy, uncouth executor of his brother's ideas. In fact, even if it is partly true that Jacopo's painting is "heavier in form and gloomier in colour", his touch is "rough and thick", his plasticity "violent and common", and his colours "gloomy, and strongly brought out by greasy, whitish brush-work", it is wrong to say (what might seem the logical conclusion of these remarks) that, compared to Lorenzo, Jacopo is tied to "less advanced, more archaic, one might say almost more fourteenth-century forms of art". On the other hand, after what has been said more than once above, one cannot go back on one's standpoint, far less accept the opinions of Venturi, van Marle, Serra, or Grassi, regarding Jacopo's lack of artistic personality.

Thus, there are two personalities, who are quite distinct. And one must add, in order to avoid misunderstandings, that Jacopo's personality is certainly more "modern" than that of his brother. His creative exuberance and search for movement reveal a temperament that is inclined to enquire and see for itself, even at the cost of appearing clumsy.

Of the two, Lorenzo was the only active follower of the "cosmopolitan" Gothic style. He became attached to that world in his youth and he never abandoned it. Apart from the influence exercised on him by northern Italian and perhaps by some transalpine paintings, he may also have been affected by the works of Sienese artists, of which there must certainly have been some examples in the Marches. Besides, it could not have been very difficult

**XX.** Jacopo Salimbeni: *Virgin and Child with Saints Sebastian and John Baptist.*
Urbino, Oratorio di San Giovanni

for an artist eager to know and see, to cross the Appenines above Fabriano and visit Assisi. Here, amongst other things, he could have seen the works of Simone Martini, whose influence was felt by all those artists, whether Italian or foreign, who were later grouped together as adherents of the International Gothic style. In other words, the problem of Lorenzo's formation must be studied alongside that of Gentile, without excluding the possibility that he may have been influenced by the latter. Jacopo, on the other hand, must have received quite a different education, for he appears to have been interested, not so much in the linear refinements of the Gothic style, as in more expressive, more dramatic art forms, such as he might have seen anywhere in the Marches, in the works of Riminese, Bolognese, or even Fabrianese artists. Indeed at Tolentino, only a few kilometres from San Severino, Marchigian painting of Riminese derivation had, fifty years earlier, left one of its masterpieces, which was certainly not unknown to the Salimbeni. Nor must we exclude the possibility, or rather forget the fact, that Jacopo went to Bologna, since there is an evident connection between the frescoes at Urbino and those of San Petronio, a connection, however, that is in my opinion more iconographic than stylistic. In Jacopo, there is the desire to see into reality, into the human spirit, a desire to capture life and the essence of things. There is something in him, therefore, that distinguishes him from his brother, and which almost isolates him in the art of his time.

Unfortunately criticism regarding both brothers, not only Jacopo, has been lacking in balance. Their painting has been called provincial, that is, of marginal importance or imitative. But was Jacopo "provincial"? To affirm this one would have to show that he was a late-comer, drifting along in the artistic currents of his day. Instead, he precedes both Pisanello and Masolino, while he was approximately contemporary with Gentile. He even comes before the author of the Treviso frescoes, that "Master of the Innocents" whom Coletti first connected with the Salimbeni, whereas he followed in their footsteps. They also preceded the still mysterious painter of the little panels representing *Scenes from the Life of St. Benedict*, even if we accept the theory advanced by Degenhart that they are an early work of Pisanello's. Finally, one might well wonder about the degree of indebtedness to the Salimbeni, and to Lorenzo in particular, of those perhaps over-estimated painters, Alberti da Ferrara and Ottaviano Nelli, both of whom were aware of the work the brothers had done at Urbino.[5]

One must admit that, in spite of the many concessions he made to a style from which no artist before Masaccio either could or wanted to free himself, Lorenzo is a very individual and vital painter. Some of his figures, such as the Centurion in the *Crucifixion*, or the young man with beautiful fair hair and a tilted hat, who appears behind the bushes in the *Sermon of St. John the Baptist* (plate 115), are really worthy of Gentile himself. He was obviously influenced by Gentile, and may even have worked with him. One must also admit that the stupendous group in the foreground of the *Crucifixion*, with the prostrate Madonna in the centre (plate XXI), is a work of the highest quality, a pure figurative invention. And when one considers the sustained excellence of his works, one must conclude that Lorenzo was no minor artist, but one of the most significant, and, I would even go so far as to say, leading, figures in the "cosmopolitan" phase of Italian Gothic, since he was active just when this tendency was about to produce its finest fruits. That Lorenzo was affected by various influences, beginning with that of Gentile, is another matter. This is a problem common to many artists of the time, and is part of that vast and, in my opinion, still unresolved question regarding their formation.

As for Jacopo, I think I have expressed myself fairly clearly. He was no willing follower of the "cosmopolitan" current, and went his own way. One wonders what would have happened to him if, instead of following the road from San Severino to Urbino, and perhaps

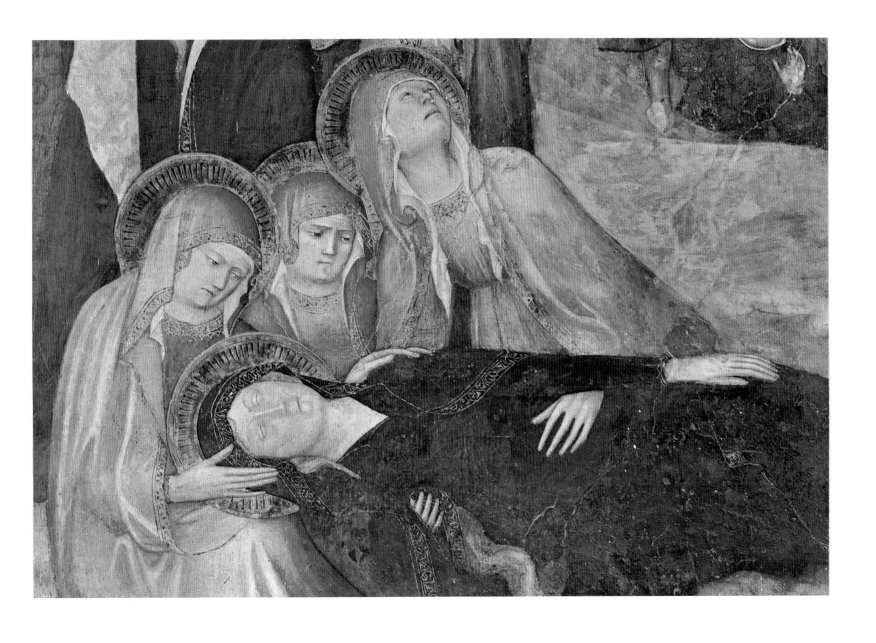

XXI. Lorenzo and Jacopo Salimbeni: *The Virgin and the Holy Women*. Detail from plate 104. Urbino, Oratorio di San Giovanni

to Fermo, he had found himself, not much later than 1416 (about 1424 or 1425), in Florence, and had climbed the scaffolding in the Brancacci chapel. The answer is not an easy one. But I think he would have been far more interested in the rough figures of Masaccio, than in the tame, gentle ones of Masolino.[6]

## Catalogue of works
[*see plates XVII–XXIII, 98–120*].

Cingoli, Church of S. Domenico (formerly), *Crucifixion* (fragment of fresco now on view in the little church of S. Nicolò).

Fermo, Oratory of St. Monica, *Frescoes*.

Foligno, Trinci Palace, *Frescoes* (?).

Perugia, National Gallery, *Crucifixion*.

S. Ginesio (Macerata), Collegiate Church, Oratory of St. Blaise in the crypt, fragmentary frescoes: *Madonna and Child, SS. Stephen and Genesius; Scenes from the Life of St. Blaise and other decorations* (signed and dated 1406).

San Severino (Marches), Pinacoteca, *Triptych with the Mystic Marriage of St. Catherine, SS. Simeon and Thaddeus* (signed and dated 1400).

San Severino (Marches), Pinacoteca, *St. Lucy* (fresco detached from the church of S. Lorenzo in Doliolo).

San Severino (Marches), Pinacoteca, *Heads of a Child and a young Woman* (fragments of frescoes from Colleluce).

San Severino (Marches), Pinacoteca, *Madonna and Child Enthroned and two Angels* (fresco detached from the church of S. Maria della Pieve).

San Severino (Marches), Church of S. Lorenzo in Doliolo, Sacristy, Frescoes in the lunette: *Crucifixion with SS. Lawrence, Bernard and others*.

San Severino (Marches), Church of S. Lorenzo in Doliolo, Crypt, *Frescoes: Scenes from the Life of St. Andrew*, in monochrome.

San Severino (Marches), Church of S. Maria del Mercato (S. Domenico), the Choir Chapel, fragmentary frescoes: *Madonna and Child with Donor and other fragmentary subjects*.

San Severino (Marches), Church of S. Maria della Misericordia, *Christ Blessing, half-figures of Prophets* (signed and dated 1404).

San Severino (Marches), Old Cathedral, first chapel on the left, *Frescoes with Scenes from the Life of St. John the Evangelist* (fragmentary, signed by Lorenzo and Jacopo).

Urbino, Oratory of St. John Baptist, *Madonna and Child* (*Madonna of Paradise*), *Madonna and Child with SS. Sebastian and John the Baptist; Crucifixion; Scenes from the Life of St. John the Baptist* (frescoes signed and dated by Jacopo and Lorenzo, 1416).

### Lorenzo d'Alessandro

Lorenzo d'Alessandro—also called the younger, to distinguish him from Lorenzo Salimbeni, his fellow townsman, but no relation—is documented from 1462 until his death in 1503. Little is known about him. In 1468 he was involved in a lawsuit together with his father, also called Lorenzo, and his brother Andrea. Other documents refer to commissions, payments, and public offices, and seem to imply that he worked almost exclusively in his home town and in the vicinity. It seems, therefore, that he never left the Marches, and that his career as a painter began in the region itself. Although he did not follow the various currents of the International Gothic movement, which were so fashionable, indeed almost predominant in his own town, one must not rule out the possibility that something of this artistic tradition did remain in him, as in the case of his other fellow townsman, Ludovico Urbani, who was probably about the same age. In fact, the frescoes in the Palazzolo chapel at Pergola (the farthest place from San Severino where Lorenzo's works are to be found) seem to be inspired by a style of painting similar to that of Ludovico's. These frescoes, in which it is not difficult to find traces of late Gothic art, have been rightly attributed to Lorenzo by Lionello Venturi. In fact, the wide sweep of the rumpled drapery, the almost affected elegance of certain figures, and the absence of any real adherence to the principles of Renaissance painting, all point to a style that finds its immediate, genuine antecedents in the art of the Salimbeni brothers. Perhaps the right approach is to say that the Pergola frescoes (though not all of them, since those on the right-hand wall representing the

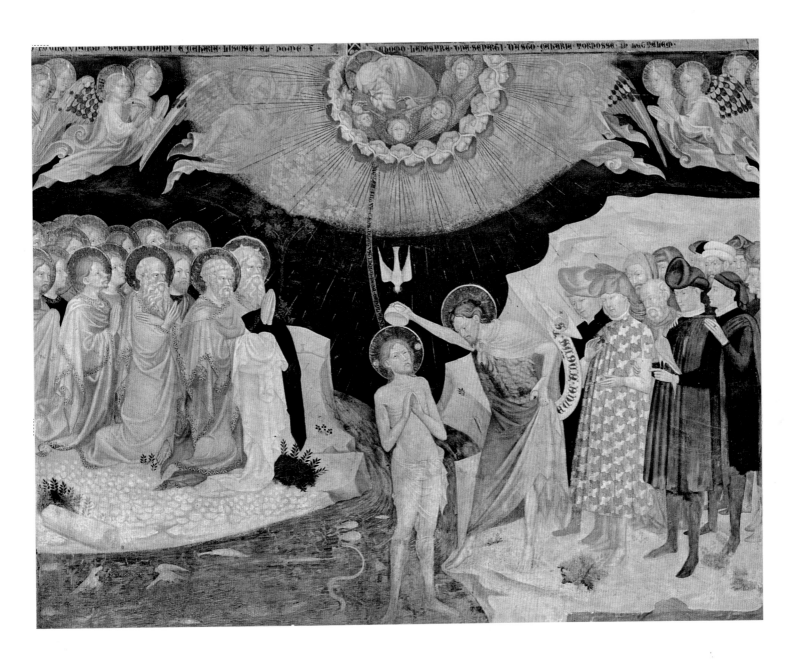

XXII. Lorenzo and Jacopo Salimbeni: *The Baptism of Christ*. Urbino, Oratorio di San Giovanni

*Annunciation*, the *Trinity*, and the *Madonna and Child* are the work of a different painter, and certainly connected with the art of Bernardino di Mariotto) represent a rather early period in Lorenzo's career, and at the same time, one of the best.

The large fresco of the *Ascension* (plates 130–131) is dominated by the elongated figure of Christ in the act of ascending from the earth, between a number of troubled, praying saints. In the sky, prophets hold long, flowing scrolls, which flutter like the clothes of the Redeemer, and contribute to the movement of the whole scene. To the right and left stand the elegant, detached figures of SS. Agapitus and Secundus, which have been rightly compared to SS. Roch and Sebastian in Lorenzo's panel of *St. Anne* in the Museo Piersanti, Matelica.

This fresco perhaps is the most individual work of the artist's, who expresses himself in cold, liquid, shadowless colours. Venturi was wrong in dating the Pergola frescoes from 1485–1495; they must have been carried out prior to the first dated works, to the Corridonia triptych, where the influence of Antonio da Fabriano is apparent, and in which we can already find traces of that of Niccolò Alunno, to whom Lorenzo became increasingly servile with the passing of time. I would also be tempted to attribute to the period of Lorenzo's youth the very beautiful figures of the Angel Gabriel and the Virgin in the *Annunciation* in the apse of the little church of S. Maria delle Macchie near Castel Raimondo. This is suggested by the sweeping movement of the drapery and the refined elegance of the whole, a suggestion I find more and more convincing. Recently, the two frescoes have been detached and restored, and published as being of uncertain attribution (*Exhibition of restored works of art*, Urbino, 1969 pp. 44 et seq.). But their attribution to Lorenzo d'Alessandro is still valid, even if the restoration has revealed that the figure of the Madonna, the architectural background and certain still life elements, such as the books on the lectern, are clearly of Renaissance inspiration. We have already seen how easily different styles can co-exist in the works of the painters of the Marches.

However, there is no doubt that towards 1480, or perhaps earlier, Lorenzo d'Alessandro came under the influence of Crivelli, and later, of Niccolò Alunno. These two artists are the sources upon which he came to rely more and more as the years went by, though his more relaxed, sometimes affectedly gentle painting, served to mitigate the precious, austere material Crivelli and Alunno provided. This is what happened in the frescoes of 1483 in the church of S. Maria di Piazza at Sarnano (plate 134), where the treatment of the figures is still that applied in the polyptychs, inspired that is, by a certain immobility and a forced restraint, which are in such contrast with the early impetus of the Pergola frescoes. The *Baptism of Christ* (plate XXV) was attributed to him by Berenson, who added that it was a copy of a lost original by Giovanni Bellini. It is certainly not impossible that Lorenzo was influenced by the Paduan school I would say, rather than Venetian; the figure of St. John the Baptist recalls the same saint in the fresco of S. Maria di Piazza at Sarnano. And besides the decisive influence exercised on him by Crivelli, there are also traces of Vivarini in his works.

As frequently happened with painters from the Marches, Lorenzo later gave way to an archaic style, as if he were incapable of adapting himself to the requirements of the new art. This is shown by his *St. Anthony of Padua* at Pollenza, which he signed in 1496, and which even at that late date is still painted as if it were part of a polyptych.[7]

Catalogue of works
[*see plates XXV*, 130–134].

Baltimore, Walters Art Gallery, *Processional Banner: Crucifixion; St. Michael adored by Members of Confraternity.*
Caldarola (Macerata), Collegiate Church of S. Maria del Monte, *Madonna and Child with Saints;* below: *Two Gentlemen in Adoration, Members of the Confraternity, and a model of Casarola Castle* (signed, dated 1491).

XXIII. Lorenzo and Jacopo Salimbeni: *St. John Baptist and King Herod*.
Detail from plate 120. Urbino, Oratorio di San Giovanni

Cleveland, Museum of Art, *Madonna and Child Enthroned with SS. Anthony Abbot, Sebastian, Mark, and Severinus.*

Corridonia (Macerata), Church of SS. Pietro e Paolo (Gallery adjoining the presbytery), *Triptych: Madonna and Child, St. John the Baptist, St. Mary Magdalen;* below: *Dead Christ between two Saints* (signed, dated 1481).

Dijon, Musée des Beaux-Arts, *Panels of a polyptych: St. Bernard, St. Agatha.*

Florence, Uffizi, *Pietà* (lunette of a polyptych).

Gagliole (Macerata), Shrine in the district of Cerqueta, *Madonna and sleeping Child;* on the sides: *SS. Anthony Abbot and Sebastian* (these frescoes have been removed and are kept temporarily in the Ducal Palace of Urbino).

Le Havre, Museum, *Panels of a polyptych: St. Francis and St. Clare* (connected with those of Dijon).

London, National Gallery, *Mystic Marriage of St. Catherine, St. Augustine and Donor* (signed).

Matelica, Piersanti Museum, *The Virgin, St. Anne, St. Sebastian and St. Roch;* above: *Dead Christ between St. Michael and St. Dominic.*

Pergola (Pesaro), Palazzo Chapel, *Ascension with figures of Prophets in the sky and Apostles,* below; on the sides, *St. Agapitus and St. Secundus* (frescoes).

Pollenza (Macerata), Church of SS. Francesco e Antonio, *St. Anthony of Padua praying to the Virgin;* below, *Kneeling Members of the Confraternity* (signed and dated 1496).

Rome, Boris Cristoff Coll., *Pietà.*

Rome, National Gallery, Palazzo Barberini, *Madonna and Child adored by SS. Francis and Sebastian, and two Putti.*

Rome, Vatican Gallery, *Fragment of fresco with Madonna and St. Anne.*

San Severino (Marches), Pinacoteca, *Madonna and Child with Angels, St. John the Baptist and St. Severinus.*

San Severino (Marches), Church of S. Lorenzo in Doliolo, Apse, to the left, *Nativity with Donor;* above: *Madonna and Child.*

San Severino, La Maestà district, Votive Fresco: *Madonna and St. Sebastian adoring Child; St. Sebastian; Madonna and Child with St. Anne; Crucifixion; Madonna and Child.*

Sarnano (Macerata), Church of S. Maria di Piazza, wall to the right, frescoed altar: *Madonna adoring Child with music-making Angels; St. John the Baptist and Donor; Bishop Saint; the Eternal; Annunciation; SS. Sebastian and Roch* (signed and dated 1483).

Serrapetrona (Macerata), Parish Church, *Polyptych: Madonna and Child, SS. Sebastian, Francis, Peter, James;* in the upper part: *Dead Christ between Angels and SS. Bonaventure, John the Baptist, Michael and Catherine;* predella: the *Apostles and other Saints* (1494).

Treia (Macerata), Georgica Academy, *Madonna and Child.*

Urbino, National Gallery, *Christ baptized by St. John.*

Zagreb, Strossmayer Gallery, *Christ between SS. Peter and Paul and the ten Apostles* (predella of a polyptych).

Location Unknown: *Madonna and Child.*

## Ludovico Urbani

The first record of this painter, who belongs to the school of San Severino where he was born, goes back to 1460. His recorded activity took place within an area comprising San Severino, Recanati, where he worked most of all, Macerata and Potenza Picena. Our information regarding him goes as far as 1493. Only two of his signed works still exist: a triptych (plates 126, 127) formerly in the cathedral of Recanati, but now in the little Diocesan Museum of the same city, and which according to Giannuzzi dates from 1477, and the *Madonna* of 1480, formerly in the Klushnsky Collection. The catalogue of his works is very short. Besides those already mentioned, there is a delightful predella in the Vatican Gallery representing the *Adoration of the Magi;* a *Madonna* in the Campana Collection, formerly at Nevers and now in the Louvre (plate 129), which is the centre of a triptych, the side panels of which are in the cathedral of Recanati; a *Madonna and Child* in a Roman collection; and finally, a number of frescoes in the Museum of the Roman Forum, attributed to him by Zeri (1948), who dates them from about 1470. It is to Zeri, who followed up the researches of Serra, that we owe the critical reconstruction of this painter's artistic personality, which until recently, has remained very much in the background. Yet he is a notable representative of that current in the painting of the Marches, which swings from local tendencies to Umbrian art, and from Umbrian art to the influence of Crivelli.

The works of Ludovico's youth follow the florid Gothic art of Lorenzo Salimbeni and Cristoforo di Giovanni. Later, they reveal the Umbrian influence of Matteo da Gualdo and Niccolò Alunno, as Serra was the first to see, and Zeri later confirmed. The influence of

XXIV. Ludovico Urbani: *The Martyrdom of St. Sebastian*. Detail from plate 126. Recanati, Museo Diocesano

Carlo Crivelli and Niccolò Alunno, together with the exchange of ideas that took place between the two, had a profound bearing on the contemporary painting of the Marches, particularly in the area between San Severino and Camerino. Zeri, discussing the frescoes in the ex-convent of S. Francesca Romana close by the Forum, had pointed out how the figure of Christ imparting His blessing is a direct derivation from earlier works by Lorenzo and Jacopo Salimbeni. Again it was Zeri who, besides indicating other indirect influences exercised by the very early fifteenth-century painting of San Severino, also points to the relations with Matteo da Gualdo, and to a certain affinity with the art of Niccolò Alunno, who came to the region "in the sixth or seventh decade of the fifteenth century. That is, in this *Crucifixion* (one of the frescoes in the ex-convent of S. Francesca Romana) we find ourselves halfway between the last followers of the Salimbeni (such as Cristoforo di Giovanni, whom the drapery of St. John Evangelist does in fact recall), and that generation of Marchigian painters, for whom the arrival of both Gozzoli and Carlo Crivelli was not to be without significance" (1948). Zeri comes to the conclusion that these frescoes, which he attributes to Ludovico Urbani, were carried out about 1470. Later, the artist was clearly influenced not only by Crivelli, but also by Giovanni Angelo da Camerino, whose *Baptist* in the Apostolic Palace of Loreto is connected with the ex-Klushnsky panel, which, in its turn, is connected with the *Crucifixion* of the Cini Foundation. It is interesting to note that Longhi also attributes this work to Ludovico Urbani. Thus, the figure of the painter has gradually been made clearer, and the number of works attributed to him increased. Zeri has also credited him with two panels representing *SS. Sebastian and Catherine of Alexandria*, and *SS. John the Baptist and Romuald* (plate 128) in the sacristy of the church of S. Teresa at Matelica, part of a polyptych the pinnacle of which, the *Crucifixion*, is at Colmar.

Berenson, too (ed. 1968), emphasizes the influence of Matteo da Gualdo and Lorenzo d'Alessandro. However, it is quite clear that the artist in his more mature years drew closer to Crivelli. In the predella of the Recanati panel, we find him trying to attain to Crivelli's rhythm, that is, to the very essence of his art, instead of falling back on a weak imitation of his incomparable *Madonnas*. Berenson further attributes the frescoes in S. Francesca Romana, which Zeri attributes to our painter, to Antonio da Viterbo the Elder.[8]

### Catalogue of works
[*see plates XIV*, 126–129].

Colmar, Musée d'Unterlinden, *Crucifixion* (pinnacle of the Matelica polyptych).

Matelica, Church of St. Theresa, Sacristy, two panels of a polyptych, *SS. Sebastian and Catherine; SS. John the Baptist and Romuald*.

Paris, Louvre (Campana Coll.), central panel of a polyptych, *Madonna and Child with Angels in Adoration* (the lateral panels are at Recanati, Diocesan Museum).

Recanati, Church of S. Maria di Castelnuovo, *Madonna and Child Enthroned with SS. Anthony Abbot and Nicholas of Bari* (signed and dated 1480).

Recanati, Diocesan Museum, *Triptych: Madonna and Child, Angels, SS. Benedict and Sebastian; Six Saints in frame;* in the lunettes: *Dead Christ and Annunciation;* predella: *four Saints and three Episodes in the Life of St. Sebastian* (signed and dated 1474).

Recanati, Diocesan Museum, *Praying Saint and St. Francis receiving the Stigmata* (side panels of the polyptych whose central part is in the Louvre).

Rome, Vatican Gallery, *Predella: Adoration of the Magi.*

Location Unknown: *Assumption of St. Mary Magdalen with four Angels* (?); *Madonna and Child.*

### NOTES

1. There is no doubt as to the accuracy of this date. The exact words of the inscription are: "In my twenty-sixth year. I, Lorenzo, did this work in the year of the Lord MCCC—in January". Therefore, it is difficult

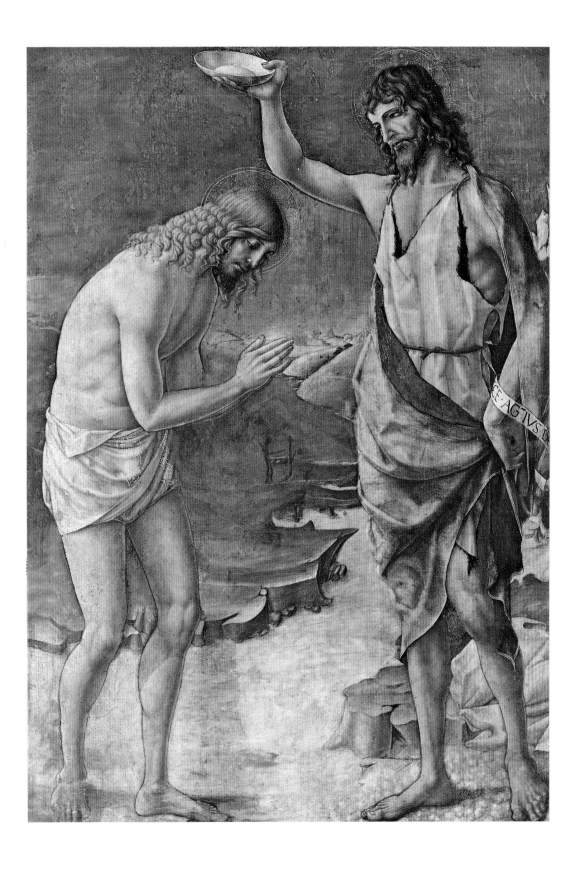

XXV. Lorenzo d'Alessandro: *The Baptism of Christ*. Urbino, Galleria Nazionale

to understand why certain modern critics (influenced by Lanzi perhaps, who said that Salimbeni was still alive in 1470?) persist in regarding the inscribed date as mutilated. It is perfectly complete. For this subject, see P. Zampetti, *Gli affreschi di L. e J. Salimbeni nell'Oratorio di S. Giovanni in Urbino*, 1956, from which I have taken the quotations that follow.

2. Longhi has thrown much light on the figure of Zanino di Pietro, whom he sees as an artst who painted under the influence of the school of Cologne. Consequently, he believes that the artist's presence in the Marches may partly explain the ultramontane or Rhenish character of the works of the San Severino painters. It should be added that this ultramontane quality, which is noticeable above all in Lorenzo's triptych of 1400, gradually disappeared. It might also have derived from the knowledge of certain northern miniatures, which the artist might have seen. As far as Zanino di Pietro is concerned, there are no exact dates to confirm the influence he is claimed to have exercised on the painters of San Severino, which remains an open question.

3. For the frescoes of San Ginesio, see G. Marchini, *Lorenzo Salimbeni*, 1406 in "Commentari", 1966, pp. 282 *et seq*. The article is of considerable interest, and the discovery serves to clarify the problems connected with the artistic personality of the artist. However, it begins strangely, with the following words: "There is a fair amount of literature dealing with the subject of Salimbeni from San Severino, some of which goes back to distant times, while books dealing with the subject have appeared in greater numbers in the last few decades. But the critically useful part of these works does not take us very far." Apart from the fact that the author does not explain how far they lead us, his statement is extremely pessimistic when we consider how much has been done since the days of Colasanti, in the period 1910–66. One has only to mention Longhi's fundamental contributions, and my own attempt to reconstruct the artistic personalities of the two brothers, to which Marchini makes no reference at all. For the fresco of S. Domenico di Cingoli, see P. Zampetti, *Antichi dipinti restaurati*, Urbino, 1953, pp. 23, 24.

4. Indeed, after this attempt, Anna Gherardini tried to take up the question again in 1958, in an article on the Salimbeni brothers which appeared in two successive parts in "Arte". This scholar does not seem to have read my work; instead, she mentions (p. 127) a certain "summer course" of mine, though it is not clear from the context where or when this took place. In any case, that "summer" smacks a little too much of holidays and (why not?) pleasant hours at the seaside. In fact, I gave a series of lectures on the Salimbeni's Urbino frescoes at the Facoltà di Magistero of the University of Urbino in the academic year 1955–56. This resulted in the book that came out in 1956, published by the Istituto del Libro of Urbino, a work neither quoted nor included in the bibliography that follows the above-mentioned scholar's article. In Marchini's article ("Commentari", 1966), the little Urbino book is also completely ignored. I would have thought that it would have been more opportune, for the purpose of clarifying the problem, to have disproved rather than to ignore. For though the book has thus been avoided, it is by no means excluded. Previously, that is after Colasanti's acute observations (1910), Serra's work (1934) marked a pause in the critical study of the subject, while Rotondi broke new ground by connecting, though not in an altogether satifactory manner, the Salimbeni brothers with the frescoes in the Oratory of S. Monica at Fermo (*Studi e ricerche attorno a Lorenzo e Jacopo Salimbeni da Sanseverino, Pietro da Montepulciano e Giacomo da Recanati*, Fabriano, 1936). In fact, these frescoes are still an enigma, made all the more mysterious by their very bad condition. And yet they are precious paintings of a high quality: and they deserve to be saved.

5. As for Ottaviano Nelli, the discovery and study of the frescoes in the apse of the church of S. Francesco at Gubbio, which apparently date from 1403, have once more raised the problem of his connections with the Salimbeni brothers and with Gentile too. However, it seems that he is more closely related, at the beginning of the century, with Lorenzo himself: we can see this in the San Severino tabernacle (1400) and in the frescoes of 1404, now in the Municipal Gallery. The Umbro-Marchigian courtly amalgam is evident, and must be studied closely in its origin, development, and in the way it devolved from a local factor to one of European dimensions. For the Gubbio frescoes, see F. Santi, *Un capolavoro giovanile di Ottaviano Nelli* in "Quaderno di Arte Antica e Moderna", Bologna, 1961.

6. Except for the information given by Amico Ricci and their signed or dated works, there is no documentary evidence at all regarding the work of the two brothers. Consequently, the information available covers the period from the triptych in the Gallery of San Severino (January 1400) to the Urbino frescoes (July 1416). No serious enquiry has yet been made into the influence exercised by the Salimbeni in the central-southern parts of Italy. Marchini makes some mention of it. However, the enquiry should be extended to cover the Apulian seaboard (not only Naples, as Marchini does). The fragmentary, by now almost undecipherable Gothic frescoes I have seen in some of the cathedrals of Apulia (on the inside of the façade of the cathedral of Otranto, for example) seem to be closely connected with the style of the San Severino painters.
The list of works that follows is, of course, only an attempt to gather together the corpus of the brothers' works. The catalogue will have to be revised to include other paintings, which are either still undiscovered, or of uncertain attribution.

7. The documents regarding Lorenzo d'Alessandro have been partly published by Amico Ricci (1834, I, pp. 193–95, 202, notes 47, 48 and 204, following note 48). See also Ricci, Pt. II, note 2 on p. 120. But the most important research in the archives has been done by V. E. Aleandri, *Note e correzioni al commentario di Maestro Lorenzo pittore severinate* in "Nuova Rivista Misena", Arcevia, 1894, p. 172; ib., *Il Primo maestro del pittore Lorenzo d'Alessandro da Sanseverino* in "Arte e Storia", 1920, pp. 17–22. The most important works on the artist are those of L. Venturi (1915), A. Colasanti (1917), B. Berenson (1932), R. Marle, XV, 1934, L. Serra, II, 1934. See also Zampetti, *Lorenzo d'Alessandro* in "Crivelli e i Crivelleschi", Exhibition Catalogue, Venice, 1961.

8. On Ludovico Urbani, the following works may be consulted: A. Ricci, 1834, I, pp. 221–22; V. E. Aleandri, XIII, 1894, pp. 153–57; Cavalcaselle–Morelli, 1861–1896, II, pp. 327–28; V. E. Aleandri, XXXIX, 1920, pp. 17–22; L. Serra, 1934, pp. 406–7; R. van Marle, XV, 1934, p. 183; F. Zeri, 1948, pp. 167–69; id., 1961, pp. 20, 43, 44, 52, 53.

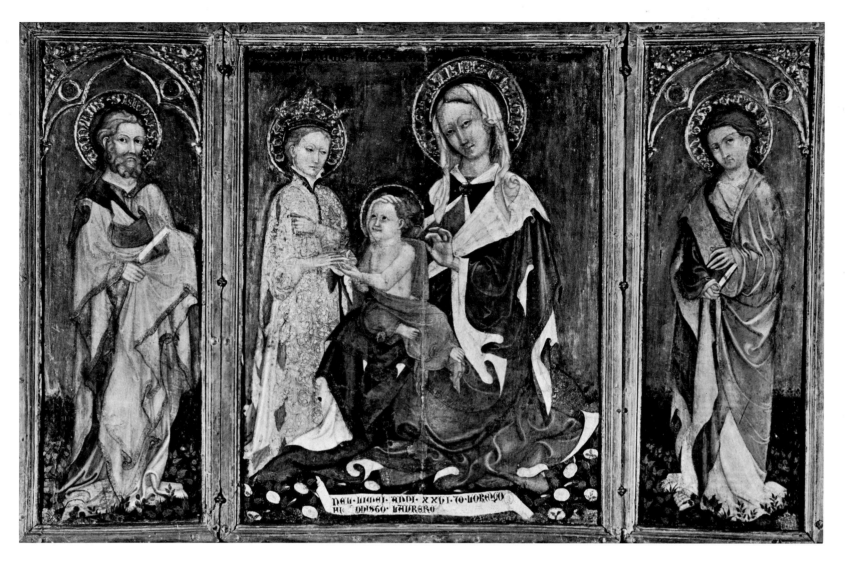

98. Lorenzo Salimbeni: *Triptych: Virgin and Child with Saints.* San Severino Marche, Pinacoteca Civica.

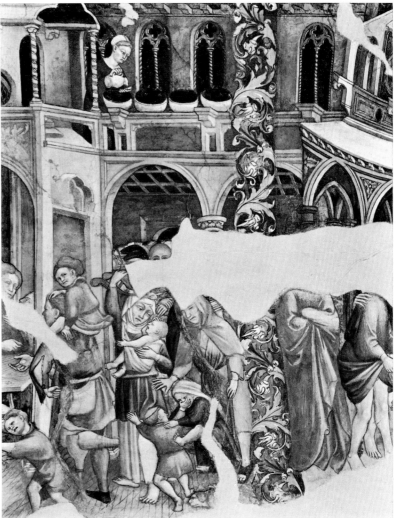

99-100. Lorenzo Salimbeni: *Virgin and Child with Saints*. San Ginesio, Crypt of the Collegiata.

101-103. Lorenzo and Jacopo Salimbeni: *Scenes from the life of Saint John Evangelist*. San Severino Marche, Duomo Vecchio.

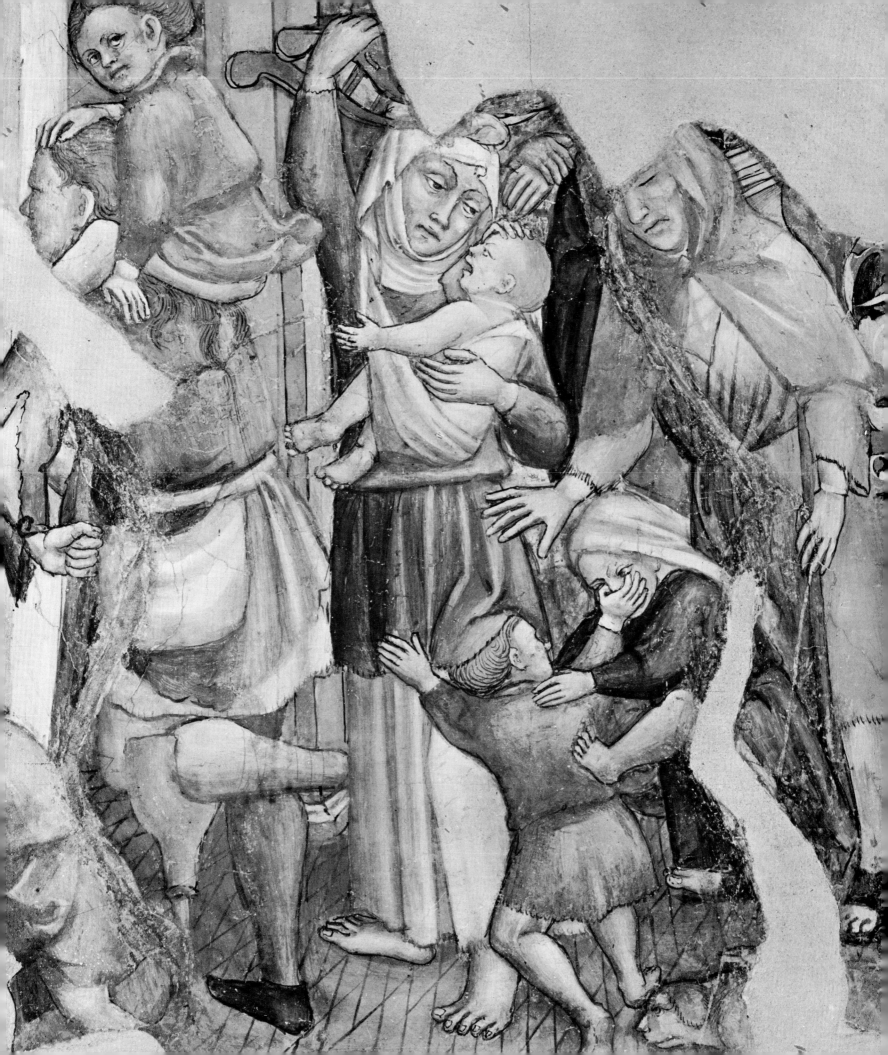

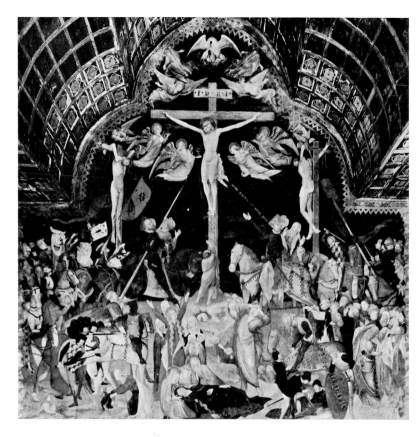

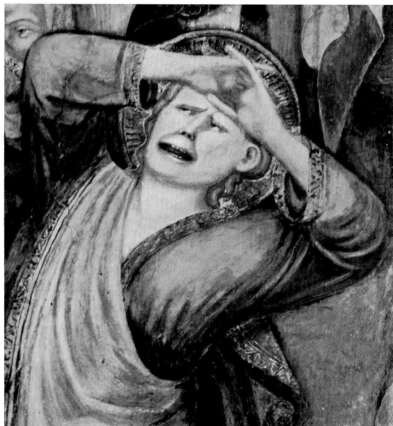

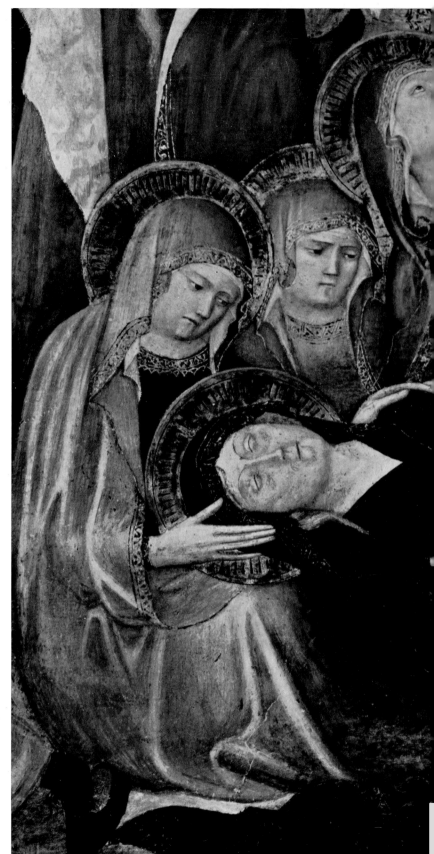

104-106. Lorenzo and Jacopo Salimbeni: *The Crucifixion*. Urbino, Oratorio di San Giovanni.

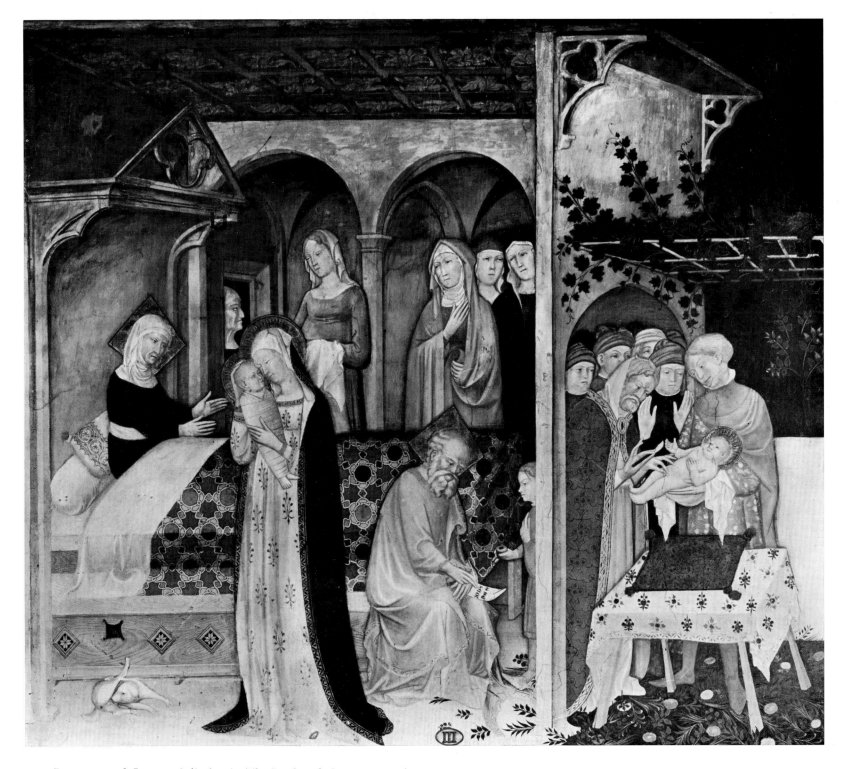

107. Lorenzo and Jacopo Salimbeni: *The Birth and Circumcision of Saint John Baptist*. Urbino, Oratorio di San Giovanni.

108. Detail from plate 107.

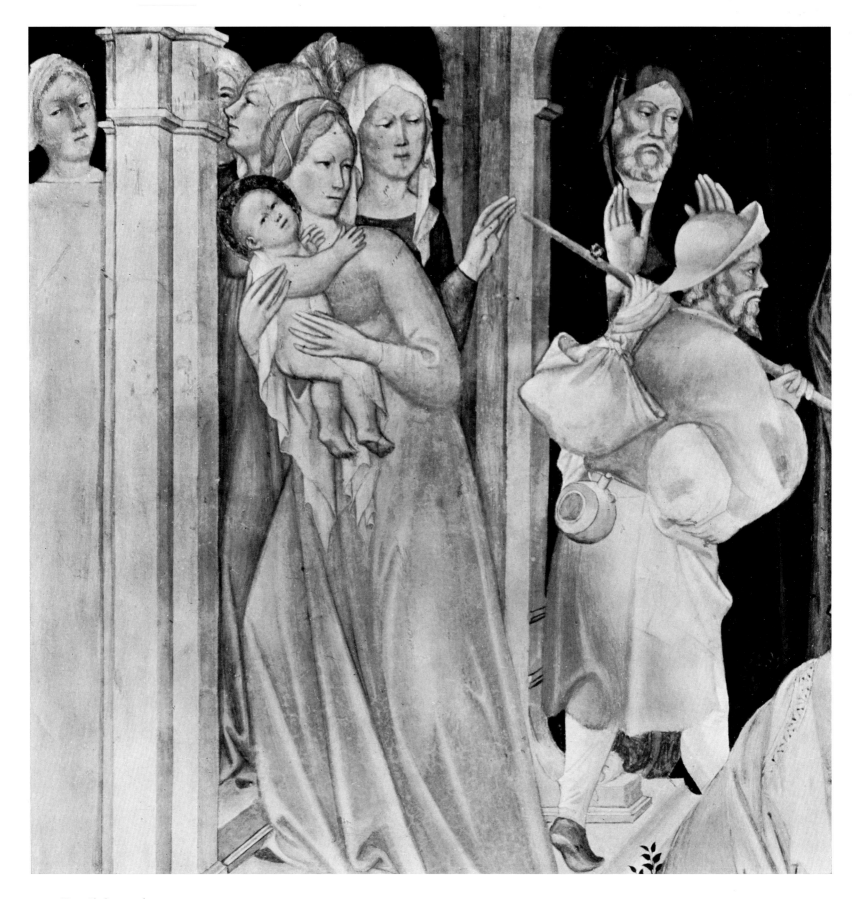

109. Detail from plate 111.

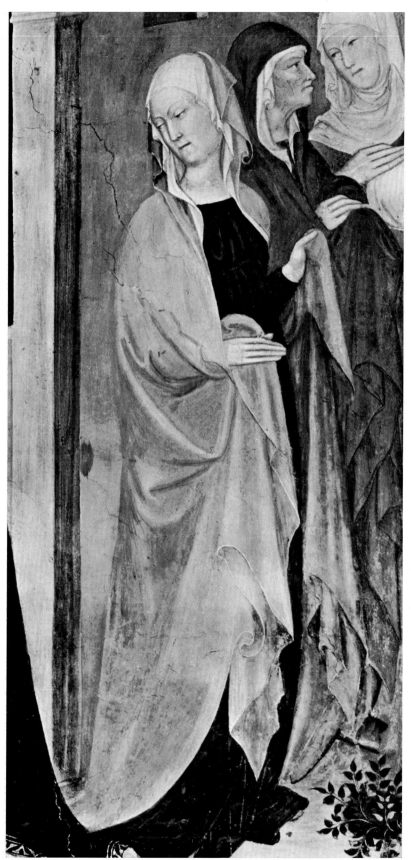

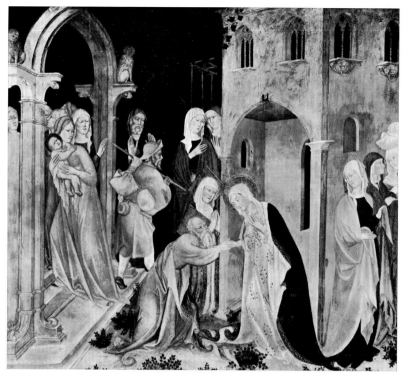

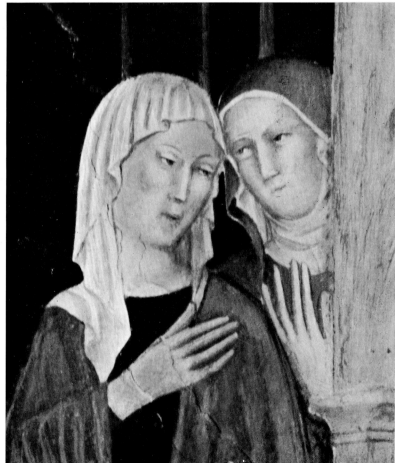

110-112. Lorenzo and Jacopo Salimbeni: *The Virgin leaving the house of Zacharias and Elizabeth*. Urbino, Oratorio di San Giovanni.

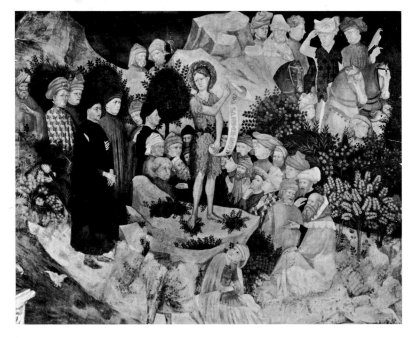

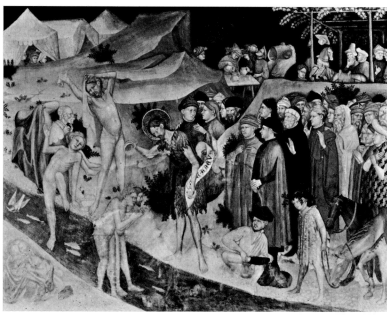

113, 115. Lorenzo and Jacopo Salimbeni: *Saint John the Baptist preaching*. Urbino, Oratorio di San Giovanni.

114, 116. Lorenzo and Jacopo Salimbeni: *Saint John baptizing neophytes*. Urbino, Oratorio di San Giovanni.

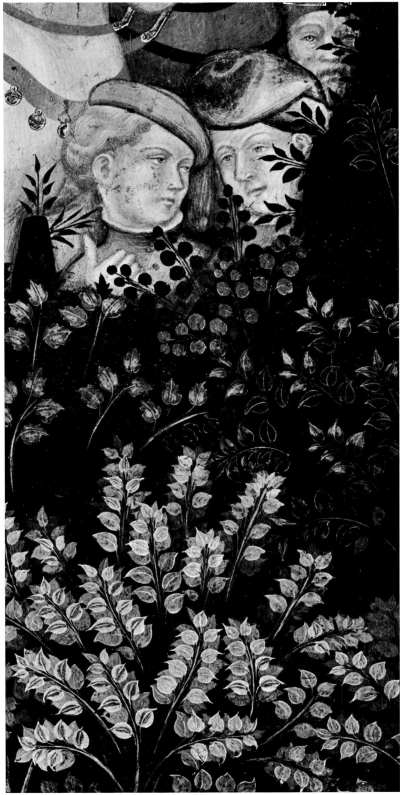

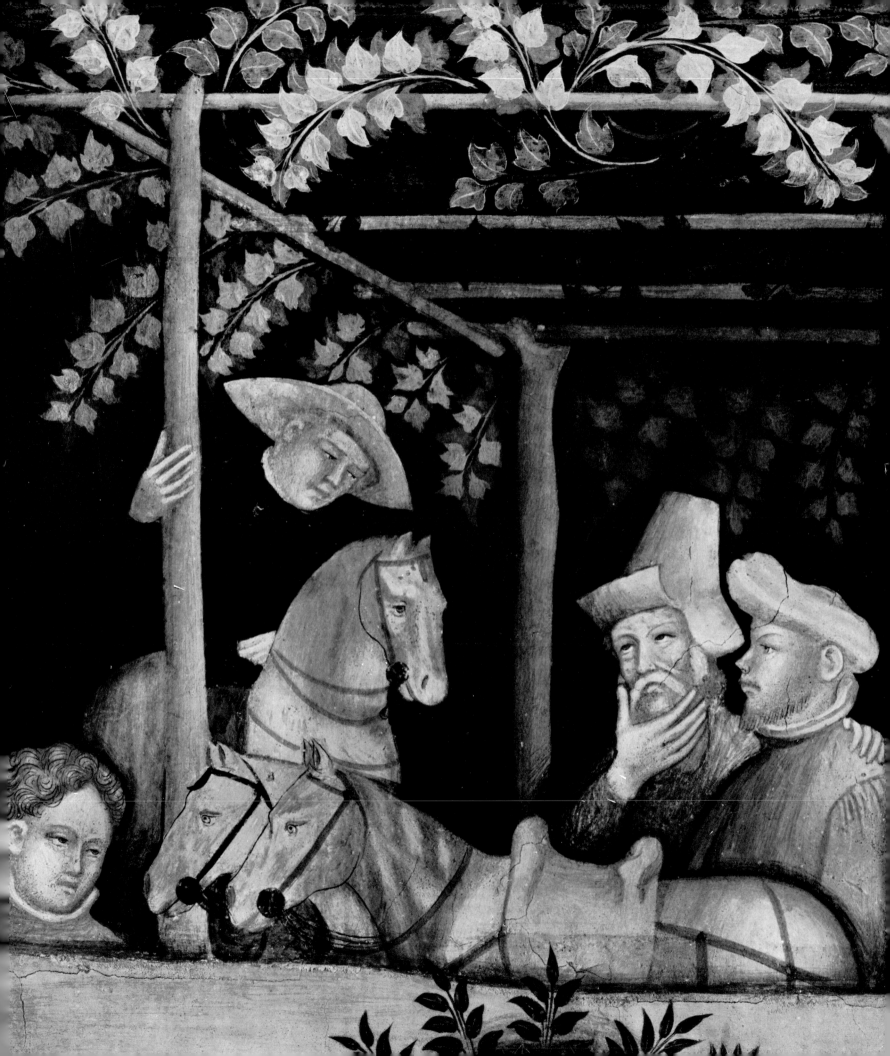

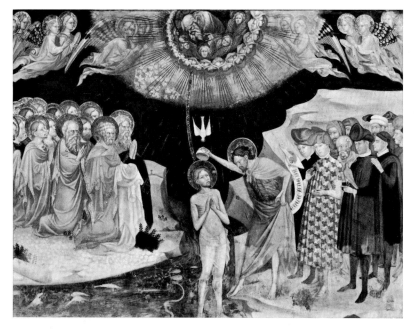

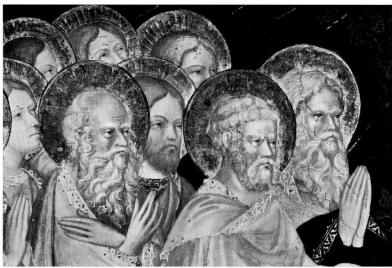

117-119. Lorenzo and Jacopo Salimbeni: *The Baptism of Christ*.
Urbino, Oratorio di San Giovanni.

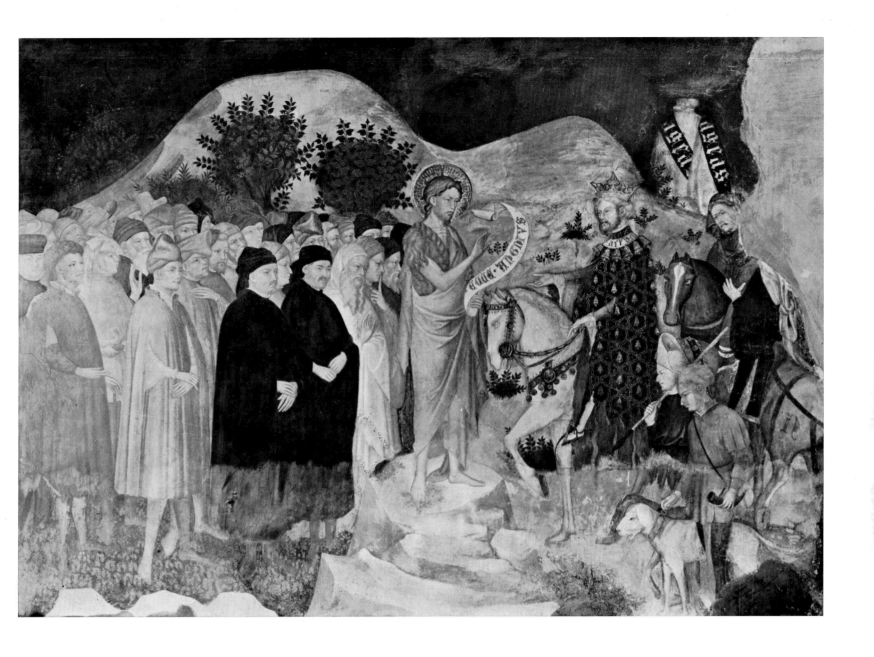

120. Lorenzo and Jacopo Salimbeni: *Saint John Baptist reproving Herod*. Urbino, Oratorio di San Giovanni.

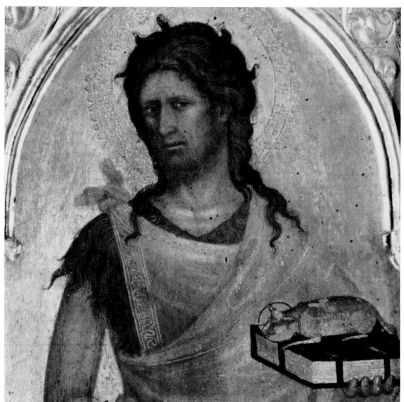

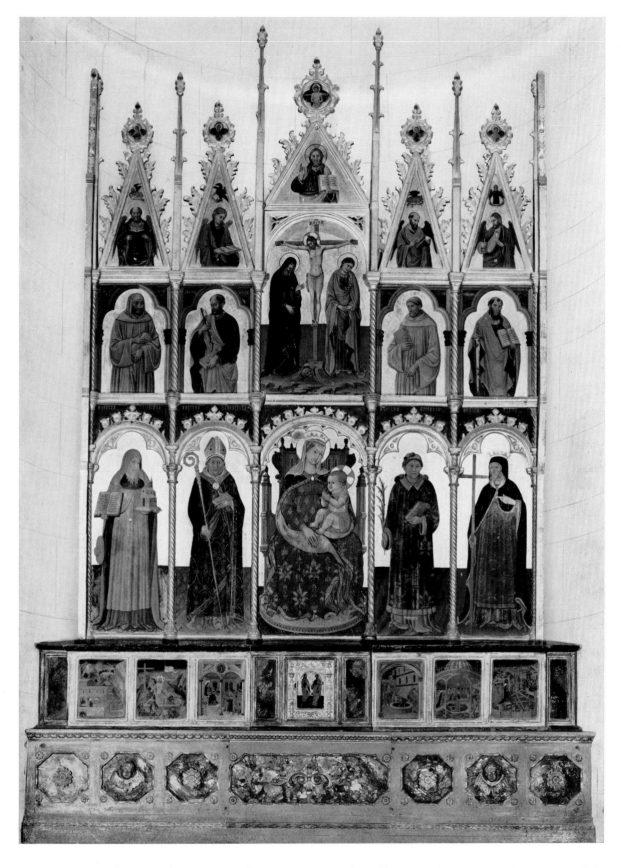

124. Giovanni Antonio da Pesaro: *Polyptych: Virgin and Child enthroned, Christ on the Cross, God the Father, and Saints*. Sassoferrato, Church of S. Croce.

121-123. Pietro da Montepulciano: *Pentaptych: Virgin and Child with Angels and Saints*. Recanati, Pinacoteca Civica.

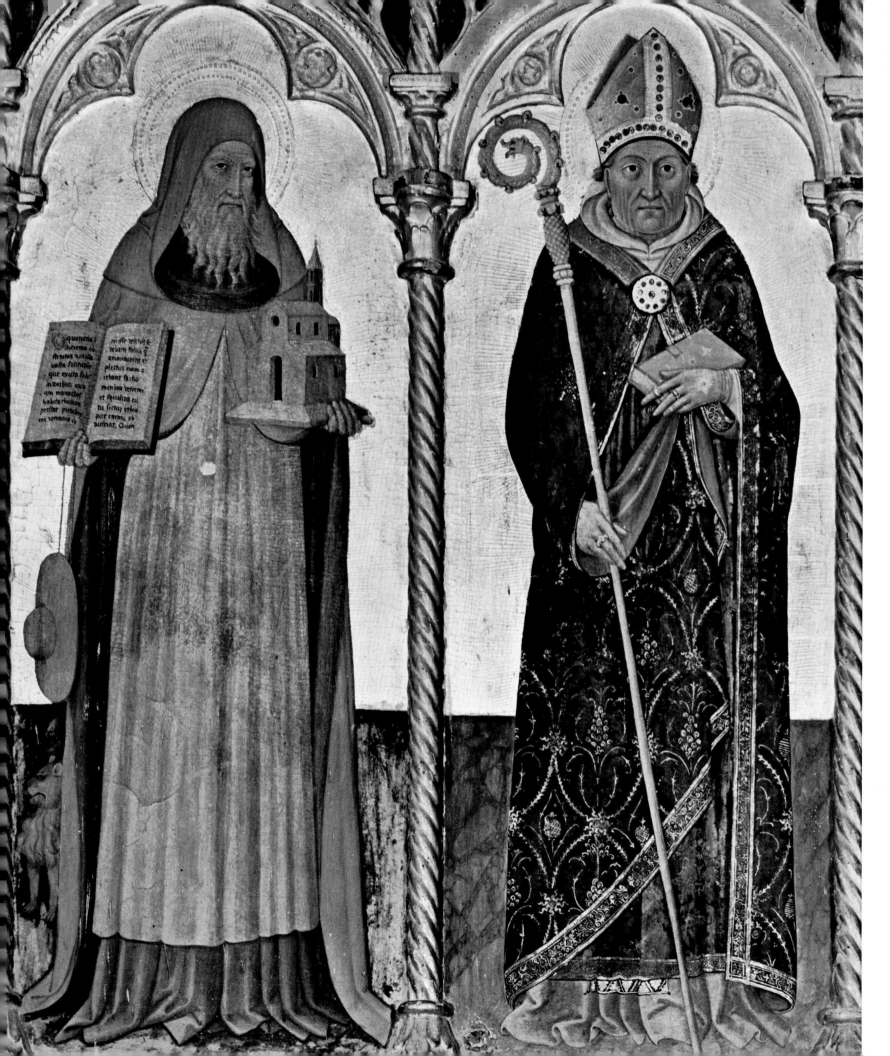

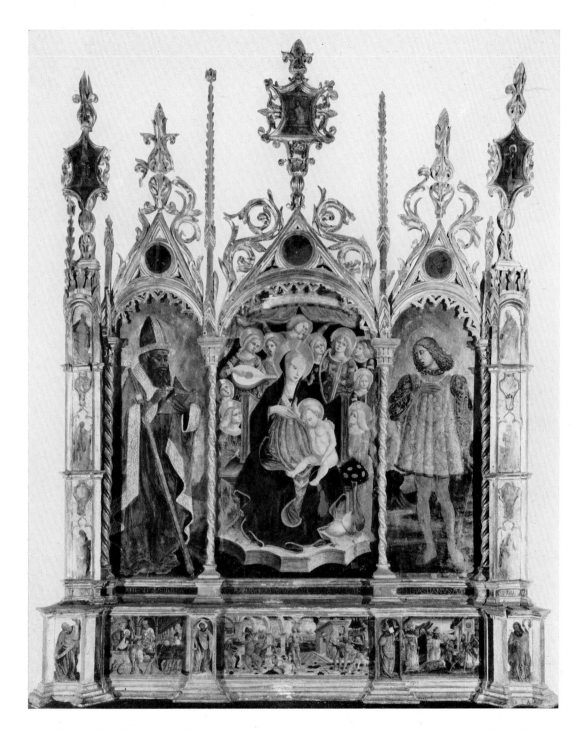

126. Ludovico Urbani: *Triptych: Virgin and Child with Angels and Saints*. Recanati, Museo Diocesano.

125. Giovanni Antonio da Pesaro: *Two Saints*. Detail from plate 124.

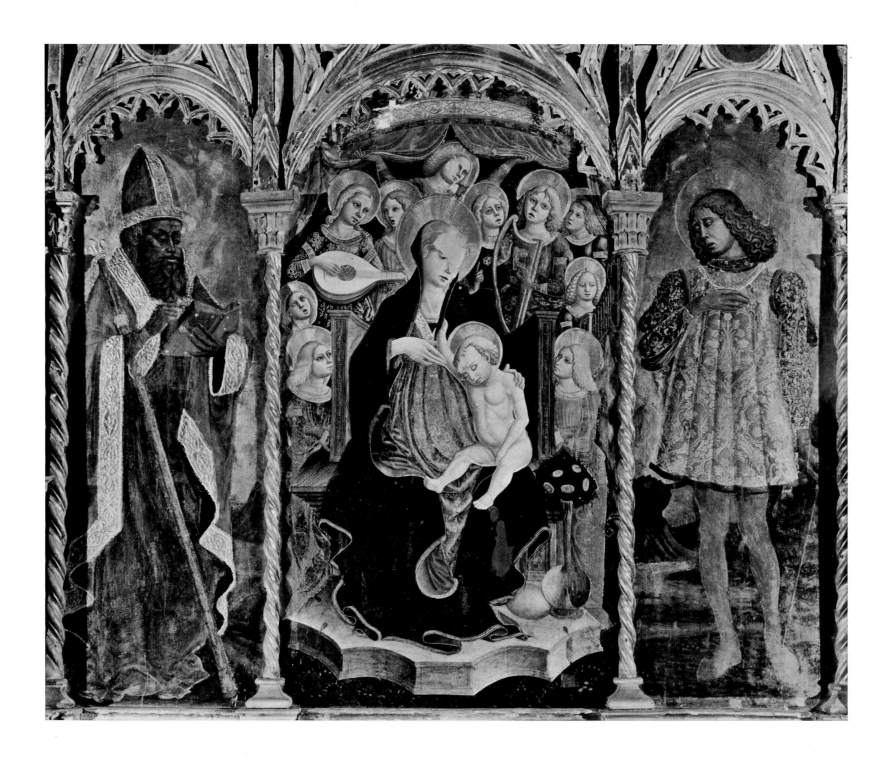

129. Ludovico Urbani: *Virgin and Child with adoring Angels*. Paris, Louvre, Campana Collection.

128. Ludovico Urbani: *Saints John Baptist, Romuald, Sebastian and Catherine*. Matelica, Church of S. Teresa, Sacristy.

127. Ludovico Urbani: *Virgin and Child enthroned with two Saints*. Detail from plate 126.

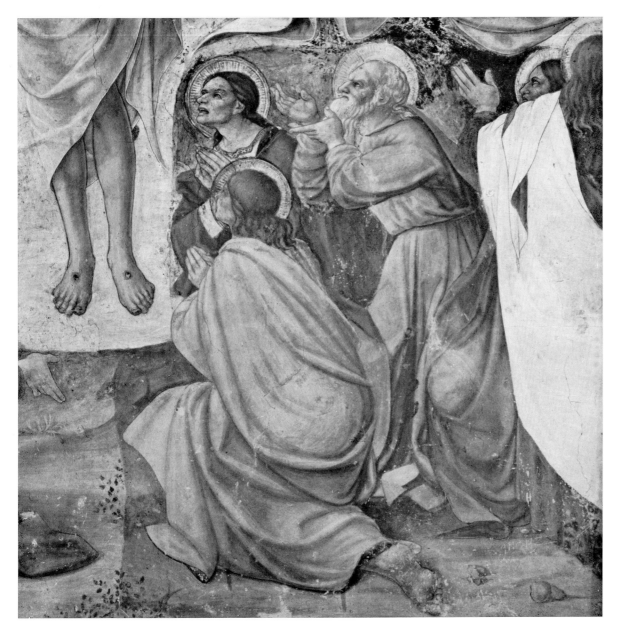

130-131. Lorenzo d'Alessandro: *The Ascension*. Pergola, Cappella del Palazzolo.

132. Lorenzo d'Alessandro: *Virgin and Child with Angels and Saints Francis and Sebastian*. Rome, Galleria Nazionale.

133. Lorenzo d'Alessandro: *The Mystic Marriage of Saint Catherine with Saints and a donor*. London, National Gallery.

134. Lorenzo d'Alessandro: *The Virgin adoring the Child with music-making Angels and Saints*. Sarnano, Church of S. Maria di Piazza.

Carlo Crivelli was born in Venice about 1430–35. The first mention of him is in 1457, when already well-known as a painter, he was brought to trial for having co-habited with a certain Tarsia, the wife of a sailor by the name of Francesco Cortese. The artist was condemned to six months in prison and made to pay a fine of 200 lire. We do not know what he did once out of prison, but this youthful misdeed must have decided his whole life. In fact, it is highly probable that he left Venice for Padua, where he frequented the local art circles dominated by Mantegna. It is also very probable that he met Schiavone either at Padua or Venice, for there is a definite stylistic affinity between the two, which is particularly noticeable in Crivelli's early works. It is significant, therefore, that after leaving the Veneto, Carlo took refuge at Zara, where his presence is recorded from the year 1465. But it is to be presumed that he had already been there for some years, for in one document he is referred to as a citizen of Zara.[1]

In 1468 Crivelli appears in the Marches at Massa Fermana, where he signed and dated a famous polyptych. From this year on there is adequate information regarding his life. He remained in the region, visiting many places, from Ascoli Piceno in the north to Pergola in the south. We find him at Ascoli in 1469, at Porto S. Giorgio in 1470, and at Ascoli again in 1473.

In a document of 1478, he is referred to as "habitator Asculi", and in the same year he bought a house in the city, in the district of S. Biagio near the cathedral. He then went to Camerino, Matelica, Fabriano, Pergola, and Fabriano again, where he left his last dated work, the *Coronation of the Virgin* of 1493, now in the Brera in Milan. The artist was once more at Fabriano in 1494, after which there is no further mention of him. Probably his last work was the triptych in the church of S. Martino at Monte S. Martino, in which he was helped by his brother Vittore.

He must have died before 7 August 1500, since in a document of that year, his wife is referred to as a widow. Moreover, since she had been in the house of her son-in-law for twenty-four years by 1524, it is possible that Crivelli died at the threshold of the new century, when his wife went to stay with her married daughter.[2]

The interesting fact to emerge from this information is that Crivelli, though born in Venice, became practically a citizen of the Marches, since he worked in the region for about thirty years or more. Nor is this all. Nearly all his works are to be found in, or come from the Marches. The only exceptions are a few paintings, such as the *Madonna* in the Museum at Verona, and one in the Museum of San Diego (the so-called Huldschinsky Madonna), which certainly belong to his early, or Paduan period.

The Verona *Madonna*, which comes from Venice and is signed, is the most striking evidence of Crivelli's debt to the school of Padua. It is the first example of that wonderful creative imagination which is a constant, living element in his works. Whatever its antecedents may be (and there is no trace of any), it is clear that this work is a product of the fertile "humus" of Padua. One might call it a composite work, so many are the affinities and connections with that school of origin, with which the artist could have been in contact even before 1457, when he is referred to as a painter. We must not forget that both Squarcione and Schiavone had been to Venice. Crivelli shows greater familiarity with the latter, who might have been his fellow pupil at the time he first began to frequent Squarcione's workshop, so coming under the influence of the greatest and most complex artist of the time, Andrea Mantegna. Thus it seems clear, without having to establish further unnecessary stages in his formation, that Crivelli came into direct contact with Mantegna and the impassioned circles around him, that is to say, with that truly revolutionary world of Padua which had grown up in the decade from 1440 to 1450. Nor must it be forgotten that it was exactly at this time that two painters from Camerino arrived in the city, Giovanni Boccati and Gerolamo di Giovanni.

No one believes any longer that Crivelli was a pupil of Antonio da Negroponte, whose altarpiece in the church of S. Francesco delle Vigne in Venice is the work of a much inferior and later artist. Antonio might have been his contemporary, but certainly not his predecessor. The idea that Crivelli was trained at Murano has also been abandoned, since his early works show that he had nothing to learn on that island, where the novelties of Padua arrived as a kind of backwash.

The *Madonna* in the Museum of San Diego must also be related to the period at Padua, since another painting that comes from the same artistic ambient and is signed "Opus P. Petri", is almost a copy of Crivelli's original.[3]

His stay in Dalmatia fills a gap in his biography, but adds nothing to the chronology of his works, since there are no paintings that can be placed between those that are most obviously Paduan in style, such as the ones mentioned above, and the 1468 polyptych of Massa Fermana. This polyptych is the first work that he painted in the Marches, the first that is signed and dated by him, and the first to reveal Crivelli's artistic personality in its entirety.

One can see here the Paduan influence and its effect. The artist is still diffident in expressing his vision, though the work is free from that ornate magniloquence and decorative superabundance which were to intrude so much in his mature works. Its chromatic texture is still far from the vivid, violent combinations of the Ascoli polyptych. Carlo Crivelli spent the first part of his time in the Marches in the district of Fermo. In fact, after the Massa polyptych, he carried out two works in the neighbourhood: the famous polyptych of Porto S. Giorgio (now dismembered and divided up among various galleries, of which a reconstruction is shown on p. 10), and the little *Madonna* of Macerata, which is really the fragment of a large polyptych, signed and dated in 1470, which was destroyed in a fire. Beginning from 1470, Crivelli's painting underwent a considerable change, and he turned to a style that is bright and violent at the same time, as the polyptychs of Montefiore dell'Aso and Ascoli Piceno bear witness (plates XXVI, 139–141). No longer is his world the unreal, fantastic, immobile one that we find in the Saints of the Massa polyptych; it has become much more lively and unrestrained, which is clearly a sign of increasing maturity, or perhaps the result of some new artistic experience. We have already referred to a similar change when talking of Gerolamo di Giovanni. Gerolamo's fresco in the chapel of Malvezzi near Bolognola represents, among other things, a *Madonna and Child* that is identical to one of Crivelli's (plates 89, 136). It is evident, therefore, that the two painters, who had perhaps already

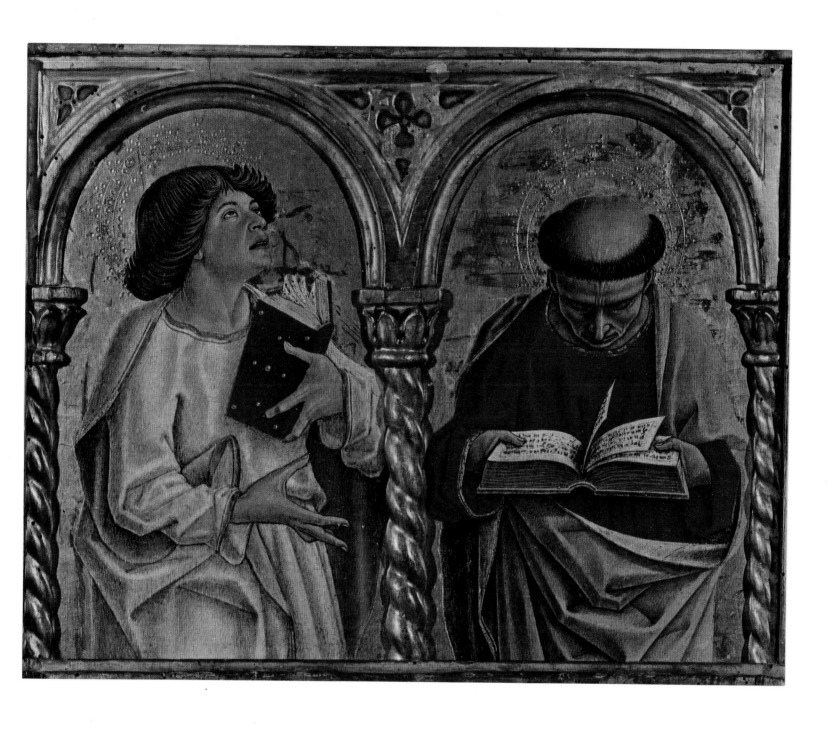

XXVI. Carlo Crivelli: *Two Saints*. Detail from a polyptych. Ascoli Piceno, Duomo

got to know each other in Padua, met once more and took note of each other's work. It is even possible that Crivelli took his inspiration from Gerolamo's Madonna, for the reasons already explained, when the Camerinese artist, at the time of Crivelli's arrival in the Marches, was already moving in a different direction. Thus, Gerolamo's fresco must have preceded Crivelli's painting. In any case, the above-mentioned works, to which we may add the Corridonia *Madonna* (plates 137–138), represent a clearly distinguishable period in the art of Crivelli. Moreover, they bear witness to its development, both in the use of colour, since his painting suddenly takes on a brightness that was previously missing, and in its structure, since his figures are now better structured and characterized by a dynamic tension which reaches hitherto unattained heights. Light, colour, and a new sense of space, these are the new elements that appear in Crivelli's painting at about the same time that Giovanni Bellini's style was also changing, under the influence of Piero della Francesca. It is possible that Crivelli, either directly, or through the mediation of Gerolamo di Giovanni, also felt the influence of the great painter, who had left so many of his works in the Marches. The dominant action of light in moulding figures in space is particularly evident in the Montefiore polyptych (plate 141).

The whole of his work in this period lives by virtue of light, and achieves a hitherto unattained purity. Perhaps the artist's most sublime creations are the figures of St. Mary Magdalen and St. Catherine, which, silently, and with that power that only a masterpiece has, trace their indelible image in our memories. The Erickson *Madonna*, painted in 1472, also helps to clear up the relationship between Crivelli and local art. It conveys the feelings of a "living" culture, a culture that is the direct result of a realistic insight into things. In the 1470s, Crivelli produced a series of polyptychs (now scattered in various places, and sometimes arbitrarily reconstituted), which suggest that he was very popular, especially in the southern parts of the region.[4]

After the outburst of his Renaissance phase, which, as we have seen, took place immediately after 1470, Crivelli's development presents no easily identifiable change; on the contrary, it now becomes more difficult to establish a chronological sequence for his undated works. On the stylistic level, his most significant painting is the *St. Mary Magdalen* in Amsterdam, in which refinement and the skill of a craftsman seem to combine in the creation of absolute perfection. Between 1475 and approximately 1485, Crivelli finally moves towards that fabulous, restless style peculiar to him, a style that is completely cut off from all contact with the prevailing taste of the time, and which turns, instead, towards increasingly abstract, unreal art forms. The violent plasticity and exasperated tension that had predominated in the Ascoli polyptych, gradually dissolve into a refined, increasingly linear decorativeness, in which the preciousness of the material, the brilliant splendour of the colours, the thrilling detail, alive and charged with incomparable force, all combine to place Crivelli beyond the orbit of any other current of painting, making him unique in the history of Italian art. We have seen that he was aware of the artistic achievements of the Renaissance. And Camerino was the centre for the diffusion of Renaissance culture in the Marches, besides being dominated by the art of Gerolamo di Giovanni, one of the first to understand the "novelty" of Piero della Francesca. Nor was there any lack of other impulses towards an open renewal of art forms in the region (there was Urbino after all); one has only to think of the frescoes painted by Melozzo and Signorelli at Loreto. Therefore, the isolation in which Carlo Crivelli shut himself was the result of a conscious choice, a renunciation of what was his for the asking: and this he did in order to pursue a vision of his own, which he gradually conceived in withdrawing from the world around him. Only in this way can the birth of certain masterpieces be explained, such as the little *Madonna* (plate XXVII) of Ancona (which is wholly orientated towards a linear style, expressive of an acute, intellectual sensibility), or other

paintings which testify to the increasingly demanding, controlled pursuit of perfection that characterizes the artist's work until about 1485.[5]

Later, beginning with the *Madonna Enthroned and Saints* in Berlin, of *c.* 1488, Crivelli's painting sank into a real state of involution. He returned to a psychological expressionism, which is no longer aggressive and pitiless, as might appear from looking at the Ascoli polyptych, but pathetic and resigned, which results in his figures adopting sorrowful, dramatic attitudes. One has only to think of the *Crucifixion* from Camerino (which certainly comes from the same polypytch as the *Madonna della Candeletta*) or of the *Pietà* from Fabriano, all works that belong to the artist's final period and which are now at the Brera. The colours in these paintings are not vivid and brilliant as before, but have become brown and reddish, devoid of all luminosity, in an atmosphere which is gloomy and sometimes leaden. It seems as if the artist were gradually losing the keen, subtle sensibility that had dominated in his earlier works, as if he were returning to the style of his first paintings, such as the Verona *Madonna* and the Massa Fermana polyptych. There is no doubt that towards the end of his life, the old artist felt the influence of Niccolò Alunno of Foligno (who was also active in the Marches, at Camerino and elsewhere), whose expressionism, which is sometimes grotesque, must have interested him to such an extent as to break the spell he had cast upon himself. And yet, with the Brera *Pietà*, he has succeeded in creating another masterpiece, which is still closely linked to his own particular world. Carlo Crivelli was not a static artist, one without any artistic development, and the fact that he left Venice and settled in the Marches, not only did not damage his creativity, but served to determine the style that was to give it expression.

## Catalogue of works
[*see plates XXVI, XXVII,* 135–144].

Amsterdam, Rijksmuseum, *St. Mary Magdalen.*
Amsterdam, Lanz Coll. (formerly), *St. Ambrose.*
Amsterdam, Proehl Coll., *St. Andrew; St. Dominic.*
Ancona, Pinacoteca Civica, *Madonna and Child.*
Ascoli Piceno, Cathedral, *Polyptych* (1473).
Ascoli Piceno, Pinacoteca Civica, *Triptych* (from the parish church of San Vito in Valle Castellana).
Ascoli Piceno, Pinacoteca Civica, *Triptych* (also from the above-mentioned church. Both triptychs are fragmentary in parts, but authentic).
Baltimore, Walters Art Gallery, *Madonna and Saints.*
Bergamo, Carrara Gallery, *Madonna and Child* (signed).
Berlin, Staatliche Museen, *Madonna Enthroned and Saints* (from the church of S. Pietro degli Osservanti, Camerino; *c.* 1488).
Berlin, Staatliche Museen, *St. Bonaventure; St. Bernard* (from the frame of the preceding altarpiece).
Berlin, Staatliche Museen, *St. Mary Magdalen.*
Boston, Museum of Fine Arts, *Panciatichi Pietà* (1475). Pinnacle of a polyptych from Ascoli Piceno; signed.
Boston, Isabella Stewart Gardner Museum, *St. George and the Dragon* (from the Porto S. Giorgio polyptych, 1470).
Brussels, Musée Royaux des Beaux-Arts, *Madonna and Child; St. Francis* (from the Montefiore polyptych).
Budapest, Museum of Fine Arts, *Madonna and Child* (signed).
Cambridge (Mass.), Fogg Art Museum, *Dead Christ between Madonna and St. John the Evangelist* (probably the lunette of a polyptych, of which the *Madonna* now in the Macerata Gallery once formed a part).
Camerino, Ducal Palace, *Frescoed Frieze.*
Chicago, Art Institute, *Crucifixion with the Madonna and St. John the Evangelist.*
Cleveland, Museum of Art, *St. Nicholas of Bari* (panel of the Erickson polyptych, 1472).
Corridonia, Parish Museum, *Madonna del Latte* (from the church of S. Agostino).
Cracow, Museum, *SS. Anthony Abbot and Lucy* (from the Porto San Giorgio Madonna, 1470).
Denver, Museum of Art, *SS. Anthony Abbot, Sebastian, Christopher and Thomas Aquinas* (probably parts of the frame of a polyptych which may have come from the cathedral of Camerino, whose central part consisted of the *Madonna della Candeletta*).

Detroit, Institute of Fine Arts, *Lamentation over the Dead Christ* (lunette of Porto S. Giorgio polyptych, 1470).

El Paso (Texas), Museum of Art (Kress Coll.), *Bust of Christ* (from the Erickson polyptych 1472).

Florence, Stibbert Museum, *SS. Catherine and Dominic* (parts of the frame of the Camerino polyptych, now at the Brera and elsewhere).

Florence, Contini Bonacossi Coll., *St. Anthony of Padua*.

Frankfurt-am-Main, Städelsches Kunstinstitut, *Annunciation* (parts of the polyptych formerly in the cathedral of Camerino, later in San Domenico, and then taken to the Brera).

Honolulu (Hawaii), Academy of Art, *SS. Andrew and Jerome* (from the Montefiore altarpiece).

London, National Gallery, *SS. Peter and Paul* (from the Porto S. Giorgio polyptych, 1470).

London, National Gallery, *Pietà* (from the Montefiore polyptych).

London, National Gallery, *The Vision of the Blessed Gabriel Ferretti* (from the church of S. Francesco ad Alto, Ancona).

London, National Gallery, *Madonna della Rondine*, with predella (from the church of S. Francesco, Matelica).

London, National Gallery, *Annunciation* (from the church of the Annunziata, Ascoli Piceno, 1486).

London, National Gallery, *Polyptych* A (from the church of S. Domenico, Ascoli Piceno, 1476).

London, National Gallery, *Polyptych* B (from the church of S. Domenico, Ascoli Piceno, 1476?).

The two polyptychs had been joined together in the last century and given the name Demidoff altarpiece.

London, National Gallery, *Madonna and Child Enthroned with SS. Francis and Sebastian* (from the church of the Franciscans, Fabriano, 1491).

London, National Gallery, *Madonna in Glory (the Immaculate Conception)*, (from the church of S. Francesco, Pergola.

London, Victoria and Albert Museum, *Madonna and Child* (signed).

London, Wallace Coll., *St. Roch*.

Macerata, Pinacoteca Civica, *Madonna and Child*, 1470 (perhaps from the church of the Minori Osservanti; fragment of a polyptych partly burnt).

Massa Fermana, Parish Church of S. Lorenzo, *Polyptych* (1468).

Milan, Castello Sforzesco, *SS. John the Evangelist and Bartolomew* (from the predella of the Erickson polyptych, 1472).

Milan, Brera, *Triptych* (first in the cathedral, then in the church of the Dominicans, Camerino, 1482).

Milan, Brera, *Madonna della Candeletta, Crucifixion* (parts of a polyptych from the Cathedral Church of Camerino).

Milan, Brera, *Coronation of the Virgin, Dead Christ between the Madonna, St. John and St. Mary Magdalen* (from the church of S. Francesco, Fabriano, 1493).

Milan, Brera, *SS. Anthony Abbot, Jerome, and Andrew; SS. James, Bernardino and Pelegrinus* (parts of a predella from the cathedral of Camerino; polyptych dated 1482).

Milan, Poli Pezzoli Museum, *St. Sebastian* (connected with the *St. Roch* of the Wallace Coll).

Milan, Poldi Pezzoli Museum, *St. Francis and Christ with the Symbols of the Passion*.

Montefiore dell'Aso, Church of S. Lucia, reconstituted *Triptych*, formerly part of a polyptych now divided up amongst various galleries.

Monte San Martino, Church of S. Martino, Altar on the right, *Polyptych* (The Madonna and Child with other figures painted by Vittore; SS. Nicholas, Michael, John the Evangelist, Martin, and Catherine are the work of Carlo).

New York, Brooklyn Museum *St. James the Elder* (panel of the Erickson Madonna; signed, 1472).

New York, Metropolitan Museum of Art, *SS. Dominic and George* (side panels of the Erickson Madonna, 1472).

New York, Metropolitan Museum of Art, *Dead Christ between the Madonna, SS. John, and Magdalen* (top panel of the Ascoli Piceno polyptych in the church of S. Domenico, 1476).

New York, Metropolitan Museum of Art, *Franciscan Reading*.

New York, Metropolitan Museum of Art, *Madonna and Child* (formerly Erickson Coll., 1472).

New York, Lehman Coll., *Madonna and Child Enthroned*.

New York, Lehman Coll., *Apostle with Scroll*.

Oxford, Ashmolean Museum, *St. John the Baptist*.

Paris, Louvre, *Pietà*.

Paris, Louvre, *Blessed Giacomo della Marca and two Donors*.

Paris, Louvre (Campana Coll.), *SS. Nicholas of Bari, Augustine, Lucy and Margaret* (on loan to Lille).

Paris, Musée Jacquemart-André, *Predella: Six Saints*.

Philadelphia, John C. Johnson Coll., *Dead Christ and two Angels*.

Poggio di Bretta (Ascoli Piceno), Parish Church, *Madonna and Child*.

Portland (Oregon), Art Museum, S. H. Kress Coll., *St. Francis; St. Nicodemus*.

Rome, Museo di Castel Sant'Angelo (Menotti gift), *Christ giving his Blessing; St. Onofrius*.

Rome, Vatican Gallery, *Blessed James della Marca*.

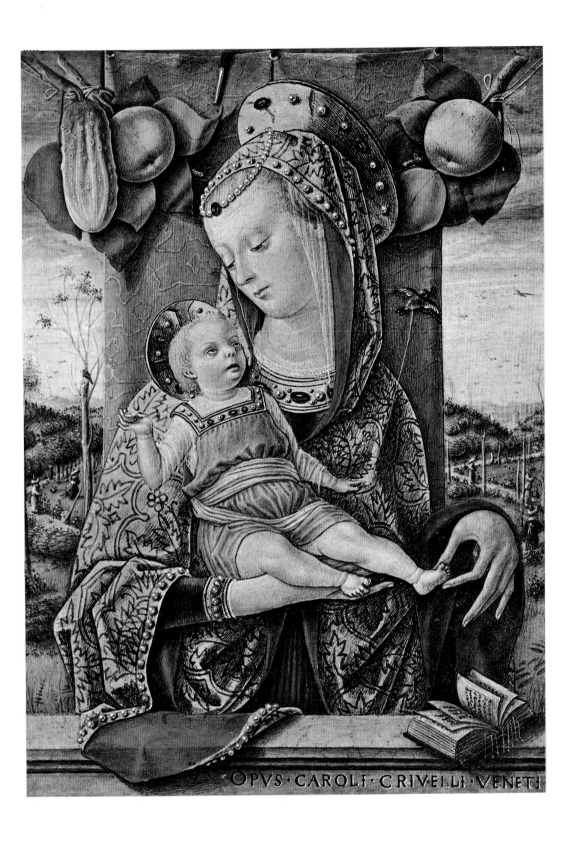

XXVII. Carlo Crivelli: *Virgin and Child*. Ancona, Pinacoteca Civica

Rome, Vatican Gallery, *Madonna*.
Rome, Vatican Gallery, *Polyptych: Madonna with SS. Jerome, Augustine, John the Baptist, and John the Evangelist*.
Rome, Vatican Gallery, *Pietà*.
San Diego (California), Fine Arts Gallery, *Madonna*.
Strasburg, Musée des Beaux-Arts, *Adoration of the Shepherds*.
Tulsa (Okla.), Philbrook Art Center, *SS. Catherine and Jerome* (from Porto S. Giorgio polyptych, 1470).
Upton House (Banbury, Oxon.), National Trust, *Two Apostles*.
Urbino, National Gallery, *Blessed James della Marca* (?).
Venice, Academy, *SS. Jerome and Augustine; SS. Peter and Paul* (from the cathedral of Camerino).
Venice, Academy, *Four small Saints*.
Venice, Cini Coll., *Madonna and Child on Parapet*.
Verona, Museo Civico, *Madonna and Angels with Symbols of the Passion*.
Vienna, Dr. Herman Eisler Coll. (formerly), *Madonna at Window with Child seated on Window-sill*.
Washington, National Gallery, Kress Coll., *Madonna*.
Washington, National Gallery, Kress Coll., *Madonna Enthroned and Donor* (from the church of Porto S. Giorgio, Porto di Fermo; see reconstruction, p. 10, above).
Williamstown (Mass.), Sterling and Francine Clark Art Institute, *Bust of Christ*.
Worcester (Mass.), Art Museum, *SS. Clare and Bernardino*.
Zurich, Abegg-Stockar Coll., *Resurrection* (from the Camerino polyptych formerly in the cathedral; it belonged with the *Annunciation* now at Frankfurt).

## *Vittore Crivelli*

No book which aims to give some account, however brief, of fifteenth-century painting in the Marches, can afford to ignore Carlo Crivelli, for his art was to a great extent a product of the region, and the result of the historical and cultural situation in which he found himself.

Naturally, we have dealt with him very briefly, but enough perhaps, to give some idea of his importance. This importance does not begin and end with Crivelli himself, but is expressed in the influence he exercised in the region, and especially in its southern parts. It may be said that all the artists who were active in the central-southern parts of the Marches adopted his style beginning with his brother Vittore. Vittore had followed him to Zara, and his presence there is recorded from 1465 onwards. He must have remained in the Dalmatian town for a long time, since he was still there in 1476, and also bought a house there. But in 1481 he too appears in the Marches, at Montelparo, where he was engaged in painting a panel for the church of the Madonna of Loreto. In the same year he signed a polyptych for the Vinci family of Fermo, which is now in Philadelphia. In 1489 he went to live at Montegranaro, then he went to Monte S. Martino; later he painted polyptychs at S. Elpidio Mare, San Severino, and other places. He did the above-mentioned polyptych at Monte S. Martino together with his brother; this is the only case of its kind, which suggests that Vittore may have completed a work left unfinished at the death of his brother. On 12 August 1501, he was commissioned to paint a panel for the church of S. Francesco at Osimo, and on 20 November of that year, he received an advance of 55 ducats out of the agreed sum of 200. But at the end of 1501 he died, and his son Jacopo (who bore the name of his paternal grand-father) asked Antonio Solario to complete the work, which he did in 1506, with the help of Giuliano Presutti da Fano.[6]

Vittore's artistic personality is wholly subservient to that of his brother, even if there is no evidence to show that they were ever together (except in the case of the Monte S. Martino polyptych, where there was not so much a collaboration perhaps, as a replacement). All Vittore's work was carried out in imitation of his brother's, and often in a very pedestrian way too. For the violent, vital outburst of creativity in Carlo finds no correspondence in the dull lifelessness of his brother, whose colours are harsh and rarely pleasant. In short, his countless *Madonnas*, triptychs and polyptychs show Vittore to be a bad version of his

XXVIII. Pietro Alemanno: *The Virgin adoring the Child*. Detail from plate 145.
Montefortino, Pinacoteca Civica

brother, a kind of standardized Crivelli, spiritually dead and characterless. Only at times is he acceptable, as in the Torre di Palme *Madonna*, or in the S. Elpidio polyptych. Here, especially in the predella, he has created what is perhaps his most beautiful work, with a narrative approach that is fresh and lively, and free from the usual ponderousness. It is even possible that he may have carried out this masterpiece after a design of his elder brother. Finally, it must not be forgotten that a number of "Crivellesque" works pass under Vittore's name, whereas they were probably done by unknown, minor assistants, whose lack of creativity has been allowed to survive parasitically at the expense of our artist, to the extent that their works have become mixed up with his; in short, imitators following an imitator.

But these painters are of no interest to us. Our interest lies in those who, following in the steps of Carlo Crivelli, and sometimes in those of his brother, succeeded in saving themselves and in expressing something of their own, such as to justify their inclusion in this study.[7]

## Catalogue of works

Altenburg, Museum, *Bust of St. John the Evangelist reading.*
Amsterdam, Rijksmuseum, *SS. Louis of Toulouse and Bonaventure.*
Ascoli Piceno, Pinacoteca Civica, *Madonna with SS. Catherine and Sebastian;* above: *Dead Christ.*
Ascoli Piceno, Pinacoteca Civica, *Annunciation.*
Ascoli Piceno, Pinacoteca Civica, *Polyptych: Madonna and Child Saints* (1489).
Baltimore, Walters Art Gallery, *St. John the Baptist and Bishop Saint.*
Bloomington (Ind.), Indiana University (Kress Coll.), *Coronation of the Virgin.*
Budapest, Museum of Fine Arts, *Madonna.*
Cambridge (Mass.), Fogg Art Museum, *St. Jerome.*
Capodarco (Ascoli Piceno), Church of S. Maria, *Polyptych: Madonna Enthroned with SS. Bonaventure, Francis, Bernardino, and John the Baptist.*
Castagnola, Thyssen-Bornemisza Coll., *St. Lawrence* (?).
Comisa (Isle of Lissa, Dalmatia), Parish Church, *Madonna adoring Child.*
El Paso (Texas), Museum of Art (Kress Coll.), *St. Francis.*
Englewood (New Jersey), Mrs. Dan Fellows Platt Coll., *St. Dominic.*
Esztergom (Hungary), Museum of Christian Art, *SS. Bernardino, Dominic, and Bonaventure.*
Falerone (Ascoli Piceno), Church of S. Fortunato, *Madonna adoring Child.*
Fermo, Church of S. Lucia, *Pietà.*
Fermo, Church of S. Lucia, *Madonna.*
Gubbio, Pinacoteca Comunale, *Small Pietà.*
Heerenberg (Arnhem), Van Heek Coll. (formerly), *SS. Anthony of Padua and Bernardino.*
Le Puy, Musée, *SS. Michael and Peter.*
London, Victoria and Albert Museum, *SS. Jerome and Catherine.*
London, R. H. Benson Coll., *Madonna and two Angels.*
London, Brinsley Marlay Coll. (formerly), *Polyptych* (now dismembered): *Madonna between SS. Nicholas of Bari and Anthony Abbot;* above, *St. Lawrence* (now at Lugano) *between SS. Peter and Jerome* (now W. P. Chrysler Jr., New York).
Marseilles, Musée des Beaux Arts, *Young Martyr.*
Massa Fermana (Ascoli Piceno), Confraternita dell'Immacolata, *Madonna of the Girdle with Angels and Worshippers.*
Massignano (Ascoli Piceno), Town Hall, *Madonna adoring Child, with two Angels.*
Milan, Brera, *Madonna adoring Child.*
Milan, Brera, *St. John the Evangelist.*
Milan, Brera, *SS. Anne and Francis.*
Milan, Brera, *SS. Philemon and Joseph.*
Monte San Martino (Macerata), Church of S. Maria del Pozzo, first altar on the left. *Polyptych: Madonna between SS. Peter and Paul;* above, *Ecce Homo between SS. Gabriel and Martin.*
Monte San Martino (Macerata), Church of S. Martino, High Altar. *Triptych: Madonna with Archangels Michael and Gabriel;* on the sides, *SS. Emidius and Anthony Abbot;* above, *Pietà.*

XXIX. Anonymous Follower of Crivelli: *Virgin and Child*. Detail.
Fermo, church of S. Agostino

Monte San Martino (Macerata), Church of St. Martin, first altar on the right, part of a polypytch: *Madonna Enthroned, Pietà, St. Blaise and St. John the Baptist* (the rest is by Carlo Crivelli).

Nashville (Tenn.), Peabody College (Kress Coll.), *St. Bonaventure*.

New Haven (Conn.), Yale University, *St. Peter*.

New Haven (Conn.), Yale University (Rabinowitz gift), *St. Peter*.

New York, Metropolitan Museum of Art, *Madonna and two Angels*.

New York, Walter P. Chrysler Jr. Coll., *SS. Peter and Jerome*.

Orléans, Musée, *Madonna adoring Child*.

Oxford, Ashmolean Museum, *St. Catherine*.

Paris, Musée Jacquemart-André, *St. Bonaventure with the Tree of Redemption and genuflecting Monk*.

Philadelphia, John G. Johnson Coll., *Polyptych: Madonna and Child with four Angels;* on the sides: *SS. Bonaventure with Tree of Redemption, John the Baptist with genuflecting Donor, Francis receiving the Stigmata and Louis of Toulouse;* predella: *Pietà, Resurrection and Saints* (from Casa Vinci, Fermo).

Richmond (Va.), Virginia Museum of Fine Arts, *Figure of a Pope*.

Ripatransone (Ascoli Piceno), Museo Civico, *S. Placido, Blessed Giacomo della Marca, SS. Orsola and Leonard*.

Ripatransone (Ascoli Piceno), Museo Civico, *Madonna with SS. Leonard and Mark*.

Sant'Elpidio a Mare (Ascoli Piceno), Town Hall, *Polyptych: Coronation, Pietà, eight Saints;* predella, *Six Episodes in the Life of St. John the Baptist*.

Sant'Elpidio a Mare (Ascoli Piceno), Town Hall, *Triptych: Visitation, SS. Francis, John the Baptist;* above, *Crucifixion* (from the church of the Minori Osservanti).

Sant'Elpidio Morico (Ascoli Piceno), Church of S. Elpidio, *Polyptych: Madonna, four Saints;* in the lunette, *Pietà*.

San Severino (Marches), Pinacoteca Civica, *Polyptych: Madonna, Pietà, eight Saints;* predella, *Last Supper and twelve Saints*.

Sarnano (Macerata), Church of S. Francesco, *Madonna and Angels adoring Child*.

Senlis, Musée, *Madonna and Angels*.

Torre di Palme (Fermo), Church of S. Giovanni Battista, *Polyptych: Madonna, Redeemer, two Angels, eight Saints;* predella, *Christ and the twelve Apostles*.

Tucson (Arizona), University of Arizona, S. H. Kress Coll., fragments of a polyptych: *Dead Christ, Madonna, St. John the Evangelist*.

Vaduz, Liechtenstein Collection, *Madonna adoring Child*.

Vienna, Count Lanckoronski Coll., *Madonna*.

Vienna, Count Lanckoronski Coll., *Madonna with open Book*.

---

## Pietro Alemanno

There is no definite information about this artist until 1475, when he signed the now dismembered polyptych of Monterubbiano. In fact, one cannot accept with any certainty the badly preserved fresco in the church of the Madonna delle Rose at Torre San Patrizio, which is dated 1466 and has a doubtful signature. It represents the Virgin with Saints in a late Gothic manner not very different from that of Arcangelo di Cola.

But leaving aside this work, which bears no trace of Carlo Crivelli's influence, the date being prior to Crivelli's arrival in the Marches anyway, our only fixed point of reference remains the above-mentioned polyptych. Its predella, which has recently been discovered on the art market, bears the following signature in clear letters: "Petrus Almanus de Choethei", that is, of Gottweich in Austria. The painting already shows the painter's full adherence to the style of Crivelli, and not to that of Gerolamo di Giovanni, as stated by Cavalcaselle and later repeated by Grassi.[8] Moreover, he followed Crivelli for the whole of his life, and is without doubt his best disciple.

There is not very much information about Alemanno. In 1477, he bought a house at Ascoli. In the same year, and again in 1482, he was involved in lawsuits for business reasons, that of 1482 concerning payment for a polyptych for the Univeristy of the Albanesi, which was placed in the cathedral, and of which one panel now exists in the Ascoli Art Gallery (Fabiani, 1951, p. 160). In 1483 he was engaged in another lawsuit with a neighbour regarding the right to use rain-water, and in 1484 he deposited some money.

In 1485 he agreed to paint four pennants with the town's emblem. In the same year he bought a vineyard in the neighbourhood of Ascoli, and another piece of land, part vineyard and part arable, in 1489. In 1491 there was another lawsuit, with a Ser Francesco Alberti, over some paintings he had carried out at Venagrande near Ascoli. In 1497 he finished an altarpiece for the church of Vallecastellana. He must have died soon afterwards, since his wife is referred to as a widow on 22 november 1498. He left five children, all under age.[9]

If we leave aside the possibility that he began painting in a manner unlike Crivelli's—which is arguable but not verifiable—we must try to reconstruct his development, but only through a stylistic examination of his works. One is tempted to think that Alemanno too—like the two Crivelli brothers—arrived in the Marches after staying at Zara, or at least somewhere in Dalmatia. A certain flair and a linear expressionism that is more apparent in his earlier works are very reminiscent of Schiavone (one thinks of the latter's Correr *Madonna*). Therefore, it is not impossible that he may have seen the Schiavone's works in his youth, besides those of Crivelli. It is also undeniable that his art follows a descending curve, and that it suffered an involution which gradually damaged its quality. His early works—such as the polyptych in the Ascoli Seminary, and to an even greater extent the Montefortino *Madonna*, (plate XXVIII, 145), together with those of Paggese di Acquasanta and Castel Folignano (plate 147)—reveal notable qualities, but these gradually disappeared to give way to an irremediable staleness. One has only to look at his late, dated works—particularly those in the Ascoli Gallery—to see the justice of Adolfo Venturi's description of him as a "poor figurine maker". But the epithet is a mistaken one, since it is based solely on a partial examination of his works.

Alemanno did not follow the development of Crivelli's art, but remained tied to the Venetian's early manner. Nevertheless, plastic vigour, simplified and transformed by means of a linear style, has its effect. Moreover, Alemanno's colours owe nothing at all to Crivelli, for they are light and tenuous, and their combinations and intonations are expressive of a sensibility which, though much less complex than Crivelli's, is just as balanced, and far from Crivelli's taste for luxuriant decorativeness. His forms are not of a violent structure, moulded in relief, but flattened on the surface. His colours, so precious and enamelled, are pure and never thick; light as soft tempera, and bright as lacquer, they have a wholly spring-like, festive air about them.

Pietro Alemanno's best works—those worthy of consideration—fall in the period 1475–1483. After this, the decadence sets in and gradually gets worse as the years go by, a decadence that justifies the low esteem in which he has been held by the critics—from Testi and Venturi to van Marle. But if his works were to be examined with the aim of discovering his artistic personality at its best, then he would be seen to acquire considerable importance.

His best qualities are revealed in the *St. Lucy* panel in the Montefortino Art Gallery (plate 146), which is part of a dismembered polyptych. It is iconographically similar to the *Magdalen* in the Ascoli Gallery, but a comparison between the two only reveals the gradual impoverishment of his style. Such a comparison, between two works that stand at the opposite poles of an easily identifiable artistic development, gives an exact idea of the way in which his creative potentialities hardened and contracted into an empty art form.[10]

Catalogue of works
[*see plates XXVIII, 145–147*].

Ascoli Piceno, Church of S. Agostino, *Madonna with SS. Julian and Sebastian.*
Ascoli Piceno, Church of S. Maria della Carità, *Madonna* (1489).
Ascoli Piceno, Pinacoteca Civica, *Magdalen; St. Lucy; St. Bernardino; St. Veneranda; Blessed James della Marca.*
Ascoli Piceno, Pinacoteca Civica, *Polyptych: Madonna and Child with Saints.*

Ascoli Piceno, Pinacoteca Civica, *Dead Christ and SS. Sebastian and Roch*.

Ascoli Piceno, Seminary, Polyptych: *Madonna and Child with SS. Stephen, Augustine, Emidius and Maurus* (1483).

Bracciano, Castle, *St. Mary Magdalen*.

Castel Folignano (Ascoli), Parish Church, *Triptych: Madonna holding Child with SS. Jerome and Catherine*.

Cerreto di Venarotta (Ascoli Piceno), Parish Church, *Madonna Enthroned, Christ the Saviour and St. Sebastian;* in the lunette, *Pietà* (1485).

Cupra Marittima, Parish Church, *Madonna and Child with SS. Bassus and Sebastian*.

Florence, Berenson Coll., *Madonna in the Rose-garden*.

Gubbia, Gallery, *Dead Christ*.

Lapedona (Ascoli), Church of S. Giacomo, *Triptych: Madonna with SS. John the Baptist and James*.

Milan, Brera, *Polyptych* (from the parish church of Monterubbiano).

Montefalcone Appennino (Ascoli Piceno), Church of the Minori Riformati, *Polyptych*.

Montefortino (Ascoli Piceno), Pinacoteca Civica, *Madonna and Child with SS. Sebastian and Cosmas; St. Lucy; Dead Christ* (panels of dismembered polyptych).

Paggese di Acquasanta (Ascoli Piceno), Church of S. Lorenzo, *Triptych: Madonna and Child with SS. Mark and Lawrence*.

Paris, Duval Foulc Coll., *Polyptych: Madonna and Child with SS. Stephen, James the Elder, Jerome and Sebastian* (signed).

Paris, Sartoris Coll. (formerly), *Madonna and Child* (signed).

Rome, Colonna Gallery, *St. John the Baptist*.

Rome, Museo di Palazzo Venezia, *SS. Peter and Michael*.

S. Ginesio (Macerata), Collegiate Church, *Madonna of Mercy* (1485).

Sarnano (Macerata), Town Hall, *Madonna of Mercy* (1494).

Torre S. Patrizio (Ascoli Piceno), Church of the Madonna delle Rose, *Madonna and Saints* (fresco of uncertain origin, 1466).

Urbino, National Gallery, *Madonna Enthroned and music-making Angels*.

Crivelli's arrival in the Marches led to a broadening of the culture that prevailed over, or had penetrated, the various currents of the local schools, a culture that was already so subtle and complex. The Tuscan influence had been enriched and made even more complex by that of Padua, which had passed directly into the region thanks to Gerolamo di Giovanni, and to other similar, secondary artists such as the Master of Patullo for example. But the advent of Crivelli represented a style that had gradually been diluted, or one even contaminated, by the contact with various other artistic tendencies. Likewise it had suffered from the co-existence of a traditional, local school still tied to the refinements of late Gothic art. But a share of the responsibility for this crisis in local art during the seventh decade of the century must also be attributed to the considerable influence exercised by the Vivarini brothers, whose polyptychs, still so exquisitely Gothic in their structural rigidity, are carried out in a style that is difficult to classify. Though characterized by a Paduan firmness, their paintings also contain soft figures and chromatic refinements. This is the result of the collaboration between the two brothers, Antonio and Bartolomeo: the first, a *manqué* follower of Mantegna; the second, a dreamer and refined creator of fables. That this cultural partnership, which was certainly hybrid, but perhaps suited to the twin needs of local art, established a hold over the local painters is demonstrated by the Monte San Martino polyptych of Gerolamo di Giovanni, in which the Camerinese painter, almost suffocating his own personality in the process, imitates the art of Bartolomeo, making it even more clumsy and provincial.

The appearance of Crivelli resulted in the diffusion throughout the central-southern parts of the region of a new, decisive, almost violent style, which injected new blood into the veins of the Venetian-Marchigian tradition and led to a flowering that becomes most evident after 1470. This outburst of activity continued to expand for the rest of the century, and even into the next, bringing about that strange stylistic marriage between Crivelli and Lotto, which is noticeable in the chameleon-like figure of Vincenzo Pagani. This artist, who was trained in the tradition of Crivelli in his youth, came under the influence of Lotto,

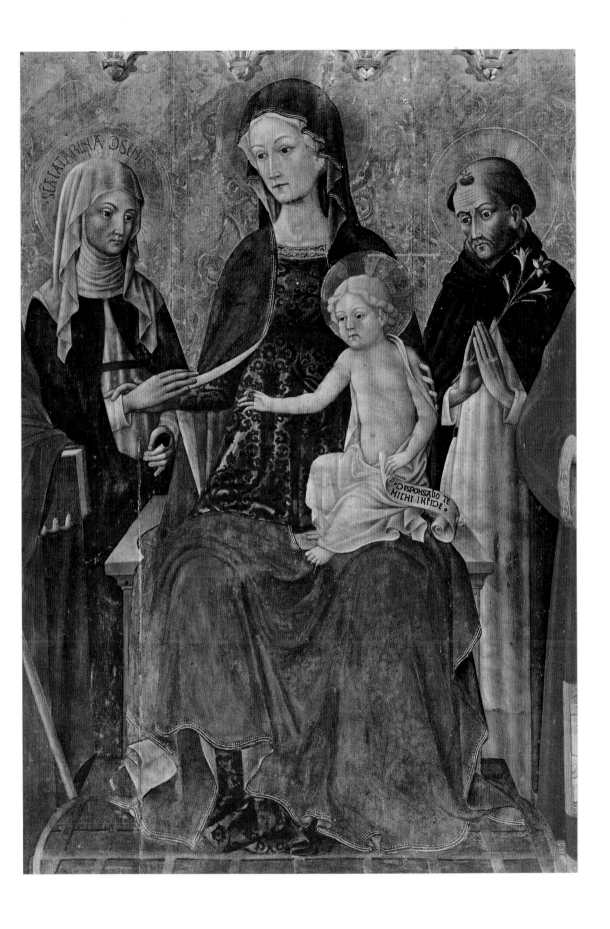

XXX. Paolo da Visso (?): *Sacra Conversazione*. Detail from plate 155.
Ascoli Piceno, Pinacoteca Civica

when the style of the latter began to spread in the region. But he also allowed other tendencies to exercise their sway over him, particularly those of Signorelli and Raphael.

It is not easy to follow the diffusion of Crivelli's influence in the Marches, especially as it appears under different forms, according to the cultural bent of the several areas. Sometimes, its source is not always the original one, Carlo himself, but Vittore too, and even Alemanno. In any case, local painting was influenced by the three, while remaining unaware perhaps, that all derived from a common source.

Some of Crivelli's followers can easily be identified with names mentioned in local documents. Others remain anonymous, or cannot be distinguished from each other. The *St. Lucy* in the town hall of Offida (plates 149–150) is generally associated with Pietro Alemanno, to whom Berenson too, attributes it in the last edition of his *Lists*. However, the attribution does not stand up to critical examination, since the panel differs considerably from Alemanno's works. Its date, 1490, is particularly significant, for at that time Alemanno was painting in that weak, dull manner already referred to, while here the figures have a firm, rigid structure. If, in fact, the figure of the Saint, the throne and some other elements may point to Alemanno's authorship, the two Angels are painted in quite a different style, whose antecedents may even be traced to Luca Signorelli. One might, therefore, suggest the name of Bernardino di Mariotto, a painter from Perugia, whose presence in the region is mentioned very early on. His first signed work, which dates from 1498, and which reveals unmistakable signs of Crivelli's influence, is to be found at Bastia near Fabriano. However, the attribution of the panel to Bernardino di Mariotto creates chronological difficulties, since it seems that he lived until 1566. Bernardino was an eclectic late-comer, and his painting contains Umbrian and Tuscan elements besides those taken from Crivelli. A document records his presence at San Severino, and he was also connected both with Signorelli and Pinturicchio.

The influence of Crivelli is undoubtedly most apparent in his early works. This can be clearly seen in the significant *Deposition* in the Gallery of San Severino (plate 151). A composite work, it is interesting in the way Crivelli's influence can be traced in the firm outlines of the figures, while the Umbrian element provides the rhythmic movement, particularly evocative of Niccolò Alunno.

Nor is Lorenzo d'Alessandro free from the influence of Crivelli, but he was equally affected by that of Alunno, as we have already mentioned in speaking of the frescoes in S. Maria di Piazza at Sarnano (plate 134). The influence of Crivelli can be felt, for example, in the *Madonna* in the Rome National Gallery (plate 137), which may have been inspired by Crivelli's painting at Corridonia. And there is no doubt that the same influence is at work, together with that of the Vivarini brothers, in the Serrapetrona polyptych. As we have already recalled, Antonio da Fabriano, too, was stimulated by the works left by the Venetian artist in the Marches. In fact, there is a trace of Venetian inspiration in Antonio's frescoes in the convent of S. Domenico, of which it has been impossible to reproduce a single part, because of their bad condition. The Madonna with the Child resting in her lap, on the upper part of the wall, is clearly Venetian in character, after the manner of Vivarini perhaps, though we must not rule out the possibility that the painter may have borrowed from Crivelli. Yet another painter at Fabriano, Francesco di Gentile, adopted, in his last works, the manner of Crivelli. In fact, as Zeri has pointed out, Francesco's *Portrait of a Young Man* (plate 30) clearly shows that the painter knew Crivelli's late works, and the *Coronation* panel in particular, where the predella has given Francesco certain ideas, which he applied in the *Portrait of a Young Man* and in the *Madonna with a Butterfly* in the Vatican Gallery (plate 29). Zeri's observation also enables us to establish a *terminus post quem* for the works which Francesco di Gentile carried out under the influence of Crivelli. Another artist from San Severino, that follower of late Gothic art, Ludovico Urbani, also succumbed

in his later works, to the Venetian painter's fascination. The scenes in the predella of his polyptych in the Recanati Diocesana Gallery (plate 126) were certainly inspired by Crivelli. This too has already been mentioned.

Stefano Folchetti da San Ginesio was also a follower of Crivelli in his own way. He is a wholly minor painter and open to a number of influences, which he sums up in a style that is evidently the result of an almost unconscious absorption of the various currents around him. In short, his work is an uncritical, unconscious pictorial *contaminatio*, which ends by being pleasant, precisely because it is unconscious and spontaneous (plates 153, 154). As Serra has rightly pointed out, Stefano Folchetti, whose activity is documented from 1492 to 1513, was affected by Umbrian influences as well as that of Crivelli. Berenson calls him a "follower of Crivelli", and places him among the Venetian painters in his *Lists*. But it is clearly more logical to define him as the local product of a more complex cultural situation, which he interprets with a certain instinctive grace of his own, but without going beyond the imitation of the works of other artists.[11]

Besides these well-known painters whom we know by name, there are a large number of anonymous artists who were inspired more or less directly by the Venetian master. One of them is the so-called Master of the Crivellesque Polyptychs, who painted a number of works now exhibited in the galleries of Chieti and Aquila, and in other collections (plate 152). He came to know Crivelli through Pietro Alemanno, whose collaborator and pupil he undoubtedly was. Bologna's interesting study[12] devoted to this painter has clarified a number of aspects regarding the painting of the southern Marches, and its penetration into the Abruzzi. Crivelli's work undoubtedly made itself felt, and fairly late, over a large part of this area, since we can find traces of his influence in a few of Cola dell'Amatrice's early works in the Gallery of Ascoli. Andrea Delitio, a controversial painter who is very difficult to categorize because of the innumerable tendencies in his work, was also partly influenced by Crivelli, as one can see in certain parts of his famous frescoes in the cathedral of Atri.[13]

Nor is this all. If one were to follow the influence Crivelli exercised on local painting in the second half of the fifteenth century, one would have to draw up a long inventory of works, such as noone has done so far. The painter of a few frescoes in the church of S. Agostino at Fermo dated 1483 (plates XXIX, 148) reveals an interesting artistic personality in the genuine, confident way in which he interprets Crivelli's art. Also anonymous is the painter of the *Madonna and Child* fresco in the old parish church of Castignano; a considerable artist and an intelligent interpreter of the works he has drawn from. Other paintings influenced by Crivelli are some panels in the Piersanti Museum at Matelica, such as a *Madonna and Child with Saints*, and a *Crucifixion*, parts perhaps of a now dismembered polyptych. Finally, another refined interpreter of Crivelli's style—perhaps the finest of all—is the painter of the *Madonna and Child* in the parish church of Arnano near Camerino. Here, the sensitive features of a Saints, now very fragmentary, are subtle and vigorous at the same time, revealing a mastery worthy of a great artist. The painter of this work must have been close to Crivelli, for he shows great originality in the interpretation of his style. Perhaps he is the same artist who painted the *Enthroned Madonna* in the church of S. Maria delle Macchie near Castelraimondo; this work is also fragmentary, but the influence of Crivelli is obvious. One day when a well-planned, co-ordinated attempt is made to rescue the frescoes that are gradually disintegrating in the churches of the Marchigian Appenines, it will be possible to reconstruct a whole current of painting which is now only mentioned by writers who deal with its "major" exponents, such as Vittore and Pietro Alemanno. But other painters who belong to this current, and who have been overlooked, are also worthy of critical attention, the results of which would establish the personal contribution each one of these artists

made.[14] Among these, one cannot fail to mention the anonymous painter of the little picture in the Brancadoro Collection at S. Benedetto del Tronto, a work similar in style to that of Giovanni Francesco da Rimini. In this panel, the weary, emaciated features of the Madonna differ from the usual pattern, and come close to the reality of the human condition, with a sense of humanity and an unexpected grandeur, even though the usual garlands of fruit recall so clearly the typical iconography of Crivelli.

## Nicola d'Ancona

In his "Memorie", Amico Ricci refers to a Maestro Niccolò di Antonio of Ancona, known as a medallist, who, in 1451, was authorized to mint silver at Macerata. He goes on to say that, "we should like to be able to present some celebrated works of his, but since we have no knowledge of them at all, we shall content ourselves with echoing the applause he won from his contemporaries, as we learn from the documents".[15]

Whether the medallist, once famous, but unknown in the days of Ricci, is to be identified with the painter, who would also be unknown, were it not for the signature on the Cornbury panel (plate 156), is an unsolved problem, and likely to remain so, until some further information comes to light. Berenson has noted, moreover, that the documents to which Ricci referred speak of Nicola, not Nicola di Antonio, which makes the problem of identification even more complicated. In his Guide to Ancona (1821), Maggiori mentions a painting by Antonio d'Ancona in the church of S. Francesco delle Scale, dated 1472. Unfortunately, this only adds to the confusion, since the name now becomes Antonio d'Ancona, and not Nicola d'Ancona. On the other hand, it is difficult to understand why Ricci speaks of him as a medallist—since even if he was famous in his own day, he was quite forgotten by Ricci's—and not as a painter, although a signed and dated picture by him was extant and was even included in a "Guide" that had come out only a few years before his own work, which was published in 1834.

To complicate matters even further, as Berenson points out in what was the first and is still the best informed study on the artist,[16] the Cornbury panel, according to Waagen, on the basis of information provided by Colucci in his *Antiquities of Piceno*, does not come from Ancona, but from Fermo or Porto S. Giorgio. If this were true, there could hardly be a connection between this painting and the one seen by Maggiori in the church of S. Francesco delle Scale at Ancona.

Until we are able to solve the problem by showing that the artist in question is one and the same person, we must fasten our attention on the following two fundamental points 1) Amico Ricci mentions an artist whom he describes as a goldsmith and medallist, who answers to the name of Nicola d'Antonio and who lived in the second half of the fifteenth century, since documents show that he was present at Macerata in 1452; 2) there is a painting (the Cornbury panel) which bears the signature of a Nicola d'Ancona, and the date of 1472, that is, the same date that was to be seen on the painting in S. Francesco delle Scale at Ancona, according to Maggiori. The signature appears in the following form: "Opus Nicolai Mi Antonii de Ancona MCCCCLXXII" (plate 156). The name of the town has been written not with the rest of the inscription at the base of the throne, but apart, on a scroll attached to the pedestal.

The painting represents the *Madonna Enthroned adoring the Child with SS. Leonard, Jerome, John the Baptist and Francis*. At the bottom of the panel, to the left, there is a minute portrait of the female donor. The style recalls immediately that of the Paduan school, and clearly points to an affinity with the work of Schiavone, as Longhi has rightly observed. There seems to be no connection however, with the painting of Marco Zoppo and Cosimo Tura,

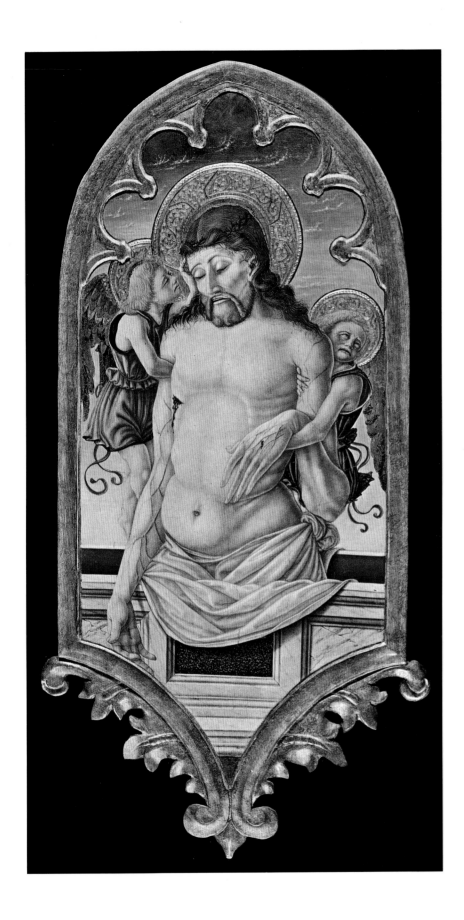

XXXI. Nicola di Maestro Antonio da Ancona: *Pietà*.
Jesi, Pinacoteca Civica

unless it be a general northern influence of Paduan origin, which is common to all the painters of the second half of the century and which also penetrated into the Marches.

It should be added that to Berenson, who started as it were from scratch, goes the merit for having discovered the painter's artistic personality, enquired into his cultural background, and, finally, for having grouped together, on the basis of the stylistic data offered by the only work that bears his signature, a number of the artist's paintings, which still constitute the most important nucleus in the catalogue of Nicola di Maestro Antonio's works. Berenson's observations are still valuable; even if not wholly acceptable, they are still significant in that they direct out attention towards the world of Padua. Besides a connection with Tura and Zoppo, Berenson saw a much closer one between Nicola and Carlo Crivelli: "standing before the original, the more I looked at it, the more I felt that its decorativeness, its violence of expression, and its forms, were indicative of a close connection between Nicola di Maestro Antonio and Carlo Crivelli". He goes on to say that "whoever taught our artist the first rudiments of painting, Crivelli was the real guiding influence in his art".[17]

After 1915, the date of Berenson's publication, which is fundamental, if only for the fact that it added the name of a painter to the history of Italian art, nothing critically positive and useful was written on the subject until 1947. In that year, Roberto Longhi devoted a brief chapter of his *Calepino Veneziano*, to the "Origins of Nicola di Maestro Antonio". He attributed to him a *Crucifixion* in the Academy of Venice, which Venturi had previously attributed to Schiavone, a suggestion that Berenson did not accept. To say that there is no doubt or difficulty entailed in the attribution of this painting to Nicola's early period, certainly does not reflect the real truth. But the fundamental importance of Longhi's observations lies in his disagreement with Berenson over the question of the artist's early training. Longhi was right in believing it more likely that Nicola's beginning were influenced by Schiavone, and that by this route he came into contact with the Paduan school, that is to say, with the art of Mantegna and Squarcione, in the years around 1450. Thus the connection with Crivelli must also be interpreted in the sense that all these artists shared one common origin.

Berenson's work was completed by Serra, Longhi, and Zeri. The first credits the artist with the altar painting of the *Annunciation and two Saints* in the National Gallery of Urbino (plates XXXII, 162), as well as an altarpiece, unfortunately in a very bad condition, in the Vatican Gallery.[18] Longhi, besides the *Crucifixion* in Venice referred to above, also attributes to him a panel (also in a very bad condition) representing SS. Sebastian, Jerome and Roch, which is in the Berlin Museum. Finally, Zeri[19] gave him the predella panels with *Scenes from the Lives of Saints* (there is also an *Annunciation*) in the Brooklyn Museum, and connects the predella with the Massimo altarpiece and with the *Resurrection* in the York Gallery, which was the lunette of the altarpiece. Zeri also credits the painter with the lunette of *St. Lucy between SS. Anthony and Bernardino* in the Montefortino Gallery, which had previously been attributed in a vague way to the Venetian school or to the circle of the Vivarini but which must undoubtedly be considered as an original by Nicola.

On the basis of these works—which had previously remained anonymous or had been wrongly attributed—it is possible to reconstruct the painter's artistic development, but not according to the path traced out for him by Serra. This postulated an initial "Gualdese" period, that is, a period dominated by the influence of Matteo da Gualdo, followed by a "Zoppesque" phase, tied that is, to the style of Marco Zoppo, until he finally passed under the influence of Crivelli (a fact that is particularly noticeable, says Serra, in the *Pietà* in the Gallery of Jesi and in the Brera *St. Peter*—though the latter has been eliminated from the artist's catalogue of works by Zeri, who rightly restores it to its real author, the so-called

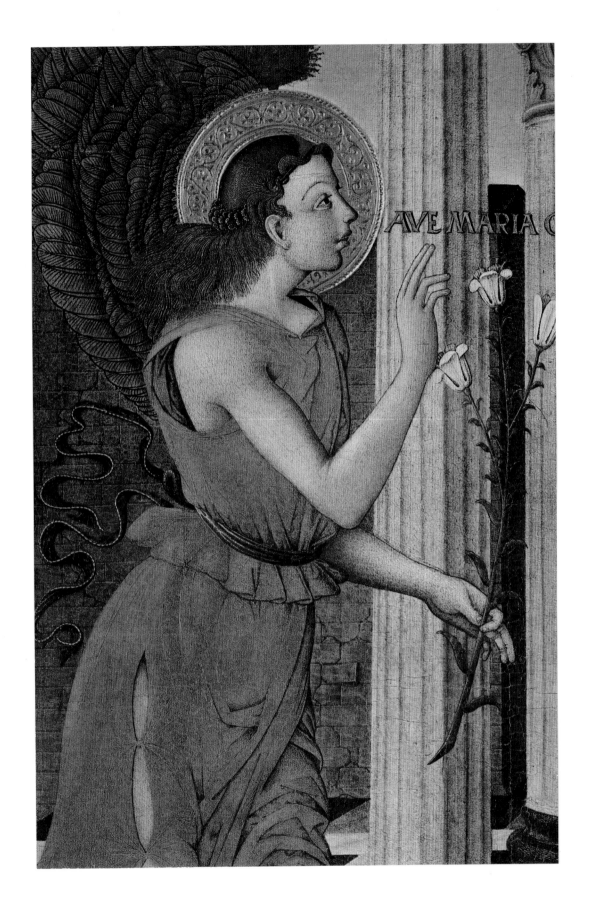

XXXII. Nicola di Maestro Antonio da Ancona: *The Angel of the Annunciation.*
Detail from plate 162. Urbino, Galleria Nazionale

Master of the Barberini Panels, Giovanni Angelo di Antonio). Serra's account turns Nicola's real artistic development completely upside down. For it is clear that Nicola, like so many other Marchigian artists of his generation, was attracted to the art of Padua in his youth, perhaps even attaining to the more violent aspects of the expressionism so characteristic of that art, only to return to increasingly milder, calmer modes of expression as the years went by. His development can be followed from the Cornbury altarpiece to that of the Massimo Collection, and finally to the Urbino *Annunciation*.

His only dated work, that of 1472 (plate 156), does not reveal any direct connection with Crivelli; rather, as we have said before, it shows the influence of Schiavone, whose colleague and intimate friend he must have been during his stay in Padua. For it would be unfair to an already excessively maligned Squarcione, to deny that the almost caricature-like expressionism of the Saints in the 1472 panel is only a forced imitation, but no less significant for this, of the Paduan artist's style, carried to the point of a paradoxical, grotesque radicalism. The *Crucifixion* in the Academy in Venice, which Longhi sees as one of Nicola's very earliest works, undoubtedly derives from that of S. Zeno, but it is not easy to establish any direct links that connect it with the artist's known works. Moreover, it recalls in a way that reveals sufficient familiarity with the artist for it not to be a coincidence, similar compositions by Boccati; so much so as to suggest that it may be the work not of Nicola, but of Giovanni Angelo di Antonio, who may have done it after visiting Padua, however briefly, together with Boccati, his friend and colleague, whom he accompanied on his various journeys in Umbria, and possibly in Tuscany. Returning to Nicola di Maestro Antonio, we must add that the 1472 altarpiece shows that he was not unaware of Piero della Francesca either. This can be seen in the luminosity of the whole painting, and in the clarity of the landscape background behind the figure of St. John. In brief, Nicola's artistic formation must have taken place, as in the case of many other painters from the Marches, in an orbit that gravitated between the style of Padua and the school of Urbino, under the influence of Piero della Francesca. Later, as we have already mentioned, his style becomes less and less violent and aggressive, until it finally loses all its pungency and is reduced to extreme fragility. But in his best works, the art of Nicola di Maestro Antonio has an inner strength and a style of extraordinary creative authenticity. We have only to look at two of his works: firstly, *Christ in the Sepulchre* at Jesi (plate XXXI), with its little clouds of "dry ice" (typical of all the Marchigian painters of Paduan extraction) floating in a turquoise sky, and Christ's swollen, violet-coloured veins standing out in His hands; and secondly, the stupendous *Magdalen* in the Ashmolean Museum in Oxford (plate 157), with a bloodless face wholly expressive of an inner spirituality, and stiff, splayed fingers, which evokes an unforgettable formal rhythm.

And so, Nicola di Maestro Antonio, previously set apart and wrapped in mystery, has come forward and revealed himself. He is by no means a follower of Crivelli, as Berenson and Serra maintained; nor did he come under his influence later on, as Longhi was inclined to believe. There is not a trace, direct or indirect, of Crivelli's influence in the 1472 panel, which was done no less than four years after the Venetian's arrival in the Marches; nor is there any trace of it in Nicola's later works, in which he yields to the pressures of local influences, in a way however, that always subordinates to that disturbed, awe-stricken world which constitutes the characteristic unity of his painting.

Catalogue of works
[*see plates XXXI, XXXII,* 156–162].

Baltimore, Walters Art Gallery, *St. John the Baptist.*
Basle, Tobias Christ Coll., *St. Anthony Abbot.*

Berlin-Dahlem, Gemäldegalerie, *St. Sebastian between SS. Jerome and Roch.*

Capetown (S. Africa), Robertson Coll., *Stonyhurst Madonna.*

Cornbury Park (Charlbury, Oxon.), Watney Coll. (formerly), now in America it seems: *Madonna Enthroned and Saints* (signed and dated 1472).

Jesi, Gallery, *Pietà.*

London, Courtauld Institute, *St. Peter.*

Montefortino, Pinacoteca, *Lunette with SS. Anthony, Lucy, and Bernardino.*

New York, Brooklyn Museum, *Decapitation of John the Baptist, Martyrdom of St. Lawrence, Annunciation, Martyrdom of St. Stephen, Miracle of St. Anthony* (predella of the Massimo altarpiece).

Oxford, Ashmolean Museum, *St. Mary Magdalen; St. Francis.*

Rome, Palazzo Massimo, *Altarpiece representing Madonna Enthroned with SS. Lawrence, Stephen and Anthony of Padua* (the lunette is in York, and the predella in Brooklyn).

Rome, Vatican Gallery, *Madonna Enthroned between SS. Anthony of Padua, Andrew, Anthony Abbot, and a Donor* (detached fresco assembled on panel).

Turin, Sabauda Gallery, *St. Jerome Repentant.*

Urbino, National Gallery, *Annunciation and two Saints* (triptych).

York, Museum, *Resurrection* (lunette of the Massimo altarpiece).

## NOTES

1.  The document testifying to the artist's condemnation is in the Archivio di Stato of Venice and was published in 1905. It is included in P. Zampetti's *Carlo Crivelli*, Milan, 1961. The document regarding Carlo Crivelli's presence in Zara has been transcribed by Praga and then published in "Arte Veneta", 1960 (P. Zampetti, *Carlo Crivelli in Zara*). As for the relationship between Crivelli and Giorgio Chiulinovich, it must be remembered that the Dalmatian left his home town when he was still very young. On 28 March 1456 he was in Venice, where he entered into a partnership with Squarcione, to whom he remained tied by contracts that were renewed in 1456 and 1458. He is undoubtedly a strict follower of Squarcione's, a fact borne out by his works as well as his own explicit declaration in the polyptychs of Turin and London, where he signs himself as a disciple of the Paduan master. It is not clear how long he stayed in Padua, but we know that on 19 November 1461 he was back in Dalmatia, in Zara to be precise, after leaving Padua as a result of a quarrel with Squarcione (something that this strange master did with all his pupils). But when Schiavone left Padua, he took with him some of his master's drawings. Schiavone's departure was, in fact, a real flight, and this led to a long dispute, which the two carried on at long distance. Nor must we exclude the possibility that Schiavone and Crivelli went to Dalmatia together. The stylistic affinity between Crivelli's early works and those of Schiavone had already caught the attention of Morelli in 1897, besides that of other critics. The discovery of the documents which testify to Crivelli's presence in Zara in 1465 suggests that the two painters may have lived together and shared their interests, and that they may have been joined by Vittore, and perhaps by Pietro Alemanno too, as his early style is also similar to Squarcione's. Though one sees the riskiness of this hypothesis, it must not be forgotten that in 1463 Giorgio Schiavone married Flavia, the daughter of Giorgio Orsini, the famous architect and sculptor who divided his activity between Dalmatia and the Marches; and not only at Ancona, as was once believed, but at the Ducal Palace of Urbino too. Moreover, Orsini must have almost certainly begun his activity in Venice, working together with Giovanni and Bartolomeo Bon on the Porta della Carta in the Doge's Palace, and probably contributing to the sculpture which decorates the corridor leading to the Arco Foscari. It is therefore almost certain that Carlo Crivelli and Giorgio Orsini must have known each other, and fairly intimately. It is not improbable, therefore, that it was the Dalmatian sculptor and architect who prepared the way for Crivelli before he went to the Marches.

2.  The series of documents at Ascoli regarding Crivelli and his family has been collected by G. Fabiani in *Ascoli nel Quattrocento*, published at Ascoli Piceno: the first part in 1950, and the second in 1951. Crivelli's wife was called Juranda Marini. She must have been considerably younger than the painter to be still alive in 1524. The artist probably married late, and in the Marches, after the wandering life of his youth was over.

3.  The Huldschinsky Madonna, which comes from the Royal Collections of Athens, has always been considered an early work of the artist. The variant, signed "Opus P. Petri", was attributed to Calzetta by Roberto Longhi in his *Lettera Pittorica a Giuseppe Fiocco* in "Vita Artistica", 1926, pp. 127-139.

4.  It is incredible how Crivelli's works were plundered in the course of the nineteenth century. This accounts for most of the difficulties involved in reconstructing his artistic development and in establishing the influence he exercised on the art of the region. These difficulties mounted as his works were gradually dismembered, and parts of his polyptychs were detached and scattered in such a way that it is now an arduous task trying to reconstruct their original appearance.

5.  The artistic personality of Crivelli is undoubtedly one of the most complex and most difficult to follow in Italian art. This is the reason why certain historicist ideas end by becoming meaningless formulae, since the artist is really *sui generis* and cannot be defined in any way, except by taking into consideration the particular artistic condition in which he lived. This is not only true of Crivelli, but also of the Marchigian painters with whom he lived. In fact, these artists can hardly ever be defined as belonging to this or that current. Sometimes it is difficult to classify them as "Renaissance" or "late Gothic" painters. The truth is that they are just themselves, even when measured according to the scale of their experiences.

6.  For the presence of Vittore Crivelli in Dalmatia and his early works in the Marches, see the catalogue of the *Mostra di Carlo Crivelli e i Crivelleschi*, Venice, 1961. That he was the brother, and not, as some critics have believed and continue to believe, the son of Carlo is proved both by their ages, the two artists having

worked contemporaneously, and by the fact that both are referred to as the sons of Jacopo; sons, therefore, of the same father. Vittore also called one of his sons Jacopo, as an evident compliment to the child's grandfather. Moreover, it has been shown, in confirmation of the above, that Vittore and Carlo died at about the same time. In fact, Carlo died shortly before the end of the century, and Vittore between 1501 and 1502.

7. In the following catalogues of works by Carlo and Vittore, the first shows, when possible, where the works come from, and how they are connected to other paintings, if they happen to be parts of a polyptych. This list, it must be remembered, has been drawn up on the basis of those compiled by Berenson, though it sometimes differs as a result of divergent points of view. For example, Berenson attributes the Cracow panel to Pietro Alemanno, whereas here it is assigned to Carlo Crivelli, as part of the Porto S. Giorgio polyptych. One might also question the attribution of the Vatican polyptych (*Madonna and Child with SS. Jerome, Augustine, John the Baptist and John the Evangelist*), which Drey (1927) excluded from his list of the artist's works, while Berenson accepted it as being largely his. It is certainly his work as far as the central panel with the Madonna and Child is concerned, while there seems to be a great affinity with Alemanno in the Saints on the lateral panels. It may be the result, therefore, of a collaboration between the two artists (a very rare case of its kind, indeed the only one, if it ever did take place). In any case, Vittore Crivelli must be excluded as its possible author, even though the work is attributed to him in the Vatican catalogue compiled by Ennio Francia (1960). As for Vittore, the catalogue that follows is based on Berenson's praiseworthy lists.

8. I fail to see any connection between Alemanno and Gerolamo di Giovanni. But for this question, see Grassi's article *Dipinti ignoti di L. Salimbeni e dell'Alemanno* in "Critica d'Arte", 1950, pp. 60–69.

9. For this subject, see Fabiani, *Ascoli nel Quattrocento*, vol. I, 1950, vol. II, 1951. The fact that when Alemanno died his children were all so young, makes it even less probable that he began painting very early in life, as the Torre S. Patrizio fresco of 1466 would confirm, were it definitely attributed to him. The fact is that the earliest information we have regarding him only goes back as far as 1477. If he was active in 1466, his date of birth would have to be moved back to 1445 at least. If, therefore, he died in 1498, with all his children under age, it seems hardly justifiable to think of him as being already old, and more logical to imagine him as a fairly young man.

10. Recent critical opinion has changed regarding the figure of Alemanno, especially after the 1950 Ancona Exhibition, and the one of Venice in 1961. See the relative ages in *Carlo Crivelli e i Crivelleschi*, Venice, 1961. Dania insists on the authenticity of the Torre S. Patrizio fresco in his excellent book, *La pittura a Fermo e nel suo circondario* (1967). The fresco is signed, but the signature is not easy to read. The inscription is quoted by Dania thus: "1466 Petrus Alima . . . pinxit". Besides, the condition of the painting, as well as the many obvious restorations it has undergone, make its interpretation a difficult and controversial matter.

11. Here is Folchetti's list of works, which is obviously incomplete, for there is no critical, exhaustive catalogue of the works of art in the region. It has been drawn up on the basis of data provided by Serra (1934) and Berenson (1958): Amandola, church of S. Francesco, *Frescoes representing the Annunciation, the Crucifixion, Evangelists and Saints;* ib., church of the Rosary, *Madonna and Child* (fresco, 1492); Philadelphia (Pa.), Johnson Collection, *Adoration of the Shepherds;* Recanati, Cathedral (Sacristy), *SS. Francis and Ubaldus;* San Ginesio, Gallery, *Madonna Enthroned with Saints* (1492); ib., *Madonna Enthroned with SS. Liberatus and Francis* (1498); ib., Collegiate Church, *Madonna Enthroned with Saints* (fresco); ib., church of S. Gregorio, *Madonna Enthroned, Angels and Donor* (Stefanus Folchetti me pinxit, 1506); ib., church of S. Michele, right-hand chapel, *Madonna Enthroned with SS. Anthony of Padua, Jerome, Francis and John the Baptist;* ib., *The Deposition with Saints;* Sarnano (Macerata), Gallery, *Crucifixion* (1513); Urbisaglia, Collegiate Church, Triptych: *Madonna with St. Catherine and other Saints;* the *Annunciation;* predella with *Christ and the Apostles* (1507); ib., chiesa della Maestà, *Pietà;* ib., church of S. Maria di Brusciano, *Madonna and Child, Angels and Donor* (1494).

12. For this subject, see F. Bologna, *La ricostruzione di un polittico e il Maestro dei Polittici Crivelleschi* in "Bollettino d'Arte", 1948, pp. 367–70.

13. Andrea Delitio has greatly interested modern critics. See E. Carli, *Per la pittura del Quattrocento in Abruzzo* in "Rivista dell'Istituto di Architettura e di Storia dell'Arte" (1952, IX, pp. 127 *et seq.*); F. Bologna, *Andrea Delitio* in "Paragone", V, 1950, pp. 44–50.

14. Amongst the painters who felt the influence of Crivelli must be included the author of the panel representing the *Madonna and Child with Saints* in the Gallery of Ascoli Piceno (plate 155), a work that has been attributed by Longhi and other critics to Paolo da Visso. This artist's formation is made up of Umbrian and Marchigian elements, though his artistic personality has not yet been completely reconstructed. He also felt the influence of the Camerinese painters, but was perhaps spurred by the presence of Crivelli. The painting in the Ascoli gallery also recalls the style of Matteo da Gualdo and Caporali. Finally, in my opinion, Nobile da Lucca, the author of the panel dated 1490 in the conventual church of Colfano (Macerata), is not so much tied to the style of Boccati (though a certain affinity may be acknowledged in the sense indicated by Vitalini Sacconi, 1967, p. 210) as to that of the followers of Crivelli, particularly that of Pietro Alemanno.

15. A. Ricci, *Memorie storiche delle arti e degli artisti della Marca di Ancona*, I, Macerata, 1834, p. 234 and notes.

16. B. Berenson, *Nicola di Maestro Antonio di Ancona* in "Rassegna d'Arte", 1915, pp. 165 *et seq.*

17. B. Berenson, *op. cit.*, pp. 167–68.

18. L. Serra, *L'arte nelle Marche*, Rome, 1934, pp. 352 *et seq.*

19. Longhi's article was published in "Arte Veneta", 1947, pp. 185–86. Zeri's *Qualcosa su Nicola di Maestro Antonio* appeared in "Paragone", 107, 1958, p. 34 *et seq.* He rightly denies that the artist painted the *Pietà* now in the National Gallery of Urbino, but formerly at Sant'Agata Feltria. As I have already said (Catalogue *Crivelli e i Crivelleschi*, Venice, 1961), I do not agree with him in attributing this painting to Vittore Crivelli, since it seems to be the work of a far better artist, and of one who had been in direct contact with the world of Venice and Padua, as his knowledge of Giovanni Bellini's *Pietà* in the Brera shows. It is another work in search of an author.

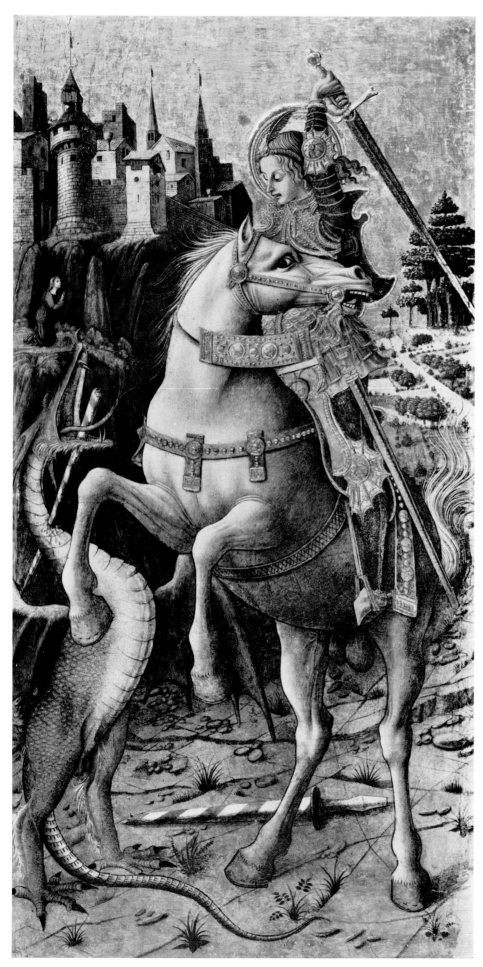

135. Carlo Crivelli: *Saint George and the dragon*. Boston, Isabella Stewart Gardner Museum.

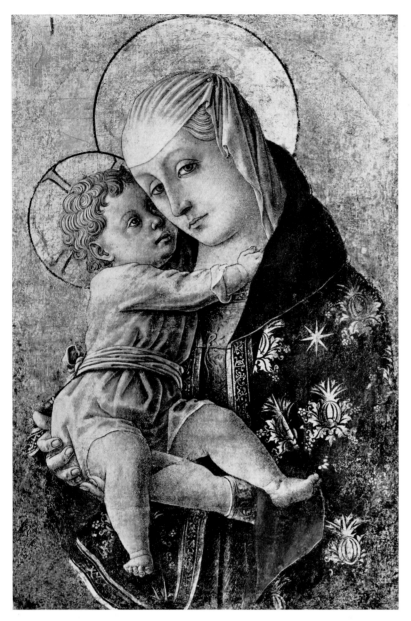

136. Carlo Crivelli: *Virgin and Child*. Macerata, Pinacoteca Civica.

137-138. Carlo Crivelli: *The Virgin nursing the Child*. Corridonia, Parish Museum.

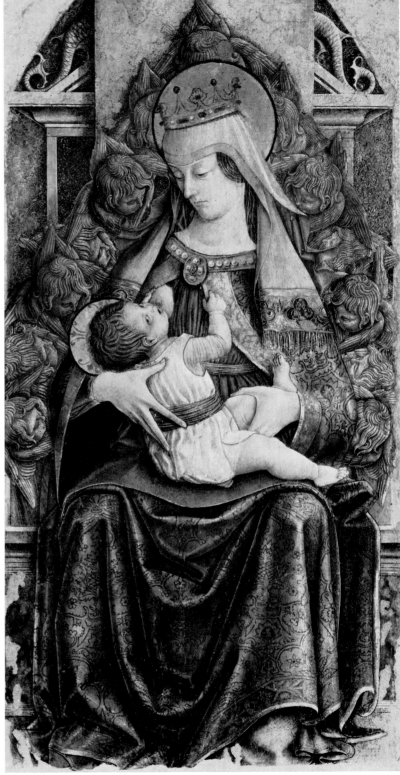

139. Carlo Crivelli: *Virgin and Child*. Detail from a polyptych. Ascoli Piceno, Duomo.

140. Carlo Crivelli: *Saint George*. Detail from a polyptych. Ascoli Piceno, Duomo.

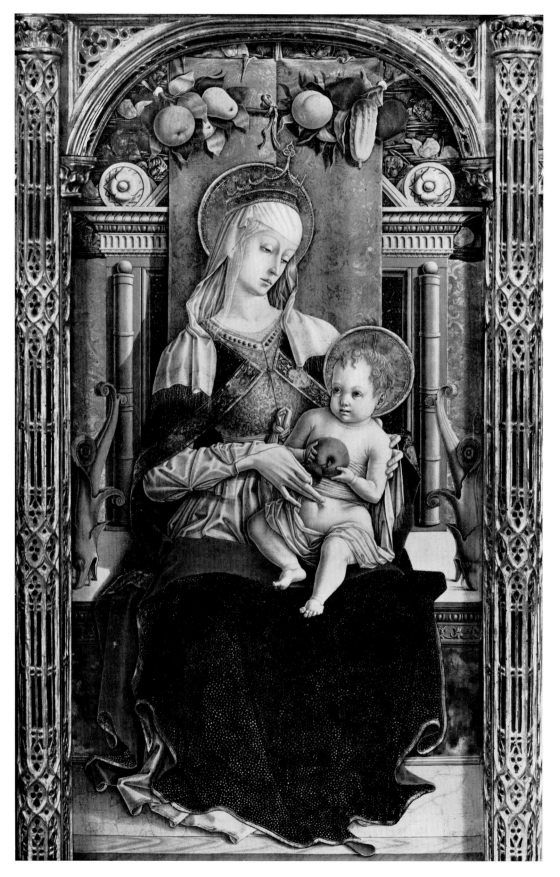

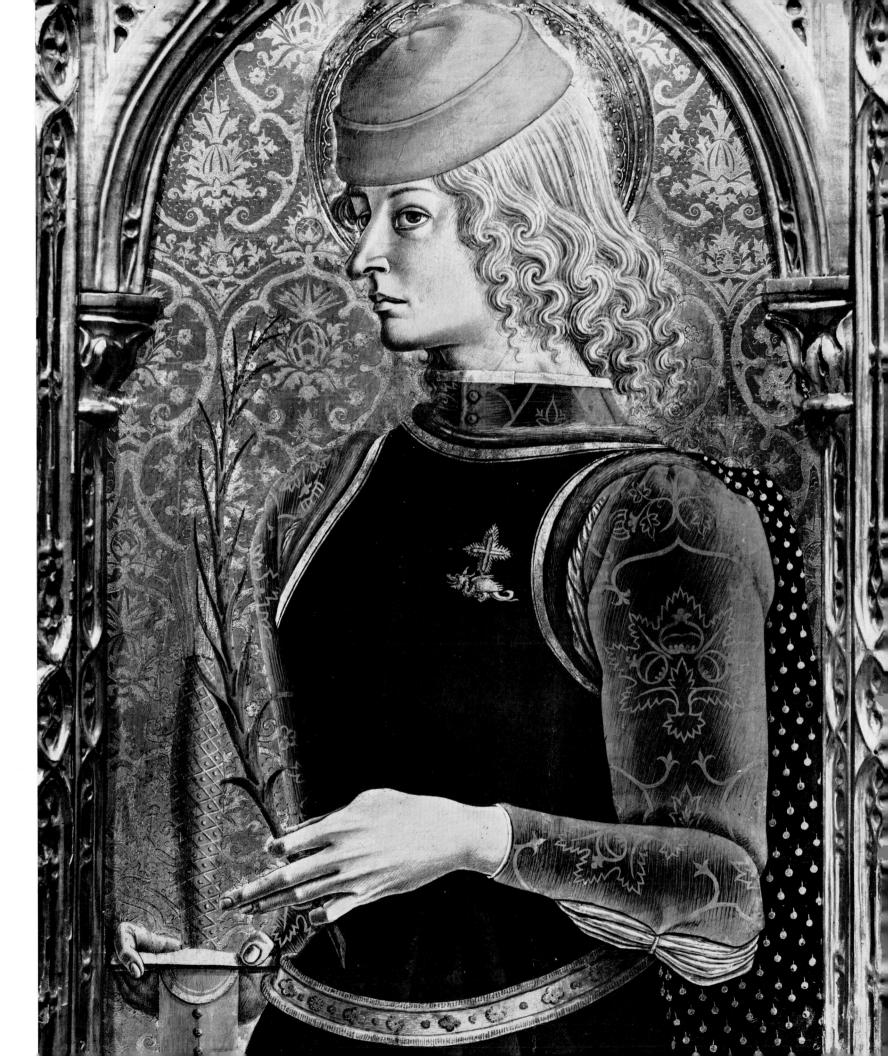

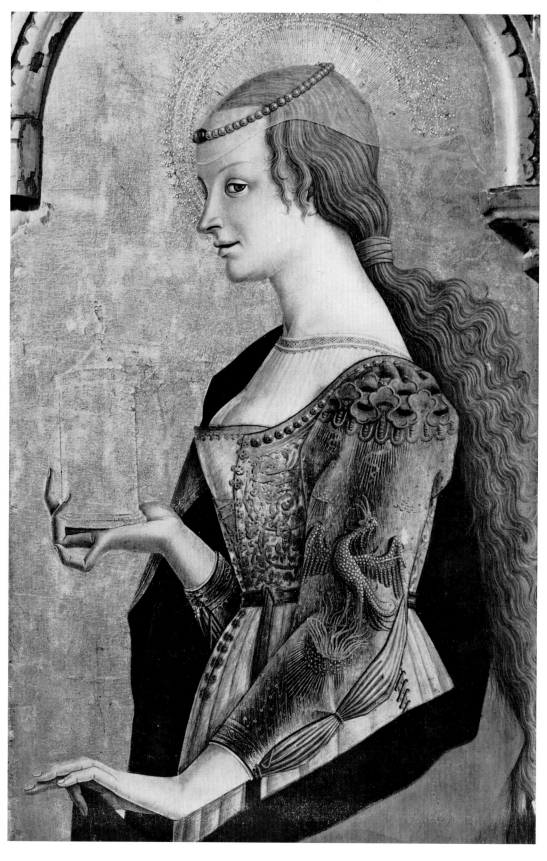

141. Carlo Crivelli: *Saint Mary Magdalen*. Detail from a triptych. Montefiore dell'Aso, Church of S. Lucia.

142. Carlo Crivelli: *Fruit*. Detail from *The Vision of the Blessed Gabriele Ferretti*. London, National Gallery.

143. Carlo Crivelli: *Landscape*. Detail from *The Vision of the Blessed Gabriele Ferretti*. London, National Gallery.

144. Carlo Crivelli: *Saint Mary Magdalen*. Detail from the *Pietà*. Milan, Brera.

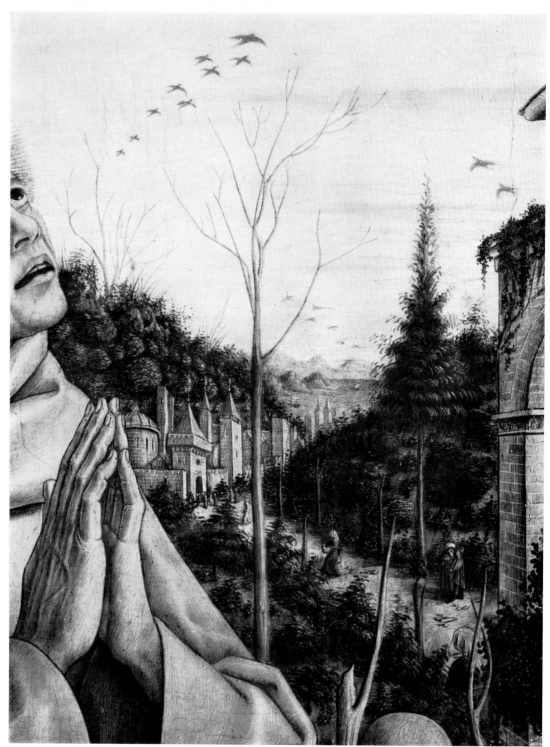

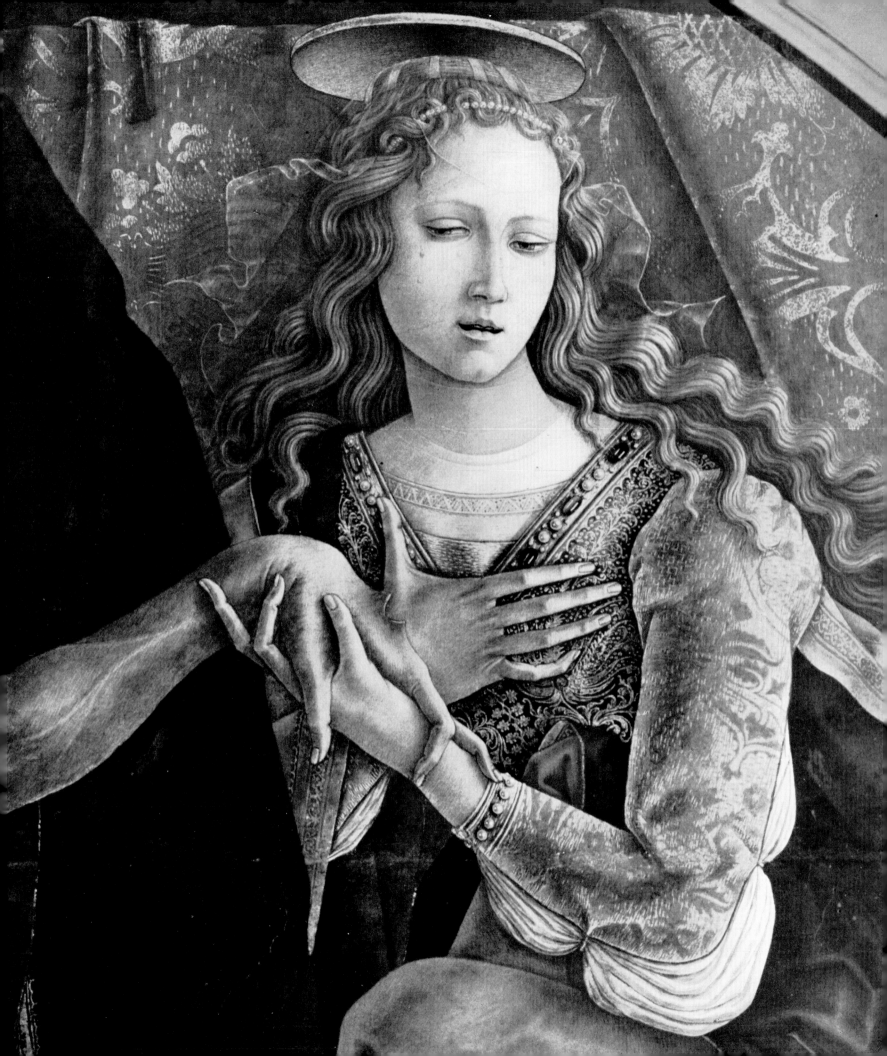

145. Pietro Alemanno: *The Virgin adoring the Child*. Montefortino, Pinacoteca Civica.

146. Pietro Alemanno: *Saint Lucy*. Montefortino, Pinacoteca Civica.

147. Pietro Alemanno: *Triptych: The Virgin adoring the Child, with two Saints*. Castel Folignano, Parish Church.

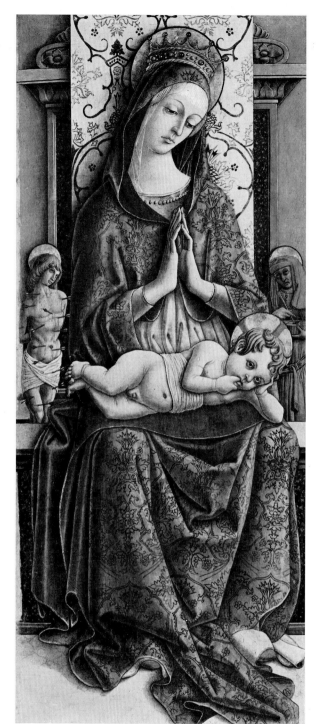

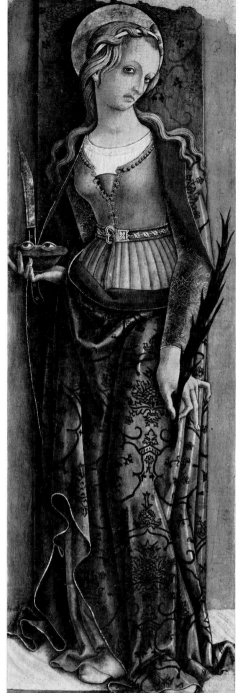

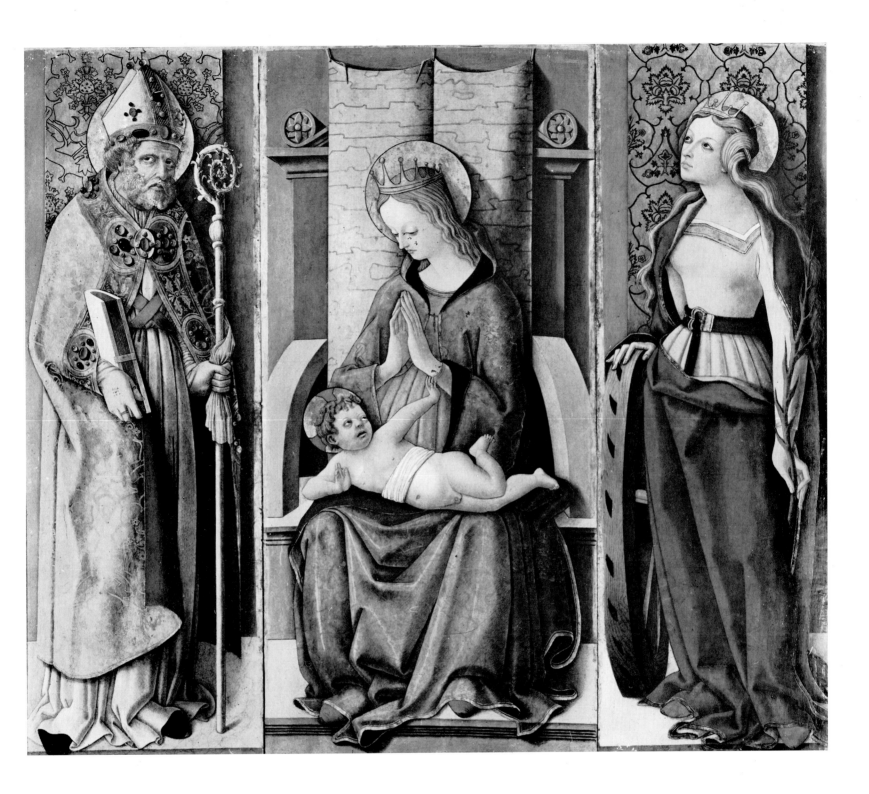

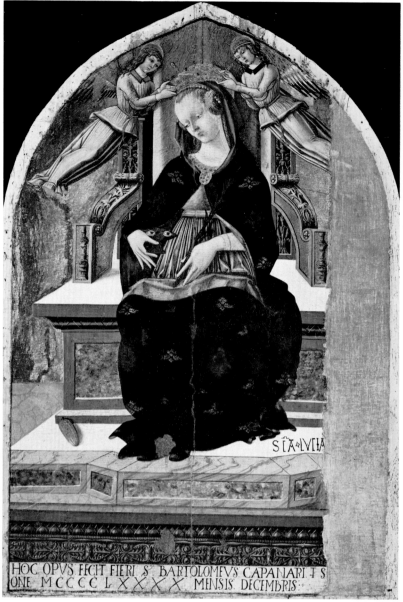

148. Imitator of Crivelli: *Virgin and Child*. Fermo, Church of S. Agostino.

149-150. Imitator of Crivelli: *Saint Lucy*. Offida, Palazzo Municipale.

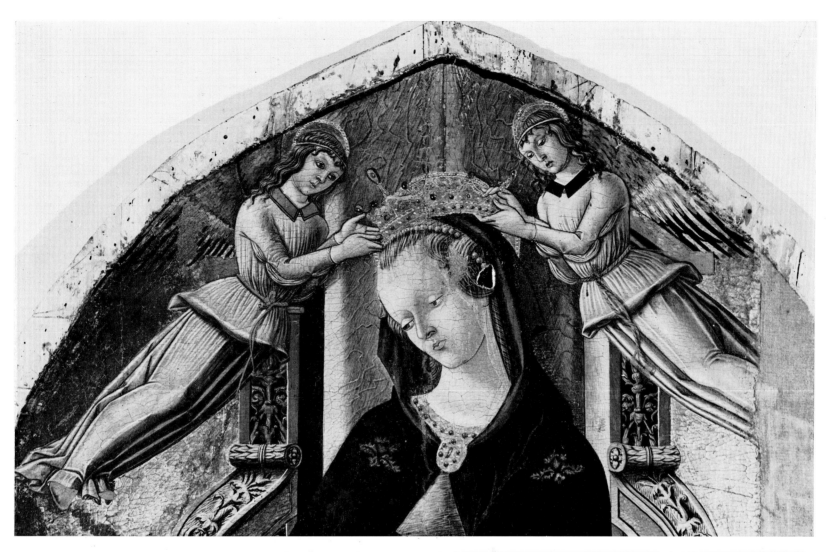

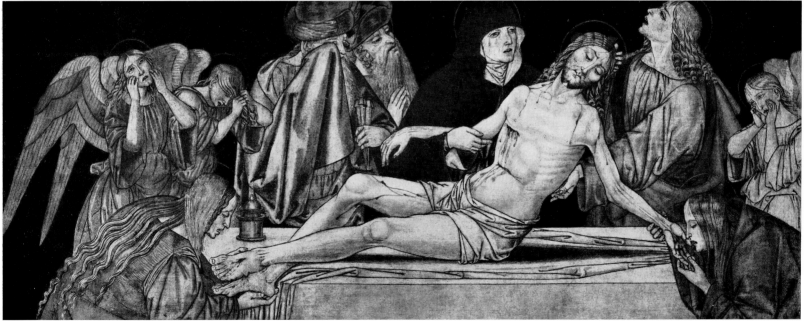

151. Bernardino di Mariotto: *The Entombment*. San Severino Marche, Pinacoteca Civica.

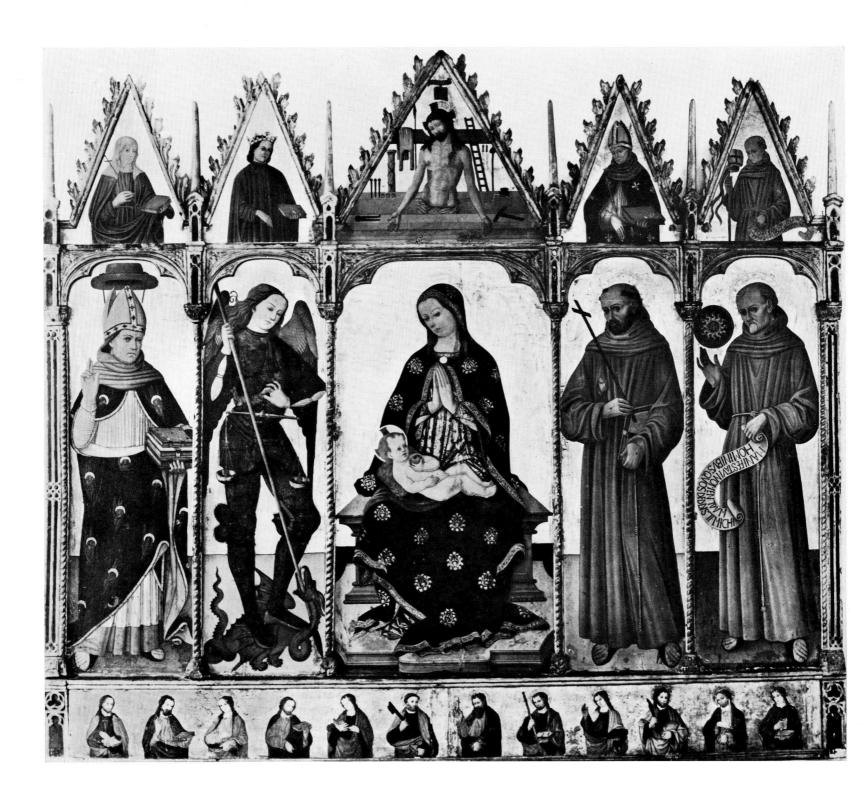

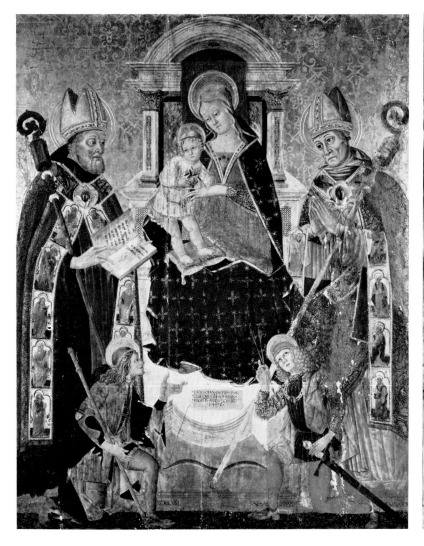 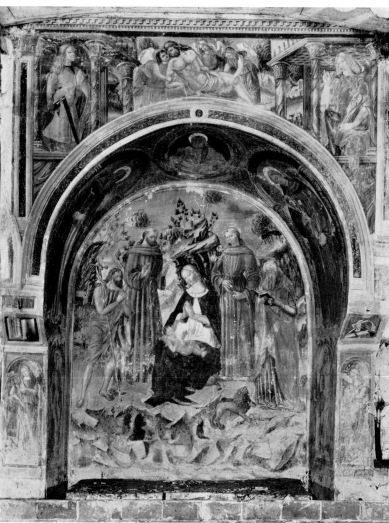

153. Stefano Folchetti: *Virgin and Child with Saints*. San Ginesio, Pinacoteca Civica.

154. Stefano Folchetti: *Frescoed niche: Virgin and Child with Saints*. San Ginesio, Church of S. Michele.

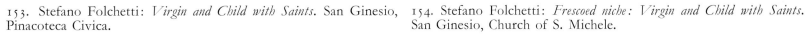

152. Master of the Crivellesque Polyptychs: *Polyptych: Virgin and Child with Saints*. Formerly Knaresborough, Harewood Collection.

 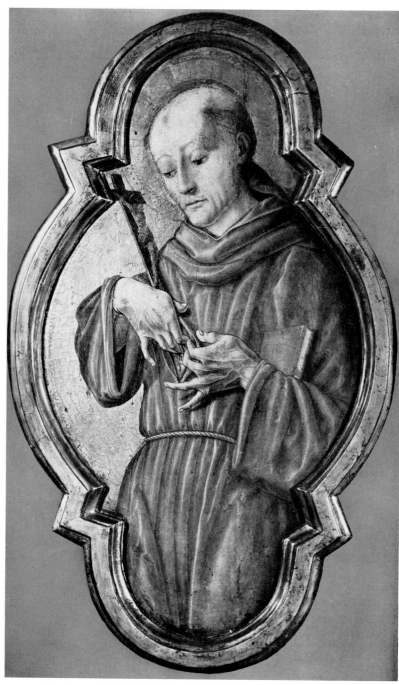

157-158. Nicola di Maestro Antonio da Ancona: *Saints Mary Magdalen and Francis*. Oxford, Ashmolean Museum.

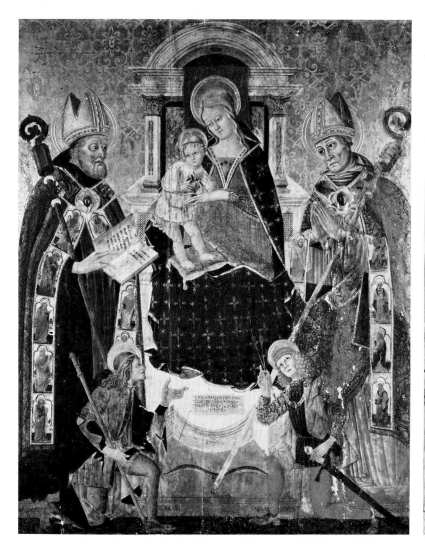

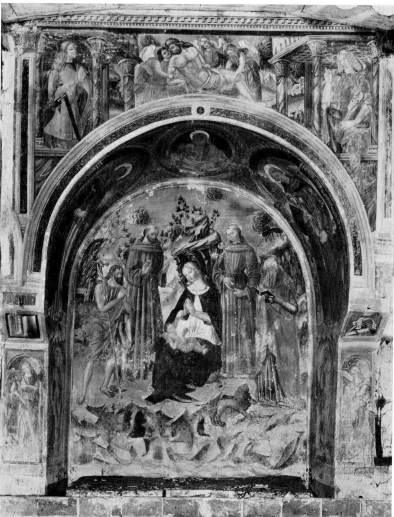

153. Stefano Folchetti: *Virgin and Child with Saints*. San Ginesio, Pinacoteca Civica.

154. Stefano Folchetti: *Frescoed niche: Virgin and Child with Saints*. San Ginesio, Church of S. Michele.

152. Master of the Crivellesque Polyptychs: *Polyptych: Virgin and Child with Saints*. Formerly Knaresborough, Harewood Collection.

155. Paolo da Visso (?): *Virgin and Child with Saints;* above, *Pietà*. Ascoli Piceno, Pinacoteca Civica.

156. Nicola di Maestro Antonio da Ancona: *Virgin and Child enthroned with Saints*. Formerly Cornbury (Charlbury, Oxfordshire), Watney Collection.

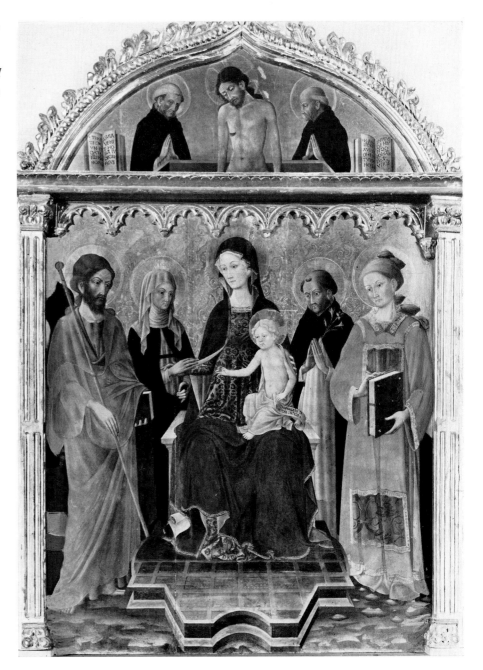

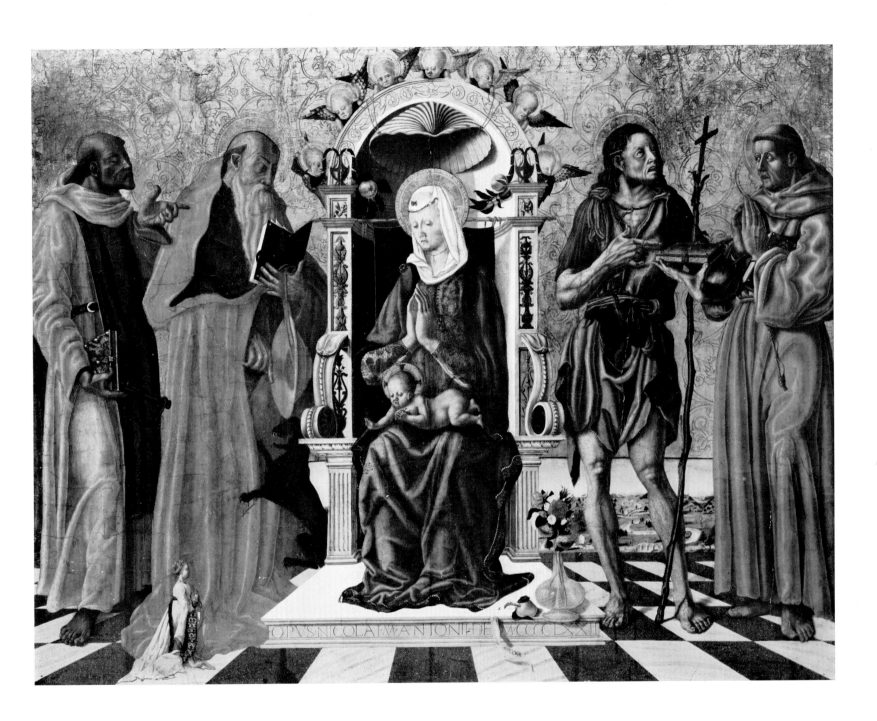

157-158. Nicola di Maestro Antonio da Ancona: *Saints Mary Magdalen and Francis*. Oxford, Ashmolean Museum.

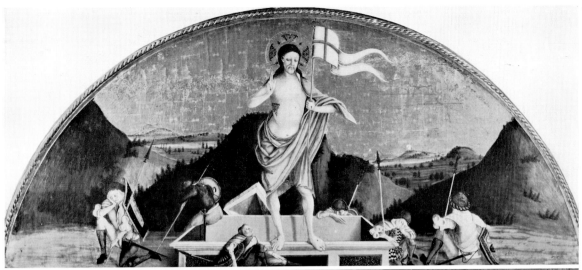

159. Nicola di Maestro Antonio da Ancona: *The Resurrection*. York, City Art Gallery.

160. Nicola di Maestro Antonio da Ancona: *Virgin and Child with Saints*. Rome, Palazzo Massimo alle Colonne.

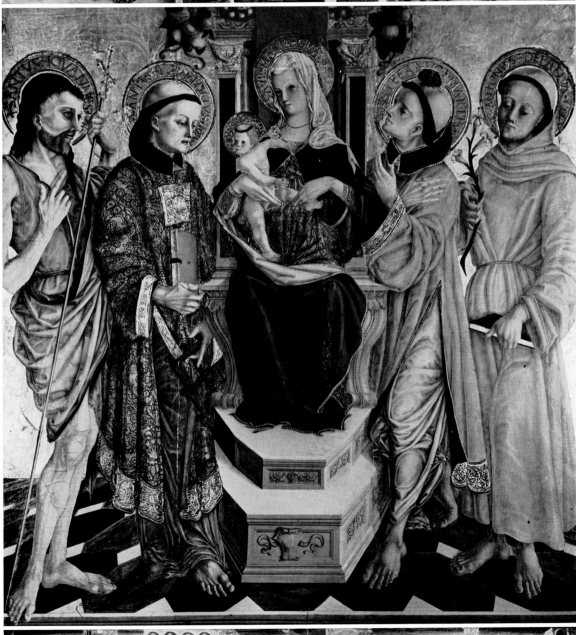

161. Nicola di Maestro Antonio da Ancona: *Predella: The Annunciation and legends of Saints*. New York, Brooklyn Museum.

162. Nicola di Maestro Antonio da Ancona: *The Annunciation.* Urbino, Galleria Nazionale.

# THE ARTISTIC ENVIRONMENT OF URBINO
## AND THE ORIGINS OF RAPHAEL

Urbino is a very ancient town, and its origins are certainly pre-Roman. But the greatest moment in its thousands of years of history came during the fourteenth and fifteenth centuries, when as a result of a series of favourable circumstances, it became one of the most vital centres of Renaissance civilization. The medieval history of Urbino is full of dramatic events, which often led to bloodshed.[1] But the centuries of strife resulted in the gradual emergence of a family of powerful lords, the Montefeltros, whose first known member is Montefeltrano, vassal of the Emperor Frederick I, more commonly known as Frederick Barbarossa. The latter invested him with the territories of Montefeltro, then Urbino, Pesaro, and Rimini. His sons were Buonconte (who is mentioned by Dante) and Taddeo, both professional soldiers, in a family tradition that was to continue down the years. Little by little, the Montefeltros prevailed over all other authority, and established their Signoria over the territory, in spite of struggles with the Pope and with the Malatesta family, who were their rivals in the area between the Marches and the Romagna. On 21 December 1375, Antonio da Montefeltro, after instigating a popular rising against papal interference, took possession of Urbino and was elected its lord by popular acclaim. Antonio, besides being a military commander, was also a very able politician, and succeeded in obtaining papal recognition of his possession from Boniface IX. Moreover, he was the first to introduce that refined court life which was to remain a characteristic of Montefeltro rule.

Before the life of Urbino underwent the changes introduced by Federico, the town had already shown signs of considerable artistic vitality, which is attested by the frescoes in S. Domenico, some of which have been attributed to the Master of the Coronation of Bellpuig, who is to be identified with the mysterious "Antonius Magister", who signed a panel in the Gallery of Urbino. Even earlier, during the fourteenth century, painters of the Riminese and Emilian schools must have been active in the town, until the advent of the International Gothic movement, which soon flourished under the guidance of four principal artists. These were the Salimbeni brothers from San Severino, authors of the frescoes in the Oratory of S. Giovanni, Antonio Alberti from Ferrara, and finally, Ottaviano Nelli from Gubbio, whose vital artistic personality must be re-examined on the basis of the frescoes he did in the church of S. Francesco in his home town, which have only recently been fully revealed. However, these artists were foreigners in Urbino, and were not permanently resident. The only local painter—who came from Pesaro not Urbino—to adhere to the International Gothic movement was Giovanni Antonio da Pesaro, whom Zeri has identified and distinguished from Antonio da Fabriano, with whom he had long been confused. Zeri has drawn up a catalogue of his works, among which are polyptychs at Sassoferrato

(plate 124, 125) and Cingoli. There is no particular distinction about this painter; he did no more than extend a style that had already spread widely. He was however, the leader of a number of artists active along the Adriatic coast, who were also influenced by the left-overs of various schools, the Riminese and Emilian schools in particular. His art is characterized by a certain immobility and a contemplative, almost iconic quality. He took his place, therefore, in an already well-established artistic current, without making any special, original contribution of his own. Moreover, it cannot be confirmed that he actually did work at Urbino, whereas he did leave traces of his work in his home town.[2]

When Antonio Montefeltro died in 1404 he was succeeded by Guidantonio, who continued his policy of friendly relations with the Church, taking as his second wife Caterina Colonna, the niece of Pope Martin V, and extending the territories under his rule as far as Massa Trabaria and Castel Durante (now Urbania). Guidantonio died in 1443, leaving the young Oddantonio the heir of vast possessions at the age of sixteen. Oddantonio was immediately invested with the duchy by Pope Eugenius IV, the ceremony being celebrated in the cathedral of Siena on 26 April 1444. But in the same year he was the victim of a plot. This led to the intervention of his half-brother, Federico, who was a professional soldier. Finding himself in the neighbourhood of the town at the time of the plot, he entered it at the head of his troops and seized the Signoria. He was twenty-two years of age at the time, but was already famous for his military prowess. Under his rule Urbino underwent so profound a change that it became of outstanding importance in the political and cultural life of Italy.

The year 1444, therefore, was a very important one in the history of Urbino. Besides being a *condottiero*, Federico was also a patron of the arts and a humanist (he had been the pupil of Vittorino da Feltre at Mantua), and he succeeded in giving the city a new impetus, increasing its wealth and making it one of the finest centres of Renaissance civilization.

Evidence of this fortunate moment in the life of Urbino, and of the enlightened, forceful personality of its ruler, is the palace which Federico built as his residence to replace the old family one, which was later rebuilt and is now the seat of the University.

The new palace was not built according to a single plan, nor over a short period of time. In all probability, work was started on it about 1450, when Federico decided to modernize and restore the old buildings which stood almost in front of the church of S. Domenico, and which are now a part of the east façade. An example of Renaissance architecture has already appeared in the work of those who carried out the first phase in the building's construction, which includes the so-called Jole apartment, after the female figure carved in the main salon of this more ancient part of the edifice. Without going into the particulars of the many arguments and theories concerning the tortuous vicissitudes of its construction, it is clear that the little palace was not intended to stand alone (in this case, it would have been no bigger than the old palace, and there would have been no point in building it), but must have been planned as the initial nucleus of a much larger building. The east façade, with its beautiful mullioned windows carried out in a Renaissance style that was still in its youth, and not free from a trace of nostalgia for Gothic forms, was extended to the north and south, where it incorporated a number of old buildings. It was then turned laterally at a right angle towards the west, so as to give the building the form of a large square, with a central courtyard in the middle. The first architects were Florentines, led by Maso di Bartolomeo, who also did the main door of S. Domenico. There were also sculptors working with them on the palace. If the palace appears to day uneven in its parts (and time has failed to amalgamate them), it is because the old plans were replaced by new ones, and its construction proceeded along far more complex lines. The new plans were drawn up by Luciano Laurana, to whom Federico granted a patent in 1468, authorizing him to assume the direction of the work. Laurana extended the construction northwards so as to join

it up with the old Montefeltro fort, the so-called "castellare", which thus became the extreme northern part of the new wing. The building was also extended to the south, with the unfulfilled intention of connecting it with the old Gothic palace of the Montefeltro. But the most important part, that which best illustrated Laurana's genius as an architect, is the western façade, which forced him to think of a special solution for the ground on which it stands, for this side of the hill runs down steeply into the valley below. Undeterred by the difficulties involved, Laurana shaped nature and the formidable hill to his own architectural vision. By levelling and reinforcing it where necessary, and then ably exploiting its contours, he created the living, dynamic, architectural unit we know, which is so well adapted to the nature of the ground itself, and whose monumental proportions blend so wonderfully with the countryside around. To make this possible, much work was involved in the excavation and reinforcement of the hill and the valley. This produced the level piece of ground called the "Mercatale", out of which rises the craggy slope that forms the base of the bold west wall, commonly known as the "façade of the little towers". The view from the west is the most famous and beautiful the palace has to offer: the wall here seems to be thrust up into space, in such a way that the other parts of the building attached to it appear to fall away, leaving it alone and detached.

This style of architecture was not new; indeed, this façade invites comparison with some of the fortified Roman gates (for example those of San Paolo and San Sebastiano), also because it has the aspect of an "entrance to a city". But Laurana's merit lies in having transformed a strictly necessary and purely functional element, such as the gate, into a completely fantastic motif of pure spatial harmony, such as the "façade of the little towers". Moreover, it serves as a point of focus, where all the various parts of the palace converge and ramify, in which they find their most perfect and hamonious solution.

The spires on the top of the two towers seem to be out of keeping with Laurana's architectural ideas, which are always calm, serene and balanced. The way in which the two terminal cones stand out against the sky spoils the effect of the whole (it must have been even worse when the roof was not yet as high as it is now), and the decorative style of the cones' polygonal bases points to a later approach than Laurana's. However, the actual construction offers no evidence that the spires are the work of a later architect, since there are no additions or reconstructions in the masonry. Thus, if we are not to attribute to Laurana something that is stylistically out of character (and if one visualizes the towers without the cones, one cannot fail to recognize that the towers are aesthetically complete in themselves), we must conclude that the façade was completed by another architect after Laurana's departure. This artist, who carried on his predecessor's plans without interruption, and finally added the spires, was certainly Francesco di Giorgio Martini of Siena. The building recedes on both sides of the towers, leaving a very large space on one side, and a smaller space on the other. Towards the north, there is an ample hanging garden, closed on the west side by a wall connecting the north-west tower with the old "castellare", which had become the duchess' apartment. Thus, the latter faces the duke's apartment, which is that part of the building which has its maximum projection in the façade itself. On the other side of the towers is the so-called "cock's courtyard".

As we have mentioned, Federico's intention was that the palace should dominate and take up most of the hillside, so as to link up with the Montefeltros' old residence, which rises on its summit. The proof of this grandiose project is in that wing, reserved for guests, which projects southwards, and which was built even before Laurana's arrival and added to after his departure. Evidence of this project, which was interrupted and never resumed, is provided by the so-called "Pasquino's courtyard", in the centre of which was to have stood the family mausoleum of the House of Montefeltro. This grandiose plan was interrup-

ted, perhaps by the death of Battista Sforza in 1472, the same year in which Laurana left Urbino. Francesco di Giorgio, who took over the direction of the work after Laurana's departure, had a hand in the construction of this part of the building, as we can see from the style of the ample loggias of the southern façade. But the attempt to attribute the whole edifice to him, which has recently been renewed on the basis of a remark of Vasari's, must be rejected, since the architectural characteristics of the building itself, together with incontrovertible documentary evidence, prove the contrary.

In the sixteenth century it was decided to extend the building, and a second storey was added. As a result, the battlements which once crowned the palace walls were filled in, and the building took on its present shape, with its large, sloping roof. The inner courtyard also suffered from the addition of a second storey to the wings, since it broke the harmony of its architectural lines. Thus, the palace we see now took many years to build, and is the result of many different, unco-ordinated projects. In spite of this, or because of it, it embodies many of the architectural and decorative aspirations of the Renaissance, of which it is one of the finest examples.

All this is confirmed by the interior of the palace. The parts that are most clearly Laurana's—the throne-room, the rooms that make the duke and duchess' apartments, and the great courtyard—do not appear to conform exactly to the original plan. The architect had treated the spatial values—proportions between open spaces and structure, between light and shade—with the greatest harmony. But later, or perhaps even before his departure, the rooms were extensively decorated by Tuscan and Lombard artists, in styles that are often very different from each other. Thus, the doorways, windows, and chimneypieces—beautiful in themselves—form a contrast, too evident to pass unnoticed, between the ideal grandeur of the architect's global vision, which aims at the creation of vast areas of enclosed space, and the analytical detail (often too plastic, powerful, and abundant) of the decoration. In spite of this, Laurana's harmonious conception can still be seen. His ambition, which he achieved, to give the various rooms a well-defined, "created" form, has been neither contaminated nor impoverished, and his spatial vision remains intact. His greatest merit lies in the fact that he created such grandeur with apparently simple means, and in this he anticipated the achievements of later artists. How Laurana succeeded in creating this masterpiece is not easy to explain. He certainly began by following Brunelleschi and Alberti, and must have seen the latter's works at Rimini and at Mantua; there is documentary evidence to show that he stayed in the latter city. But he also felt the direct influence of Roman architecture. It has also been pointed out that he might have felt the influence of Piero della Francesca, the greatest artist ever to stay at the court of Federico. The *Flagellation of Christ* (plate XXXIII), which had already been completed by the time Laurana arrived at Urbino, could not have failed to interest him. The perfect harmony of its perspective, the relationship between architecture and figures, and finally, that grave solemnity, together with the crystalline clarity of the whole, must have been a decisive influence in the formation of Laurana's artistic sensibility. In this panel, light penetrates Italian art perhaps for the first time, with very specific functions of giving unity to the figures and objects, containing both in an immobility full of potential energy. The meaning of the painting too, is hidden and implied, for perspective is used to overcome the limits of time and space, and to create a metaphysical parallel between Christ in the background, and Duke Oddantonio da Montefeltro who also died at a very early age, the victim of a plot; the victim too, of evil counsellors, who stand by his side in the painting, and who were really responsible for his death; betrayed, therefore, like Christ, by those closest to him. The composition is bold and highly original, and has been conceived in a most subtle way, hidden as it is, in its monumental luminosity and apparent detachment from all human content.

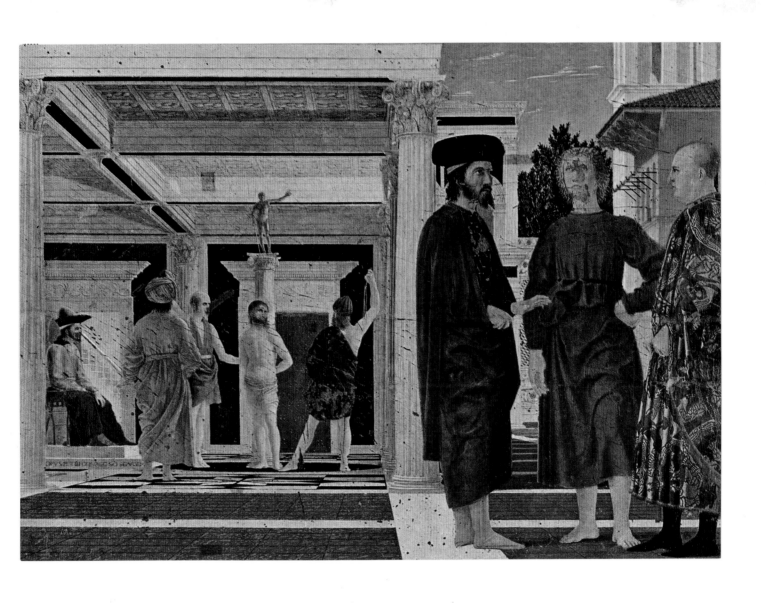

XXXIII. Piero della Francesca: *The Flagellation of Christ*. Urbino, Galleria Nazionale

Other artists from divers places entered into this refined, detached world, and contributed to the creation of that particular cultural atmosphere characteristic of Urbino. This was the world that gave birth to the art of Raphael, and where it first developed; for the origins of Raphael are to be found in Urbino, not in Florence or Rome. And when he left the city, he took with him that sense of the universal which characterized its culture, and which he must have absorbed from the architecture and painting of his native environment.

When Federico died suddenly in 1482, the duchy passed to his son Guidobaldo, who was by then only fourteen years of age. In 1488 Guidobaldo married Elisabetta Gonzaga. But life was soon made difficult for him on account of the tumulutous events that took place in Italy during the pontificate of Alexander VI, when Cesare Borgia began his conquest of the various towns of the Marches, leaving death and tragedy in his wake, as in the case of the ducal family of Camerino referred to earlier. Guidobaldo managed to escape, first to Mantua, then to Venice. After the death of the Pope, when Cesare's good fortune came to an end, the young duke was able to return to his city, which then went on to attain unprecedented splendour. Elisabetta Gonzaga gathered round her the most illustrious figures in Italian culture, such as Baldassare Castiglione, Cardinal Bembo, as well as Bibbiena, who presented his *Calandria* for the first time in the palace theatre. Not having a male heir, Guidobaldo adopted the little son of one of his sisters, Francesco della Rovere, with the consent of Cardinal Giulio della Rovere, who was later to become the great Pope Julius II. The latter nominated Guidobaldo Gonfalonier of the Holy Roman Church, and did much for the importance of Urbino. In the same period, the College of Doctors was built, the first nucleus of the free University of Urbino. And it was from here that the young, but already famous Raphael (after his experiences at Perugia), left for Florence in 1504, whence he later set out on his conquest of Rome.

Federico had given hospitality to many artists of different extraction at Urbino, among them even some foreigners, such as the Fleming, Justus of Ghent, and the Spaniard, Pedro Berruguete. First of all came Piero della Francesca, then Melozzo da Forlì, Paolo Uccello, Luca Signorelli, Giovanni Boccati and, in all probability, Giovanni Angelo di Antonio, the so-called Master of the Barberini Panels. In his library, there was "a great number of very excellent Greek, Latin and Hebraic books . . . which he considered to be the supreme glory of his great palace", which, also according to Castiglione, by virtue of its size and the way it was constructed, "seemed more like a city in the form of a palace, rather than a palace".

Urbino, therefore—and the confirmation is provided by Castiglione himself—had reached a degree of refinement and culture that left an indelible mark on the Italian civilization of the Renaissance. The purpose of this study does not require us to follow its political fortunes any further, since this would go beyond the limits of our subject. It is enough to add that two of the greatest artists of the Renaissance came from the artistic environment of Urbino: Bramante and Raphael.

### Giovanni Santi

The best known local painter is undoubtedly Giovanni Santi, who was born at Colbordolo near Urbino in 1435, and whose artistic personality has perhaps been overshadowed by the fame of his son Raphael. He was attached to the court of Urbino, a humanist as well as a painter, and was the author of a rhymed chronicle, which, though of little poetic value, is very important, since it describes events in Urbino. He also wrote a play in verse in 1482, on the occasion of the marriage between Guidobaldo and Elisabetta Gonzaga. The decisive influences on his painting were Melozzo da Forlì, Piero della Francesca, and Luca Signorelli. Although he is not a master of the highest rank, his work must not be considered second-

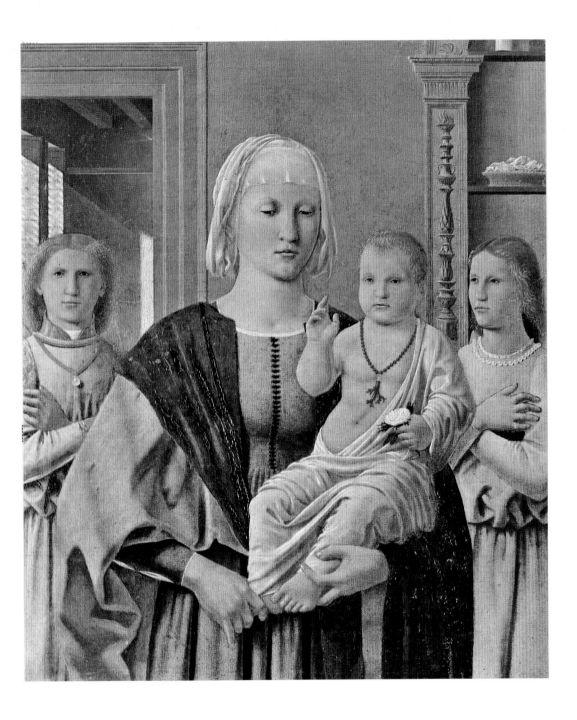

XXXIV. Piero della Francesca: *The Madonna of Senigallia*. Urbino, Galleria Nazionale

rate, but rather as the product of a cultural situation determined by the presence at Urbino of a number of men of genius. He was, in fact, the leader of the local school, in which his son learnt the rudiments of his art.[2]

How well he knew the art of his day is clearly revealed in his own rhymed chronicle. Of Flemish artists, he refers to Jan van Eyck and Rogier van der Weyden, but forgets to mention Justus of Ghent, who was active at the court of Federico. Of Italians he praises Gentile da Fabriano, and thus provides precious evidence of how great Gentile's fame continued throughout the century. He also mentions Pisanello and Fra Angelico. His list of artists is a long one, and includes Masaccio, Filippo Lippi, Domenico Veneziano and Andrea del Castagno, as well as Paolo Uccello, whom he certainly met at Urbino. He then goes on to mention Perugino, Leonardo, Botticelli and others still, without forgetting the Bellini brothers, Cosimo Tura, Ercole de' Roberti, or Antonello—"a very open man"—finally ending up with Mantegna, so highly esteemed by the Duke of Urbino, and Melozzo, "so very dear to me". Perugino, Melozzo, and Signorelli were, in fact, the sources of his inspiration. Perhaps he was less able to understand Piero della Francesca, even though he knew him very well, having had him as his guest in 1469.

Giovanni Santi took up painting, as he himself confesses, after a very difficult childhood. He was fortunate enough to win the friendship of Federico, to whom he was indebted for a great part of his knowledge of painting. It is significant that, when speaking of Mantegna, he refers to the duke's great enthusiasm for his painting. Santi's artistic personality developed with a certain consistency, in spite of the comings and goings of artists who were certainly much greater than himself, and in spite of inevitable brusque changes of direction due to the multiplicity of styles with which he was surrounded. But it was the influence of Melozzo, above all, that prevailed over him, as in the case of Marco Palmezzano. However, he had a sense of balance and a compositional style that expressed itself in the search for harmony, while his figures are motionless and solemn, modelled by light. In his best known works, such as the two altarpieces of Gradara and Montefiorentino (plates 168–169), Santi hardly seems to merit the invective poured on him by Venturi for example. His later works are too crowded, and lose that sense of proportion and thoroughness that he sometimes reveals elsewhere. But this is not a good reason for condemning him. On the other hand, perhaps under the influence of Perugino, he feels the value of atmosphere, and knows how to create space and a sense of the infinite. In this respect, the Cagli frescoes (plates 166–167), with their soft, fresh colours, and that terse air filled with light, are the finest examples of his art.

This is not the moment to deal with the problem, which has already often been examined, of the possible influence he may have exercised over his son. When Santi died, Raphael was only eleven years old, too young to understand and create. However, it is not impossible that Raphael began by following in the footsteps of his father, even after the latter had died. After all, Giovanni Santi was a man of culture, and in his works he had shown an understanding of certain values, which seem to impregnate the very air of Urbino, and which Raphael later mastered in so complete and conscious a manner.[3]

Catalogue of works
[see plates XXXVII, 166–172].

Berlin (East), Bodemuseum, *Madonna and Child with Saints*.
Budapest, Museum of Fine Arts, *Christ between two Angels*.
Cagli, Gallery, *St. Sebastian* (fragmentary fresco).
Cagli, Church of S. Domenico, *Madonna and Child with Saints, Resurrection*.
Cagli, Church of S. Domenico, *Annunciation*.

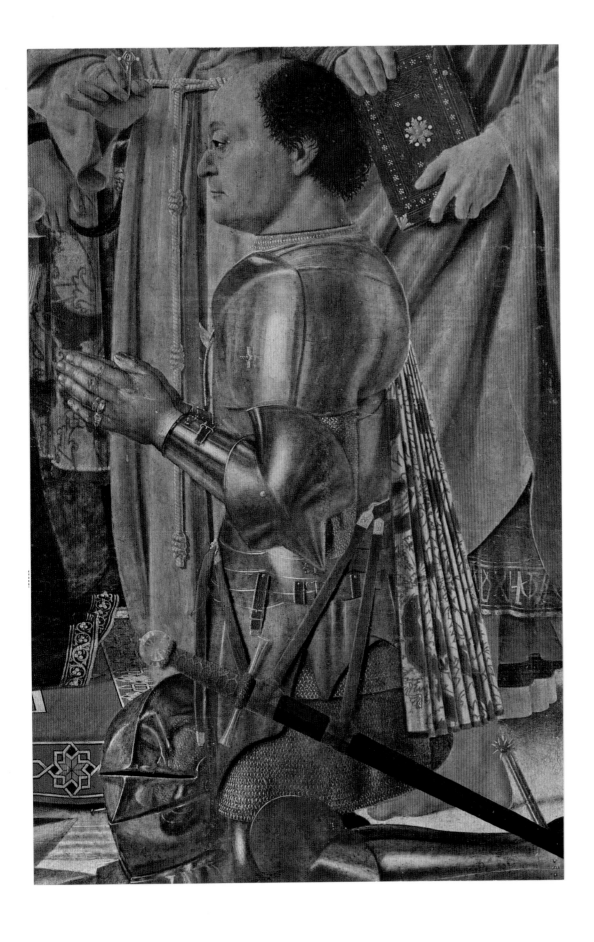

XXXV. Piero della Francesca: *Federico da Montefeltro*. Detail from plate 163. Milan, Brera

Cagli, Town Hall, *Madonna and Child with two Saints* (fresco).

Castagnola, Thyssen-Bornemisza Coll., *Portrait of a little Boy.*

Fano, Gallery, *Madonna and Child with four Saints.*

Fano, Church of S. Maria Nova, *Visitation.*

Florence, Corsini Gallery, *Decorative Panels* (from the little temple of the Muses of the Ducal Palace of Urbino; carried out with the help of Evangelista di Pian di Meleto).

Florence, Marchese Ginori Coll., *Two panels with Shepherd and Nymph* (painted in collaboration with Timoteo Viti according to Berenson).

Gradara, Town Hall, *Madonna and Child with SS. Stephen, Sophia, Michael, and John the Baptist* (1484).

London, National Gallery, *Madonna and sleeping Child.*

Pian di Meleto (Pesaro), Conventual Church of Montefiorentino, Oliva Chapel, *Madonna and Child with SS. Jerome, Anthony Abbot, Francis and George, music-making Angels and kneeling Donor.*

Rome, Vatican Gallery, *St. Jerome Enthroned.*

Urbino, National Gallery, *Madonna Enthroned with SS. John the Baptist, Francis, Jerome, Sebastian, and the Buffi Family* (1489).

Urbino, National Gallery, *Dead Christ supported by Angels, Christ on the Tomb, Christ and the Madonna.*

Urbino, National Gallery, *Six Apostles.*

Urbino, National Gallery, *Archangel Raphael and Tobias* (partly restored).

Urbino, National Gallery, *Martyrdom of St. Sebastian* (also attributed to Evangelista di Pian di Meleto).

Urbino, National Gallery, *Annunciation* (from the Brera Gallery, formerly in the church of S. Maria Maddalena at Senigallia).

## Evangelista di Pian di Meleto

Evangelista di Pian di Meleto has been fully dealt with, especially by Adolfo Venturi, who took him to be Raphael's first master. However, he remains an obscure figure, since there is not a single work that can be attributed to him with certainty. The documents inform us that on 10 December 1500, Raphael was commissioned to do an altarpiece representing the Blessed Nicola da Tolentino for the church of S. Agostino at Città di Castello, with Evangelista as his assistant. By that date, therefore, though still very young, he had surpassed the man supposed to be his master. In all probability, Evangelista should be considered a modest collaborator of Giovanni Santi's, to whom he is so similar that the two are often confused. It is probable that on Santi's death in 1494 the young Raphael looked to Evangelista for guidance before finding his own feet, for by 1500 their relationship had been reversed, to the extent that Raphael is already referred to as "Master", although he was only seventeen.

It is not yet possible to draw up a catalogue of Evangelista's works, though Berenson and Venturi have credited him with a number of paintings that are connected with Giovanni Santi. Among these are the famous *Muses* in the Corsini Gallery of Florence (plates 173–176), as well as the *Apostles* in the National Gallery of Urbino. The *Muses*, in particular, share certain affinities, and are rather different from the panels and frescoes that are definitely Santi's. Hence the above attributions must be given due consideration, even though there is no definite proof upon which to base them. But the figure of Evangelista, as reconstructed by Venturi, must be completely revised, because that critic attributed to him many works that are originals by Santi.[4]

## Bartolomeo di Gentile

Bartolomeo was born about 1465. A clear idea of his artistic personality is provided above all, by the *Madonna* in Lille (plate 178), which is signed and dated 1497. This painting reveals his adherence to the style of Giovanni Santi, whom he imitates in a rather stale manner in various altarpieces and frescoes which denote his limitations.

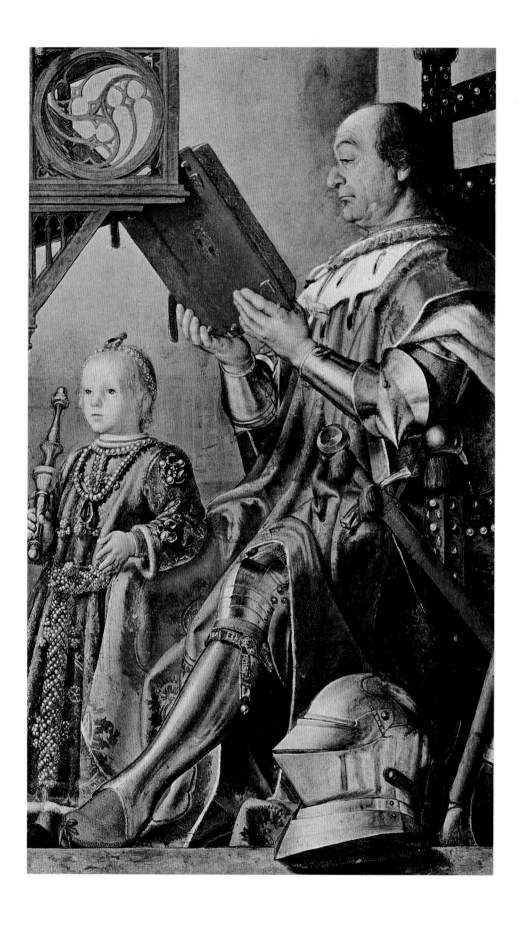

XXXVI. Pedro Berruguete: *Federico da Montefeltro and his son Guidobaldo*. Detail.
Urbino, Galleria Nazionale

## Catalogue of works

[*see plates* 178, 179].

Budapest, Museum of Fine Arts, *Madonna and Child, SS. Catherine and Peter* (1488).
Budapest, Museum of Fine Arts, *Madonna and Child with Saints* (1504).
Cambridge (Mass.), Fogg Art Museum, *Portrait of a young Lady.*
Ginestreto (Pesaro), Vecchia Pieve, *Madonna and Child with four Saints.*
Lille, Musée des Beaux-Arts, *Madonna and Child Enthroned* (1497).
Monteciccardo (Pesaro), Church of S. Sebastiano, *Madonna and Child with SS. Francis, Catherine, Sebastian* (1508).
Montefiore Conca, Church of S. Paolo, *Madonna of Mercy with SS. John the Evangelist, Paul, Francis, Sebastian.*
Urbino, National Gallery, *Martyrdom of St. Sebastian* (the attribution is Berenson's who believed that it was carried out by Bartolomeo after a design by Giovanni Santi. Though the work is much damaged and not very clear, it is probably Santi's work, and is therefore also included in his catalogue of works).

## Timoteo Viti

Timoteo Viti was born at Urbino in 1465. At an early age he went to Bologna, where he frequented the school of Francia. Towards 1494 he returned to his native city, where there is a fresco of the *Madonna of Mercy* in the church of S. Agostino. Not all critics are agreed in attributing this work to him, but bearing in mind the damage caused by time, it seems undoubtedly characteristic of his style, and the attribution is to be accepted. In 1504 he painted an altarpiece representing the *SS. Thomas and Martin with Archbishop Arrivabene and Duke Guidobaldo* for the city cathedral, a work now in the National Gallery of Urbino (plates XXXVIII, 180). This painting has a special importance, since it reflects that sense of proportion and of harmony between atmospheric and architectonic space which is typical of the culture of Urbino. Moreover, the two figures taken from real life, and Duke Guidobaldo in particular, have been done with such psychological insight as to provide us with a clue to Timoteo's art, which was clearly influenced by Melozzo da Forlì and Piero della Francesca.

The date of this work, 1504, coincides with Raphael's final departure from his native city, since he arrived at Florence in the same year. One wonders what chances there were of the two artists meeting, and to what extent they may have influenced each other. Timoteo Viti is sometimes mentioned as Raphael's master. In fact, he arrived at Urbino just at a time when he might have contributed to the young artist's formation, after the death of his father, when the young Raphael had been left at the mercy of Evangelista di Pian di Meleto, who was Giovanni Santi's *famulus* rather than his assistant, and little suited therefore, to act as guide to the young, precocious genius. Therefore Raphael must have turned to Perugino though the theory that he may have taken an interest in Timoteo Viti's work is not to be discarded, since Timoteo undoubtedly had something to offer him. The portrait of Guidobaldo kneeling down suggests a parallel with the papal dignitaries in the *Miracle of Bolsena* which Raphael painted four years later. Did he remember Timoteo Viti's painting? Everything is possible, and everything must be verified in the history of art, even if one were to affirm that the figures in the famous Vatican fresco are not Raphael's work, but Lotto's.[5]

## Catalogue of works

[*see plates XXXVIII,* 180].

Bergamo, Carrara Academy, *St. Margaret.*
Bologna, Pinacoteca Civica, *St. Mary of Egypt.*
Bristol, City Art Gallery, *Agony in the Garden.*
Cagli (Urbino), Church of S. Angelo, *Noli me Tangere; SS. Michael the Archangel and Anthony Abbot.*
Cleveland, Museum of Art, *Agony in the Garden* (miniature).
Florence, Corsini Gallery, *Apollo; Thalia* (from the Ducal Palace of Urbino).
Fossombrone (Pesaro), Chapel in the Bishop's Palace, *Crucifixion with Saints and Donor* (doubtful).

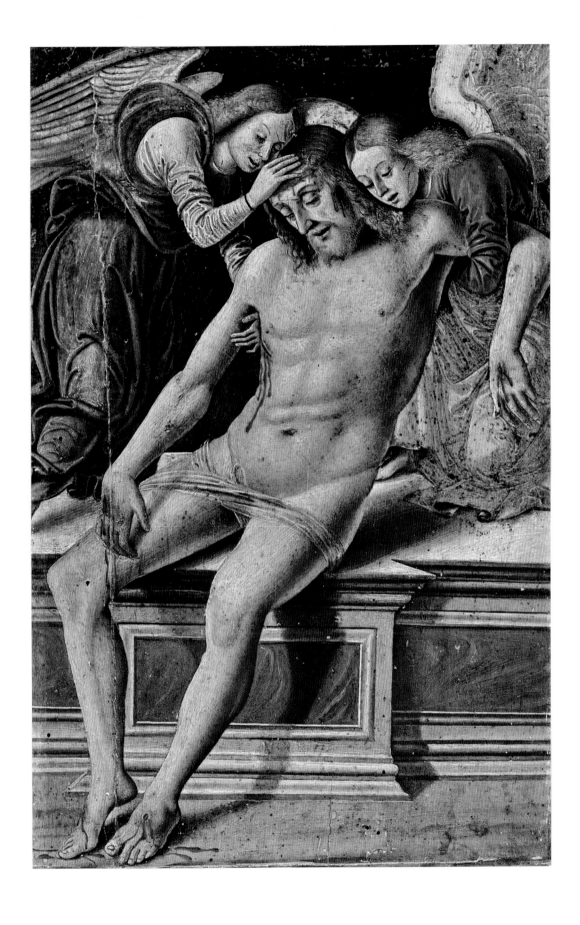

XXXVII. Giovanni Santi: *Dead Christ supported by two Angels*. Urbino, Galleria Nazionale

Gubbio, Cathedral, *St. Mary Magdalen* (signed, 1521).
Milan, Brera, *Annunciation with SS. John the Baptist and Sebastian*.
Milan, Brera, *Madonna and Child with SS. Crescentius and Vitalius*.
Milan, Brera, *Trinity with St. Jerome and Donor*.
Munich, Alte Pinakothek, *St. Michael*.
Urbino, Church of S. Agostino, *Madonna freeing a Child of the Demon* (1504).
Urbino, National Gallery, *SS. Roch and Joseph*.
Urbino, National Gallery, *St. Sebastian*.
Urbino, National Gallery, *SS. Thomas and Martin with Archbishop Arrivabene and Duke Guidobaldo* (1504).
Urbino, National Gallery, *Annunciation* (stained glass).
Urbino, National Gallery, *St. Apollonia*.

## The origins of Raphael

Raffaello Santi, the son of Giovanni and Magia Ciarla, was born at Urbino on 6 April 1483. As we have seen, his father was a painter and man of letters of some distinction, besides being connected with the Montefeltro family. We may suppose, therefore, that Raphael lacked nothing in the way of material comfort as a child, and that he grew up in a refined cultural atmosphere. His mother died on 7 October 1491, and his father on 1 August 1494. His father had married again on 25 May 1492, his second wife being Bernardina Parte, who had a posthumous daughter by him. The young artist was probably in close relations with the man who helped his father, Evangelista di Pian di Meleto, but his real school was the artistic environment in which he lived, and the works of art left behind by the artists whom Federico and Guidobaldo da Montefeltro had gathered about them at Urbino. He must have been particularly attracted by the paintings of Piero della Francesca, who lived at the court, and who had left at least four works at Urbino: the *Flagellation*, (plate XXXIII), the *Portraits of Federico da Montefeltro and Battista Sforza with their respective allegories*, and the *Altarpiece of St. Bernardino*, now at the Brera (plates XXXV, 163), which he painted for the tomb of the great *condottiero* Federico. A work that has been included among those of Raphael's youth is a processional banner, painted on both sides, which is now in the Gallery of Città di Castello, and which came from the Ospedale della Misericordia. On one side of the banner is depicted the *Crucifixion*, on the other, the *Madonna of Mercy*.

It has been attributed to Raphael by Longhi, who believes that it may be Raphael's first work. And rightly so, for the *Madonna of Mercy* clearly reveals "the outlook of an artist from Urbino influenced by Perugino". But even before the banner, in which certain qualities which were later to become characteristic of the great genius can already be seen, Raphael had perhaps painted his first work, in the house where he was born. This is the fresco of the *Madonna and Child* (plates XXXIX, 181), which Cavalcaselle believed to be the work of his father, but which has recently been claimed for the son, in accordance with tradition. The iconography of the sleeping Child perhaps goes back to Antonio Alberti's polyptych of 1439, or more probably to that in Lorenzo Salimbeni's fresco in the Oratory of S. Giovanni, the *Madonna of Paradise*. The young Raphael must have known this latter work—and may have meditated on it deeply—since it was part of the most extensive pictorial scheme to which he had access in his youth. In 1500 he received his first documented commission, the altarpiece of S. Niccolò da Tolentino at Città di Castello. In the relative document he is referred to as "Master", and Evangelista di Pian di Meleto as his assistant. He received the commission for the *Coronation of the Virgin* from the convent of Monteluce at Perugia between 1501 and 1503. Though the painting was carried out by the artist's pupils after his death, and is therefore of no value in assessing his style during that period, it is still very important, for it shows that he was already famous by that date. In the same period he painted the *Coronation of the Blessed Nicola da Tolentino*, which was unfortunately half-

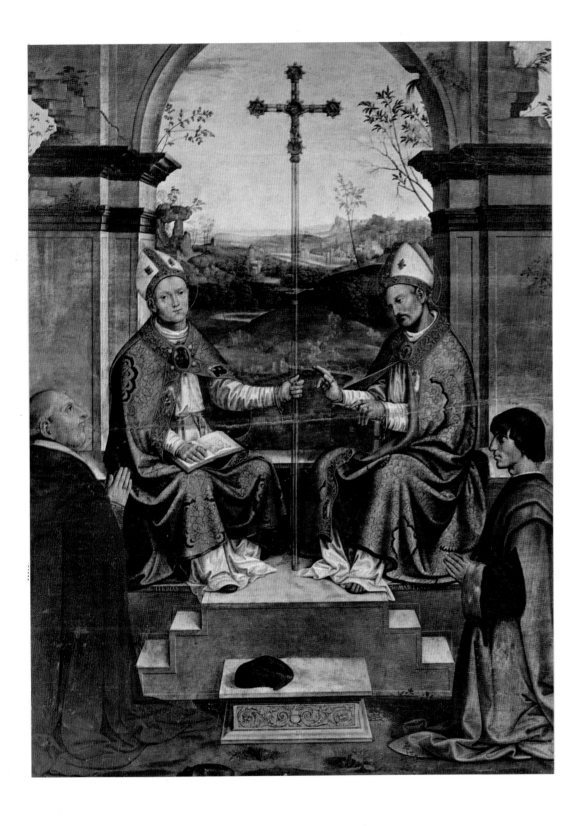

**XXXVIII.** Timoteo Viti: *Saints Thomas and Martin with Duke Guidobaldo and Archbishop Arrivabene.* Urbino, Galleria Nazionale

destroyed in the eighteenth century, and of which only a few fragments remain. These are an *Angel* in the Tosio Martinengo Gallery at Brescia, and the *Madonna, Eternal and Angels* in the National Gallery of Naples, though these latter were probably painted by Evangelista di Pian di Meleto who, according to the documents, assisted Raphael in this altarpiece.

The young artist's name is also connected with other works, the attribution of which is the subject of controversy. Some of them however, are generally accepted as his, and a list of these is given below. The list ends at the moment when Raphael finally left Urbino and Perugia for Florence. This first period culminated in the *Marriage of the Virgin*, now at the Brera (plates 184–185), which Raphael painted for the church of S. Francesco dei Minori Conventuali at Città di Castello, a little town halfway between the Marches and Umbria, perhaps closer to Urbino than to Perugia. He did a lot of work here in those early years, as if to show how attached he still was to his native city. In the *Marriage of the Virgin*, which is often said to be modelled on Perugino's Roman fresco, the *Giving of the Keys to St. Peter*, Raphael seems to have had in mind the church of S. Pietro in Montorio, which Bramante had built in 1502. That the painter was affected by the ideas of his great fellow townsman is shown by the fact that, years later, when he conceived that ideal exaltation of a perfect world, which is embodied in the *School of Athens* (plates 186–187), that world is again shaped by the architecture of Bramante, and certainly connected with the new designs Bramante was planning for the Basilica of St. Peter's. It follows that, throughout the influences, the many experiences, and I would even say, the deviations of his Florentine period, he never wavered from his pursuit of that concept of ideal harmony, which his formation at Urbino had instilled in him, and which culminates in the first of the Vatican *stanze*, where a certain classic ideal—the pursuit of harmony as goal of the human spirit—reaches its greatest lyrical tension. But that ideal did not hold sway for long: it was overwhelmed by the dramatic visions of Michelangelo in the frescoes of the Sistine Chapel—the work of a genius who was stirred to meet the new needs of an impending European crisis.

In order to clarify the subject further, a list is given below of the works that may be attributed to Raphael's earlier years. The predella of Perugino's Fano altarpiece (plates XL, 182–183) has been included among them, for in all probability, it is either wholly or partially Raphael's work. The initial stages in the development of Raphael's art, besides being the subject of numerous publications, are too well known and, at the same time, too complex for us to pursue the argument further.

However, it has seemed right to mention them briefly, if only as a *pro memoria*, since Raphael, more than any other painter, embodies the ideals of the classical world. Perhaps it was the Temple of the Muses and the little chapel attached to Federico's study in the Ducal Palace which inspired him with that vision of ideal perfection and man's highest aspirations that was in his mind when he conceived the *Disputa over the Blessed Sacrament* and the *School of Athens*.[6]

Catalogue of early works
[*see plates XXXIX*, 181, 184–187].

Bergamo, Carrara Academy, *S. Sebastian.*
Berlin, Staatliche Museen, *Solly Madonna.*
Berlin, Staatliche Museen, *Madonna and Child with SS. Jerome and Francis.*
Brescia, Tosio-Martinengo Gallery, *Angel* (fragment of the *Coronation of St. Nicholas of Tolentino*, from the church of S. Agostino at Città di Castello).
Città di Castello, Pinacoteca, *Banner: Crucifixion; Madonna of Mercy.*
Città di Castello, Pinacoteca, *Trinity with SS. Sebastian and Roch;* the *Creation of Eve.*
Fano, Church of S. Maria Nova, *Predella of the altarpiece by Perugino* (collaboration).

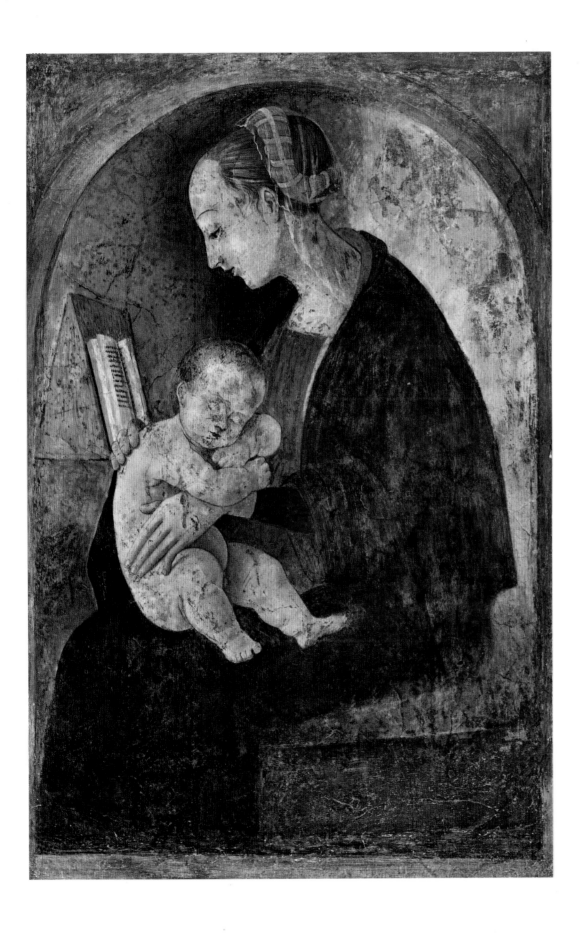

XXXIX. Raphael: *Virgin and Child*. Urbino, House of Raphael

Lisbon, National Museum, *Miracle of St. Cyril* (part of the predella of the Mond Crucifixion).
London, National Gallery, *Mond Crucifixion* (painted for the church of S. Domenico at Città di Castello).
Milan, Brera, *Marriage of the Virgin*, 1504 (painted for the church of S. Francesco dei Minori Conventuali at Città di Castello.
Raleigh (N. C.), Museum of Art, *Miracle of St. Jerome* (fragment of the predella of the Mond Crucifixion).
Urbino, House of Raphael, *Madonna and Child* (fresco).

## NOTES

1. For the history of Urbino in the Renaissance, the following works are particularly recommended: P. Alatri, *Federico da Montefeltro: Lettere di Stato e d'Arte*, Rome, 1949; B. Baldi, *Della Vita e de' Fatti di Federico da Montefeltro* (ed. 1826, Bologna); B. Castiglione, *Il Cortigiano* (1524), Venice, 1528; G. Franceschini, *Saggi di storia montefeltresca e urbinate*, Urbino, 1957; id., *Figure del Rinascimento Urbinate*, Urbino, 1959; A. Lazzari, *Memorie istoriche dei Conti e Duchi di Urbino* in "Antichità Picene di G. Colucci", Fermo, 1795; C. Maltese, *Opere e soggiorni urbinati di Francesco di Giorgio* in "Studi artistici urbinati", Urbino, I, 1949; G. Marchini, *Il Palazzo Ducale di Urbino* in "Rinascimento", IX, n. 1, 1958; id., *Aggiunte al Palazzo Ducale di Urbino* in "Bollettino d'Arte", 1960; G. Pacchioni, *L'opera di Luciano Laurana a Mantova* in "Bollettino d'Arte", 1923-24; R. Papini, *Francesco di Giorgio architetto*, Florence, 1946; P. Rotondi, *Il Palazzo Ducale di Urbino*, vols. I and II, Urbino, 1950; M. Salmi, *Piero della Francesca e il Palazzo Ducale di Urbino*, Florence, 1945; G. Santi, *Cronaca rimata* (ed. Holtzinger, Stuttgart, 1893); L. Serra, *L'Arte nelle Marche*, Rome, 1934; Vespasiano da Bisticci, *Vita di Federico da Urbino* (written between 1482 and 1498) in "Collezione d'opere inedite o rare", I, Bologna, 1892.

2. In reconstructing the artistic personality of Giovanni Antonio da Pesaro, Zeri excludes the possibility that local influences, of the florid Gothic of a Pietro di Domenico or of Gentile da Fabriano himself, may have had any bearing on his formation. Instead, he sees a connection between the artist and the late Gothic style of Emilia, adding that "the little panels representing the scenes of the Passion (the reference is to the Sassoferrato polyptych) are pervaded by a narrative feeling so exuberant and effective that its only immediate antecedents are to be found in those Bolognese cycles that take their lead from the Cappella Bolognini" (see Giovanni Antonio da Pesaro in "Proporzioni", 1948). Here, in alphabetical order of places, is the painter's catalogue of works, according to Zeri's reconstruction: Apiro, chiesa della Misericordia: *Madonna of Mercy* (re-attributed to Giovanni Antonio by van Marle, vol. VIII, pp. 292 and 300); Candelara, church of Santa Maria dell'Arzilla: *Madonna of Mercy* (signed and dated 1461; see Serra, *L'Arte nelle Marche*, vol. II, p. 230); Cingoli, Cathedral: *Polyptych, Magdalen and four Saints* (Berenson's attribution of this painting to Antonio da Fabriano is qualified by a question mark): Cingoli, church of Sant'Esuperanzio; *Polyptych, Madonna and four Saints* (greatly damaged and restored; Berenson attributes it with reserve to Lorenzo d'Alessandro); formerly in Florence, Volterra Collection: the *Martyrdom of St. Blaise* (published by van Marle as belonging to the "School of Pisanello", vol. VIII, fig. 123); ib., Bellini Collection: *Altarpiece, Madonna, five Saints and Donor* (dated 1473; attributed by Longhi to Giovanni Antonio); Jesi, Civic Museum: *Madonna Enthroned* (published as a Sienese work by Serra in his "Inventory of the works of art in the Provinces of Ancona and Ascoli Piceno", Rome, 1936, p. 108. In my opinion, this panel was originally flanked by two *Saints* now in the Palazzo Venezia Museum of Rome); Naples, National Museum, no. 52: *St. Peter Damian* (a replica or copy of the panel in the Ravenna Academy Gallery. Cf. Colasanti in "L'Arte", 1907, p. 416); formerly at Pesaro, Private Collection: *St. Mark the Evangelist* (signed and dated 1463. Published by van Marle, vol. VIII, fig. 189); Ravenna, Academy, no. 188: *St. Peter Damian*; Rome, Private Collection: the *Martyrdom of St. Blaise* (which comes from the J. P. Gentner Collection in Florence); ib., Palazzo Venezia Museum: *St. John the Baptist and a Bishop Saint* (the attribution is Longhi's; they are certainly the side panels of the Jesi Madonna); ib., the *Martyrdom of St. Blaise*; Saltara, church of San Francesco di Rovereto: *Frescoes: six Saints and Crucifixion* (attributed to Antonio Alberti by E. Carli in "Rivista dell'Istituto di Architettura e Storia dell'Arte", 1941, I-III, p. 203, no. 7); ib., church of Santa Maria della Fonte: *Fresco: Madonna of Mercy*; Sassoferrato, church of Santa Croce: *Polyptych*; Urbino, National Gallery: *Banner, Madonna Enthroned and Crucifixion* (attributed by Berenson with reserve to Antonio da Fabriano in "Proporzioni", 1948). On Antonio Magister see the study by M. Boskovits in "Arte Illustrata" May–June 1969.

There are some very interesting frescoes in the cemetery church of Castel Ferretti (Ancona), and I do not think they have ever been studied. They represent various subjects and are probably the work of several painters—all done in the first half of the fifteenth century however. On the wall at the back of the church, in the centre, is a painting of the Eternal holding a Crucifix adored by two angels. To the left and right of the central group stand SS. Peter and Paul. On the lower part of the same wall, in the centre, is depicted the Madonna of Mercy, flanked by SS. Stephen and Bernardino of Siena.

On the wall to the left is a frescoed pentaptych representing from left to right: St. Sebastian, the Madonna and Child, a Bishop Saint Enthroned, a Pope Saint, and St. John the Baptist. Other Saints follow, and continue on the corresponding right-hand wall. On the latter there is also a Crucifixion with the group of holy women and other figures. These frescoes are of considerable interest and constitute the largest group of paintings in the district of Ancona. They are in urgent need of restoration, and it is comforting to learn that the Superintendence for the Galleries of Urbino has provided for the removal of the *Madonna of Mercy* and other single figures. About these no further information can be given, since they cannot be seen at the present moment. But the sinopie that remain on the walls suggest that the frescoes are by a painter of considerable stature. It can be said in conclusion, that the part with the Eternal and the Crucifixion may be attributed to an artist close to Carlo da Camerino, while the Madonna of Mercy and the other Saints may be the work of Giovanni Antonio da Pesaro. This is only a suggestion, which must be demonstrated of course, especially after the paintings have been restored. However, I have chosen this opportunity to make

XL. Perugino (or Raphael?): *The Presentation in the Temple*. Fano, church of S. Maria Nuova

some general remarks on the chapel, precisely because of its possible connection with Giovanni Antonio.

3. It is important that Giovanni Santi should be re-examined in the light of his best works, not in that of his least successful ones. Only in this way shall we be able to solve the problem of his possible collaboration with Evangelista di Pian di Meleto, a painter who still requires much explanation. It is clear, for example, that the quality and style of the decorative panels in the Corsini Gallery of Florence, which come from the little Temple of the Muses in the Ducal Palace, are such that it is not easy to include them among the authentic works of Giovanni Santi. The artist must be examined on the basis of works such as the Montefiorentino altarpiece, or the frescoes in the church of S. Domenico at Cagli, which are all of unquestionable quality. For in these paintings we can see that Santi—inspired by the example of Piero della Francesca and the other artists at Urbino—had taken the same path as Perugino, and was also concerned with the study of space and atmospheric values. This is mentioned, because, when looking for the origins of Raphael, one must not forget the possible influence his father may have exercised on his precocious genius, before pointing to that which Perugino undoubtedly had on him.

4. In 1483, the year in which Raphael was born, Evangelista was working in Giovanni Santi's *bottega* as a "famulus", or aide. In 1487, together with the sculptor Ambrogio da Milano (who had been called to Urbino to work on the Ducal Palace), he acted as witness to the drawing up of the old artist's will. After Santi's death, Evangelista stayed in the *bottega* and soon became Raphael's assistant, as is proved by the commission for the altarpiece for the church of S. Nicola da Tolentino at Città di Castello. Further information shows that, after Raphael's departure, Evangelista only carried out works of secondary importance, such as those in the chapel of the Holy Sacrament in the cathedral, which he did together with others. He died on 18 January 1549. An over-generous attempt to reconstruct the painter's artistic personality was made by Adolfo Venturi in his "Storia dell'Arte Italiana". Van Marle has also studied him in the article *Giovanni Santi, Bartolomeo di Maestro Gentile ed Evangelista di Pian di Meleto*, in "Bollettino d'Arte", 1933.
Previously, L. Calzini had also written on the subject, *Raffaello ed Evangelista di Pian di Meleto*, in "Rassegna Bibliografica dell'Arte Italiana", 1909. But for this still obscure painter, particular attention must be given to Roberto Longhi's essay, *Percorso di Raffaello giovane*, in "Paragone", 65, May 1955.

5. The allusion is to the still controversial question of possible contacts between Raphael and Lotto, who were both working in the Vatican Stanze in 1509. For this subject, see the following works: E. Zocca, *Le decorazioni della stanza dell'Eliodoro e l'opera di Lorenzo Lotto a Roma* in "Rivista dell'Istituto Nazionale di Archeologia e Storia dell'Arte", Rome, 1953; A. M. Brizio, *Il percorso dell'Arte di Lorenzo Lotto*, "Arte Veneta", 1953. See also P. Zampetti, *Libro di spese diverse di Lorenzo Lotto*, Venice–Rome, 1969, p. LII.

6. For Raphael's formation, the following works are particularly recommended, besides the above-mentioned article by Longhi: S. Ortolani, *Raffaello*, Bergamo, 1942 (last ed. 1948 has a large bibliography); the two volumes, *Tutta la pittura di Raffaello*, edited by Ettore Camesasca, Milan, 1956.
What Bramante did in Urbino, before setting out for Milan, is still unknown. The attempt to attribute to him the church of S. Bernardino has proved vain, while the idea that he collaborated with Justus of Ghent and Pedro Berruguete in painting the "illustrious men" in the Duke's "little study" is also mistaken. What is certain however, is that he took with him from Urbino that sense of "enclosed space", which formed the basis of architectural ideas in the Cinquecento, ideas that he both pursued and realized.

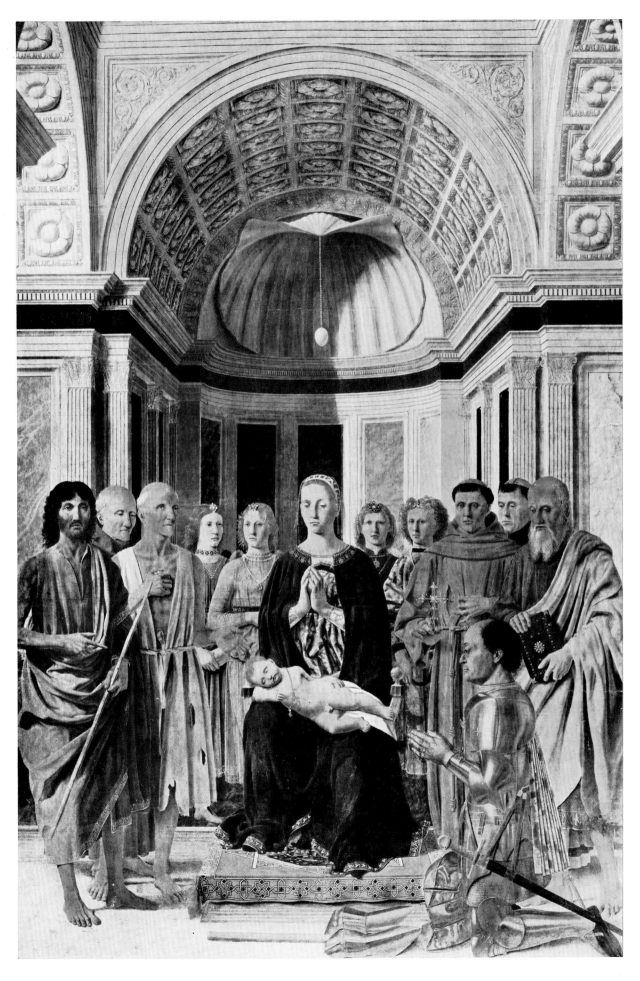

163. Piero della Francesca: *Virgin and Child with Saints and Federico da Montefeltro*. Milan, Brera.

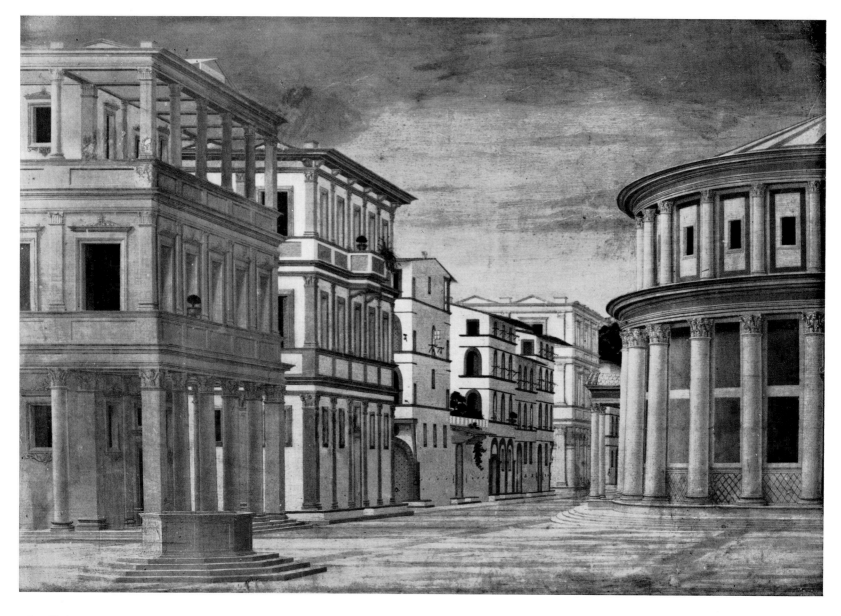

164. Unknown Painter: *Ideal view of a city*. Detail. Urbino, Galleria Nazionale.

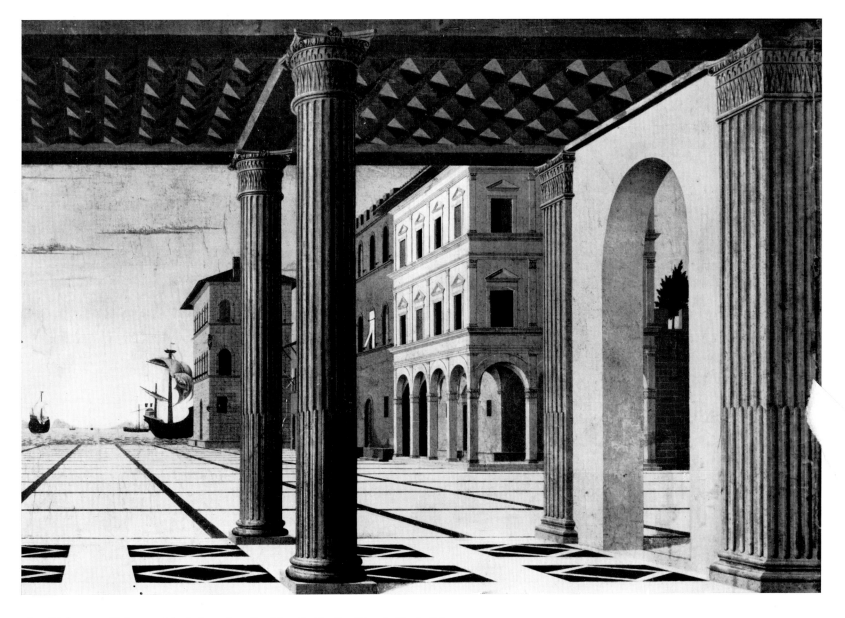

165. Unknown Painter: *Ideal view of a city*. Detail. Berlin (East), Bode Museum.

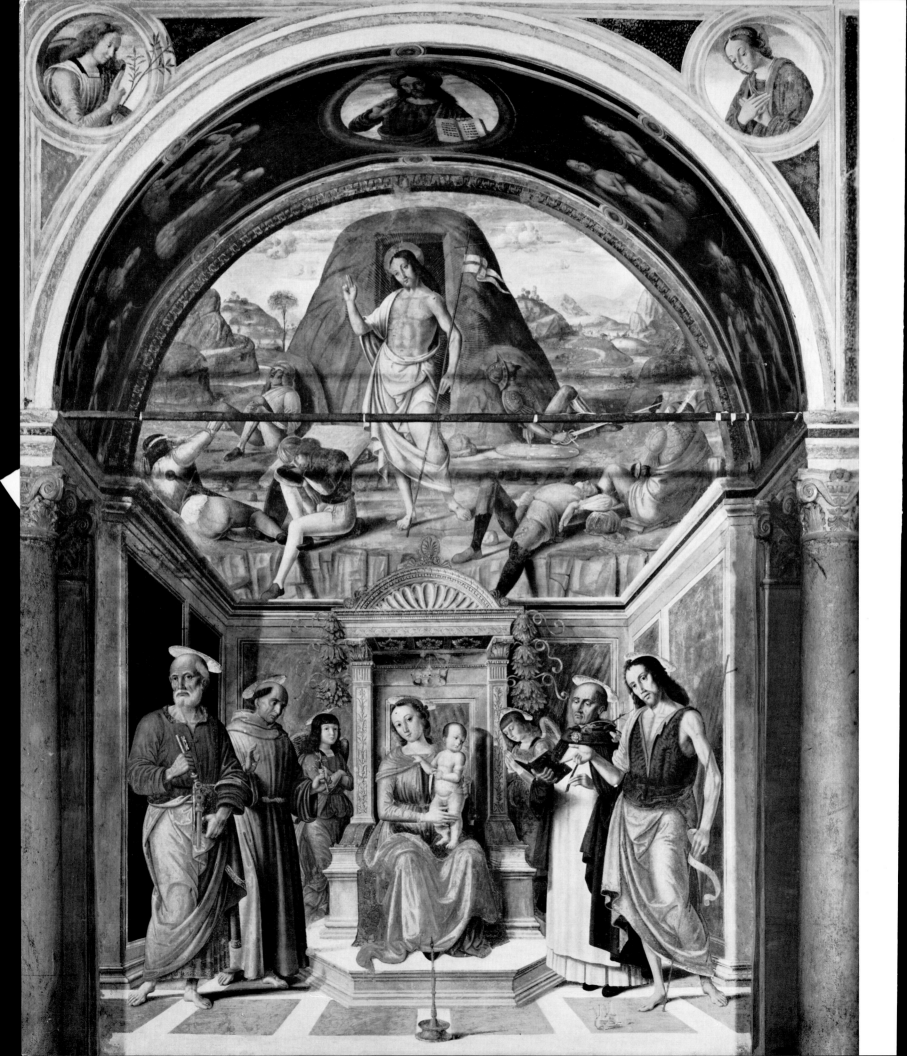

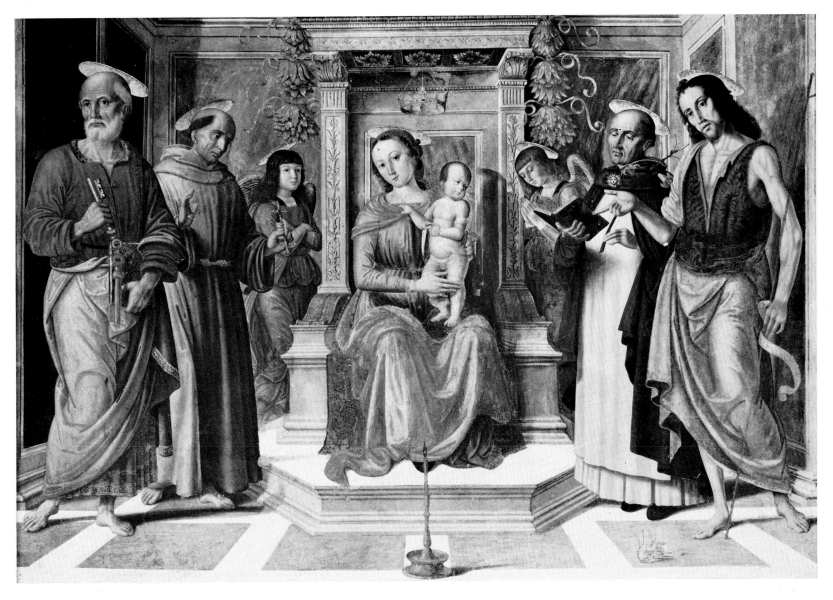

166-167. Giovanni Santi: *Frescoed niche: Virgin and Child with Angels and Saints; above, The Resurrection.* Cagli, Church of S. Domenico.

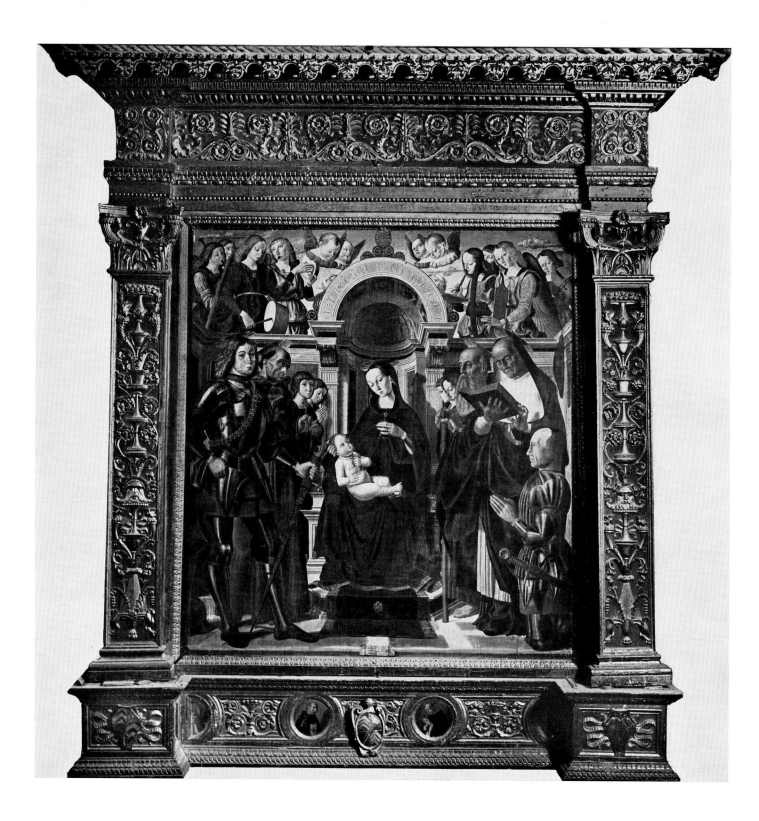

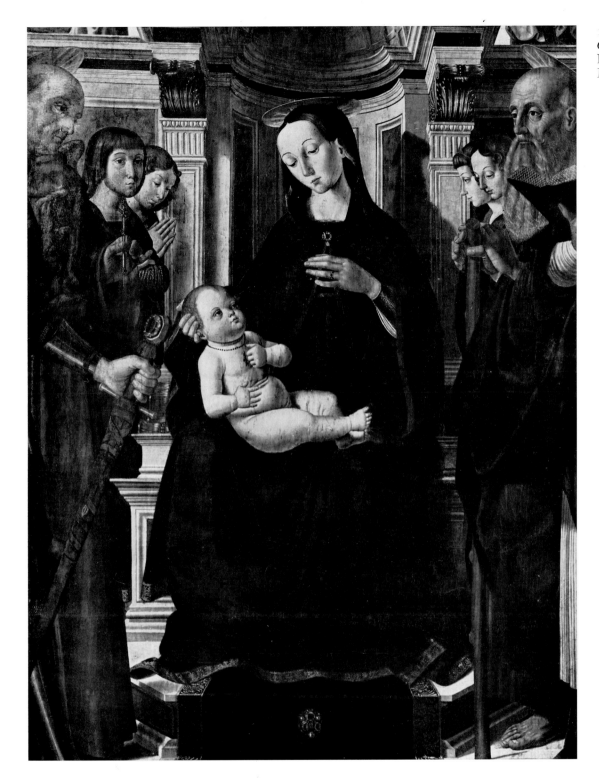

168-169. Giovanni Santi: *Virgin and Child with Angels and Saints and a donor.* Pian di Meleto, Convent Church of Montefiorentino.

170. Giovanni Santi: *The Annunciation*. Urbino, Galleria Nazionale.

171-172. Giovanni Santi: *An Apostle and Saint John Evangelist*. Urbino, Galleria Nazionale.

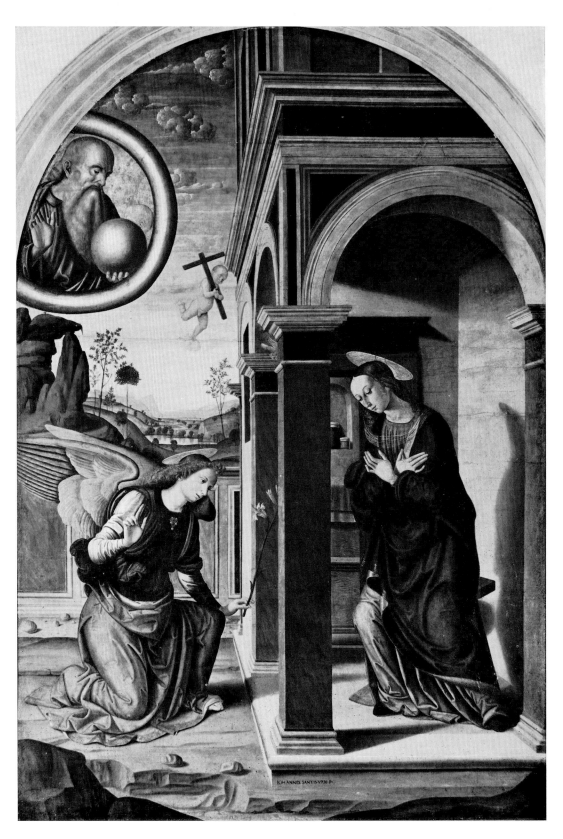

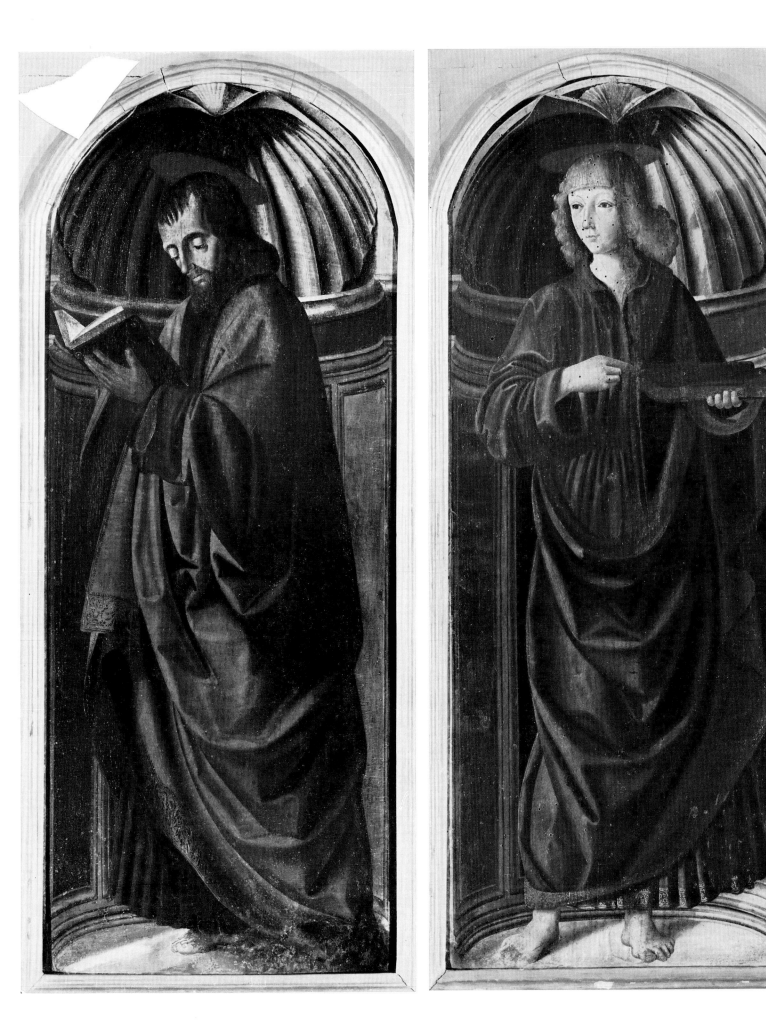

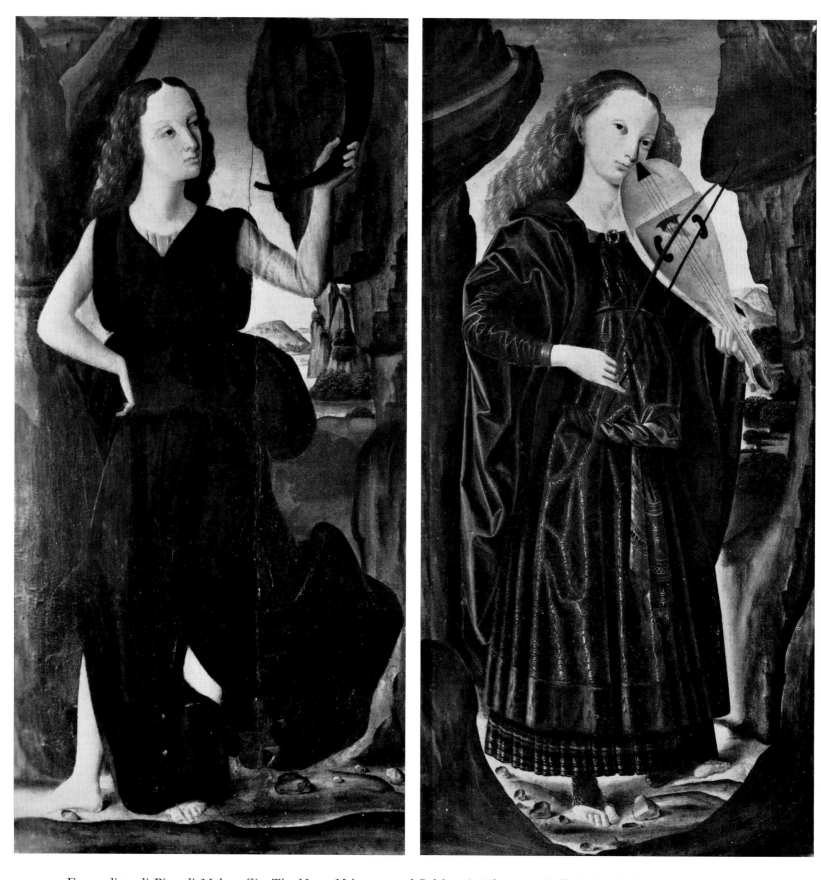

173-174. Evangelista di Pian di Meleto (?): *The Muses Melpomene and Polyhymnia*. Florence, Galleria Corsini.

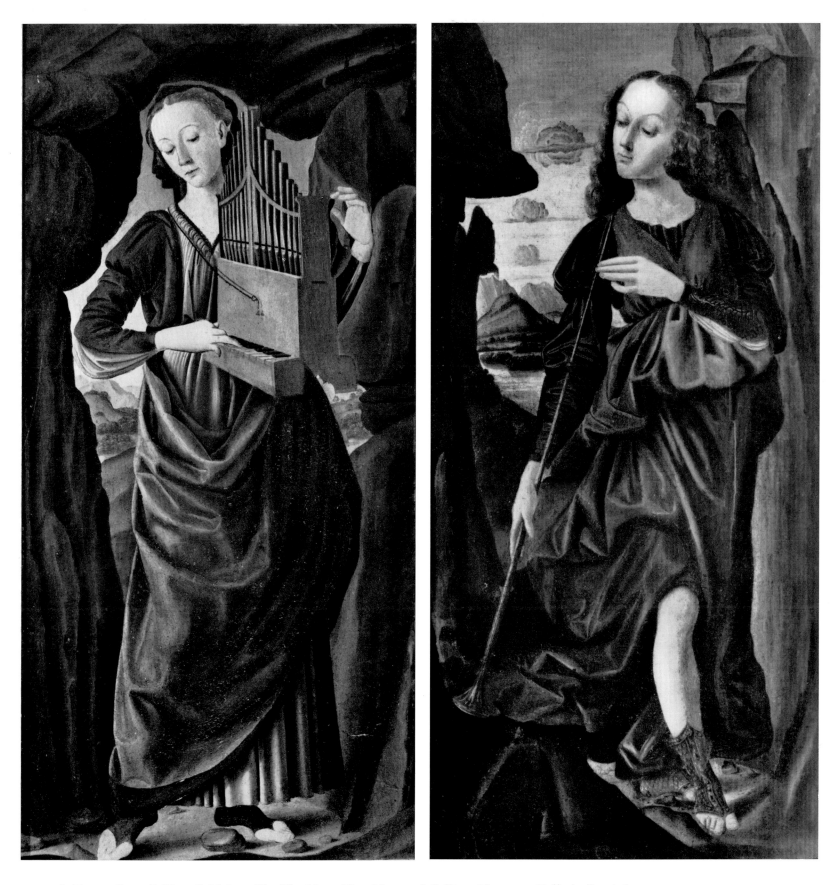

175-176. Evangelista di Pian di Meleto (?): *The Muses Terpsichore and Calliope*. Florence, Galleria Corsini.

177. Giovanni Santi: *The Annunciation*. Cagli, Church of S. Domenico.

178. Bartolomeo di Gentile: *Virgin and Child*. Lille, Musée des Beaux-Arts.

179. Bartolomeo di Gentile: *Virgin and Child with Angels and Saints*. Budapest, Museum of Fine Arts.

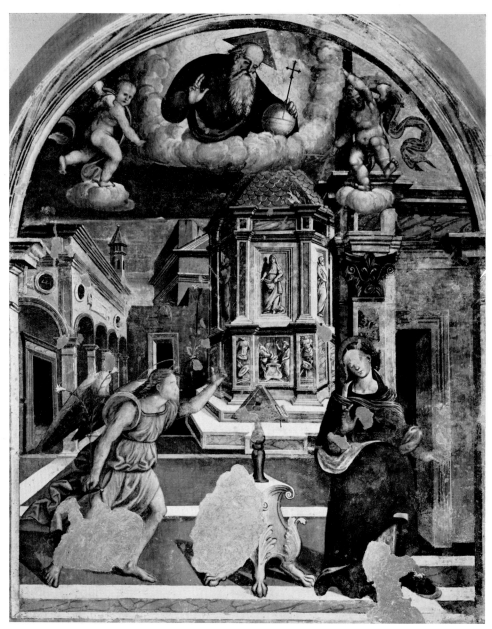

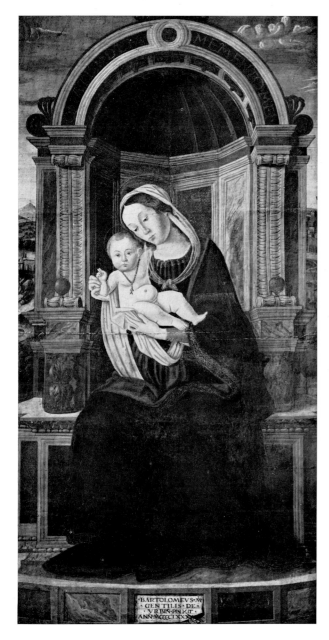

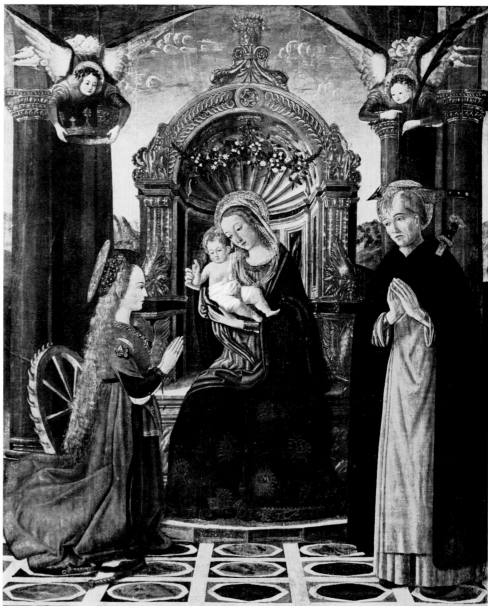

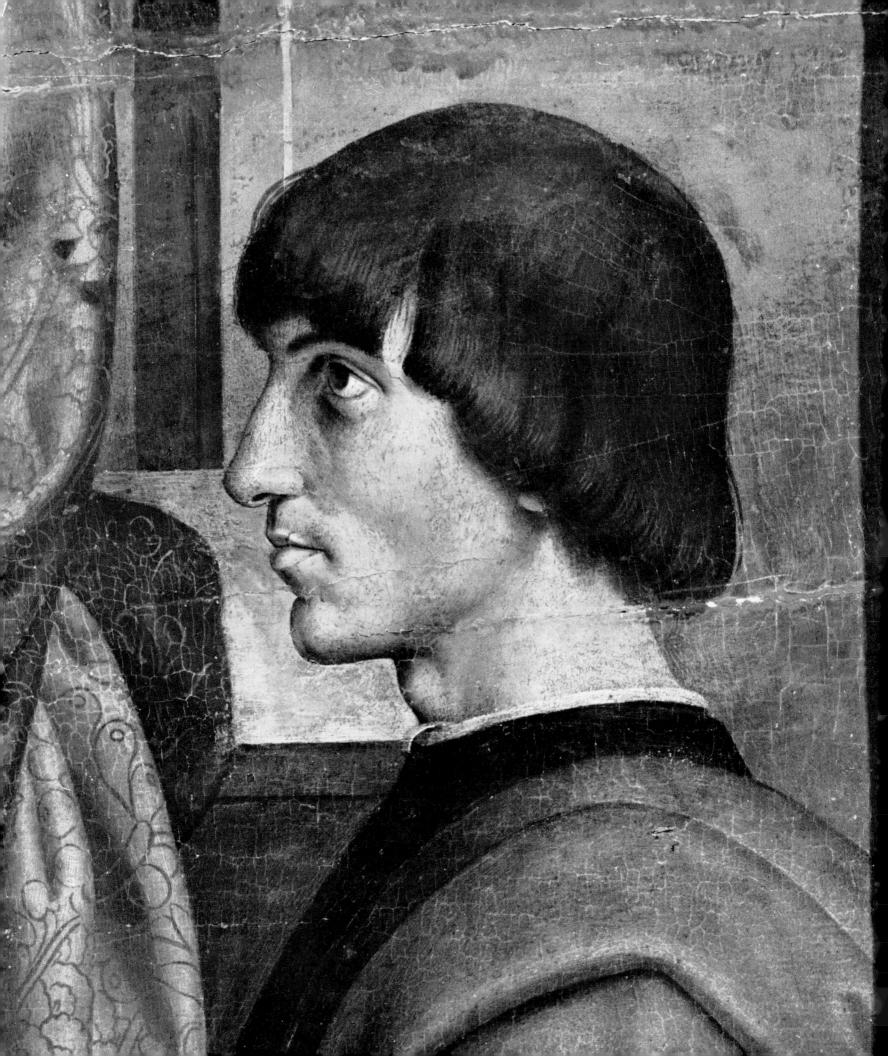

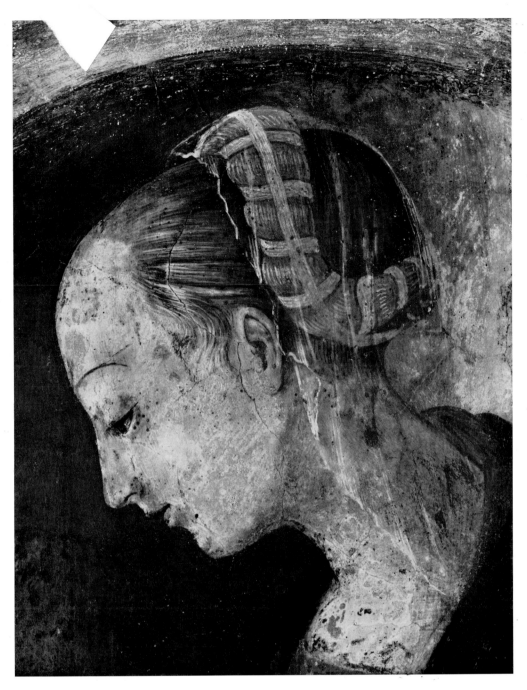

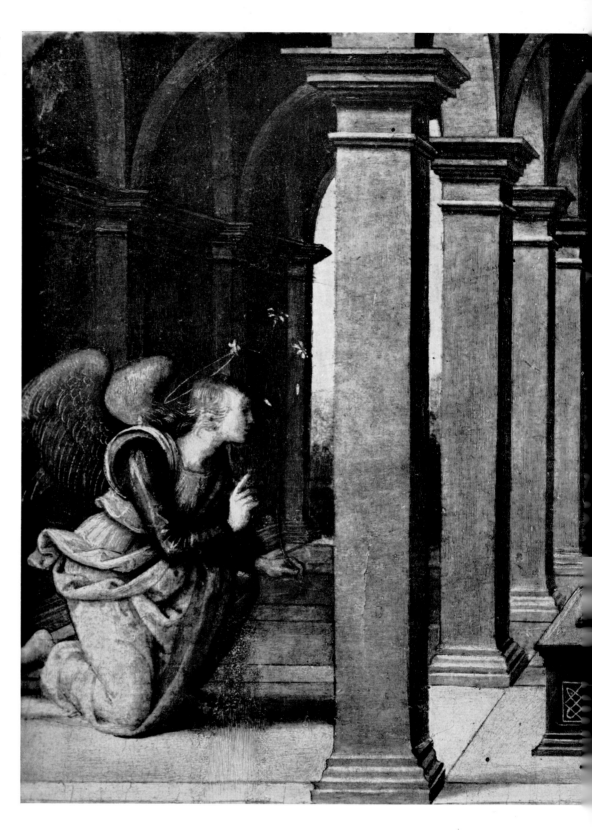

183. Perugino (or Raphael?): *The Annunciation*. Fano, Church of S. Maria Nuova.

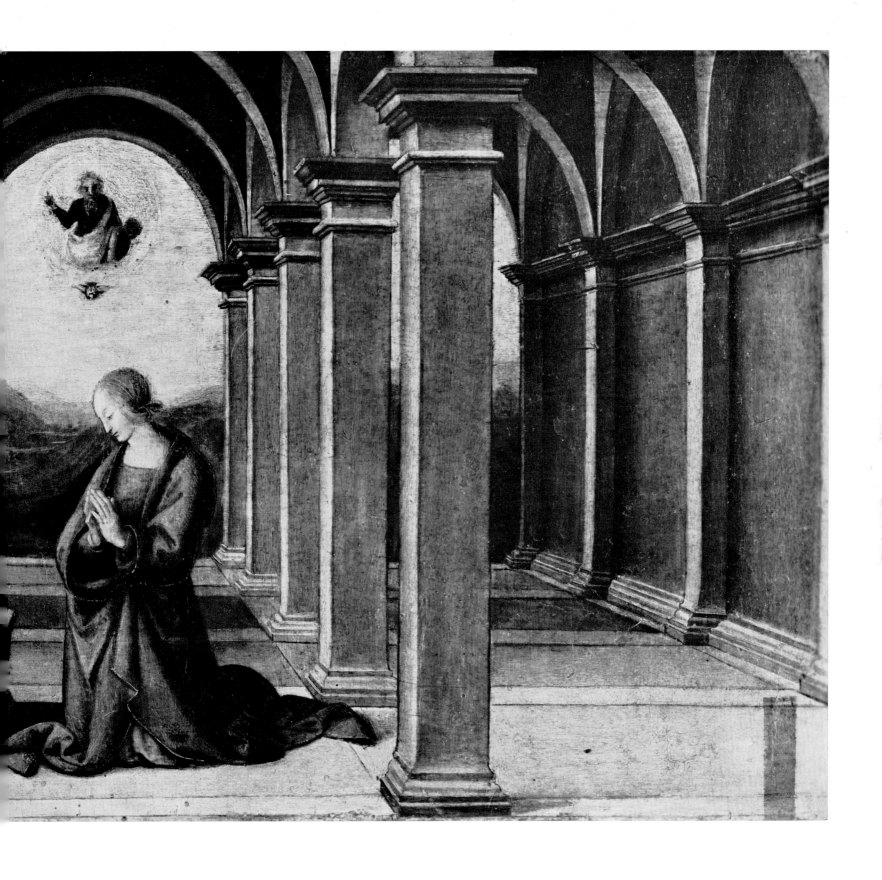

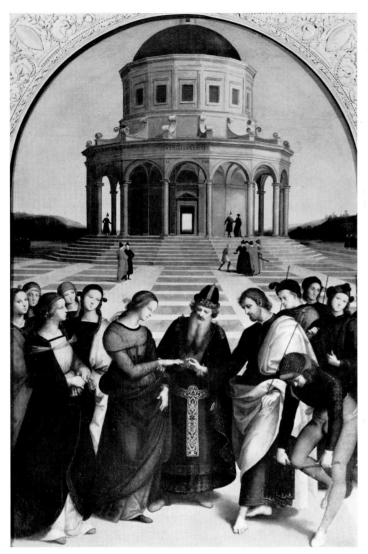

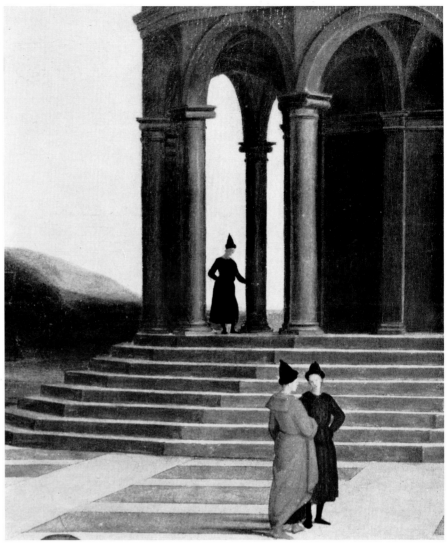

184-185. Raphael: *The Marriage of the Virgin*. Milan, Brera.

186. Raphael: *The School of Athens*. Rome, Palazzo Vaticano, Stanze.

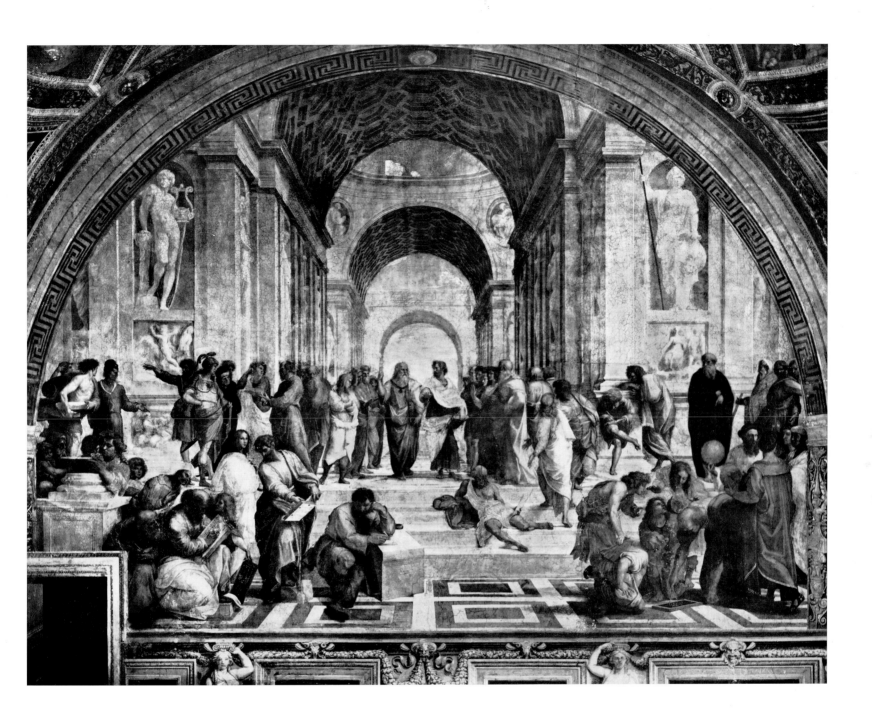

187. Raphael: Detail from *The School of Athens* (plate 186).

BIBLIOGRAPHY / INDEX OF NAMES / LIST OF ILLUSTRATIONS / ACKNOWLEDGEMENTS

ALATRI, P., *Federico da Montefeltro: Lettere di Stato o d'Arte*, Rome, 1949.

ALAZARD, J., *La Galleria d'Urbino*, in 'Gazette des Beaux-Arts', 59, 1917, pp. 262-263.

ALEANDRI, V.E., *Bernardino di Mariotto pittore e la sua dimora a Sanseverino dal 1502 al 1521*, in 'Nuova Rivista Misena', I, 1891.

ALEANDRI, V.E., *Note e correzioni al commentario di Maestro Lorenzo, di Maestro Alessandro pittore sanseverinate*, in 'Nuova Rivista Misena', Arcevia, 1894, p. 171.

ALEANDRI, V.E., *Dei pittori sanseverinati Cristoforo di Giovanni, Bartolomeo Friginesco e Ludovico Urbani, nella metà del sec. XV*, in 'Arte e Storia', XIII, 1894, pp. 153-157.

ALEANDRI, V.E., *Notizie da S. Severino Marche*, in 'Arte e Storia', XIV, 1895, p. 112.

ALEANDRI, V.E., *La Pinacoteca Civica di S. Severino*, in 'Gallerie Nazionali Italiane', III, 1897.

ALEANDRI, V.E., *Sulla famiglia dei pittori Lorenzo e Giacomo di Salimbeni da S. Severino*, in 'Arte e Storia', XX, 1901.

ALEANDRI, V.E., *Documenti per la Storia dell'Arte nelle Marche*, in 'Rassegna bibliografica dell'Arte Italiana', VIII, 1905.

ALEANDRI, V.E., *Il pittore C. Crivelli a Camerino*, in 'Rassegna bibliografica dell'Arte Italiana', VIII, Ascoli Piceno, 1905, pp. 154-157.

ALEANDRI, V.E., *Il Duomo antico di S. Severino*, San Severino, 1906.

ALEANDRI, V.E., *Il Palazzo in Roma, la famiglia e il ritratto di Giambattista Caccialupi sanseverinate*, in 'Arte e Storia', XXVII, 1908, pp. 136-138.

ALEANDRI, V.E., *Il primo maestro del pittore Lorenzo d'Alessandro da Sanseverino*, in 'Arte e Storia', XXXIX, 1920, pp. 17-22.

ALGRANTI, G., *Antologia di dipinti di cinque secoli*, Palazzo Serbelloni, Milan, 1971.

ALLEVI, G., in 'Nuova Rivista Misena', V, 1894, p. 183.

ANDREANTONELLI, S., *Breve ristretto della Storia di Ascoli*, Salvioni, 1676, pp. 31-33.

ANNIBALDI, G., *A proposito del ritrovamento del dialogo contro i Fraticelli*, in 'Picenum Seraphicum', 1970, pp. 178-189.

ANSELMI, A., *La Madonna del Crivelli in Ancona*, in 'Nuova Rivista Misena', III, Arcevia, 1890, p. 176.

ANSELMI, A., *Il ritrovamento di un quadro di Lorenzo d'Alessandro*, in 'Nuova Rivista Misena', V, Arcevia, 1892, pp. 60-61.

ANSELMI, A., *Il ritrovamento della tavola di Luca Signorelli dipinta in Arcevia*, in 'Nuova Rivista Misena', V, Arcevia, 1892, p. 79.

ANSELMI, A., *Oratorio di S. Mariano*, in 'Nuova Rivista Misena', V, Arcevia, 1892, p. 9.

ARINGOLI, D., *La beata Battista Varano*, Fabriano, 1928.

ASTOLFI, C., *Quadri del Pagani e dell'Alemanni*, in 'L'Arte', IV, 1901, pp. 217-218.

ASTOLFI, C., *Dipinti del Folchetti, di Durante Nobili, del Pagani e dell'Alemanni*, in 'L'Arte', IV, 1901, p. 425.

ASTOLFI, C., *Di alcuni quadri a Pausola e a Fermo del Crivelli etc.*, in 'L'Arte', V, 1902, pp. 192-194.

ASTOLFI, C., *A proposito della origine tedesca di Pietro Alemanni*, in 'L'Arte', VI, 1903, pp. 205-206.

ASTOLFI, C., *Conferma della origine tedesca di Pietro Alemanni*, in 'Arte e Storia', 1904, p. 87.

ASTOLFI, C., *Un'altra tavola di Pietro Alemanni già nella nostra chiesa di S. Francesco*, in 'Bollettino storico Monterubbianese', 1904, July.

AURINI, G., *Di un ignoto bassorilievo quattrocentesco dell'Ospedale militare di Ancona*, Ancona, 1908.

BACCI, M., *Il punto su Giovanni Boccati*, in 'Paragone', 1969, nos. 231 and 233.

BALDI, B., *Della vita e de' fatti di Federico da Montefeltro*, (ed. 1826, Bologna).

BALDORIA, N., *Quattro nuovi quadretti di C. Crivelli nelle Gallerie di Venezia*, in 'Archivio storico dell'Arte', 1890, pp. 158-159.

BAMBINI, A.M., *Pietro Alemanno*, (doctoral thesis, University of Urbino, 1954-55).

BARONI, C. - DELL'ACQUA, G.A., *Tesori d'arte di Lombardia*, Milan, 1952.

BAUTIER, P., *Le tableaux italiens des Musées Royaux de Bruxelles*, (Conférences 1940-41), Brussels, 1941.

BAUTIER, P., *Madonna and Child enthroned with Donors etc.*, in 'Art News', 1946, February.

BEGNINI, V., *Compendioso ragguaglio delle cose di Fabriano*, Fabriano, 1924.

BERCKEN, E. V.D., *Malerei der Renaissance*, in 'Ober-italien', Wildpark-Potsdam, 1927, p. 83.

BERENSON, B., *The Venetian Painters of the Renaissance*, London-New York, 1894, II ed. 1907.

BERENSON, B., *Venetian Painting at the Exhibition of Venetian Art*, The New Gallery, London, 1895.

BERENSON, B., *The Venetian Painters of the Renaissance*, III ed., New York-London, 1899.

BERENSON, B., *The Venetian Painters of the Renaissance*, London, 1901.

BERENSON, B., *Gentile da Fabriano* (Scoperte e primizie artistiche), in 'Rassegna d'Arte', IV, 1904, p. 158.

BERENSON, B., *The North Italian Painters of the Renaissance*, New York-London, 1907.

BERENSON, B., *Gerolamo di Giovanni da Camerino*, in 'Rassegna d'Arte', VII, 1907, pp. 129-135.

BERENSON, B., *The Central Italian Painters of the Renaissance*, II ed., New York-London, 1909.

BERENSON, B., *The Venetian Painters of the Renaissance*, III ed., New York-London, 1911.

BERENSON, B., *Catalogue Johnson coll.*, Philadelphia, 1913, pp. 75-80, 96.

BERENSON, B., *Nicola di maestro Antonio di Ancona*, in 'Rassegna d'Arte', XV, 1915, pp. 165-174.

BERENSON, B., *Venetian Painting in America: the Fifteenth Century*, New York, 1916.

BERENSON, B., *Dipinti veneziani in America*, Milan, 1919.

BERENSON, B., *The Study and Criticism of Italian Art*, I, London, 1920.

BERENSON, B., *Missing Pictures by Arcangelo di Cola*, in 'Studio International', 1929, pp. 21-25.

BERENSON, B., *Quadri senza casa: Arcangelo da Camerino*, in 'Dedalo', 1929.

BERENSON, B., *Italian pictures of the Renaissance*, Oxford, 1932.

BERENSON, B., *I pittori Italiani del Rinascimento*, Milan, 1936.

BERENSON, B., *Pitture italiane del Rinascimento*, Milan, 1936.

BERENSON, B., *Italian Pictures of the Renaissance, Venetian school*, I, London, 1957.

BERENSON, B., *Pitture italiane del Rinascimento, Scuola Veneta*, I, Florence, 1958.

BERENSON, B., *Italian Pictures of the Renaissance: Central Italian and North Italian School*, London, 1968.

BERNARDINI, G., *Le Gallerie Comunali dell'Umbria*, 1906, p. 25.

BERNARDINI, G., *Poche spigolature in alcune Gallerie tedesche*, in 'Rassegna d'Arte', XI, 1911, p. 42.

BERNARDINI, G., *Due quadri in Urbino*, in 'Rassegna d'Arte', XV, 1915, pp. 61-62.

BERNARDINI, G., *Sette dipinti della raccolta Lazzaroni*, in 'Rassegna d'Arte', XI, 1911, pp. 100-104.

BERTI TOESCA, E., *Arte italiana a Strigonia*, in 'Dedalo', XII, 1932, p. 956.

BERTINI, G., *Catalogo generale della fondazione artistica Poldi-Pezzoli*, Milan, 1881.

BIALOSTOCKI, J., *A lunette above Crivelli's St. George*, in 'Burlington Magazine', XCVIII, London, 1956, pp. 370-373.

BIGIARETTI, L., *Il Museo Piersanti in Matelica*, Florence, 1917.

BINDI, V., *Artisti abruzzesi*, Naples, 1883.

BODE, W. VON, *Die Heilige Magdalene von C. Crivelli*, in 'Jahrbuch der K. Pr. Ksts', Berlin, 1890, pp. 63-64.

BODE, W. VON, *Beschreibendes Verzeichnis der Gemälde im Kaiser Friedrich Museum*, Berlin, 1904, p. 88.

BODE, W. VON, *Fabriczy. Der Cicerone*, ed. 1904, II se., 3, p. 678.

BODE, W. VON, *Die Sammlung O. Huldschinsky*, Berlin, 1908, p. 38.

BOECK, W., *An unpublished Drawing by Crivelli*, in 'Burlington Magazine', LIX, 1931, pp. 72-75.

*Bollettino d'arte del Ministero dell'Istruzione Pubblica*, Rome, 1908, p. 73.

BOLOGNA, F., *La ricostruzione di un polittico e il Maestro dei polittici Crivelleschi*, in 'Bollettino d'Arte', XXXIII, 1948, pp. 367-370.

BOLOGNA, F., *Di alcuni rapporti tra Italia e Spagna e Antonius Magister*, in 'Arte Antica e Moderna', 1961.

BOMBE, W., *Antonio da Fabriano*, in 'Thieme-Becker Allgemeines Lexikon der Bildenden Künstler', Leipzig, I, 1907, p. 586.

BOMBE, W., *Bernardino di Mariotto*, in 'Thieme-Becker Allgemeines Lexikon der Bildenden Künstler', Leipzig, III, 1909.

BOMBE, W., *Boccati Giovanni*, in 'Thieme-Becker Allgemeines Lexikon der Bildenden Künstler', Leipzig, IV, 1910, p. 153.

BORENIUS, T., *Catalogue of the Benson Collection*, 1912.

BORENIUS, T., *La Mostra di dipinti veneziani primitivi al Burlington Fine Arts Club*, in 'Rassegna d'Arte', XII, 1912, p. 88.

BOSCHINI, M., *Le ricche miniere della pittura veneziana*, Venice, 1684, p. 30.

BOSKOVITS, M., *Il problema di Antonius Magister e qualche osservazione sulla pittura marchigiana del Trecento*, in 'Arte Illustrata', May-June, 1969, pp. 4-19.

BOTTARI, S., *Le Mostre del Mantegna e del Crivelli*, in 'Arte Veneta', 1961.

BOTTI, G., *Catalogo delle RR. Gallerie di Venezia*, Venice, 1891.

BOVIO MARCONI, I., *Rilievo quattrocentesco rappresentante la visione del beato Gabriele Ferreti*, in 'Bollettino d'Arte', VIII, 1929, II, pp. 400, 406-407.

BRANDI, C., *La pittura riminese del Trecento*, (Catalogue), Rimini, 1935.

BRIGANTI, G., *Un inedito di Nicola di Maestro Antonio*, in 'Arte Antica e Moderna', Bologna, 1961, p. 177.

BRIZIO, A.M., *Il percorso dell'arte di Lorenzo Lotto*, in 'Arte Veneta', 1953.

BROUSOLLE, I.C., *La jeunesse du Pérugin et les origines de l'Ecole Ombrenne*, Paris, 1901.

BRUGNOLI, M.V., *La Mostra del Crivelli a Venezia*, in 'Bollettino d'Arte', 1961.

BRUTI LUBERATI, *Lettera sopra Monte Santo*, III, Ripatransone, 1840, p. 5.

BURROUGHS, B., *Catalogue of Paintings*, 1926.

BUSCAROLI, R., *Melozzo e il Melozzismo*, Bologna, 1955, pp. 155-165.

BUSCHMANN, P., *Carlo Crivelli e le sue opere nella National Gallery di Londra*, in 'Emporium', 1901, p. 332.

CALZINI, E., *Un'opera dell'Alamanni?* (review), in 'Rassegna bibliografica dell'Arte Italiana', II, Rocca S. Casciano, 1899, p. 129.

CALZINI, E., *Di alcune pitture di Cola dell'Amatrice*, in 'Rassegna Bibliografica dell'Arte Italiana', III, Ascoli Piceno, 1900, pp. 115-123.

CALZINI, E., *I quadri di scuola italiana nella Galleria Nazionale di Budapest* (review), in 'Archivio Storico dell'Arte', III, 1900, p. 156.

CALZINI, E., *Note sulla pittura in Ascoli* (Cola dell'Amatrice), in 'Rassegna Bibliografica dell'Arte Italiana', III, Ascoli Piceno, 1900, pp. 183-185, 187.

CALZINI, E., *Una tavola di Pietro Alemanni*, in 'Rassegna Bibliografica dell'Arte Italiana', III, Ascoli Piceno, 1900, pp. 9-12.

CALZINI, E., *Un'opera giovanile del Filatesio*, in 'Rassegna Bibliografica dell'Arte Italiana', IV, Ascoli Piceno, 1901, pp. 26-31.

CALZINI, E., *Di alcune opere d'arte a Santelpidio a Mare*, in 'Rassegna Bibliografica dell'Arte Italiana', IV, Ascoli Piceno, 1901, pp. 184-189.

CALZINI, E., *Di un dipinto di C. Crivelli nella Pinacoteca Vaticana*, in 'Rassegna Bibliografica dell'Arte Italiana', IV, Ascoli Piceno, 1901, pp. 164-165.

CALZINI, E., *Veneto* (review), in 'Rassegna Bibliografica dell'Arte Italiana', V, Ascoli Piceno 1902, pp. 111-112.

CALZINI, E., *Annunzi e Notizie*, in 'Rassegna Bibliografica dell'Arte Italiana', V, Ascoli Piceno, 1902, p. 39.

CALZINI, E., *La chiesa e il convento dell'Annunziata in Ascoli Piceno*, in 'Rassegna Bibliografica dell'Arte Italiana', V, Ascoli Piceno, 1902, pp. 4-11.

CALZINI, E., *Ancora della tavola dell'Alamanni* (review), in 'Rassegna Bibliografica dell'Arte Italiana', VI, Ascoli Piceno, 1903, p. 146.

CALZINI, E., *Di una tavola di Cola dell'Amatrice*, in 'Rassegna Bibliografica dell'Arte Italiana', VI, Ascoli Piceno, 1903, pp. 4-8.

CALZINI, E., *Civico Museo di Camerino*, 1904.

CALZINI, E., *A Monteprandone e ad Acquasanta (note d'arte). Quadri di Scuola Crivellesca*, in 'Rassegna Bibliografica dell'Arte Italiana', VII, Ascoli Piceno, 1904, pp. 61-69.

CALZINI, E., *La Raccolta Duranti*, in 'Rassegna Bibliografica dell'Arte Italiana', VII, Ascoli Piceno, 1904, pp. 13-15.

CALZINI, E., *Un'ancona di Cola d'Amatrice del 1571*, in 'Rassegna Bibliografica dell'Arte Italiana', VII, Ascoli Piceno, 1904, pp. 138-140.

CALZINI, E., *Una tavola di scuola crivellesca*, in 'L'Arte', VII, 1904, p. 192.

CALZINI, E., *L'Arte Marchigiana*, in 'Rassegna Bibliografica dell'Arte Italiana', VIII, Ascoli Piceno, 1905, pp. 177-180.

CALZINI, E., *L'antica arte Marchigiana all'Esposizione di Macerata*, in 'Rassegna Bibliografica dell'Arte Italiana', VIII, n. 8-10, Ascoli Piceno, 1905, pp. 129-137.

CALZINI, E., *Di due quadri di Cola d'Amatrice*, in 'Rassegna Bibliografica dell'Arte Italiana', IX, Ascoli Piceno, 1906, pp. 53-56.

CALZINI, E., *Amatrice, Cola dall'*, in 'Thieme-Becker Allgemeines Lexikon der Bildenden Künstler', Leipzig, I, 1907, pp. 381-385.

CALZINI, E., *Altre opere ignote di Cola d'Amatrice*, in 'Rassegna Bibliografica dell'Arte Italiana', X, Ascoli Piceno, 1907, pp. 103-108.

CALZINI, E., *Una tavoletta crivellesca*, in 'Rassegna Bibliografica dell'Arte Italiana', XVII, Ascoli Piceno, 1914, p. 23.

CAMESASCA, E., *Tutta la pittura di Raffaello*, Milan, 1956.

CANTALAMESSA CARBONI, G., *Memorie intorno i Letterati e gli artisti della città di Ascoli nel Piceno*, Ascoli, 1830.

CANTALAMESSA G., *Artisti Veneti nelle Marche*, in 'Nuova Antologia', 1892, pp. 401-431.

CANTALAMESSA, G., *RR. Galleria di Venezia*, in 'Gallerie nazionali italiane', II, 1896, pp. 30-34.

CANTALAMESSA, G., *Un dipinto di C. Crivelli nella Pinacoteca Vaticana*, in 'Rassegna d'Arte', I, 1901, pp. 49-53.

CANTALAMESSA, G., *C. Crivelli. Frammenti di uno studio circa gli artisti veneti nelle Marche*, in 'Studi Marchigiani', I and II, 1905-1906, Macerata, 1907, pp. 101-118.

CANTALAMESSA, G., *Conferenze d'Arte*, Rome, 1926.

CAPPONI, *Guida alla Cattedrale basilica di Ascoli Piceno*, 1912.

CARDARELLI, C. - ERCOLANI, E., *La civica pinacoteca di Ascoli Piceno*, Ascoli, 1954, pp. 46-47.

CARDONA, M., *Camerino: un secolo e sei pittori*, Camerino, 1965.

CARDUCCI, G., *Su le memorie e i monumenti di Ascoli*, Fermo, 1853.

CARLI, *Per la pittura del Quattrocento in Abruzzo*, in 'Rivista dell'Istituto di Architettura e Storia dell'Arte', 1952, IX, p. 127.

CAROCCI, G., *Notizie di Sanseverino*, in 'Arte e Storia', XIV, 1895, p. 56.

CAROTTI, *Catalogo della R. Pinacoteca di Brera*, Milan, 1901.

CASTIGLIONE, B., *Il Cortegiano*, (1524), Venice, 1528.

Catalogues of Collections and Exhibitions

Austria: *Catalogue des Tableaux de la Collection Camillo Castiglioni*, Vienna, 1925, p. 3, n. 10.

Belgium: *Catalogue du Musée des Beaux-Arts de Bruxelles*, Brussels, 1958.

*La Peinture venitienne*, Brussels, 1953-54.

France: *Catalogue du Musée des Beaux-Arts de Strasbourg*, 1912, n. 224; 1938, n. 213.

*Catalogue du Musée National du Louvre*, Paris, 1926.

*Catalogue de l'Exposition de l'Art italien*, Paris, 1935, n. 133.

*L'Europe gothique*, Paris, 1968.

Germany: *Katalog der Gemälde Galerie: die Italienischen Meister*, Berlin, 1930, pp. 38-40, 116.

*Katalog: 500 Jahre venezianischer Malerei*, Schaffhausen, 1953, May-June, pp. 25-26.

Great Britain: *Catalogue of the Wallace Collection, Pictures and Drawings*, London, 1928, p. 64.

*Catalogue of the Exhibition of Italian Art in London, January-March 1930*, Oxford-London, 1931, pp. 66-68.

*Catalogue of the Paintings in the Ashmolean Museum*, Oxford, n.d.

Hungary: *Catalogue of the Museum of Gerevich Tibor*, Budapest, 1948, pp. 66, 68.

*Christian Art in Hungary, Collections from the Esztergom Museum of Christian Art*, Budapest, 1965.

Italy: *Catalogo delle RR. Gallerie di Venezia*, Venice, 1887.

*Catalogo della Mostra di Belle Arti, esposizione regionale marchigiana*, Macerata, 1905.

*Catalogo della Vendita dei quadri ed oggetti d'Arte del fu Rev. J. Nevin*, Rome, 1907, pl. II.

*Catalogo della Galleria Nazionale Palazzo Barberini*, Rome, 1953.

Catalogue, *Dai Visconti agli Sforza*, Milan, 1958.

Catalogues, *Mostra di opere d'arte restaurate*, Urbino, 1967, 1968 and 1969.

*Catalogo Mostra-Vendita Finarte*, Milan, March 1971 (*predella of Giovanni Boccati*).

Japan: *Masterpieces of the ex-Matsukata Collection*, Museum of Western Art, Tokyo, 1960.

Netherlands: *Catalogue of the Rijksmuseum, Amsterdam*, Amsterdam, 1948, p. 29.

Catalogue, *De Venetiaanse Meesters*, July-October, 1953, Amsterdam, 1953, pp. 30-32.

U.S.A.: *Catalogue of the J. Bache Collection*, New York, 1929.

*Catalogue of the Paintings in the Bache Collection*, New York, 1937.

*Handbook of the Cleveland Museum of Art*, Cleveland, 1958.

*Catalogue of the Holden Collection*, Cleveland, 1917, pp. 33, 63.

*Catalogue of the Paintings in the Museum of Fine Arts*, Boston, 1921, p. 10.

*Catalogue of Paintings and Sculpture from the Samuel H. Kress Collection*, Washington, 1949, p. 79.

*Catalogue of the Sterling and Francine Clark Art Institute*, Williamstown, Mass., 1961.

CAVALCASELLE, G.B. - MORELLI, G., *Catalogo delle opere d'arte nelle Marche e nell'Umbria. Le Gallerie Nazionali Italiane*, Documenti storico-artistici 1861-1895, Rome, 1896.

CECCHITTELLI, G., *Maria Vergine e Santi. Tavola di C. Crivelli*, in 'Ape Regina', V, 1839, p. 51-52.

CENTANNI, L., *La parrocchia dei SS. Giovanni Battista ed Evangelista*, Monterubbiano, 1947.

CENTANNI, L., *Le spoliazioni di opere d'arte fatte alle Marche sotto il primo regno italico*, in 'Atti e Memorie della Deputazione di Storia Patria per le Marche', Ancona, 1950.

CESARI, C., *S. Bernardino da Siena o S. Giacomo della Marca? A proposito di un dipinto di C. Crivelli*, in 'Rassegna d'Arte', I, 1901, pp. 178-180.

CIAMMARCI, G.I., *Compendio di memorie istoriche sulle chiese di Ascoli*, 1797.

CICOGNA, E., *Iscrizioni Veneziane*, vol. II, p. 412, Venice, 1927.

CHIAPPINI, I., *Rapporti tra Gentile da Fabriano e Jacobello del Fiore*, (doctoral thesis, University of Urbino, 1967-68).

CHIAPPINI, I., *Per una datazione tarda della Madonna Correr di Jacobello del Fiore*, in 'Bollettino dei Musei Civici Veneziani', 1968, IV.

COLASANTI, A., *Un politico di G. Boccati a Belforte*, in 'L'Arte', VII, 1904, pp. 477-481.

COLASANTI, A., *La Tavola di Vittore Crivelli in Falerone*, in 'Rassegna d'Arte', V, 1905, p. 157.

COLASANTI, A., *Note sull'antica pittura fabrianese: Allegretto Nuzi e Francesco di Cecco Ghissi*, in 'L'Arte', IX, 1906.

COLASANTI, A., *Per la storia dell'arte nelle Marche*, in 'L'Arte', X, 1907, pp. 409-422.

COLASANTI, A., *Un quadro di Cola dell'Amatrice a Chieti*, in 'Bollettino d'Arte del Ministero della Pubblica Istruzione', II, 1908, pp. 396-397.

COLASANTI, A., *Gentile da Fabriano*, Bergamo, 1909.

COLASANTI, A., *Lorenzo e Jacopo Salimbeni da S. Severino*, in 'Bollettino d'Arte', IX, 1910.

COLASANTI, A., *Affreschi inediti di Lorenzo D'Alessandro da Sanseverino*, in 'Rassegna d'Arte', XVII, 1917, pp. 81-92.

COLASANTI, A., *Un Trittico ignorato di Antonio da Fabriano*, in 'Rassegna d'Arte', XIX, 1919, p. 201.

COLASANTI, A., *Nuovi dipinti di Arcangelo di Cola da Camerino*, in 'Bollettino d'Arte', 1922.

COLASANTI, A., *Italian Painting of the Quattrocento in the Marches*, Florence-Paris, 1932.

COLASANTI, A., *Affreschi nella chiesa di S. Ildebrando a Fossombrone*, in 'Bollettino d'Arte', 1936.

COLETTI, L., *I primitivi: I Padani*, Novara, 1947.

COLETTI, L., *Il maestro degli Innocenti*, in 'Arte Veneta', 1948.

COLETTI, L., *Pittura veneta del Quattrocento*, Novara, 1953.

COLLOBI, L., *Lazzaro Bastiani*, in 'La Critica d'Arte', IV, 1939, p. 36.

COLUCCI, *Antichità Picene*, Fermo, 1795, pl. XXIII.

CONTI, A., *Camerino e i suoi dintorni*, 1879.

CONTI, A., *Catalogo delle Regie Gallerie di Venezia*, Venice, 1895.

CORNELIUS, F., *Ecclesiae Venetae antiquis Monumentis*, Venice, 1749.

COTT, P.B., *The Theodore T. and Mary G. Ellis Collection: Continental European Paintings*, Worcester Art Museum Annual, vol. IV, 1941, pp. 18, 21, 29, 30.

CRISTOFANI, G., *La Mostra d'antica arte umbra a Perugia*, in 'L'Arte', X, 1907, pp. 294-296.

CROWE, J.A. - CAVALCASELLE, G.B., *A History of Painting in north Italy from the Fourteenth to the Sixteenth Century*, London, 1871.

CROWE, J.A. - CAVALCASELLE, G.B., *Italian Painting*, London, 1903, p. 242.

CROWE, J.A. - CAVALCASELLE, G.B., *Storia della pittura in Italia*, Florence, 1898, VIII; id., 1902, IX.

CROWE, J.A. - CAVALCASELLE, G.B., *History of Painting in North Italy*, (ed. Borenius), London, I, 1912.

DANIA, L., *La pittura a Fermo e nel suo circondario*, Milan, 1967.

DAVIES, M., *The Annunciation by C. Crivelli*, London, 1947.

DAVIES, M., *National Gallery Catalogues*, The Earlier Italian Schools, London, 1951, I ed.; 1961, II ed.

DEFENDI, G., *Gallerie di Quadri del cav. Oggioni*, in 'Gazzetta privilegiata di Milano', 1836, nn. 21, 22, 25.

DEGENHART, B., *Italienische Zeichnungen des frühen 15. Jahrhunderts*, Basle, 1949.

DEGENHART, B., *Pisanello*, Turin, 1945.

DELL'ACQUA, G.A. - RUSSOLI, F., *La pinacoteca di Brera*, Milan, 1960, nos. 28-31.

DELOGU, G., *Arte Italiana in Ungheria*, in 'Emporium', XLII, Bergamo, 1936, p. 184.

DESTRÉE, J., *Sur quelques Peintres des Marches et de l'Ombrie*, Brussels-Florence, 1900, pp. 21-28.

DOUGLAS, L., *Esposizioni londinesi*, in 'L'Arte', VI, 1903, p. 108.

DREY, F., *Carlo Crivelli*, Munich, 1927.

DREY, F., *Neu entdeckte Werke Carlo Crivellis und seines Kreises*, in 'Pantheon', IV, Munich, 1929, II, pp. 525-529.

*Elenco degli oggetti esposti, Museo Civico e Raccolta Correr*, Venice, 1899.

FABIANI, G., *Ascoli nel Quattrocento*, Ascoli Piceno, I, 1950.

FABIANI, G., *Ascoli nel Quattrocento*, Ascoli Piceno, II, 1951.

FABIANI, G., *Cola dell'Amatrice secondo i documenti di Ascoli*, Ascoli, 1952.

FACIO, B., *Degli uomini illustri*, 1455-56.

FALOCI PULIGNANI, M., *Bartolomeo di Tommaso pittore umbro del XV secolo*, in 'Rassegna d'Arte umbra', III, 1921, p. 65.

FELICIANGELI, B., *Opere ignorate di Giovanni Boccati*, in 'Rassegna Bibliografica dell'Arte Italiana', IX, 1906, pp. 1-13.

FELICIANGELI, B., *Sulla vita di Giovanni Boccati da Camerino*, San Severino, 1906.

FELICIANGELI, B., *Un'altra tavola di Giovanni Boccati*, in 'Rassegna Bibliografica dell'Arte Italiana', X, Ascoli Piceno, 1907, pp. 97-102.

FELICIANGELI, B., *Documenti relativi al pittore Giovanni Antonio da Camerino*, in 'Arte e Storia', 1910.

FELICIANGELI, B., *Sulle opere di Girolamo di Giovanni pittore del secolo XV*, Camerino, 1910.

FELICIANGELI, B., *Pittori camerinesi del Quattrocento*, Chieti and Potenza, 1910.

FELICIANGELI, B., *Sul tempo di alcune opere d'arte esistenti in Camerino*, in 'Atti e Memorie della Dep. di Storia Patria per le Marche', Series V, X, fasc. I, 1915, pp. 77-84.

FERRARI, G.E., *Miscellanea in onore di G. Praga, le carte di Storia e di Erudizione*, Venice, 1959.

FETIS, E., *Catalogue du Musée de Bruxelles*, I ed., 1865.

FETIS, E., *Catalogue du Musée Royal de Belgique*, IV ed., Brussels, 1877, p. 113.

FIAMMA, P., *Vera origine delle Chiese di S. Lorenzo e S. Sebastiano nelle isole dette Gemini*, Venice, 1645, p. 27.

FIOCCO, G., *Le Regie Gallerie dell'Accademia di Venezia*, Catalogue, Bologna, 1924.

FIOCCO, G., *L'arte di A. Mantegna*, Bologna, 1927.

FIOCCO, G., *Un Crivelli ignoto*, in 'Rivista d'Arte', II, 1930, pp. 237-241.

FIOCCO, G., *Ein neuer Crivelli*, in 'Pantheon', VII, Munich, 1931, I, pp. 248-250.

FIOCCO, G., *I pittori marchigiani a Padova alla metà del Quattrocento*, in 'Atti dell'Istituto Veneto', 1931-32.

FIOCCO, G., *Porträts aus der Emilia*, in 'Pantheon', II, Munich, 1932, pp. 337-343.

FIOCCO, G., *Niccolò di Pietro, Pisanello e Vencislao*, in 'Bollettino d'Arte', 1952, I.

FIOCCO, G., *Un'opera di Nicola di Maestro Antonio d'Ancona*, in 'Arte Veneta', 1952, I.

FIOCCO, G., *L'ingresso del Rinascimento nel Veneto*, in 'Venezia e l'Europa', Venice, 1956, pp. 16-17.

FIOCCO, G., *L'Arte di Andrea Mantegna*, Venice, 1959, pp. 54, 55, 79.

FISKOVIC, C., *Zadarski Sredovjecni Majstori*, Split, 1959, pp. 103-104, 188, 210.

FLAT, P., *Les premiers Venitiens*, Paris, 1899.

FOGOLARI, G., *Gallerie di Venezia*, Milan, 1924.

FRANCESCHINI, G., *Saggi di storia montefeltresca e urbinate*, Urbino, 1957.

FRANCESCHINI, G., *Figure del rinascimento urbinate*, Urbino, 1959.

FRANCIA, E., *Pinacoteca Vaticana* (Catalogue), Milan, 1960.

FRANCIS, H.S., *St. Nicolas by C. Crivelli*, in 'Bull. of the Cleveland Museum of Art', 39, 1952, pp. 187-189.

FRASCARELLI, G., *Memorie della basilica e convento dei padri minori conventuali in Ascoli*, Ascoli Piceno, 1855.

FRENFANELLI, CIBO, *Nicolò Alunno e la scuola umbra*, Rome, 1872, p. 112.

FRIEDMANN, H., *The symbolism of Crivelli's Madonna and Child enthroned with donor, in the National Gallery*, in 'Gazette des Beaux-Arts', September-October 1947, pp. 65-72.

FRIMMEL, T., *Lexikon der Wiener Gemäldesammlungen*, I, Munich, 1913, p. 352.

FRIZZONI, G., *Una rettifica in proposito di C. Crivelli*, in 'Arte e Storia', XX, 1891, pp. 11-12.

FRIZZONI, G., *Arte Italiana del Rinascimento*, Milan, 1891.

FRIZZONI, G., *La Pinacoteca di Brera*, in 'Archivio Storico dell'Arte', V, 1892, p. 404.

FRIZZONI, G., *La raccolta del Senatore G. Morelli in Bergamo*, in 'Archivio Storico dell'Arte', V, 1892, p. 219.

FRIZZONI, G., *Importanti aste di opere d'arte a Londra e a Parigi*, in 'Archivio Storico dell'Arte', V, 1892, p. 360.

FRIZZONI, G., *La Galleria Nazionale di Londra e i suoi recenti aumenti in fatto d'arte italiana*, in 'Archivio storico dell'Arte', I, 1895, pp. 87-105.

FRIZZONI, G., *La peinture en Europe - La Belgique* (review), in 'Archivio Storico dell'Arte', II, 1896, p. 399.

FRIZZONI, G., *Notizie artistiche*, in 'Nuova Antologia', 1899.

FRIZZONI, G., *Einige auserwählte Werke der Malerei in Pavie* (review), in 'Rassegna Bibliografica dell'Arte Italiana', V, 1902, p. 78.

FRIZZONI, G., *La peinture en Europe - Rome* (review), in 'Rassegna Bibliografica dell'Arte Italiana', VI, 1903, p. 179.

FRIZZONI, G., *Intorno a due dipinti di scuole italiane nel museo di Digione*, in 'Rassegna d'Arte', IX, 1909, p. 59.

FRIZZONI, G., *Una nuova perla nel Gabinetto dei Veneti del Museo Poldi Pezzoli a Milano*, in 'Rassegna d'Arte', XII, 1912, p. 120.

FRY, R., *La mostra d'antichi dipinti alle 'Grafton Galleries' di Londra*, in 'Rassegna d'Arte', X, 1910, p. 36.

FRY, R., *Exhibition of pictures of the Early Venetian school at the Burlington Fine Arts Club* parts I-III, in 'Burlington Magazine', XX, 1911, p. 346; XXI, pp. 47f, 95f.

FRY, R., *Madonna and Child by Carlo Crivelli*, in 'Burlington Magazine', XXII, 1913, p. 309.

GAMBA, C., *La Ca' d'Oro e la Collezione Franchetti*, in 'Bollettino d'Arte', 1916, pp. 321-334.

GAMBA, C., *Pittura umbra del Rinascimento*, Novara, 1949.

GARRONI, M.L., *Annuario bibliografico di Storia dell'Arte 1956-57*, Modena, 1960.

GASPARRI, D., *Illustrazione del Polittico di Carlo Crivelli in Torre di Palme*, 1897.

GAYE, G., *Kunstblatt Stuttgart und Tübingen*, XX, 1839, nn. 21, 81-83.

GAYE, G., *Carteggio inedito di artisti*, Florence, I, 1839.

GEIGER, B., *Carlo e Vittore Crivelli*, in 'Thieme-Becker, Allgemeines Lexikon der Bildenden Künstler', VIII, Leipzig, 1913.

GEREVICH, T., *A Krakoi czartoryski képtar olasz mesterei*, Budapest, 1918, pp. 153-159.

GEREVICH, T., *Esztergomi mükincsek*, I, Budapest, 1928, p. 238.

GHERARDINI, A., *Lorenzo e Jacopo Salimbeni da S. Severino*, in 'L'Arte', LVII, 1958.

GIANANDREA, A., *Olivuccio di Ciccarello*, in 'Nuova Rivista Misena', III, 1891, Arcevia, pp. 181-182.

GIANANDREA, A., *Della Signoria di Francesco Sforza nella Marca etc.*, Florence, 1898.

GNOLI, U., *L'arte Italiana in alcune Gallerie francesi di provincia*, in 'Rassegna d'Arte', VIII, 1908, p. 206.

GNOLI, U., *L'Arte umbra alla mostra di Perugia*, Perugia, 1908.

GNOLI, U., *Una tavola sconosciuta di Cristoforo da S. Severino e Angelo da Camerino*, in 'Rassegna Bibliografica dell'Arte Italiana', XII, 1909, pp. 151-158.

GNOLI, U., *Opere sconosciute di Pietro Alemanno*, in 'Rassegna d'Arte', XII, 1911, p. 206.

GNOLI, U., *Lorenzo e Jacopo Salimbeni...*, in 'Rassegna d'Arte umbra', 1911.

GNOLI, U., *Giannicolo di Paolo (Nuovi documenti)*, in 'Bollettino d'Arte', XII, 1918, p. 37.

GNOLI, U., *Pietro da Montepulciano e Giacomo da Recanati*, in 'Bollettino d'Arte', 1921-22.

GNOLI, U., *Pittori e Miniatori nell'Umbria*, Spoleto, 1923, pp. 160-161.

GODFREY, F.M., *Early Venetian Painters 1415-1493*, London, 1954, p. 27.

GOMBOSI, G., *Una Madonna con due santi di Antonio da Fabriano*, in 'Rassegna Marchigiana', XI, 1933, pp. 37-40.

GOWER, R., *The Northbrook Gallery; an illustrated, descriptive and Historical Account of the Collection*, 1885.

GRASSI, G., *Dipinti ignoti di L. Salimbeni e dell'Alemanno*, in 'Critica d'Arte', IX, 1950, pp. 60-69.

GRASSI, G., *Tutta la pittura di Gentile da Fabriano*, Milan, 1953.

GRIGIONI, C., *A proposito di alcuni dipinti Crivelleschi*, in 'Rassegna Bibliografica d'Arte Italiana' IV, Ascoli Piceno, 1901, pp. 173-178.

GRIGIONI, C., *Il trittico di Cupra Marittima e la Scuola Crivelliana*, in 'Rassegna Bibliografica d'Arte Italiana', VI, Ascoli Piceno, 1903, pp. 165-170.

GRIGIONI, C., *Una tavola di Pietro Alemanni già in S. Francesco di Monterubbiano*, in 'Bollettino storico Monterubbianese', 1903, January.

GRIGIONI, C., *Ancora della tavola dell'Alemanni già in S. Francesco di Monterubbiano*, in 'Bollettino storico Monterubbianese', 1903, March.

GRIGIONI, C., *Notizie biografiche ed artistiche intorno a Vittorio e Giacomo Crivelli*, in 'Rassegna Bibliografica dell'Arte Italiana', IX, Ascoli Piceno, 1906, pp. 109-119.

GRIGIONI, C., *Per la storia della pittura in Ascoli Piceno nella seconda metà del sec. XV*, in 'Rassegna Bibliografica dell'Arte Italiana', XI, Ascoli Piceno, 1908, pp. 1-5.

GRONAU, G., *L'art venitien à Londres*, in 'Gazette des Beaux-Arts', March, 1895, pp. 164-166.

*Guida storico-artistica di Camerino e dintorni*, Terni, 1927.

HEIL, W., *The Bache paintings at the Metropolitan (the Madonna and Child)*, in 'Art News', 1943, p. 28.

HEINRICH, T.A., *The Lehman Collection*, in 'Bulletin of the Metropolitan Museum of Arts', XII, 1954, p. 220.

HENDY, F., *The Isabella Stewart Gardner Museum, Catalogue of paintings*, Boston, 1931.

HOLMES, C., *The Italian Exhibition*, in 'Burlington Magazine', February, 1930, pp. 55-72.

JACOBSEN, E., *Umbrische Malerei des 14. 15. und 16. Jhrdt. zur Kunstgeschichte des Auslandes H.*, 107, 1914, p. 62.

JOCELYN FOULKES, C., *L'esposizione d'arte italiana a Londra*, in 'Archivio Storico dell'Arte', 1894, p. 264.

KOLENDIC, P., *Slikar Juraj Culinovic u Sibeniku*, in 'Vjesrik za archeologiju i historiju dalmatisku', XLIII, Split, 1920, pp. 117-190.

KRISTELLER, P., *Carlo Crivelli*, in 'Das Museum', V, 1900, pp. 13-16.

KUKULJEVIC, I., *Slovnik Umjetnikah Jugoslovanskih*, Zagreb, 1858, pp. 401-403.

LACLOTTE, M., *De Giotto à Bellini* (Catalogue of the exhibition), Paris, 1956.

LAFARGE - JACCACI, *Noteworthy Painting*, 1907.

LAFENESTRE, G. - RICHTENBERGER, E., *La peinture en Europe - Venise*, Paris, 1897.

LANGTON DOUGLAS, R., *A Madonna by Vittorio Crivelli*, in 'Art in America', 1943, pp. 29-31

LANZI, L., *Storia pittorica della Italia*, Bassano, 1789.

LAZZARI, A., *Memorie istoriche dei conti duchi di Urbino*, in 'Antichità picene', Fermo, 1795.

LAZZARI, T., *Ascoli in prospettiva*, Ascoli, 1724.

LAZZARINI-MOSCHETTI, *Documenti relativi alla pittura padovana del sec. XV*, in 'Nuovo Archivio Veneto', N.S. XV, Venice, 1908.

LEHMAN, R., *The Philip Lehman collection*, 1928.

LENZI, A., *Il museo Stibbert*, Florence, 1917.

LEONI, A., *Ancona illustrata*, Ancona, 1832, p. 209.

LEOSINI, A., *Monumenti storici ed artistici della città di Aquila*, Aquila, 1848.

LEPORINI, L., *Ascoli Piceno. Guida artistica*, Ascoli Piceno, 1955.

LOESER, C., *I quadri italiani nella Galleria di Strasburgo*, in 'Archivio Storico dell'Arte', 1896, pp. 279-280.

LOGAN BERENSON, M., *Due dipinti in Cleveland*, in 'Rassegna d'Arte', VII, 1907, p. 3.

LOGAN BERENSON, M., *I dipinti italiani a Cracovia*, in 'Rassegna d'Arte', XV, 1915, p. 26.

LONG, B.S., *Catalogue of the Jones Collection, Victoria and Albert Museum*, 1923, p. 6.

LONGHI, R., *Lettera pittorica a G. Fiocco*, in 'Vita artistica', 1926, November, pp. 127-139.

LONGHI, R., *Una coronazione della Vergine di Domenico da Montepulciano*, in 'Vita artistica', 1927.

LONGHI, R., *Un chiaroscuro e un disegno di Giovanni Bellini*, in 'Vita artistica', 1927, p. 134.

LONGHI, R., *Piero della Francesca*, 1927 and Milan, 1947 and 1963.

LONGHI, R., *Officina Ferrarese Roma*, 1934 (II ed. 1956).

LONGHI, R., *Fatti di Masolino e Masaccio*, in 'La Critica d'Arte', 1940.

LONGHI, R., *Viatico per cinque secoli di pittura veneziana*, Florence, 1946.

LONGHI, R., *Calepino Veneziano. Gl'inizi di mastro Antonio da Ancona*, in 'Arte Veneta', 1947, 3, pp. 185-186.

LONGHI, R., *Arcangelo di Cola: un pannello con la 'Sepoltura di Cristo'*, in 'Paragone', 3, 1950.

LONGHI, R., *Prefazione alla 'Guida alla mostra della pittura bolognese del Trecento'*, Bologna, 1950.

LONGHI, R., *Il maestro di Pratovecchio*, in 'Paragone', 35, 1952.

LONGHI, R., *Bramante pittore e il Bramantino di W. Suida*, in 'Paragone', 63, 1955.

LONGHI, R., *Percorso di Raffaello Giovine*, in 'Paragone', 65, 1955.

LONGHI, R., *Crivelli e Mantegna: due Mostre interferenti e la cultura artistica nel 1961*, in 'Paragone', 145, 1962.

LONGHI, R., *Un 'famigliare del Boccati'*, in 'Paragone', 153, 1962.

LOZZI, C., *Una tavola della gioventù di Pietro Alamanni*, in 'L'Arte', V, 1902, pp. 178-180.

LUDWIG, G. VON, *Archivalische Beiträge zur Geschichte der venezianischen Malerei*, (Carlo Crivelli), in 'Jahrbuch der K.Pr. Ksts', Berlin, 1905, pp. 2-4.

LUZI, E., *La Cattedrale Basilica di Ascoli Piceno*, Ascoli, 1850.

LUZI, E., *Le pitture di M. Bonfini, del Maestro Nicola Filotesio e di una tavola di Carlo Crivelli*, in 'Arte e Storia', XI, 1892, pp. 193-196.

MAGAGNATO, L., *De Altichiero a Pisanello* 'Catalogue of the Verona exhibition), Venice, 1958.

MAGGIORI, A., *Le pitture, sculture, architetture di Ancona*, Ancona, 1821.

MAGGIORI, A., *Dell'itinerario d'Italia e sue più nobili curiosità d'ogni specie*, Ancona, 1832, II, p. 219.

MAGGIORI, A., *Manoscritto del sec. XIX*. Fermo, Municipal Library, now being catalogued.

MALAGUZZI VALERI, F., *Catalogo della R. Pinacoteca di Brera*, Bergamo, 1908.

MALTESE, C., *Opere e soggiorni urbinati di Francesco di Giorgio*, in 'Studi artistici urbinati', 1949.

MARABOTTI MARABOTTINI, A., *Allegretto Nuzi*, in 'Rivista d'Arte', 1953.

MARANESI, F., *Gli affreschi di S. Agostino di Fermo*, Fermo, 1914.

MARANESI, F., *Guida storico ed artistica della città di Fermo*, Fermo, 1945.

MARANESI, F., *Mostra di arte sacra antica*, Fermo, 1951.

MARCHINI, G., *Il palazzo ducale di Urbino*, in 'Rinascimento', 1958.

MARCHINI, G., *La Pinacoteca ducale di Urbino*, in 'Bollettino d'Arte', 1960.

MARCHINI, G., *Mostra di affreschi staccati*, Urbino, 1964.

MARCHINI, G., *L'Arte nelle Marche*, in 'Marche', Milan, 1965.

MARCHINI, G., *Lorenzo Salimbeni, 1406*, in 'Commentari', 1966.

MARCHIONNI, *Notizie storiche e statistiche di Offida*, 1889.

MARCOALDI, *Sui quadri dei pittori fabrianesi*, Fornari, 1867.

MARCONI, P. - SERRA, L., *Il Museo Nazionale delle Marche in Ancona*, Rome, 1934, p. 29.

MARCONI, S., *Le Gallerie dell'Accademia di Venezia* (Catalogue), Venice, 1949.

MARIACHER, G., *Il Museo Correr di Venezia*, Venice, 1957.

MARIOTTI, C., *I maestri lombardi in Ascoli P.*, in 'Rassegna Bibliografica dell'Arte Italiana', III, Ascoli Piceno, 1900, pp. 211-217.

MARIOTTI, C., *Oggetti sacri d'argento esulati da Ascoli nel 1796*, in 'Rassegna Bibliografica dell'Arte Italiana', III, Ascoli Piceno, 1900, p. 144.

MARIOTTI, C., *A proposito di un dipinto di C. Crivelli*, in 'Rassegna Bibliografica dell'Arte Italiana', IV, Ascoli Piceno, 1901, pp. 107-113.

MARIOTTI, C., *Intorno ad alcune pitture scoperte nel palazzo del popolo di Ascoli Piceno*, in 'Rassegna Bibliografica dell'Arte Italiana', XV, 1912, pp. 56-60.

MARIOTTI, C., *Musei e Gallerie pontificie*, III, Guida della Pinacoteca Vaticana, Rome, 1913.

MARIOTTI, C., *Ascoli Piceno*, (Italia Artistica n. 69), Bergamo, 1913.

MARIOTTI, C., *Un dipinto votivo di Pietro Alamanni*, in 'Rassegna Marchigiana', V, 1927, pp. 307-311.

MARIOTTI, C., *Intorno a un dipinto di Carlo Crivelli*, in 'Saggi di Storia e d'Arte Ascolana', Ascoli Piceno, 1935.

MARLE, R. VAN, *The Italian Schools of painting*, VIII, 1927.

MARLE, R. VAN, *Die Sammlung Joseph Spiridon*, in 'Cicerone', 1929, p. 185.

MARLE, R. VAN, *The Italian Schools of painting*, XIV, The Hague, 1933.

MARLE, R. VAN, *Una Madonna inedita di G. Schiavone*, in 'Bollettino d'Arte', XXVII, 1934, pp. 485-486.

MARLE, R. VAN, *The Italian Schools of painting*, XV, The Hague, 1934.

MARLE, R. VAN, *The Italian Schools of painting*, XVIII, The Hague, 1936.

MASSIMI, B., *Cola dell'Amatrice*, Amatrice (Rieti), 1939.

MATHER, F.J., *Una Madonna di Carlo Crivelli*, in 'Art in America', 1913, p. 48.

MATHER, F.J., *History of Painting*, 1923, pp. 334-335.

MATHER, F.J., *Venetian Painters*, Chapter VI, London, 1937.

MAZZINI, F., in 'Bollettino d'Arte', 1952.

MAZZINI, F., *Guida di Urbino*, Vicenza, 1962.

MAZZOCCHI, L., *Cola dell'Amatrice* (doctoral thesis, University of Urbino, 1956-57).

MELCHIORRI, S., *Leggenda del Beato Gabriele Ferretti in Ancona etc.*, Ancona, 1844, pp. 70, 74, 77.

MICHELINI TOCCI, L., *I pittori del Quattrocento ad Urbino e a Pesaro*, Pesaro, 1965.

MODIGLIANI, E., *Catalogo della Pinacoteca di Brera*, Milan, 1935.

MOLAJOLI, B., *Ignorati affreschi di Antonio da Fabriano*, in 'L'Arte', XXX, 1927, p. 267.

MOLAJOLI, B., *Gentile da Fabriano*, Fabriano, 1927.

MOLAJOLI, B., *Una tavola di Lorenzo d'Alessandro da Sanseverino*, in 'Rassegna Marchigiana', VI, 1928, pp. 193-198.

MOLAJOLI, B., *Un tabernacolo di Antonio da Fabriano*, in 'Rassegna Marchigiana', VI, 1928, pp. 301-303.

MOLAJOLI, B., *Restauri di dipinti nelle Marche*, in 'Bollettino d'Arte', XXVI, 1932-33, pp. 389.

MOLAJOLI, B., *Pietro Alamanno*, in 'Enciclopedia Italiana', Treccani, XXVII, 1935.

MOLAJOLI, B., *Guida artistica di Fabriano*, Fabriano, 1936, (II ed., 1968).

MOLINER, E., *Le Musée Poldi-Pezzoli à Milan*, in 'Gazette des Beaux-Arts', 1889, p. 309.

MONTEVECCHI, *Delle opere di maestro Gentile da Fabriano*, Pesaro, 1830.

MORASSI, A., *La Regia Pinacoteca di Brera*, Rome, 1932.

MORASSI, A., *Il Museo Poldi-Pezzoli in Milano*, Rome, 1936 (II ed.).

MORELLI, G., *Le opere dei Maestri italiani nelle Gallerie di Monaco, Dresda, Berlino*, Bologna, 1886.

MORELLI, G., *Della Pittura Italiana*, Milan, 1897.

MORONI, *Dizionario di Erudizione Ecclesiastica*, 47, Venice, 1858.

MORTARI, L., *Opere d'arte in Sabina*, Rome, 1957.

MORTARI, L., *La pala di Nicola di Maestro Antonio in casa Massimo*, in 'Bollettino d'Arte', 1961, pp. 147-177.

MOSCHETTI, A., *Schiavone Giorgio*, in 'Thieme-Becker, Allgemeines Lexikon der Bildenden Künstler', Leipzig, XXX, 1936, pp. 48-49.

MOSCHETTI, A., *L'Affresco della Pietà scoperto nella Chiesa degli Eremitani a Padova*, in 'Dedalo', 1925-1926, pp. 701-707.

MOSCHINI MARCONI, S., *La Mostra della Pittura Veneta nelle Marche*, in 'Panorama dell'arte italiana', 1950.

MOSCHINI MARCONI, S., *Galleria dell'Accademia di Venezia*, Rome, 1955.

NATALI, G., *L'Arte nelle Marche*, Rome, 1905.

NATALI, G., *L'Arte Marchigiana a proposito della Esposizione di Macerata*, Macerata, 1906.

NATALI, G. - VITELLI, E., *Storia dell'Arte*, II, Turin, 1914.

OCHENKAWSKI, H., *Galeria Obrazow Katalog Tymozasowy*, Krakow, 1914, n. 26.

OFFNER, R., *The Barberini Panels and their Painter*, in 'Medieval Studies in memory of A. Kingsley Porter', Cambridge Mass., 1939.

ORSINI, B., *Descrizione della Pittura, Architettura di Ascoli*, Perugia, 1790.

ORTOLANI, S., *Raffaella*, Bergamo, 1942 (last ed. 1948 with extensive bibliography).

PACCHIONI, G., *L'opera di Luciano Laurana a Mantova*, in 'Bollettino d'Arte', 1923-24.

PACCHIONI, G., *La Galleria Sabauda a Torino*, Rome, 1951.

PALLUCCHINI, R., *Capolavori dei Musei Veneti (Catalogue)*, Venice, 1946.

PALLUCCHINI, R., *Trésors de l'Art venitien (Catalogue)*, Lausanne, 1947.

PALLUCCHINI, R., *Commento alla Mostra di Ancona*, in 'Arte Veneta', Venice, 1950.

PALLUCCHINI, R., *La Pittura Veneta del Quattrocento*, Istituto di Storia dell'Arte, Università di Padova, 1956-57, I.

PALLUCCHINI, R., *La Pittura Veneta del Quattrocento*, Istituto di Storia dell'Arte, Università di Bologna, 1957-58, II.

PAOLETTI, P., *Catalogo delle RR. Gallerie di Venezia*, Venice, 1903.

PAOLUCCI, A., *Per Girolamo di Giovanni da Camerino*, in 'Paragone', 1970, n. 239.

PAPINI, R., *Il Dono Menotti*, in 'Rassegna d'Arte', XX, 1920, p. 62.

PAPINI, R., *Francesco di Giorgio architetto*, Florence, 1946.

PARRONCHI, A., *L.B. Alberti pittore*, in 'Burlington Magazine', 1962.

PARRONCHI, A., *Studi su la 'dolce' Prospettiva*, Milan, 1964.

PERKINS, F.M., *Pitture Italiane nella Raccolta Johnson a Filadelfia*, in 'Rassegna d'Arte', V, 1905, p. 130.

PERKINS, F.M., *Note sull'Esposizione d'Arte Marchigiana a Macerata, dicembre 1905*, in 'Rassegna d'Arte', VI, 1906, pp. 49-56.

PERKINS, F.M., *Due opere inedite di Vittore Crivelli*, in 'Rassegna d'Arte', VIII, 1908, p. 120.

PERKINS, F.M., *Dipinti Italiani nella Raccolta Platt*, in 'Rassegna d'Arte', XI, 1911, pp. 5, 6.

PERKINS, F.M., *Un dipinto del Crivelli*, in 'Rassegna d'Arte', XI, 1911, p. 207.

PERKINS, F.M., *Un gonfalone di Giovanni Boccati*, in 'Rassegna d'Arte', XII, 1912, pp. 170-171.

PERKINS, F.M., *A painting by C. Crivelli*, in 'Art in America', XI, 1923, pp. 119-122.

PERKINS, F.M., *Lorenzo d'Alessandro*, in 'Thieme-Becker Allgemeines Lexikon der Bildenden Künstler', XXIII, Leipzig, 1929, pp. 389-390.

PIGLER, A., *Regi Keptar Katalogusa*, Budapest, 1954.

PIGNATTI, T., *Pittura Veneziana del Quattrocento*, Bergamo, 1959.

PIRRI, *Gli affreschi di S. Maria in Vallo di Nera*, 1917.

PLATT, D.F., *Una Pietà del Crivelli*, in 'Rassegna d'Arte', VI, 1906, p. 30.

PODESTÀ, A., *La Pittura Veneta nelle Marche alla Mostra di Ancona*, in 'Emporium', November, n. 671, Bergamo, 1950.

PONZI, C., *Il '400 e il piccolo maestro di 'Lu Patullo'*, in 'L'Appennino camerte', 14 Nov. 1959.

PONZI, C., *Gli affreschi della Cappella del Patullo e l'arte Camerinese del '400*, in 'Il Ducato dei Varano', Camerino, 1967.

POUCEY, F., *Pannelli di Cambridge di Carlo da Camerino*, 1948.

PREVITALI, G., *Collezionisti di primitivi nel Settecento*, in 'Paragone', IX, 113, 1959, pp. 8, 13, 14, 17, 18, 25.

PRIJATELJ, K., *Profilo di Giorgio Schiavone*, 'Arte Antica e Moderna', 9, 1960, pp. 47-63.

PROCACCI, U., *Il soggiorno fiorentino di Arcangelo di Cola*, in 'Rivista d'Arte', 1929.

PUYVELDE, L. VAN, *The Taste of John G. Johnson Collection (Pietà)*, in 'Art News', 1941, p. 19.

RAFFAELI, F., *Catalogo di quadri di varie scuole pittoriche raccolti dal conte A. Caccialupi*, Macerata, 1870.

RICCI, A., *Delle opere di Carlo Crivelli nella Marca d'Ancona*, in 'Giornale delle Belle Arti', I, 1833, pp.

RICCI, A., *Memorie storiche delle Arti e degli Artisti della Marca di Ancona*, Macerata, 1834.

RICCI, C., *La Pittura antica alla Mostra di Macerata*, in 'Emporium', February 1906, pp. 100-120.

RICCI, C., *Pietro Alemanno*, in 'Thieme-Becker Allgemeines Lexikon der Bildenden Künstler', I, Leipzig, 1907, p. 166.

RICCI, C., *La Pinacoteca di Brera*, Bergamo, 1907.

RICCI, C., *Cenni storici*, in 'La Pinacoteca di Brera', Bergamo, 1908, p. VI.

RICHTER, J.P., *The Mond Collection*, I, London, 1910, pp. 125-128.

RICHTER, G.M., *Rehabilitation of Fra Carnevale*, in 'Art Quarterly', 1940.

ROMANI, G., *Un Trittico di Giovanni Boccati*, in 'Rivista Critica d'Arte', 1909, vol. I, p. 8.

ROMANI, R., *Affreschi del sec. XV a Bolognola, Villa Malvezzi*, Fabriano, 1926.

ROSSI, A., *Lorenzo di maestro Alessandro pittore severinate*, Perugia, 1876.

ROSSI, A., *Cola dell'Amatrice a Norcia*, in 'Archivio Storico dell'Arte', I, n. 3, Rome, 1888.

ROTONDI, P., *Studi e ricerche intorno a Lorenzo e Jacopo Salimbeni da S. Severino etc.*, Fabriano, 1936.

ROTONDI, P., *Guida del Palazzo Ducale di Urbino*, Urbino, 1948.

ROTONDI, P., *Il Palazzo Ducale di Urbino*, 1950.

ROTONDI, P., *Contributi urbinati al Bramante pittore*, in 'Emporium', 1951.

RUSSOLI, F., *Il Museo Poldi-Pezzoli in Milano*, Florence, 1951.

RUSSOLI, F., *La Pinacoteca Poldi-Pezzoli*, Milan, 1955.

SABBATINI, R., *La scuola di Carlo Crivelli* (doctoral thesis, University of Bologna, 1951-52).

SALMI, M., *Jacopo Bedi*, in 'Art in America', 1923, p. 150.

SALMI, M., *La scuola di Rimini*, in 'Rivista dell'Istituto di Archeologia e Storia dell'Arte', Rome, 1932.

SALMI, M., *Piero della Francesca e il palazzo ducale di Urbino*, Florence, 1945.

SALMI, M., *Masaccio*, Milan, 1948.

SALMI, M., *Contributo a Belbello da Pavia*, in 'Miscellanea Giovanni Galbiati', II, Milan, 1951, pp. 327-328.

SALMI, M., *Mostra dei quattro Maestri del primo rinascimento*, Florence, 1954.

SALMI, M., *Cosmè Tura*, Milan, 1957.

SALVI, G., *La Cappella della Madonna del Popolo in Sanginesio e la Tavola di Pietro Alemanni, pittore Ascolano*, in 'Nuova Rivista Misena', V, Arcevia, 1892, pp. 67-69.

SANTANGELO, A., *Catalogo dei dipinti di Palazzo Venezia*, Rome, 1947.

SANTI, F., *Gli affreschi di Lazzaro Vasari in S. Maria Nuova di Perugia*, in 'Bollettino d'Arte', 1961.

SANTI, F., *La pinacoteca comunale di Gualdo Tadino*, Rome, 1966.

SANTI, G., *Cronaca rimata* (ed. Holbinger, Stuttgart, 1893).

SANTONI, M., *Un trittico bruciato di Arcangelo di Cola da Camerino*, in 'Nuova Rivista Misena', III, 1890.

SANTONI, M. - ALEARDI, V., *La Pinacoteca e il Museo di Camerino*, Camerino, 1903.

SASSI, R., *Documenti di pittori fabrianesi*, in 'Rassegna Marchiagiana', II, 1924, pp. 473-488.

SASSI, R., *Documenti di pittori fabrianesi*, in 'Rassegna Marchigiana', III, 1925, pp. 45-56.

SASSI, R., *La famiglia del pittore Antonio da Fabriano*, in 'Rassegna Marchigiana', V, 1927, pp. 197-201.

SASSI, R., *Arte e Storia fra le rovine di un antico Tempio Francescano*, in 'Rassegna Marchigiana', V, 1927, pp. 247-429.

SCHMARSOW, A., *Melozzo da Forlì*, Berlin, 1886.

SCHMARSOW, A., *Frammenti di una Predella di Masaccio*, in 'L'Arte', X, 1907, pp. 209-217.

SCHMARSOW, A., *Joos van Gent und Melozzo da Forlì in Rom und Urbino*, Leipzig, 1912.

SCHNEIDER, A., *Iuraj Culinovic Hrvatski Slikar XV Veka*, in 'Nova Europa', XXV, Zagreb, 1932, 12, pp. 636-643.

SERRA, L., *Nuovi acquisti della Galleria Nazionale di Urbino*, in 'Bollettino d'Arte del Ministero della Pubblica Istruzione', N.S., I, 1921, p. 273.

SERRA, L., *Itinerario artistico delle Marche*, 1921-1923.

SERRA, L., *Le Gallerie Comunali delle Marche*, Rome, n. d. [1925].

SERRA, L., *Elenco delle opere d'Arte mobili nelle Marche*, Pesaro, 1925.

SERRA, L., *Un nuovo dipinto di Antonio da Fabriano*, in 'Rassegna Marchigiana', III, 1925, p. 338.

SERRA, L., *Nuove attribuzioni a Vittore Crivelli*, in 'Rassegna Marchigiana', VII, 1929, pp. 327-332.

SERRA, L., *L'Arte nelle Marche*, I, Pesaro, 1929.

SERRA, L., *Pietro Alemanno. Due opere anteriori all'influsso crivellesco*, in 'Rassegna Marchigiana', VIII, 1930, pp. 167-185.

SERRA, L., *Il Palazzo Ducale e la Galleria Nazionale di Urbino*, Rome, 1930, pp. 97-98.

SERRA, L., *Pietro Alemanno: Tentativo di una cronologia delle opere*, in 'Rassegna Marchigiana', VIII, 1930, pp. 124-224.

SERRA, L., *Girolamo di Giovanni da Camerino*, in 'Rassegna Marchigiana', VIII, 1930, pp. 246-267.

SERRA, L., *Due opere inedite di Lorenzo d'Alessandro*, in 'Rassegna Marchigiana', IX, 1931, pp. 131-140.

SERRA, L., *La pittura del Rinascimento nelle Marche — Relazioni con l'Arte Umbra*, in 'Rassegna Marchigiana,' IX, 1931, pp. 279-293.

SERRA, L., *Crivelli Carlo*, in 'Enciclopedia italiana', Treccani, XI, 1931.

SERRA, L., *Crivelli Vittorio*, in 'Enciclopedia italiana', Treccani, XI, 1931.

SERRA, L., *La pittura del rinascimento nelle Marche. Relazioni con la scuola veneta*, in 'Rassegna Marchigiana', X, 1932, pp. 67-86; 93-113.

SERRA, L., *Francesco di Gentile da Fabriano*, in 'Rassegna Marchigiana', XI, 1933, pp. 73-109 (with bibliography).

SERRA, L., *L'arte nelle Marche*, II, Rome, 1934.

SERRA, L., *L'Arte nelle Marche*, in 'Rassegna Marchigiana', XII, 1934, pp. 395-405.

SERRA, MOLAJOLI, ROTONDI, *Inventario degli oggetti d'arte delle Provincie di Ancona ed Ascoli Piceno*, Rome, 1936.

SERVANZI COLLIO, S., *Resto d'una tavola presso il valente intagliatore in legno Venanzio Bigioli*, in 'Il Tibenno. Giornale artistico, letterario, istruttivo con varietà', VIII, n. 50, 1843.

SERVANZI COLLIO, S., *Pittura in tavola di C. Crivelli nella Chiesa di S. Francesco di Matelica*, in 'Il Raffaello', 1879, (Off-print from nos. 2-3, Urbino, 1879, pp. 38-39).

SHAPLEY, F.R., *Paintings from the Samuel H. Kress Collection. Italian Schools XIII-XV Century*, London, 1966.

SIEPI, *Descrizione di Perugia*, 1822.

STERLING, C., *Catalogo dell'Esposizione della Collezione Lehman di New York al Museo de l'Orangerie*, Paris, 1957, pp. 10-11.

SUIDA, W., *Italian primitives in the Marinucci collection in Rome*, in 'Apollo', 1934, p. 122.

SUIDA, W., *Catalogue of the S. H. Kress Collection of Italian painting*, The Rockhill Gallery, Kansas City, Missouri, 1952.

SUIDA, W., *Bramante pittore e il Bramantino*, Milan, 1953.

SUIDA, W., *The S. H. Kress Collection*, in the Honolulu Academy of Arts, Honolulu, 1952.

SWARZENSKI, G., *The Master of the Barberini Panels: Bramante*, in 'Bulletin of the Museum of Fine Arts', Boston, XXXVIII, (1940).

TEREY, G. DE, in 'Zeitschr. f. bildende Kunst', XXXIII, 1893, p. 170.

TEREY, G. DE, *Catalogue of the paintings by old Masters*, (Budapest, National Museum), Budapest, 1931, p. 31.

TESTI, L., *Storia della Pittura Veneziana*, II, Bergamo, 1915.

THIEME-BECKER, *Francesco di Gentile*, in 'Allgemeines Lexikon der Bildenden Künstler', XII, Leipzig, 1916, pp. 302-303.

TICOZZI, S., *Dizionario degli Architetti, scultori e pittori...*, Milan, 1830.

TIETZE, H. - TIETZE CONRAT, E., *The Drawings of the Venetian Painters*, New York, 1944, p. 164.

TOESCA, P., *Storia dell'arte italiana, il Trecento*, Turin, 1951.

TOSCANO, B., *Bartolomeo di Tommaso e Nicola da Siena*, in 'Commentari', 1964, pp. 37-51.

URBANI, G., *Leonardo da Besozzo e Perinetto da Benevento dopo il restauro degli affreschi di San Giovanni a Carbonara*, in 'Bollettino d'Arte', 1953, pp. 297-306.

URBINI, G., *Bernardino di Mariotto*, in 'Augusta Perusia', 1907, p. 161.

UVODIC, A., *Iuraj Culinovic*, Spalato, 1933.

VALENTINER, R., *Bulletin of the Detroit Institute of Arts*, VI, 1924-25, p. 87.

VALENTINER, R., *Unknown Masterpieces*, 1930, p. 20.

VANDOYER, J.L., *Venetian Painting*, London, 1958, pp. 12, 49.

VASARI, G., *Le vite de' più eccellenti pittori ecc.*, I ed. 1550, II ed. 1578 (ed. Milanesi, Florence).

VASARI, G., *Le vite di Gentile da Fabriano e Pisanello a cura di A. Venturi*, Florence, 1899.

VENTURI, A., *La Galleria Naz. di Roma*, in 'Le Gallerie Italiane', II, Rome, 1896, p. 137.

VENTURI, A., *La Madonna nell'Arte*, Milan, 1900.

VENTURI, A., *G. Cantalamessa, C. Crivelli, frammenti di uno studio ecc.* (review), in 'L'Arte', X, 1907, p. 398.

VENTURI, A., *Studi sull'arte umbra del '400*, in 'L'Arte', 1909, XII, pp. 188-202.

VENTURI, A., *Bibliografia artistica* (review), in 'L'Arte', XIII, 1910, p. 398.

VENTURI, A., *Di Arcangelo di Cola da Camerino*, in 'L'Arte', XIII, 1910, pp. 377-381.

VENTURI, A., *Storia dell'Arte Italiana*, Vol. VII, 1, Milan, 1911.

VENTURI, A., *Storia dell'Arte Italiana*, Vol. VII, 2, Milan, 1913.

VENTURI, A., *Storia dell'Arte Italiana*, Vol. VII, 3, Milan, 1914.

VENTURI, A., *Storia dell'Arte Italiana*, Vol. VII, 4, Milan, 1915.

VENTURI, A., *North Italian painting of the Quattrocento*, VII, 1930.

VENTURI, L., *Le origini della Pittura Veneziana*, Venice, 1907.

VENTURI, L., *Nella Galleria Nazionale delle Marche*, in 'Bollettino d'Arte', VIII, 1914.

VENTURI, L., *A traverso le Marche*, in 'L'Arte', XVIII, 1915, pp. 172-208.

VENTURI, L., *Alcune opere della Collezione Gualino nella R. Pinacoteca di Torino*, 1928.

VENTURI, L., *Contributi di Carlo Crivelli, a Vittore Carpaccio*, in 'L'Arte', n. s., I, 1930, pp. 384-395.

VENTURI, L., *Contributi a Masolino, a Lorenzo Salimbeni e a Jacopo Bellini*, in 'L'Arte', 1930.

VENTURI, L., *Pitture Italiane in America*, Milan, 1931.

VENTURI, L., *Italian painting in America*, II, New York, 1933.

VENTURI, L., *Il caso Crivelli*, in 'L'Européa letteraria', 1961, pp. 289-291.

VERTOVA, L., *Early Italian paintings at the Orangerie*, in 'Burlington Magazine', 1956, pp. 310, 312.

VESPASIANO DA BISTICCI, *Vita di Federico da Urbino*, in 'Collezioni d'opere inedite o rare', I, Bologna, 1892.

VITALINI SACCONI, G., *Pittura Marchigiana: La Scuola camerinese*, Trieste, 1968.

VOLPE, C., *La Pittura riminese del Trecento*, Milan, 1965.

WAAGEN, G.F., *Verzeichnis der Gemälde, Sammlung des Königlichen Museums in Berlin*, Berlin, 1830.

WAAGEN, G.F., *Treasures of Art in Great Britain*, II, London, 1854.

WAAGEN, G.F., *Galleries and Cabinets of Art in Great Britain*, vol. IV, London, 1857.

WEALE-RICHTER, *Catalogue of the Pictures of the Earl of Northbrook - of the Italian School*, 1880.

WEBER, S., *Fiorenzo di Lorenzo*, Strasbourg, 1905, pp. 11-14.

WERZSACHER, H., *Katalog der Gemälde des Städelschen Kunstinstituts*, I, Aeltere Meister, Frankfurt, 1900, pp. 80-81.

WITTGENS, F., *Il Museo Poldi Pezzoli a Milano*, Milan, 1937.

ZACCARINI, D., *Antonio Alberti il suo maestro etc.*, in 'L'Arte', 1914.

ZAMPETTI, P., *Catalogo della Mostra della Pittura Veneta nelle Marche*, Bergamo, 1950.

ZAMPETTI, P., *La Mostra della Pittura Veneta nelle Marche*, in 'Bollettino d'Arte', 1950, pp. 372-375.

ZAMPETTI, P., *Considerazioni su Pietro Alemanno*, in 'Arte Veneta', 1951, pp. 101-110.

ZAMPETTI, P., *Il Polittico di Carlo Crivelli nel Duomo di Ascoli Piceno*, in 'Emporium', December, 1951, pp. 242-256.

ZAMPETTI, P., *Un Polittico poco noto di Carlo e Vittorio Crivelli*, in 'Bollettino d'Arte', 1951, pp. 130-138.

ZAMPETTI, P., *Carlo Crivelli nelle Marche*, Urbino, 1952.

ZAMPETTI, P., *La Mostra d'Arte Sacra a Fermo*, in 'Bollettino d'Arte', 1952, pp. 89-90.

ZAMPETTI, P., *Il Palazzo Ducale di Urbino e la Galleria Nazionale delle Marche*, Rome, 1952 and 1956, II ed.

ZAMPETTI, P., *Antichi dipinti restaurati*, Urbino, 1953.

ZAMPETTI, P., *Gli affreschi di Lorenzo e Jacopo Salimbeni nell'Oratorio di S. Giovanni di Urbino*, Urbino, 1956.

ZAMPETTI, P., *Carlo Crivelli a Zara*, in 'Arte Veneta', 1960, pp. 227-228.

ZAMPETTI, P., *Il Crivelli nelle Marche*, in 'Rivista di Ancona', November-December 1960, n. 6, pp. 26-31.

ZAMPETTI, P., *Carlo Crivelli e i Crivelleschi* (Catalogue of the exhibition), Venice, 1961.

ZAMPETTI, P., *Carlo Crivelli*, Milan, 1961.

ZAMPETTI, P., *La pittura del Quattrocento nelle Marche e i suoi rapporti con quella Veneta*, in 'Umanesimo Europeo e Umanesimo Veneziano', Florence, 1963.

ZAMPETTI, P., *Una chiesa eremitica ed un'antologia pittorica*, in 'Atti e Memorie. Deputazione Storia e Patria per le Marche', Ancona, 1966.

ZAMPETTI, P., *Carlo Crivelli e l'ambiente artistico Marchigiano del sec. XV*, in 'Rinascimento Europeo e Rinascimento Veneziano', Florence, 1967.

Zampetti, P., *Libro di spese diverse di Lorenzo Lotto*, Venice-Rome, 1969.

Zampetti, P., *Master of Patullo*, in 'A dictionary of Venetian Painters', Leigh-on-Sea, I, 1969.

Zanetti, *Della Pittura Veneziana*, V, Venice, 1771, pp. 18-19.

Zanotto, *Venezia e le sue Lagune*, Venice, 1847.

Zeri, F., *Giovanni Antonio da Pesaro*, in 'Proporzioni', 1948, pp. 164-165.

Zeri, F., *Carlo da Camerino*, in 'Proporzioni', 1948.

Zeri, F., *A proposito di Ludovico Urbani*, in 'Proporzioni', 1948, p. 167.

Zeri, F., *Arcangelo di Cola da Camerino: due tempere*, in 'Paragone', 7, 1950.

Zeri, F., *A Lunette above Crivelli's St. Peter and St. Paul*, in 'Burlington Magazine', XCII, 1950, p. 197.

Zeri, F., *Un affresco del Maestro dell'Incoronazione di Urbino*, in 'Proporzioni', 1950.

Zeri, F., *Trenta dipinti antichi della collezione Saibene*, Milan, 1955.

Zeri, F., *Arcangelo di Cola: due tempere*, in 'Paragone', 1952.

Zeri, F., *Il Maestro dell'Annunciazione Gardner*, in 'Bollettino d'Arte', 1953, p. 125.

Zeri, F., *Qualcosa su Nicola di Maestro Antonio*, in 'Paragone', IX, 1958, pp. 34-41.

Zeri, F., *Due dipinti, la filologia e un nome. Il Maestro delle tavole Barberini*, Turin, 1961.

Zeri, F., *Cinque schede su Carlo Crivelli*, in 'Arte Antica e Moderna', 1961.

Zeri, F., *Appunti nell'Ermitage e nel Museo Puskin*, in 'Bollettino d'Arte', 1961, pp. 219-236.

Zeri, F., *Bartolomeo di Tommaso da Foligno*, in 'Bollettino d'Arte', 1961, pp. 41-64.

Zeri, F., *Un unicum su tavola del Maestro di Campodonico*, in 'Bollettino d'Arte', IV, 1963.

Zeri, F., *Opere maggiori di Arcangelo di Cola*, in 'Antichità viva', November-December 1969.

Zocca, E., *Le decorazioni della stanza dell'Eliodoro e l'opera di Lorenzo Lotto a Roma*, in 'Rivista dell'Istituto Nazionale di Archeologia e Storia dell'Arte', Rome, 1954.

## COLOUR PLATES

I. Allegretto Nuzi: *St. Mary Magdalen*. Detail from a polyptych. Fabriano, Pinacoteca Civica.

II. Anonymous Painter from Fabriano, 14th-15th century: *The Crucifixion*. Fabriano, Pinacoteca Civica.

III. Gentile da Fabriano: *The Coronation of the Virgin*. Detail from plate 5. Milan, Brera.

IV. Gentile da Fabriano: *Watching Shepherdesses*. Detail from plate 12. Florence, Uffizi.

V. Gentile da Fabriano: *Two Ladies*. Detail from plate 12. Florence, Uffizi.

VI. Jacobello del Fiore: *St. Lucy dragged by oxen*. Fermo, Pinacoteca Civica.

VII. Jacobello del Fiore: *St. Lucy in the Burning Bush*. Fermo, Pinacoteca Civica.

VIII. Antonio da Fabriano: *Virgin and Child*. Matelica, Museo Piersanti.

IX. Carlo da Camerino: *Virgin Annunciate*. Detail from plate 46. Urbino, Galleria Nazionale.

X. Arcangelo di Cola: *Madonna of Humility*. Ancona, Pinacoteca Civica.

XI. Arcangelo di Cola: *Virgin and Child Enthroned*. Osimo, church of S. Marco.

XII. Arcangelo di Cola: *Virgin and Child with two Angels*. Camerino, Pinacoteca Civica.

XIII. Giovanni Boccati: *Saints and Angels*. Detail from plate 59. Perugia, Galleria Nazionale.

XIV. Giovanni Boccati: *The Embracement*. Detail from the predella of the polyptych (plate 68). Belforte del Chienti, Parish church of S. Eustacchio.

XV. Gerolamo di Giovanni: *The Crucifixion*. Sarnano, church of S. Maria di Piazza.

XVI. Master of Patullo: *The Lamentation over the Dead Christ*. Camerino, Pinacoteca Civica.

XVII. Lorenzo Salimbeni: *The Mystic Marriage of St. Catherine*. Detail from plate 98. San Severino Marche, Pinacoteca Civica.

XVIII. Lorenzo Salimbeni: *The Martyrdom of St. Stephen*. Detail from plate 99. San Ginesio, Crypt of the Collegiata.

XIX. Lorenzo Salimbeni: *The Madonna of Paradise*. Urbino, Oratorio di San Giovanni.

XX. Jacopo Salimbeni: *Virgin and Child with Saints Sebastian and John Baptist*. Urbino, Oratorio di San Giovanni.

XXI. Lorenzo and Jacopo Salimbeni: *The Virgin and the Holy Women*. Detail from plate 104. Urbino, Oratorio di San Giovanni.

XXII. Lorenzo and Jacopo Salimbeni: *The Baptism of Christ*. Urbino, Oratorio di San Giovanni.

XXIII. Lorenzo and Jacopo Salimbeni: *St. John Baptist and King Herod*. Detail from plate 120. Urbino, Oratorio di San Giovanni.

XXIV. Ludovico Urbani: *The Martyrdom of St. Sebastian*. Detail from plate 126. Recanati, Museo Diocesano.

XXV. Lorenzo d'Alessandro: *The Baptism of Christ*. Urbino, Galleria Nazionale.

XXVI. Carlo Crivelli: *Two Saints*. Detail from a polyptych. Ascoli Piceno, Duomo.

XXVII. Carlo Crivelli: *Virgin and Child*. Ancona, Pinacoteca Civica.

XXVIII. Pietro Alemanno: *The Virgin adoring the Child*. Detail from plate 145. Montefortino, Pinacoteca Civica.

XXIX. Anonymous Follower of Crivelli: *Virgin and Child*. Fermo, church of S. Agostino.

XXX. Paolo da Visso (?): *Sacra Conversazione*. Detail from plate 155. Ascoli Piceno, Pinacoteca Civica.

XXXI. Nicola di Maestro Antonio da Ancona: *Pietà*. Jesi, Pinacoteca Civica.

XXXII. Nicola di Maestro Antonio da Ancona: *The Angel of the Annunciation*. Detail from plate 162. Urbino, Galleria Nazionale.

XXXIII. Piero della Francesca: *The Flagellation of Christ*. Urbino, Galleria Nazionale.

XXXIV. Piero della Francesca: *The Madonna of Senigallia*. Urbino, Galleria Nazionale.

XXXV. Piero della Francesca: *Federico da Montefeltro*. Detail from plate 163. Milan, Brera.

XXXVI. Pedro Berruguete: *Federico da Montefeltro and his son Guidobaldo*. Detail. Urbino, Galleria Nazionale.

274

# ACKNOWLEDGEMENTS

The publishers are grateful to the following photographers and collections for the supply of photographic material:

Aix, Fréquin: 58

Baltimore, Walters Art Gallery: 38, 39

Berlin East, Bodemuseum: 165

Berlin West, Walter Steinkopf: 3, 4

Boston, Isabella Stewart Gardner Museum: 135

Budapest, Museum of Fine Art: 179

Cambridge, Fitzwilliam Museum: 48, 49

Camerino, Foto Carnevali: 28, 87, 88, 89, 90, 92

Cleveland, Museum of Art: 47

Florence, Alinari: 30, 78, 173, 175, 176, 186, 187

Florence, Berenson Archive: 52, 152, 156

Florence, Scala: XXXIII

Florence, Gabinetto Fotografico degli Uffizi: 69, 149

Helsinki, Ateneum: 61

Lille, Studio Gérondal: 178

London, Her Majesty the Queen: 133

London, National Gallery: 17

Milan, Electa Archive: 162

Milan, Bruno Pagani, Electa: IV, V, 8, 9, 10, 12, 15, 18, 19

Milan, Mario Perotti: 7

New Haven, Yale University Art Gallery: 16

New York, Metropolitan Museum of Art: 74, 75

Palermo, Soprintendenza alle Gallerie: 70

Paris, Giraudon: 13, 14, 71

Paris, Jean Paul Sudre: 129

Philadelphia, John G. Johnson Collection: 53, 54, 55, 56, 57

Pistoia, Foto Zenit-Color: 151

Ponce, Museo de Arte: 40

Rome, Gabinetto Fotografico Nazionale: 34, 36, 37, 82, 105, 106, 108, 116, 132, 141, 161, 168, 169

Rome, Archivio Fotografico Vaticano: 21, 22, 23

Southampton, Art Gallery: 2

Urbino, Foto Moderna: 164

Urbino, Soprintendenza alle Gallerie: 29

Venice, Fondazione Giorgio Cini: 63, 72, 80, 81

Venice, Foto Rossi: 50, 62

Washington, National Gallery of Art: 20, 73

*Special thanks are due to Federico Zeri for pl. 24. All the other black and white and colour photographs are the work of Bruno Balestrini, Director of the Photographic Department of Electa Editrice.*